UNDERSTANDING AND CREATING ART

Second Edition

Book One

UNDERSTANDING AND CREATING ART

Second Edition

Ernest Goldstein
Theodore H. Katz
Jo D. Kowalchuk
Robert J. Saunders

West Publishing Company
St. Paul New York Los Angeles San Francisco

ABOUT THE AUTHORS

Ernest Goldstein is an art critic, educator, and author of books on art, literature, and film. He is the creator of the *Let's Get Lost in a Painting* series and author of four of the books in the series: *The Gulf Stream, The Peaceable Kingdom, Washington Crossing the Delaware,* and *American Gothic.*

Theodore H. Katz, Ed.D. is an artist, teacher and administrator. Formerly Chief of the Division of Education of the Philadelphia Museum of Art, he has created model programs in art education throughout the United States for the Ford Foundation, Carnegie Corporation, National Endowment for the Arts and Humanities and the Smithsonian Institution. He is the author of *Museums and Schools: Partners in Teaching.*

Jo D. Kowalchuk has recently retired from the position of Program Specialist in Arts Curriculum for the Palm Beach County Schools in Florida. She has taught art in Alabama, Georgia, and Florida. She has served as Vice President of the National Art Education Association and has served on the Editorial Advisory Board of *School Arts* magazine. She is an active member of Delta Kappa Gamma International.

Robert J. Saunders, Ed.D. is Art Consultant for the Connecticut Department of Education and has taught art in California, New York, and New Jersey. He is the author of several books in art education including *Teaching Through Art* and *Relating Art and Humanities to the Classroom.* With Ernest Goldstein he co-authored *The Brooklyn Bridge* in the *Let's Get Lost in a Painting* series. He is a frequent contributor to art education journals.

Editorial Development and Supervision

Charles W. Pepper

CONTRIBUTORS

Several Activities, Annotations:
Elizabeth L. Katz and Janice Plank
Whitehall City Schools
Whitehall, Ohio

Photography Activities:
Constance J. Rudy
Palm Beach County Schools
Palm Beach, Florida

Printmaking Activities:
Elizabeth Kowalchuk
Palm Beach County Schools
Palm Beach Florida

Computer Activities:
Dr. Linda L. Naimi
Consultant, Computer Technology
State Department of Education
Hartford, Connecticut

Craft Activities:
Maryanne Corwin
Palm Beach County Schools
Palm Beach, Florida

Watercolor Activities:
Susan Carey
Eau Claire City Schools
Eau Claire, Wisconsin

Student Art Work from:
Joanna Brown & Paul Krepps
Art Specialists
Palm Beach County Schools
Palm Beach, Florida

Nellie Lynch
Art Supervisor, Duval County
Jacksonville, Florida

Fran Phelps
Art Specialist, Jacksonville Museum
Jacksonville, Florida

Janice Rice
Art Supervisor
Alachua County
Gainesville, Florida

Cover: Diego Velásquez. *The Maids of Honor* (Las Meninas), 1656. Oil on canvas. 10′ 5 1/4″ × 9′ 3/4″. The Prado Museum, Madrid. Courtesy of The Granger Collection. *Back cover:* Gianlorenzo Bernini, *David* 1623. Marble. Life-size. Galleria Borghese, Rome. *Page iii:* Detail from Winslow Homer, *The Gulf Stream,* 1899. Oil on canvas, 28″ × 49″. The Metropolitan Museum of Art, New York, NY. Wolfe Fund, 1906. Catherine Lorillard Wolfe Collection. *Page iv:* Diego Rivera, *Zapatista Landscape—The Guerilla.* 1915. Oil on canvas. Detroit Institute of Art.

CONTENTS

PART II

THE ARTIST IN THE COMMUNITY 153

UNIT 4

LET'S GET LOST IN A PAINTING: AMERICAN GOTHIC 155

Review, The Visual Elements of Art 193

Review, The Compositional Principles of Design 194

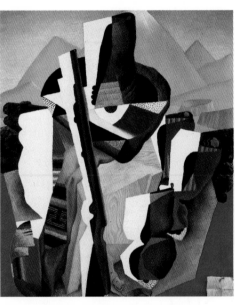

UNIT 5

FORMS OF EXPRESSION 197

UNIT 6

SPECIAL PROJECTS 287

PART III
ART APPLICATIONS 295

UNIT 7
THE ART MUSEUM EXPERIENCE 297

UNIT 8
COMPUTERS AND ART 305

UNIT 9
CARTOONS, ANIMATION AND ENTERTAINMENT 313

INTRODUCTION

The philosopher Aristotle, in the fourth century, B.C., placed a higher value on artistic truth than on political truth. Aristotle believed that any era in history can be understood better by a study of its art than by a study of its historic events, places, kings, treaties, and warriors.

Through the centuries scholars have attempted to explain precisely why art is so important to human beings. Most agree that art satisfies a number of human needs. Art satisfies us by allowing personal expression communicating the joy and sorrow of life and death, by expressing the most personal feelings of the mind and soul, and by recording the glories and tragedies of a society.

This book is devoted to the visual arts. You will become involved in making art, looking at and discussing art of your own and of others. You will study art history and the relationships of the arts to the culture from which they came, and make and justify judgments about aesthetic merit.

There are two principle themes in this book which give the names to the two major parts—*The Artist and Nature* and *The Artist in the Community*. A great deal of visual art has been devoted to these themes. In each part you will first study one significant work of art in depth. Next, you will look closely at the visual elements artists use in creative expression and the rules of composition that guide their use. You will then see examples of how many artists have applied these visual elements in several forms of expression and create your own art in the various forms.

Whether you choose a career in art or not, this art course will be of enormous importance to you for the rest of your life. Its content will provide a foundation in what is popularly called cultural and visual literacy. The understanding of the visual world is essential for a successful career in any field in the twenty-first century.

Many years after Aristotle's time, art was termed "the persistent event." This means that the work of art remains as a testament to its age long after the great figures of an era are dead. When the social, economic, political, and technological influences of an age have been changed, discarded, forgotten, or lost, the art of that time is still alive. Thus, the artist is the only victor in the human struggle against time.

Ernest Goldstein
Theodore H. Katz
Jo D. Kowalchuk
Robert J. Saunders

PART

I

THE
ARTIST
AND
NATURE

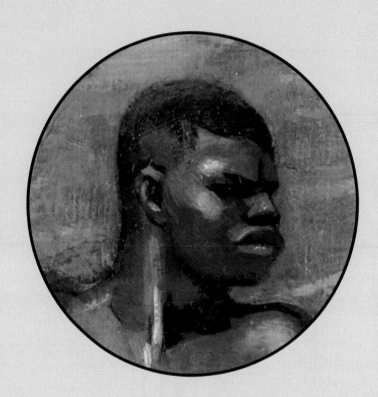

A detail from *The Gulf Stream*.

LET'S GET LOST
IN A PAINTING

The Gulf Stream
by Winslow Homer

Did you ever look at a painting and say to yourself, "I like it. I don't know why, I just like it?" And did you ever wonder what the artist did to make you feel that way?

*As you enter the world of Winslow Homer's **The Gulf Stream**, you will seek answers to these questions and many others. The real fun will be in the challenge to look and find the answers yourself. They may be quite different from anyone else's. That is not important. In the end, only you can say whether you like it—or even decide what it means. Before you begin, turn the page and study the painting.*

Figure 1. *The Gulf Stream* by Winslow Homer. (Pages 4-5) Winslow Homer, *The Gulf Stream*. 1899. Oil on canvas, 28" x 49". The Metropolitan Museum of Art, New York, NY. Wolfe Fund, 1906. Catherine Lorillard Wolfe Collection.

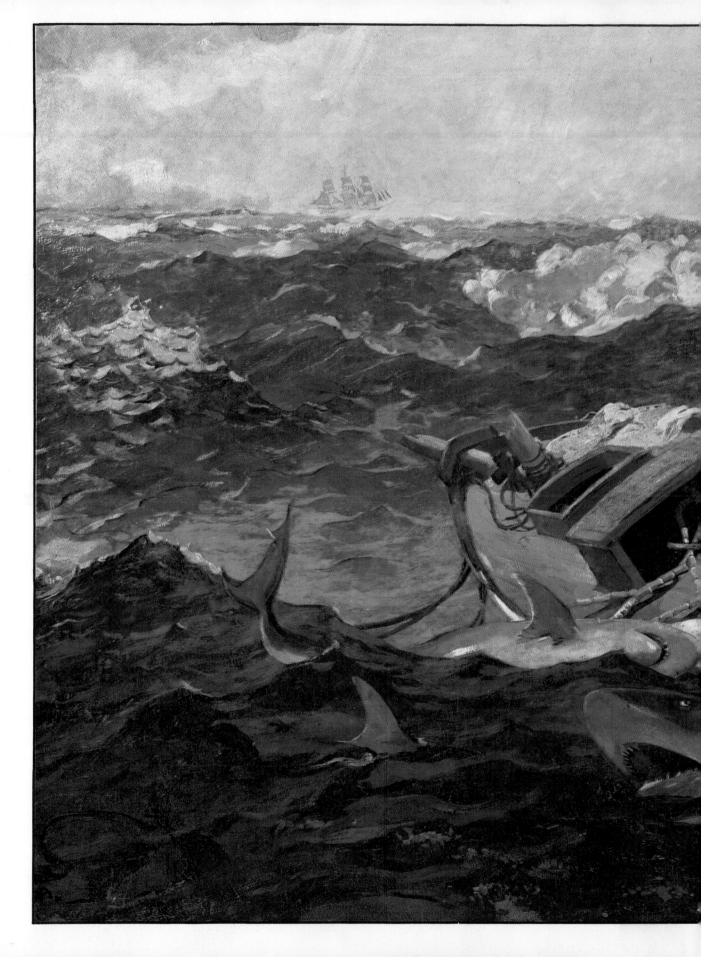

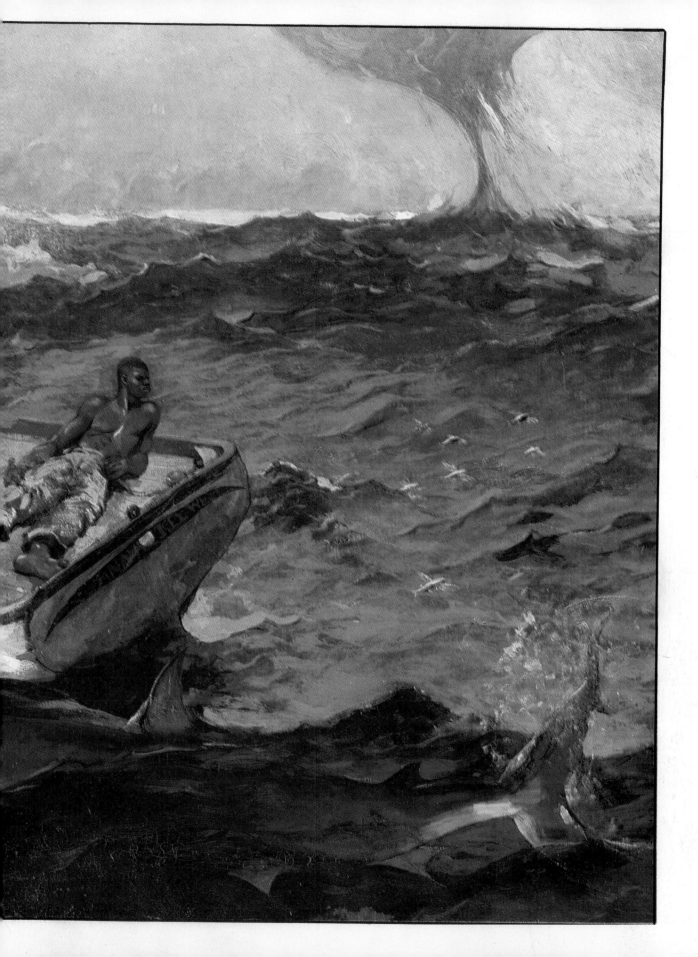

PAINTING A STORY

What's happening here? We see a storm, a shipwreck, and hungry sharks waiting for a human meal. But the sharks are not really waiting; one of them is trying to jump into the boat. That big one in front with the scary eye and jaws full of terrible teeth wants to leap right out of the picture and bite the viewer.

The ocean is full of sharks. How many do you see in the painting? Count them! One…two…three…maybe four or five? A hundred beneath the water possibly? Try again. That big one in front—is that his tail in the lower right corner? Or are there two different sharks? How can you tell? Place your finger on the head and trace the line into the water back to the tail. Still not sure? The artist wants you to think there are many sharks. Even when the artist plays tricks with your eyesight, the answer is there. Some detective work is needed.

Figure 2. Detail from *The Gulf Stream* (Figure 1).

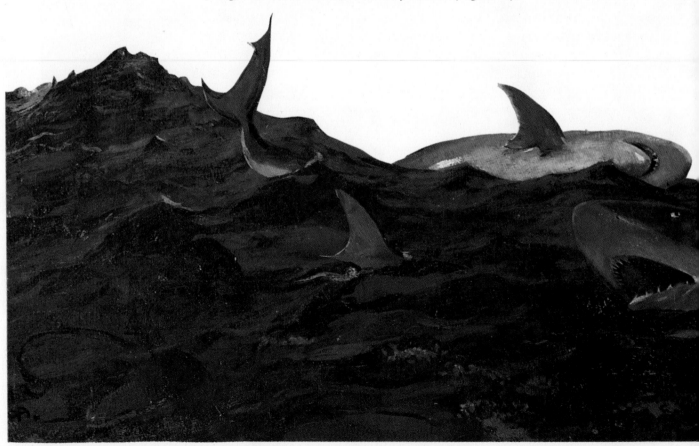

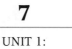

Figure 3. Shark fins.

The clue is in the fins. Look at the illustration (Figure 3) and study the different kinds of shark fins.

Now go back to that big shark in the front. The fins on top separated by the water are the dorsal fins. You can almost make out the pectoral fin below and near the mouth. In the water is the pelvic fin, followed by the anal fin and the big lopsided tail swishing red spray.

There is one shark in front. A second shark is near the boat and again its body is separated by the water. Can you name the big fin almost touching the cabin? You are right if you called it the pectoral. There is another pectoral fin—of a third shark! You know what it is because the shape is the same as the large pectoral fin of the shark near the boat. Now can you see the three sharks? Before reading on, try making your own sketch of them in the water. Which way

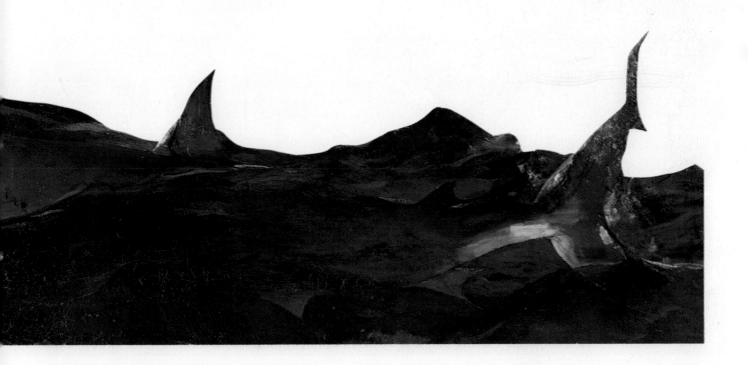

are they moving? The outline shown in Figure 4 is what the artist has in mind.

If your eye is really sharp, you can even tell the kind of shark. Find the tail of the shark near the boat. Trace the line of the fin and you will come to a funny hitch. That hitch and the round, pointed snout reveal it is a sand shark.

Now that you know the number of sharks you might ask, "So what?" What does it tell you about the painting? The answer is not in what you see, but how you look. You get the feeling of an ocean full of monsters. Yet there are only three. Looking at a painting is like solving a puzzle. The artist has given the clues. Now you must find them.

If the sharks do not get the man, there is still more danger out there. Look at the ocean. The water is rough, and the waves are high. In the right rear corner of the

Figure 4. Outline of sharks in detail from *The Gulf Stream* (Figure 1).

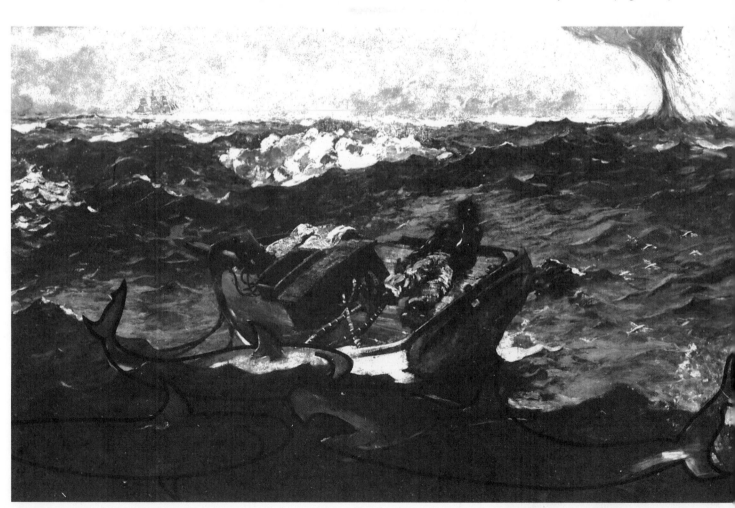

Figure 5. Detail of the waterspout in *The Gulf Stream* (Figure 1).

painting there is more trouble. Big trouble. A waterspout (Figure 5). A waterspout is a tornado on the water. Sailors have a very simple rule about it: DANGER, get away fast! That sailing ship on the left-hand side got the message. It is at full sail going as fast and as far away as possible.

Is the storm coming toward the man in the boat, or has it already gone by? Waterspouts are tricky and follow no one direction. How can you tell, or *can* you tell? The boat tells a lot. A bowsprit is the large pole that holds the sail. Here, the bowsprit is broken. Sails are hanging over the boat and the rudder is gone. The boat is helpless and drifting out of control. The man and his boat have been through a storm—perhaps caused by the waterspout.

Waterspouts are common in the Gulf Stream. Now, how do you know it is the Gulf Stream? Even if you do not know the title, the artist gives clues. First, the name of the boat, painted on the back, is *Anne of Key West*. Key West is at the

tip of Florida (see Figure 6). Second, sand sharks and flying fish—those specks of white to the right of the boat—are found in the Gulf Stream off the coast of Florida. Third, the Gulf Stream is marked by deep blue water that is much bluer than the ocean around it.

Winslow Homer finished painting *The Gulf Stream* in 1899. The date is in black at the lower left corner. From the very first time it was shown, people have been frightened by it. It is called a dramatic painting because you can "read" it like a drama or story—a horror story!

If the sharks or the storm do not get the man, there is still trouble. The boat could plow into a reef. That big white curlicue behind the boat may be caused by waves crashing over a coral reef. Or again, all alone, deserted by the only possible help—a ship going the other way—with no food or water, the man could starve to death. So, his end could be near. Anyway, that is what you see at first glance, and that is what everyone has always seen, a frightening picture.

When the painting was first shown in a museum, a group of confused people wrote to Winslow Homer and asked him to explain what he meant. Homer gave the following answer: "The sharks and the boat are not important to the picture. They have been blown out to sea by a hurricane. The man on the boat, who seems so hot and dazed, will be rescued and live happily ever after."

What a strange thing to say! Naturally, nobody believed him then, and to this day, people continue to think the worst. How is a happy ending possible when death seems so close?

Homer said that the man will live "happily ever after." Perhaps he was kidding, but maybe he wasn't. Remember, his letter said that the sharks and the boat were not important to the picture. So, what is the story about? When a great artist does a dramatic painting, he does not give you the whole story. He selects one moment, one special moment when time stands still on the canvas. It is the moment that puts you inside and tells everything—what happened and what will happen. Now, return to the picture and find that moment.

Figure 6. Map of the Gulf Stream and the Keys off the tip of Florida, with inset detail from *The Gulf Stream* (Figure 1). ➤

COLOR AND LIGHT

If the ocean has danger, it also has great beauty. A viewer once told the famous English ocean painter, J. M. W. Turner, that she had never seen the colors of the water that he had put in his painting. Turner responded, "Ah, but don't you wish you could?" And that's the same feeling you get from the blues, blue greens, violets, sapphires, and emeralds of *The Gulf Stream*.

Try to imagine where the sun is. You say it is not there? But it is. Sunlight is falling directly on the boat. Homer shows the position of the sun by means of shadow and color. If you wanted to discover that position through shadows, here is one possible solution. Study the diagram in Figure 7 for help. You can see the shadow on the sugarcane, the man, and the mast. The shadow on the sugarcane falls at an angle. If a line is drawn from the cane to the cabin cover, it moves up to the right. The shadows on the man point to the light overhead. When you line up these shadows with those of the mast, they all line up above his head. The sun is directly above his head.

Homer's use of brown is another clue to the position of the sun. There are dark browns, almost in shadows, on the side of the cabin and lower left side of the boat. There are sunny white browns on the upper part of the deck and pink-and-white browns on top of the cabin and on the sailor's skin. If you go to the Metropolitan Museum of Art in New York City and see the original painting, get close to it. You will see how much variety Homer puts into his browns.

Homer knew the laws of color and understood that the best way to contrast the rich variety of browns was by the use of black and white. He often said that the proper use of black and white can suggest color. Now look at the whites. The tropical sun overhead is very strong. It is so hot that you can see white beads of perspiration on the man's dark skin. Direct sunlight is falling on the warm whites of the sail, on the man's body, pants, and on the lower corner of the boat. The white becomes less bright when it is picked up on the flying fish and the sharks. Toward the waterspout the white looks cold, like the green of the crashing waves. Notice the solid white line between the blue-gray waterspout and the sailing ship (Figure 8). At first, the white border seems like the horizon, but it is not. It is probably foam coming off the waves whipped up by the

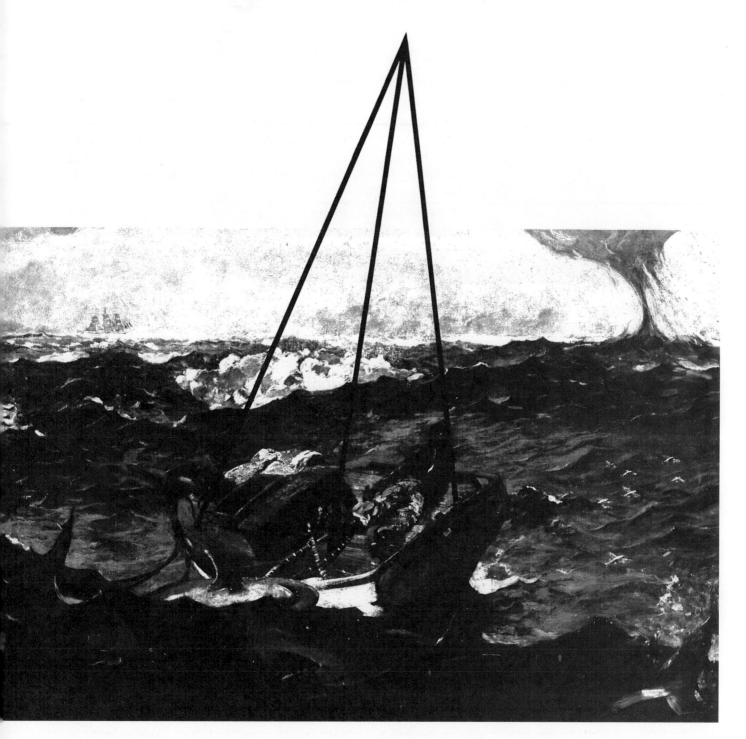

Figure 7. Lines point to the sun directly above the sailor in this detail from *The Gulf Stream* **(Figure 1).**

winds of the storm. As your eyes pass the sailing ship to the left and return to the center of the picture, you can again pick up direct sunlight with flecks of warm white dancing on top of the waves.

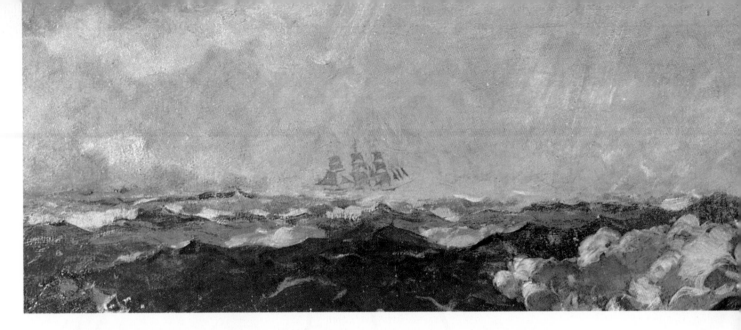

Figure 8. Detail from *The Gulf Stream* (Figure 1). Notice how Homer used white to indicate sunlight and sea foam.

The color in *The Gulf Stream* is one of the glories of American art—an achievement! A boat of brown is lightened by black and darkened by white against the rich blues of the sea. The blues are darkened at the crest of the waves and lightened by direct sunlight. The more you look, the more color you see. All that beauty should not have an unhappy ending.

That is what you see, but what does the painting say? What is all that red stuff in the water? Could it be blood? Is the man alone because another friend was thrown overboard? It looks like blood, but it is not. It is seaweed. Red seaweed floats into the Gulf Stream from the Gulf of Mexico. In this case it could have been dug up by the storm. On the other hand, there is that big open gash close to the mouth of the big shark. Mysterious—and frightening! Homer might have put it there to give a feeling of violence.

THE DRAMA WITHIN AND WITHOUT

If all these terrible things might be happening to the man on the boat, how do you think he feels? What is going on inside his mind? Take a careful look (Figure 9). Read his face. Does he have the look of a man who has lost a battle? Does he seem frightened? Scared? Angry? Determined? Or is he just waiting for something to happen? Can you really tell?

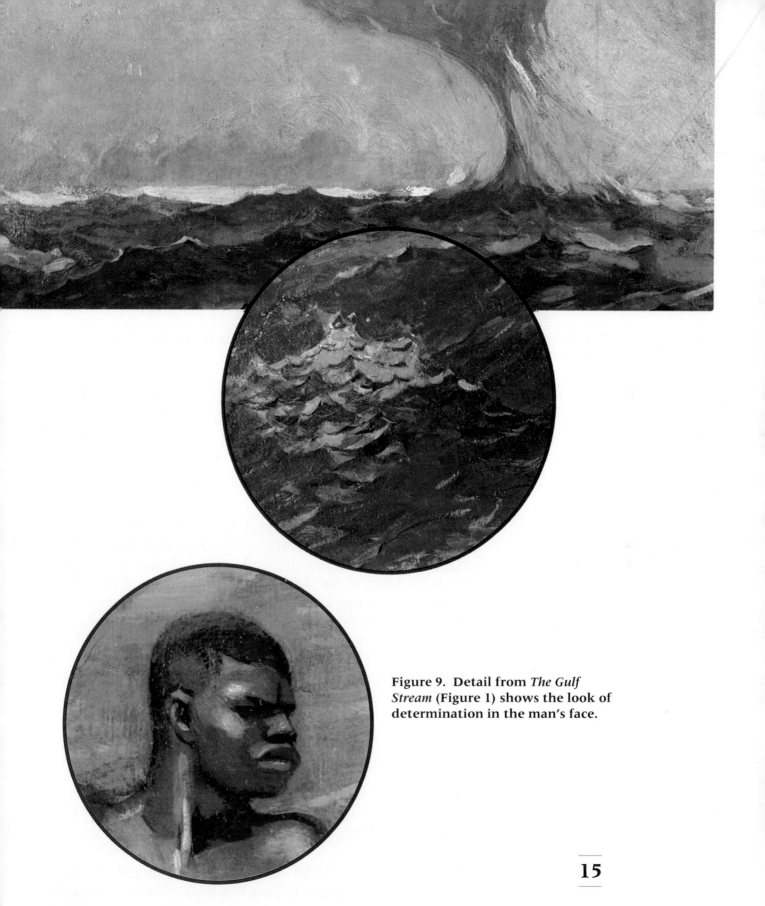

Figure 9. Detail from *The Gulf Stream* (Figure 1) shows the look of determination in the man's face.

15

A famous critic looked at the picture for a long time and came up with this idea: "The important point of this story is the man's distance from a shore or even a safe place. The man is still alive, but not for long. The picture is designed like a big trap ready to close. On one side of the trap are the sharks, and on the other side is the waterspout. The man has not only lost the battle, but does not even have any strength left to call for help from the other ship. Even if he escapes these dangers around him, he will probably starve from lack of food and water."

Do you agree? Is that what you see on the man's face? Take another look. What can you tell about him? He is very strong. From the way he is sitting, you can see the great strength in his arms and chest. The body is relaxed, and he is resting on one elbow.

Notice how the artist has turned his head. From this position you can see determination in the powerful neck and jaw. And he is looking straight out to the side. That tells a lot. If he were a beaten man, a defeated man, he would be looking down. If he were looking up, he might be either desperate and praying to the heavens, or sure that help was coming. But the man is looking to the side. Whatever he is looking at, whatever he is thinking, remains a mystery. What you do know is that this is not the look of someone who has given up the battle.

Another reason Homer may have painted the man leaning and looking to the right is because he wanted you to look in that direction. If you do, you will see the flying fish, which point to the waterspout. The waterspout leans to the left, toward the sailing ship. The ship directs the eye back into the painting—back to the man. Which way do the sharks and the boat direct you to look? The big shark points left, but its fin points up right. The smaller shark points right. In a painting this is called movement. Figure 10 shows the movement in Homer's painting.

THE BOAT

The man has been in trouble before, and perhaps in these very same waters. How can you know that? More detective work. How about the boat? What kind is it? A sailboat, but what kind of sailboat? You might say, "What difference does it make? A boat is a boat." Not so. In this

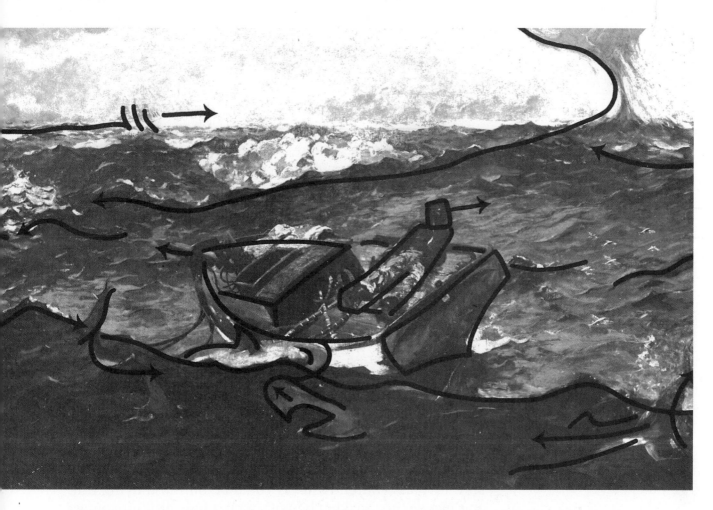

Figure 10. Arrows indicate the movement in this detail from *The Gulf Stream* (Figure 1).

case, the sailboat is a very special kind—a smack boat sloop. Smack boats have a well or hole between the cabin and hatch to keep the fish. The illustration (Figure 11) shows what the boat looked like before the storm, when it was intact. You can see all the fishing gear on the boat: fish pots, water barrels, nets, and conch shells.

Although these boats are no longer in use, they are part of the American heritage. Like the boat in the picture, they looked something like a tub. They were workboats, and the men who sailed them were always on the water.

The brave sailors who worked on these boats around the Gulf Stream were traditionally known for their strength and courage. They worked on the ocean day and night, year after year, and often went to sea in bad weather. The smack boat sailor was a great sailor. It was said that he could smell bad weather. He could read the clouds for signs of land beyond the horizon. He could even steer his boat by the

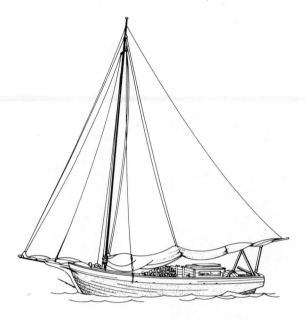

Figure 11. The boat as it might have looked before the storm.

formations of grass and coral in the seabed when out of sight of land.

The man in the painting was this kind of sailor. Now, look again at his face and what do you see? Does *he* think he will make it? He has strength and courage. What else does the sailor have? Remember the sugarcane in his right hand? He is not going to starve because sugarcane offers both food and water. His eyes could be on those flying fish, and maybe, just maybe, he will catch a few. And, of course, it is possible that he may have some fish in the well.

Now can you tell if the boat is sinking? Again, Homer gave the answer. Put your finger on the corner of the stern, or the back end. Trace the edge of the boat, including the space hidden by the shark. The line of the boat is above the water. It is not taking on water. In sailors' language, the ship still has "integrity." This is the position Homer wanted. Compare it to an earlier study of *The Gulf Stream* (Figure 12A). In this work the boat is taking on water. In the final picture, it is not clear. The boat is helpless and tipping, but it is not sinking, yet.

MORE MYSTERIES

In fact there are several problems in this picture that are not clear. For example, sharks never come to the top of the water during a storm. They stay far below. The water is

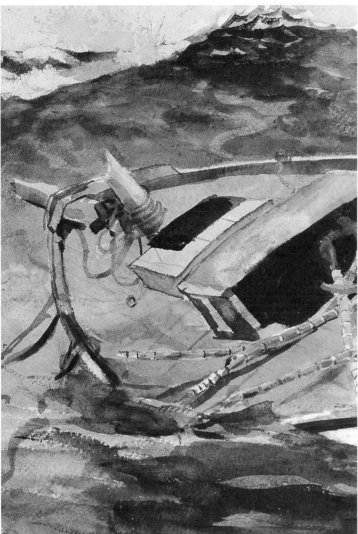

Figure 12A. Early Study for *The Gulf Stream*. Winslow Homer, *The Gulf Stream.* Probably 1885. Watercolor, black chalk. 10 1/2" x 20 5/8". Gift of Charles Savage Homer, 1912. Courtesy the Cooper–Hewitt Museum, Smithsonian Institution/Art Resource, New York.

Figure 12B. Compare the boat in this detail of Figure 1 to the earlier version of *The Gulf Stream* (Figure 12A).

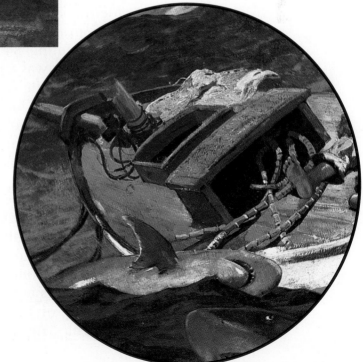

rough, but it still might not be made so by the waterspout. Now things really get tough. Homer knew sharks, and he knew that the sand shark does not attack human beings. In a frenzy, however, sharks attack anything, and there is that big gash near the big shark's mouth. So you still really do not know what is going on.

In his letter of explanation, Homer said there was another story. In fact there are two dramas. The first one is outside the man—on the ocean. The second one, inside the man, begins with his relaxed position and the bold look on his face. What you think might happen changes once you are inside the painting. At that moment the question becomes: What does *he* think will happen? What is on the sailor's mind? Or put another way—what was on Homer's mind? For that answer you must go to the history of this artist and his method of work.

THE ARTIST

Winslow Homer was born in Boston in 1826 and died in Prouts Neck, Maine, in 1910. During his lifetime he had become the outstanding artist of the American outdoors. His paintings of hunting scenes in the Adirondacks, fishermen on dories, and waves smashing against the rocky coast of Maine are now part of the American heritage. When the Metropolitan Museum of Art in New York City bought *The Gulf Stream*, it paid him the highest amount he ever received for a painting, $4,500—a great sum of money in those days.

Homer was a man who liked to be alone. And so, to this day, very little is known about him. He lived like a pioneer. At the age of forty, he left city life and moved to the lonely ocean village of Prouts Neck, Maine. His home there is pictured in Figure 13. He kept away from people, even art critics and buyers, and talked to no one about himself or his work.

When Homer was quite old, the writer William Howe Downes asked him for information for a biography. Homer answered: "I think that it would probably kill me to have such a thing appear, and as the most interesting part of my life is of no concern to the public, I must decline."

This was not Homer's first refusal. In the letter about the meaning of *The Gulf Stream*, he had written the following thought: "You ask me for a full description of my picture

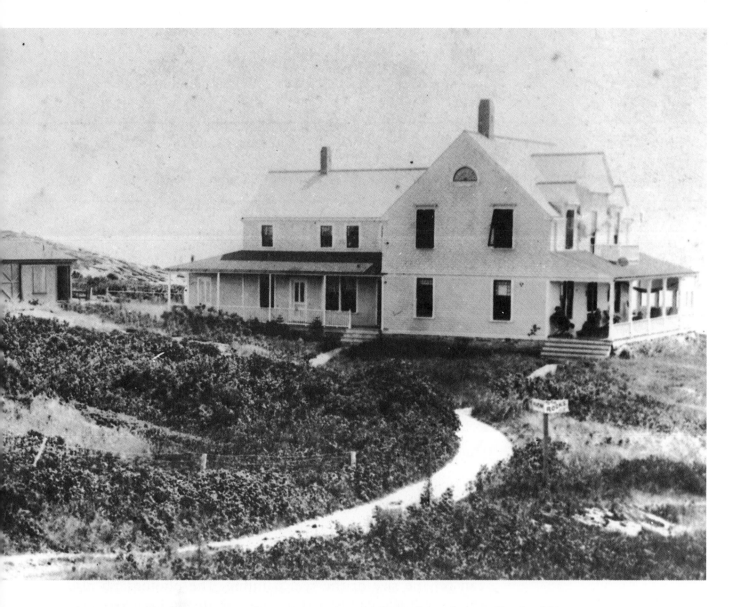

Figure 13. Winslow Homer's home at Prouts Neck, Maine. The smaller building to the left was his studio. Winslow Homer, *The Ark and Homer's Studio (Formerly The Stable) at Prouts Neck, Maine.* c 1885. Photograph. The Homer Collection, Bowdoin College Museum of Art, Brunswick, Maine.

The Gulf Stream. I regret very much that I have painted a picture that *requires* any description." But the picture's meaning is not clear, and it does require description. There are two valuable clues outside this work. For help you can go to his other paintings and to some important events during his lifetime.

You can start your detective work with a photograph (Figure 14). There is only one photograph of Homer in his studio. He is standing in front of *The Gulf Stream.* How big do you think the painting is? Here is a clue: Homer was

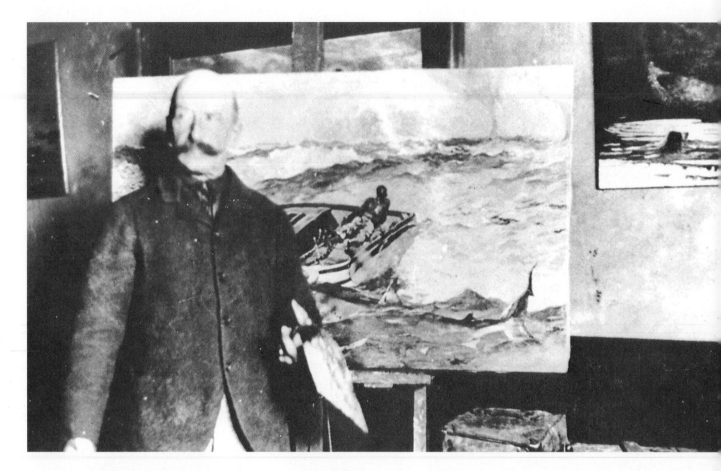

Figure 14. Homer in his studio at work on *The Gulf Stream*. Unknown photographer,
Winslow Homer Working on "The Gulf Stream" in his Studio. The Homer Collection, Bowdoin College Museum of Art,
Brunswick, Maine.

approximately five feet six inches tall. The painting is 28 by 49 inches. If you measure this rectangle on the floor, you can get the size of the real painting. The photograph also shows that the painting is unfinished. In the background it is possible to make out two waterspouts. There is still no white spray over the tail, and the waves are not fully painted.

How long does it take to finish a painting? When did Homer know that the work was done—that the color, design, and idea all fit together? He started *The Gulf Stream* in 1897, and finished it two years later in 1899. During those two years the painting was shown and returned to him for more changes. Why? Even after he worked out the details, Homer considered the painting a failure if the viewer did not understand the idea. His work was not simply a photograph of what he saw, but rather his way of expressing feelings and ideas. At that time people did not understand what he was trying to do.

Today viewers consider the painting "great." You can look at it time and again and always find something new—a little detail, not seen before, to add to your pleasure. For example, sharks really do not have teeth like the ones in the painting. But who cares? When the shark opens its mouth, you see jaws, but Homer painted *maws*. MAW, now that is a word! *Maw* means "gullet" in a very special sense—the gullet of a wild, man-eating creature. And that is what you see and feel—a shark too close to the man in the boat, ready to swallow the victim whole.

The ability to describe a thing and give it such powerful feelings is the inspiration of the artist. This was Homer's gift: to describe and to communicate with feeling. If you use your imagination, you can see how he gives feeling to the shape of the ocean. Once he puts terror into his picture, the whole design cries out "Danger!" Figures 15 and 16 show

Figure 15. Notice how the image of the shark is repeated in the upper half of the painting. Detail from *The Gulf Stream* (Figure 1).

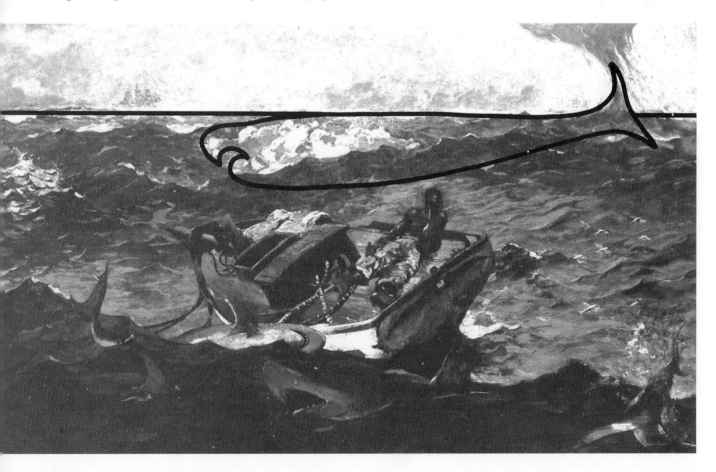

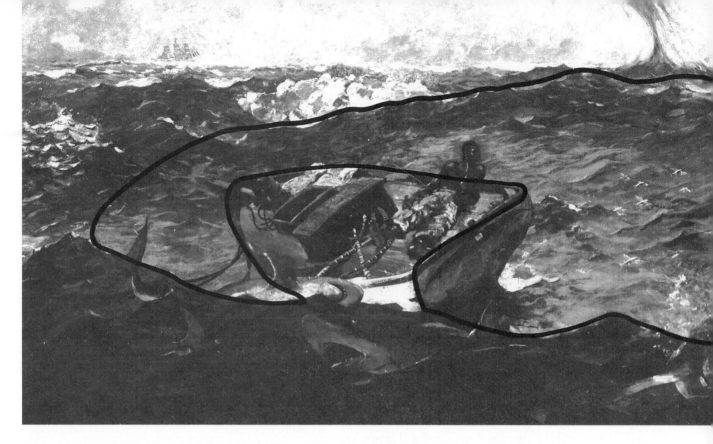

Figure 16. Another image of the shark devouring the boat is shown here. Detail from *The Gulf Stream* (Figure 1).

how the frightening image of the shark repeats itself in the design. In the first illustration, the water forms a pattern of the huge fish with its tail as the waterspout. In the second illustration, the lines of the big waves meet to form one large, terrifying shark with the boat in its maw. The design becomes one shape—one emotion—one overpowering feeling—TERROR!

INFLUENCE OF OTHER ARTISTS

It is likely that Homer had seen a similar technique used before. In 1854, Admiral Perry made his famous trip to Japan and opened its ports to the world. Soon after, sailors brought back art prints of the Japanese masters. America and Europe suddenly discovered Japanese art. Hokusai (Hoh-koo-sigh´) was one of the greatest of the Japanese artists. Homer knew his picture *The Great Wave Off Kanagawa* (Figure 17). In the illustration you can see the same lacy

lines of the waves. Hokusai's large wave rolls over into curlicues—much like Homer's design of the reef. The technique is Japanese, a pretty ornament on top of the water. Hokusai's wave looks like a monster reaching out over the men in the boats, like Homer's wave, ready to swallow up the sailor. But it is remarkable that in the center of both works there is such a quiet feeling. In Hokusai's a peaceful Mount Fuji, and in Homer's, the relaxed body of the man, create calm.

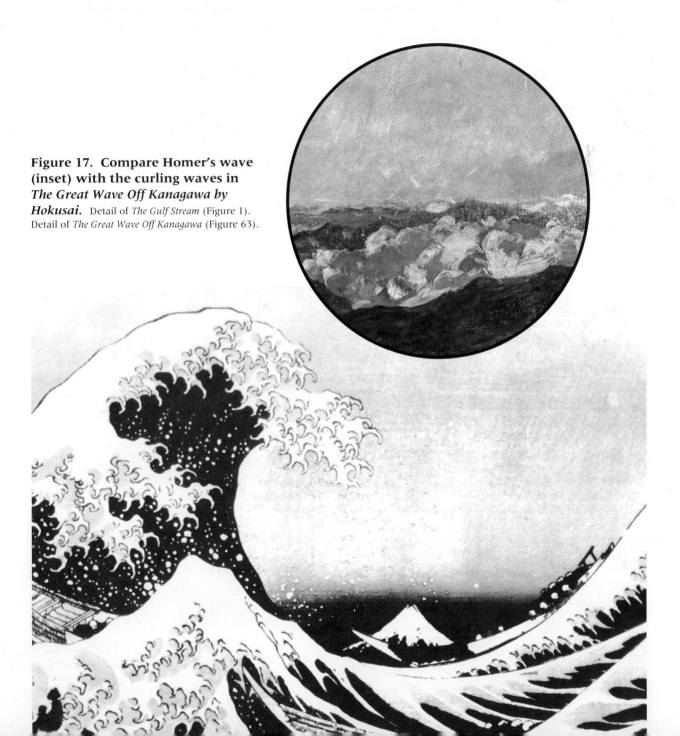

Figure 17. Compare Homer's wave (inset) with the curling waves in *The Great Wave Off Kanagawa by Hokusai.* Detail of *The Gulf Stream* (Figure 1). Detail of *The Great Wave Off Kanagawa* (Figure 63).

The Gulf Stream was not the first work in which Homer had painted sharks. He first went to the Bahamas in 1885 and soon after did a watercolor called *Shark Fishing* (Figure 18). Notice the power of the man using only a small line to battle the monster. Homer's watercolors and paintings of the tropics are remarkable for their strong colors and dramatic stories of man's war with nature. His pictures have no pity for man or beast. Two more works will illustrate this point further.

The watercolor *Rum Cay* (Figure 19) tells a brutal story. Look at the strength of the man: the powerful head and chest, the whole body excitedly bent toward one object—the turtle. The turtle is going to lose. In 1899, Homer painted a watercolor which he also named *The Gulf Stream*

Figure 18. *Shark Fishing* **by Winslow Homer, painted several years before** *The Gulf Stream.* Winslow Homer, *Shark Fishing.* 1885. Watercolor on paper. 13 7/8″ x 20″. Private collection, New York.

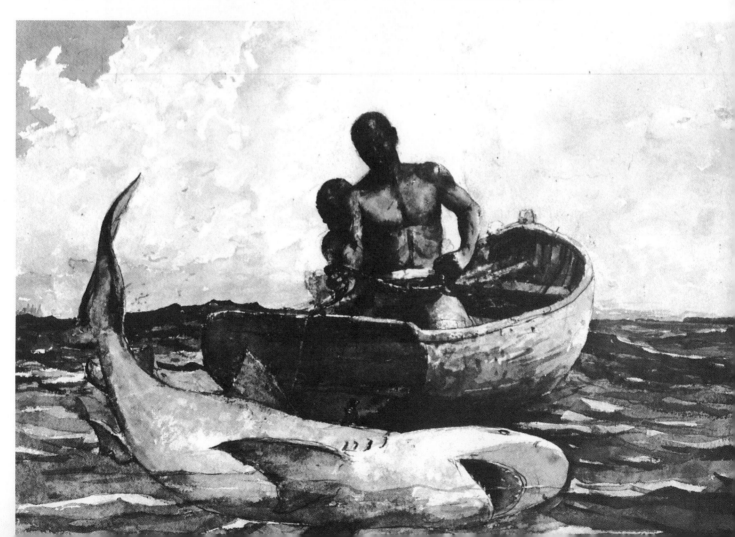

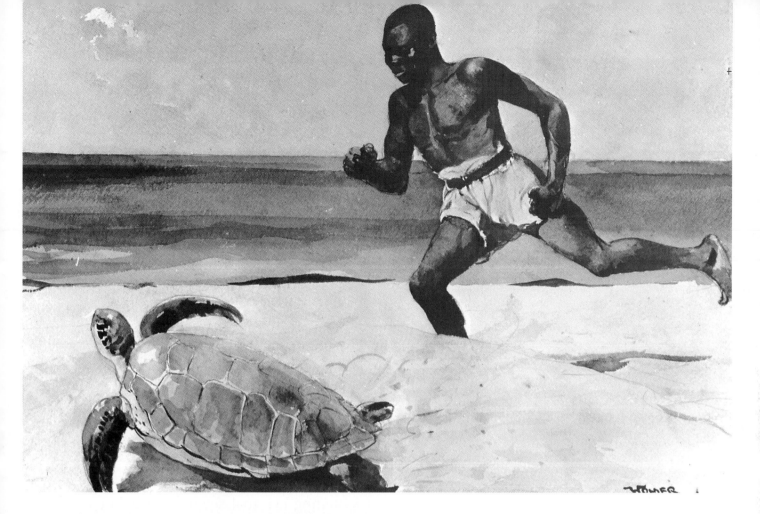

Figure 19. *Rum Cay,* **another watercolor by Homer showing a dramatic scene from the Bahamas.** Winslow Homer, *Rum Cay.* 1898-1899. Watercolor on paper. 15″ x 21 3/8″. Collection of Worcester Art Museum, Worcester, Massachusetts.

(Figure 20). Notice that the lower side of the boat is almost in the water, while the man is high above the cabin with his shirt on. These earlier works can be considered the beginning of a drama not finished until 1899 in *The Gulf Stream.*

The first shark Winslow Homer saw could have been in *Brook Watson and the Shark* (1778) by John Singleton Copley (Figure 21). Homer grew up near Boston. When he was very young, his parents knew how well he could draw. They also knew it was very important for him to see the work of other artists. Since *Brook Watson and the Shark* hung in the Boston Athenaeum, it is possible that young Winslow saw it many times. *The Gulf Stream* and Copley's painting are somewhat alike. Copley placed the shark right in front, leaping out of the water. Homer's shark has the same huge mouth and knife-sharp teeth as Copley's. In both pictures

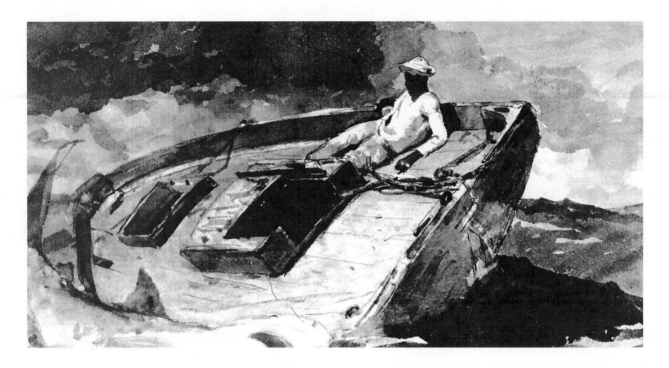

Figure 20. An earlier version of *The Gulf Stream*. Winslow Homer, *Early Study for The Gulf Stream*. 1899. Watercolor on paper. 10 1/2" x 20 5/8". Art Institute of Chicago.

the shark has a frightening eye that seems almost human. But you can find something even more interesting in comparing the two. Look at the faces of the men in Copley's painting. They are all frightened and upset, except one man in the center. There stands a black sailor, calm, confident, and strong before the danger.

There is something else about the Copley work that Homer knew. Brook Watson, the man in the water, was actually attacked by a shark. However, a happy ending followed his terrible adventure. Later, Watson became Lord Mayor of London and paid Copley to paint this scene. Maybe this is what Homer meant when he said *The Gulf Stream* had a happy ending.

Homer had an uneasy feeling about *The Gulf Stream*. Before he finished, he wrote to his agent that he did not want "the public to poke its nose into the picture." Homer knew his people. The public was not used to seeing such terror in paintings. He was sure people would get the wrong idea, and they did. For years he had painted fishermen catching sharks. When the audience first saw *The Gulf Stream*, many people said, "Now it is the shark's turn to catch the fisherman."

At the first showing of *The Gulf Stream*, the critics were divided in their reports. One writer was shocked by such an awful subject. Another could not understand why "the ship was not wet with seawater" or "how the man kept himself from sliding down the boat." This last critic looked at the painting as if it were a photograph. He missed the idea in

Figure 21. *Brook Watson and the Shark* by John Singleton Copley. John Singleton Copley, *Brook Watson and the Shark.* 1778. Oil on canvas. 72 1/2″ x 90 1/2″. The National Gallery of Art, Washington, D.C. Ferdinand Lammont Belin Fund.

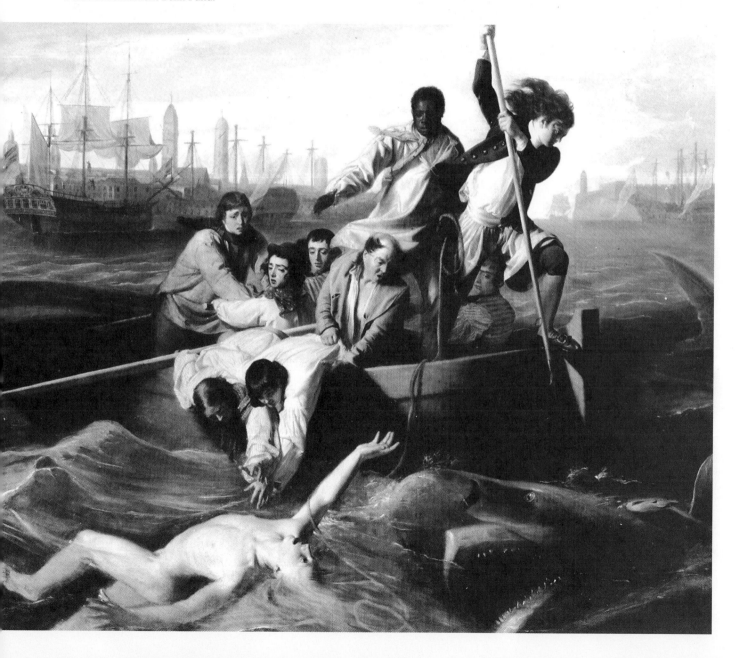

every way. With time, these kinds of questions have been answered. But there are other questions about the painting that still deserve attention. Here is one: Does it make any difference to the picture or to the story if the man is white or black? There is no one answer.

This question was often asked in a different way: Why did Homer put a black man on the boat? What a sad question, and because of the date—1899! The Civil War had ended in 1865. Thirty-four years had passed. It is sad because the fight for equal rights in art had not ended. Most paintings treated African-Americans as objects, not as people. The Copley painting was the great exception. Before the Civil War, most paintings of African-Americans showed them either suffering in slavery, happily dancing, or playing banjos. Now, Homer puts a black man in a boat in the middle of the ocean at the center of his picture. And what a magnificent human being he is! This man is not a slave. What appears at first glance to be a ball and chain to his left is an illusion. The left hand is hooked in the belt loop of his pants.

Do you think the man's color makes a difference in the story? Maybe, but no one is sure. Did it make any difference to Homer? The artist cannot lie! A great work of art is Homer's way of telling the truth. There is always a reason for his choice of color, although you may never fully understand it. However, two events in Homer's lifetime tell a lot about his sense of color. They are the Civil War and the publication of a remarkable book, *The Laws of Contrast of Colour* by M. E. Chevreul.

AN IMPORTANT LESSON

During the Civil War, Homer was a war artist for *Harper's* magazine. He made several trips to the war front, and sometimes he saw the fighting. At the front, he made sketches and then came back to New York to finish the drawings. He was what is now called an artist-reporter.

In 1875, ten years after the Civil War had ended, Homer made a trip to Petersburg, Virginia. That year is important not only in the life of the artist but also in the history of American painting. Homer had been to Petersburg before, in 1865, after a terrible battle. He went back in 1875 and decided to live in the African-American neighborhood and paint. The war had been over for a long time, but there was still hate. Some white troublemakers from Petersburg were

angry. Homer paid no attention. One day, a group of toughs decided to drive him out of town. One rough-looking fellow threatened him. Homer said, "I looked him in the eyes, as Mother told us to look at a wild cow," and the man ran away. Homer did not know what had happened. But a man, who had hidden under the porch, explained that he ran because he thought Homer had a gun in each hand and was ready to shoot him. After that, no one bothered Homer again. He painted a whole series of works showing African–Americans—at work, in church, at play—no different from white Americans except for the color of their skin.

One of these works is *The Visit of the Old Mistress* (Figure 22). The mistress has come back to visit with the ex-slaves.

Figure 22. Homer's *The Visit of the Old Mistress.* Winslow Homer, *The Visit of the Old Mistress.* Oil on canvas, 1876. 18" x 24 1/8". The National Museum of American Art, Smithsonian Institution, Washington, D.C. Gift of William T. Evans.

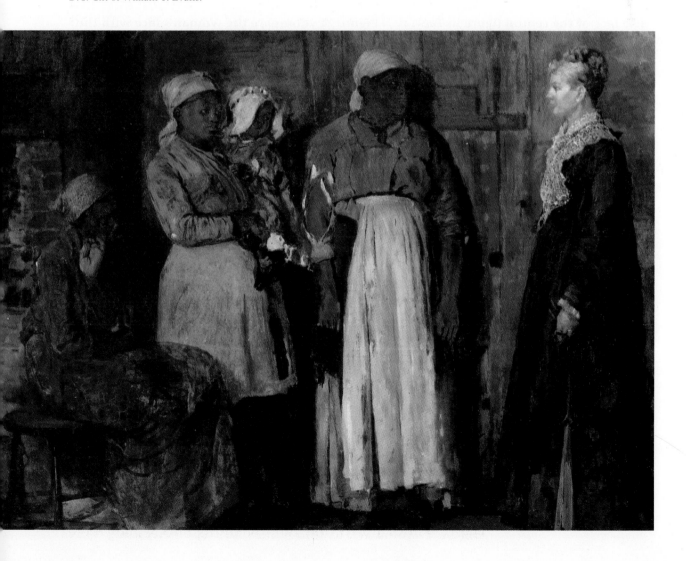

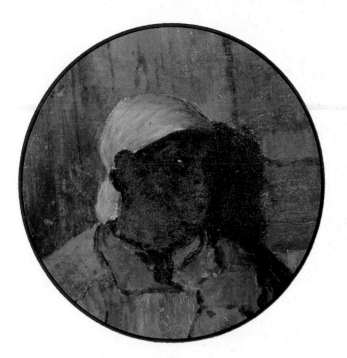

Figure 23. The face of the central figure in *The Visit of the Old Mistress.* Detail from Homer's *The Visit of the Old Mistress* (Figure 22).

Figure 24. Compare the woman's face with the face of the man in these details from *The Gulf Stream* (Figure 1), and *The Visit of the Old Mistress* (Figure 22).

What did she expect to find? What does her face tell you? She seems confused because she is not getting the friendship that she might have wanted. What do you see in the faces of these ex-slaves? Look closely at the eyes and mouths of the ex-slaves. You can see dignity, but also scorn. What do you see on the face of the large woman in the middle (Figure 23). Does her look remind you of one you have seen somewhere else? Compare her face with that of the man in *The Gulf Stream* (Figure 24), and decide for yourself.

THE ARTIST AT WORK

In the lower left corner of *The Gulf Stream* are the date and the signature of the artist in black. From our earlier study, you know how Homer used black and white to contrast color. To paint the rich colors of *The Gulf Stream*, an artist could spend a lifetime: first in seeing such beauty and then putting it on canvas for others to enjoy. Sometimes Homer's work was slow and tiring. After *West Point, Prouts Neck* (Figure 25), Homer described his technique. "The picture is painted *fifteen minutes after sunset*—not one minute before—since up to that minute the clouds would have

their edges lighted with a brilliant glow of color—but now, in this picture, the sun has gone beyond their range and they are in shadow. The light is from the sky in this picture. You can see that it took many days of careful study to get this effect with the sea and tide just right."

Anytime you see his work you can study color and shadow and always determine the time of day. He once said about a picture he was painting, "I work hard every afternoon from 4:30 to 4:40 (ten minutes), that being the limit of the light in the picture."

Besides those minutes, Homer spent hours and years studying the effects of sunlight on color. You might ask how he knew that the colors he saw were true. A little more detective work!

Figure 25. *West Point, Prouts Neck* **shows Homer's dedication to capturing the colors and beauty of the moment.** Winslow Homer, *West Point, Prouts Neck.* 1900. Oil on canvas. 30 1/16" x 48 1/8". Courtesy of Sterling and Francine Clark Art Institute, Williamstown, Massachusetts.

Homer kept a book which he read and reread. He once even called it his "bible." That book was M. E. Chevreul's *Laws of Contrast of Colour*. Chevreul, a French scientist, published his work in 1839. It was translated into English in 1858. Ever since the book appeared, it has influenced everything from housing to flower arrangement and furniture. By reading Chevreul's experiments, artists had a guide to study the sun's effects on light and color.

Homer had mastered Chevreul's laws. He knew that every object brightens if placed against a shadow. He understood how black makes brown look light, or blue look dark.

Once again refer to *The Gulf Stream* (Figure 26) and see how Homer used Chevreul's law of color contrast with browns and blues. Find the black in the painting. You see it in the empty space in the cabin and in the hatch, on the man's head, on the bottom of his pants, and around the dark border of the boat. Within the boat, the dark browns get lighter, while outside the boat the light blues get darker. In art this is called depth of color. The effects are surprising because the more you look, the more colors you will find.

An artist once asked Homer if he changed the colors he saw. Homer, shocked by the question, answered, "Never, never. When I have selected a thing, I paint it exactly as it appears." Then he added something interesting: "Of course, you must not paint everything you see. You must wait, and wait patiently, for the wonderful to come and hope to have the sense to see it."

Waiting patiently is one way of describing Homer's life and work. His house at Prouts Neck was right on the ocean. From his window, he could study the waves rolling in against the coast, sending off sprays of light and color. He even built a "paint house" that he could move close to the ocean in a storm. His only interest was his work.

Another artist tells a story of his visit to Homer. "During my visit, a storm swept the coast. No one at Prouts Neck, not even the oldest people, could remember such bad weather. The wind blew a gale. The rain was heavy. There were clouds of mist over the rocks and the sound of the ocean rose over the waves." Homer was excited and said they had to see it at once! They put on rain coats and walked along the shore. They had to hold on to the rocks, or the wind would have knocked them down. Homer watched the clouds for a change in the weather.

It was for this moment that he had waited. For this he was always ready, with his paintbrush in his hand. For these moments Homer lived and remained alone.

There is no one answer to the question of why the man in the boat is black. Homer saw a lone black sailor in a smack boat and painted him. But a Winslow Homer work includes his genius, his life, and his vision. Homer's vision not only opens the eye to the visual splendor in nature, but also challenges the mind to understand the man. This

Figure 26. Note how Homer contrasted dark and light areas to highlight objects in the painting. Detail from *The Gulf Stream* (Figure 1).

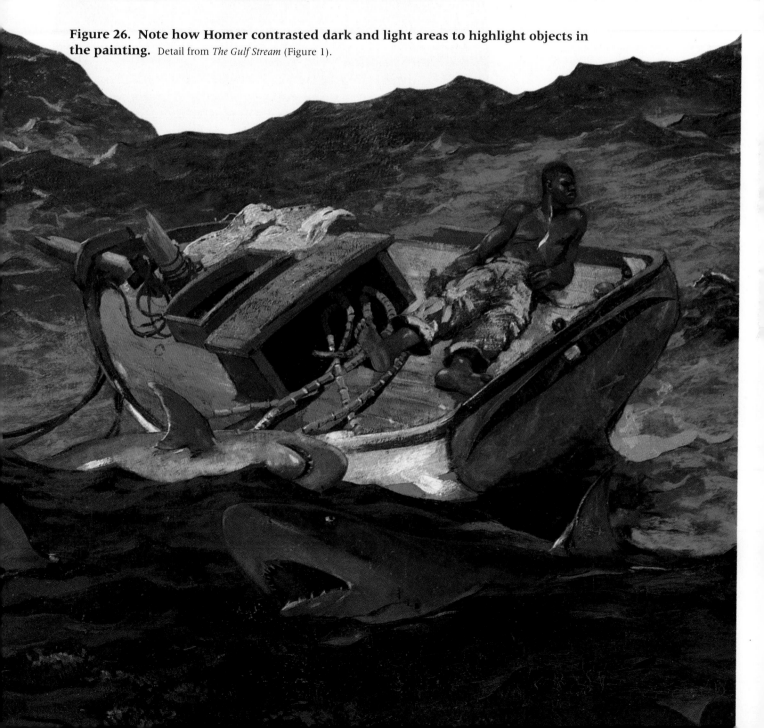

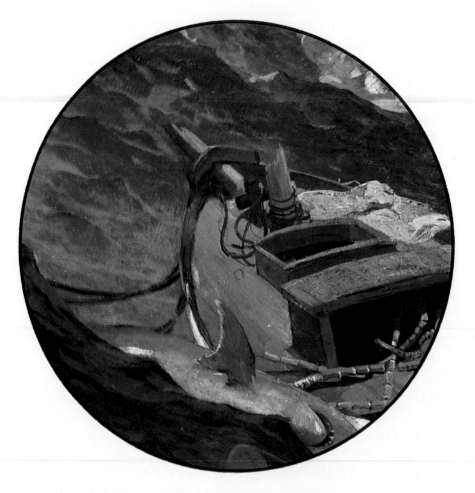

Figure 27. Detail from *The Gulf Stream* **(Figure 1) shows a rope leading to something hidden from view.**

African–American is an example of people who have faced danger before and have survived.

You still don't know what will happen to the sailor. Take one more look and figure out which way the boat is drifting (in Figure 27). Beneath the broken mast a rope hangs in the water. It seems to be fastened to something below the wave, perhaps a sea anchor. Although hidden from view, something is almost pulling the boat, or even guiding it. The boat is moving between the waves and the storm into the beautiful, blue water. Perhaps into safety? Something unknown is directing it. But what?

You do not know because Homer did not want you to. Perhaps he himself did not know.

You went against the artist's wish and poked your nose into his painting. You went looking for the moment that would give you the key to the puzzle. And what did you find? Another puzzle! Although you still do not know the

ending, you do know that it will be different from what you had expected.

When you are led to expect one thing and something else happens, that is called *irony.* It would be visual irony if the beautiful ocean were to destroy the brave sailor, for we do not expect the beautiful to be destructive. It would be dramatic irony if he were close to land and could not reach it.

But there are other ironies in this masterpiece. There is the irony of the Gulf Stream itself. In Homer's time, very little was known about "the river of blue." Ponce de Leon, the Spanish explorer, first described it; sailors navigated it; and scientists—even Benjamin Franklin, made charts of its currents. But in spite of all the effort and study, the Gulf Stream remained a mystery. Very little was known about where it began and ended, or what part it played in the ocean's flow. It is an irony that people try so hard to understand and still know so little about the Gulf Stream, the end of the story, or life itself for that matter. Homer's mystery reminds us we cannot know the future.

It is now many years later. *The Gulf Stream* hangs in the Metropolitan Museum, and still haunts the viewer. So why do people love this painting even as it chills them and makes the future as scary as the eye of the shark?

The answer to this question is the key to the mystery. The horror is there. And yet one man's calm and courage give the work strength and dignity—and perhaps even faith. He is alone against the elements, but not defeated.

Like the man in the boat, Homer was alone. We are all alone when the real trouble comes; when the monsters come out of the deep into our dreams. Alone when the world closes in on us, adrift in currents of doubts, fearful about tomorrow. But that sailor knows something. Whatever it is, he is strong enough to look away from terror. In his look is the final irony. Homer was able to scare everyone who looked at *The Gulf Stream.* Everyone except the one man who could not be frightened—the man in the boat.

And who is that man in the boat? He is every one of us.

Summary Questions

1. Artists often paint people in relation to nature. They may show people enjoying nature, playing or working in

natural settings, or struggling against nature's forces. After reading about Winslow Homer's *The Gulf Stream,* which type of painting do you think this is? Discuss the different natural forces that threaten the man in the boat.

2. Many people think the man in *The Gulf Stream* will come to an unhappy end. Give reasons that will support this conclusion.

3. Why is it said that *The Gulf Stream* has "great depth of color"? In your answer, explain what *depth of color* means and give specific details from the painting.

4. How did Homer use M. E. Chevreul's law of color contrast? In your answer, point out specific uses in *The Gulf Stream.*

5. How did Homer move the viewer's eye from place to place in *The Gulf Stream?*

6. You have read about some ways in which *The Gulf Stream* and John Singleton Copley's painting *Brook Watson and the Shark* are alike. What are some ways in which the two paintings are different?

7. In what way was his home in Prouts Neck, Maine, important to Homer's work?

8. Look carefully at the picture of *The Great Wave Off Kanagawa* by Hokusai (page 25). How are the fishermen in the boats struggling against nature? Are these fishermen in more, or less, immediate danger than the man in *The Gulf Stream?* What details in the two paintings help you to come to your conclusion?

CAUTION

In the art activities sections students will be using many different types of materials.

This caution symbol is placed thoughout the book next to activities in which materials are used which contain chemicals or other ingredients that may be hazardous to students. These materials should **not** be used by students without supervision by teachers. Students should be instructed to consult the teacher before proceeding with any activity which has this caution label next to it.

This caution label also refers to the proper handling of instruments, such as knives, scissors, etc.

THE VISUAL ELEMENTS OF ART

Introduction

Look once again at the painting of *The Gulf Stream* on pages 4 and 5. This time try to see it not as a picture of a man in a boat, but as elements of color, line, shape, form, texture and space. An *element,* by definition, is something fundamental or essential. The **elements of art** are color, line, shape, form, texture, and space and they are fundamental to art. Each artist may use the elements in different ways, but artworks cannot be created without them.

There are principles, or rules, which determine how effectively an artist uses the elements of art. The terminology of the principles may vary slightly from artist to artist or among those who talk and write about art. The principles most often used in visual art are repetition, variety (or contrast), emphasis, movement and rhythm, proportion, balance, and unity. These terms may be new to you now, but they will soon become familiar. They are basic to art, and are based on common sense. The use of them will become natural to you as you progress through the course.

We will first study the elements of art. Then we will see how these elements are handled by studying the principles of design.

Color

Of all the elements of art, color has received the most attention and investigation throughout the centuries. Where do colors come from? How do we see them? How do they affect us? Theories about color have been of interest to philosophers, scientists, artists, and art teachers for many hundreds of years.

Color is an important part of our world. Have you ever thought about just what color is? For centuries thinkers have inquired into the nature of color and its relationship to light and darkness. As you may recall from our study of *The Gulf Stream,* Winslow Homer was greatly influenced by

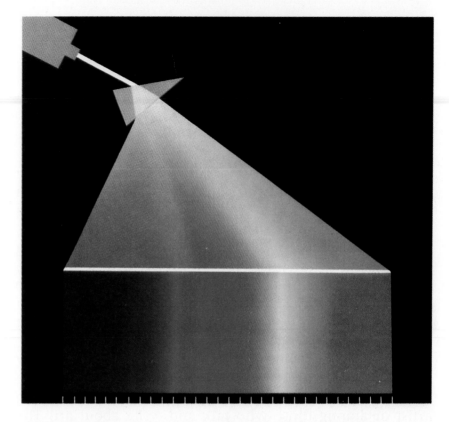

Figure 28. The prism breaks up the white light rays into a spectrum of color. (Courtesy Van Nostrand, Reinhold, N.Y.)

M. E. Chevreul's book on color. Your study of color begins here with Sir Isaac Newton, one of the greatest scientists who ever lived. Do you recall hearing of him in other courses?

In the 1660s, Newton passed a narrow beam of white sunlight through a rod of glass which is called a **prism.** What do you think he found? The beam of white sunlight was broken up, or **refracted,** into a *spectrum* of all of the colors of the rainbow. (See Figure 28.) He then reversed the process and passed the spectrum of refracted light back through a reversed prism. What do you think happened then? He got white light. Newton concluded that white light is made up of all the colors of the spectrum.

Newton carefully studied the spectrum. He observed that the red light rays at one end of the spectrum and the violet ones at the other end seemed to have similar color qualities. He attached one end to the other as if he were buckling a belt. In doing so, he invented the first **color wheel.** Where red and violet overlapped, Sir Isaac found purple, a new color without any specific light rays, and thus not in his original spectrum.

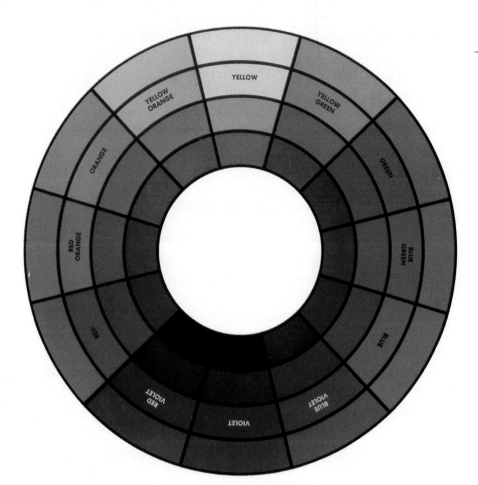

Figure 29. The color wheel shows the basic colors and the gradations between them. (Courtesy M. Grumbacher, Inc.)

Newton's discoveries about color and light provided the basis for all following scientific work on color. The next important step in color theory was the publishing of the **pigment color theory** in 1756 by J. C. LeBlon. This color theory established the foundation for the color wheel that is in common use today, shown in Figure 29.

Recall that Newton had demonstrated that white light is made up of all the colors of its spectrum. It naturally follows then that black is the absence of all colors in the light color theory. Do you see why?

LeBlon's demonstration did not deal with white light. It dealt with the practicality of mixing pigments. Much of the information you will study about color in the next few pages comes from LeBlon's pigment color theory. In mixing paints, black is the sum of all colors. White is the absence of color. Black and white are not shown on the color wheel and are called **neutral colors.** Gray, when mixed from black and white, is also called a neutral color.

When two colors are mixed, a third color results because the mixture reflects a different light. Other factors also affect the way we see color. The surrounding colors and the quality and intensity of the light in which colors are viewed are two such factors. Let's begin our study of the visual elements of art by looking at the basic properties of color.

The Properties of Color Color has three properties.

1. **Hue** is the term that we use to designate and refer to a color such as red, yellow, green, or blue.

2. **Value** refers to the degree of lightness or darkness of a hue. Adding white to a hue gives a *higher* value to a hue. We call this higher value a **tint** of the hue. For example, pink is a tint made by adding white to red. Adding black or a darker color to a hue results in a lower value. We call this lower value a **shade** of the hue. For example, maroon is a shade of red.

3. **Intensity** is the term that defines the strength and force of a hue. The full intensity hues appear around the outer edge of the color wheel. Look at green, for example. The green on the outer edge is a full intensity green. What color do you see *directly opposite* green? That's right, red. As you follow the greens from the outer edge toward the center of the color wheel more of green's opposite color (red) is being added. This *lowers* the intensity of the greens with each step closer to the center. Take the time to firmly fix this concept in your mind by looking at several other examples on the color wheel.

The Colors on the Color Wheel The **primary colors** are red, yellow, and blue. These are called primary because they cannot be created from any combination of the other colors on the color wheel. They are also called primary because all other colors may be made by mixtures of these three. Figure 30 is a helpful illustration for understanding these mixtures.

The **secondary colors** are green, orange, and violet. Green is made from an *equal* mixture of blue and yellow. Orange results from an equal mixture of red and yellow. Violet is from an equal mixture of blue and red. Do you have the primary and secondary colors fixed in your mind? If so, let's go on to the intermediate colors.

The **intermediate colors** are made from mixtures of a primary color and a secondary color. One example is

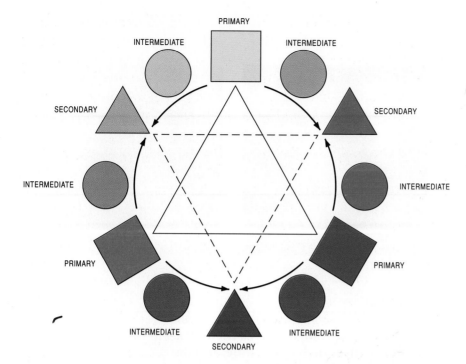

Figure 30. Primary Colors An imaginary equilateral triangle (solid line in illustration) placed on a color circle so that one point of the triangle is at yellow, will locate the remaining two primary colors (red and blue) at the other two points.

Secondary Colors Orange, violet, and green are the secondary colors. Each is placed between the two primaries that are mixed to produce it. The secondaries may be located on the color wheel by an inverted triangle (dotted line) as illustrated.

Intermediate Colors All the additional hues which fall between the primary and secondary colors around the color circle are known as intermediate colors and can be produced by the mixture of adjoining primary and secondary colors.

yellow-green, which is mixed from yellow (a primary color) and green (a secondary color). Before you continue, look at all of the intermediate colors on the color wheel (Figure 30), and determine the two colors which were mixed to produce each of them.

Complementary colors are *directly opposite* each other on the color wheel. They are also the colors which are *least like* each other. For example, look at yellow and violet. At full intensity (the hue in the outermost ring of the color wheel), there is no yellow at all in violet, no violet at all in yellow.

Analogous colors are those that are *next to each other* on the color wheel, such as blue and blue-violet, or red and red-orange.

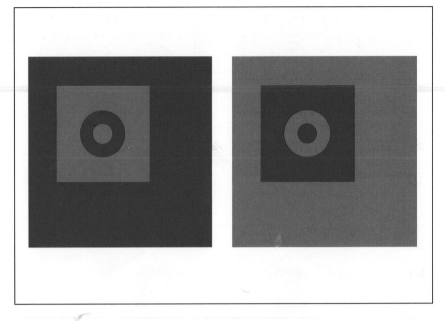

Figure 31. Warm colors, such as the red, seem to come forward, while cool colors, such as the blue, recede.

Warm colors are those associated with sunlight, warmth, and fire. They are on one side of the color wheel and the "cool colors" are on the other. **Cool colors** are those that are associated with coolness, sky, water. Cool colors seem to recede when placed next to warm colors, and warm colors seem to come forward when placed next to cool colors (see Figure 31).

A harmonious color pattern is one that results in a pleasing relationship of the three dimensions of color—hue, value, and intensity.

Activity 1—Color Divide a piece of drawing paper into six equal parts. In each part use your pencil to draw a two inch square. Divide each square in half. In each section of your paper, use crayons to place two full intensity complementary colors side by side. When you have completed the six figures look at the results. How would you describe the results of putting the complements next to each other?

The results are exciting to the eye. From the discussion above, describe how you could soften the effects in mixing colors.

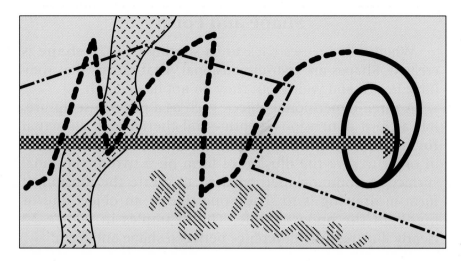

Figure 32A. Lines

Line

You know what a **line** is. Try to define it. It is easy to define particular *kinds* of lines such as power lines, clothes-lines, or the line of scrimmage. In a picture, a line may represent an actual line or an object. Line lends direction and can suggest movement. Lines can be short, long, thin, wide, up-and-down (vertical), sideways (horizontal), diagonal, zig-zag, or simply free-form. The possibilities are limitless. One of the most complex and continuous lines you can draw is one that you have been making for years. It is the wonderful line that spells your full name. Take pleasure in it, as it is a line no one else has.

Activity 2—Line Diagram the lines in *The Gulf Stream.* First, take a piece of clear plastic paper about the same size as the reproduction on pages 4-5. Place it over the repro-duction. Using a grease pencil, carefully diagram the most important lines you can see. Next, remove the diagram, place it over a blank paper, and look at it. What kinds of lines do you find? Are they repeated? Which of the terms below best describe the lines in your diagram?

vertical	horizontal	short	zig-zag
long	active	diagonal	thin
flowing	restful	curved	wide

Shape and Form

When a line closes back to its starting point, a **shape** is created. Shapes are two-dimensional. That means that they have height and width, but they do not have depth.

A three-dimensional object, such as a piece of sculpture, has a third dimension—depth—and therefore is an actual **form.** In painting and drawing, artists use various methods in order to give the illusion of form on a two-dimensional surface. A common method used to create the illusion of form in drawing is to shade one side of an object and/or highlight the opposite side. The examples in Figure 32 clearly illustrate the difference between shape and form:

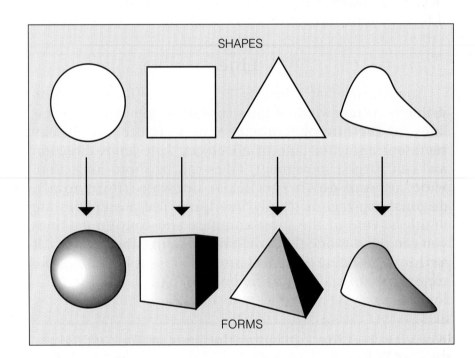

Figure 32B. Shapes and forms.

Activity 3—Shape and Form To see the difference between shape and form, find a three-dimensional object such as a plastic cup, apple, orange, ball, tube, or box. Make two drawings of the object. First, make an outline drawing in which you only show the shape. Next to it on the same paper, make another outline drawing of the object and then add shading to create form. Study the objects carefully. Does your shaded object have form?

Texture

The way the surfaces of things feel is their **texture.** Textures may be real or visual. **Real texture** can be felt by touching. It can be rough or smooth, fine or coarse, wet or dry, soft or hard. Sculptors, architects, and craftspersons often choose a material for its real textures, or the sensation of touch it offers.

Visual texture gives the appearance to the eye of being rough or smooth, etc. But when we try to feel this texture with our fingers, we feel only the surface of paper, or canvas and paint or the wax from crayons.

An artist can enrich our experience of a painting with visual textures. Look at the textures in *The Gulf Stream* (pages 4-5). Compare the texture of the boat deck with that of the man's pants or his skin. Would you say the ocean has a rough texture? When you touch real water, how does it feel? The visual textures in a painting may vary from the real textures of the objects painted.

Can you tell the difference between the visual textures of the painting and the real textures in the surface of the painting? Look closely at the bottom of the painting, below the first shark. Use a magnifying glass if you have one. Do you see the cracks in the surface of the paint? They come with age. However, if you feel the picture in the book, you are really feeling paper with colored ink on it.

Activity 4—Texture You can produce the appearance of texture in your artwork. One way to achieve texture is to do rubbings. Look around your classroom and find a flat surface with a definite texture. The air conditioning or heating vents, the floor, the wall, or the bottom of a sports shoe are places to start looking. You'll need a 9- by 12-inch sheet of newsprint and a large dark crayon with the wrapper removed. Place the paper over the textured object and rub gently with the side of the crayon. Make sure you hold the paper securely. If the section you are rubbing is large or the area has a very subtle texture, you may wish to tape your paper in place.

After you have finished one rubbing, try doing another one. This time, after you have completed about half of the rubbing, move the paper slightly. Replacing the dark crayon with another color, continue the rubbing. You will get an interesting double image.

CAUTION A reminder to check the room for textured objects that might be dangerous.

Space

Space is everywhere, surrounding us. In an artwork, forms and shapes are defined by the space around them. Three-dimensional artworks, such as architecture and sculpture are also defined by the space within. For example, look at Barbara Hepworth's sculpture *Figure in a Landscape* and the discussion on page 112.

In all of the forms of art, space is defined as positive or negative. **Positive space** is the area of the shapes and forms, and **negative space** is all of the empty areas around, above, under, and between the positive areas.

In two-dimensional art forms such as painting and drawing, the handling of space can be complex. The artist generally has the goal of giving the viewer the *illusion* of depth on a two-dimensional surface.

Activity 5—Space Look at Homer's *The Gulf Stream* on pages 4-5. Cover the ship and waterspout with your hands. Then take your hands away. Does the horizon look farther away with or without them? Consider the space between the ship and waterspout. Imagine them closer together. What does that do to the iliusion of space that Homer tries to create? How would the effect of space in the painting change if the ship and waterspout were not in the picture? Discuss these differences in class and justify your opinion.

THE COMPOSITIONAL PRINCIPLES OF DESIGN

Introduction

The **principles of design** are the rules by which artists *use* the visual elements to create works of art. As was mentioned earlier, the key terms we will use for these rules are repetition, variety and contrast, emphasis, movement and rhythm, proportion, balance, and unity.

The principles of design are important to us for two distinct reasons:

1. They help us organize a visual composition.

2. They provide criteria which we use to understand, appreciate, and evaluate works of art.

Professional artists become so familiar with these principles that they rarely think about them consciously. You will encounter examples in which artists have attempted to bend the rules. They have experimented to see just how far they can go and still create a successful work. The principles of design are:

Repetition

Do you think that *The Gulf Stream* would be as exciting if we saw only one shark? What would happen to the picture if there were several more sharks? Notice how Homer repeated the flying fish to move your eye toward the waterspout. Can you find the different places in which Homer repeated the same hue of light red? Look at the spray from the shark's tail, at the water, and the deck of the boat.

On the other hand, too much **repetition** can become monotonous. It may make good wrapping paper, or a polka-dotted fabric, but a work of art needs variety to keep interest alive.

Variety or Contrast

Variety and **contrast** are provided by the use of different colors, lines, shapes, forms, textures, and objects. For a good example, look at Grant Wood's *Fall Ploughing* (Figure 135, page 187). Wood uses repetition in the rows of hay stacks and the furrowed ground, contrasting them with the round forms of the trees. What other evidence of repetition and contrast can you find in this painting?

Homer used contrast more subtly in *The Gulf Stream*. Rather than show three whole sharks, Homer painted one complete shark in front to establish its identity. Then he painted just the pectoral fin of a second shark, and the tail and underside of a third shark. The fact that we cannot see each of them completely makes the painting more mysterious and interesting.

Homer also varied his colors to add interest. Notice the orange line on the side of the boat. The red in the water and on the deck of the boat are less bright. How does the bright red line add contrast? Does that one slash of white paint across the red line make it more or less noticeable? Look at

the variety of blues and greens in the water. Do you think there would be as much contrast if the man were wearing a white shirt? Compare him with the man in the white shirt and hat in an earlier version of *The Gulf Stream* (Figure 20, page 28). Imagine the man without the shirt. How would that affect the contrast?

Too much variety and contrast can be chaotic, disorderly, and disturbing to the viewer. The human mind likes order. It usually needs something to capture and hold its attention.

Emphasis

Emphasis is the way artists give certain elements or objects in an artwork more importance than other elements or objects. An element or object that is emphasized usually dominates the composition. Other elements and objects are subordinated. In other words, **emphasis** defines the center of interest and gives most works of art their meaning. For an example of emphasis, look at Imogen Cunningham's photograph, *The Three Ages of Woman, on Fillmore Street,* on page 255. Which age dominates? Why?

In *The Gulf Stream,* the man and the boat are the dominant objects. They are larger than the sharks and have contrasting colors. The different values of brown and white and the spot of red on the boat contrast with the blue and green colors of the water. The sharks are less important than the boat, because their color is darker and closer to the value of the water.

Activity 6—Emphasis Choose a geometrical shape and cut six copies of it in varying sizes from a 9- by 12-inch sheet of gray or tan paper. Place the shapes in a line on a 12- by 8-inch sheet of paper. Step back and look at the arrangement. Do any of the pieces catch your eye? Do they all look much the same? Select one shape and use a crayon to change the color to a much brighter shade. Replace the piece and again look at the arrangement. Which piece do you see first? Color can be used to achieve emphasis in a work.

Return to the original six neutral shapes. (You'll need to cut out another piece in place of the one you colored.) This time take one of the shapes and add an overall pattern to create a textured surface. You can create your own pattern or do a rubbing to achieve a textured effect. Replace the piece in the pattern and observe. Does texture also con-

tribute to the principle of emphasis? When you have an arrangement that demonstrates emphasis, paste the pieces down. Label the design **EMPHASIS.**

Movement and Rhythm

There are two types of movement in artworks—actual movement (motion) and visual movement (perceived motion). Some pieces of sculpture, such as mobiles (see Figure 33), actually move. **Visual movement,** on the other hand, only takes place in the mind and the eye of the viewer who is looking at a static piece of art. How does this work? Let's look at *The Gulf Stream.*

Homer controls our attention and eye movement by having the sailor look to the right. In the section above on emphasis, we noted that the man and the boat were the

Figure 33. Actual motion in sculpture. Alexander Calder, *Red Gongs.* Mobile. Sheet aluminum, sheet brass, steel rod and wire, red paint. Overall length approximately 12 feet. The Metropolitan Museum of Art, New York. Fletcher Fund, 1955.

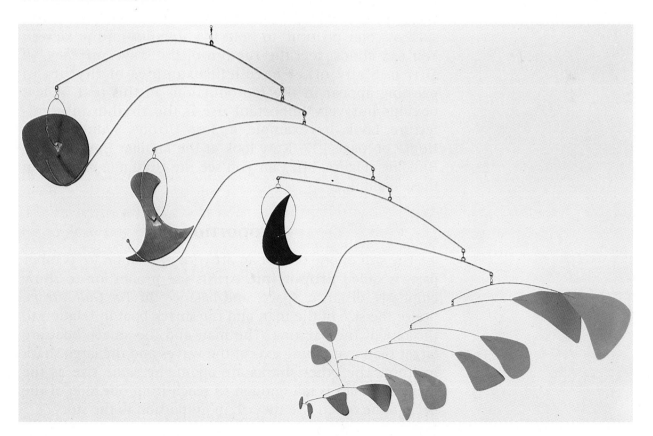

dominant objects in the painting. So, if we look at the man first, we are naturally attracted by his gaze to the right. As we follow his gaze, we see the flying fish. And which way are they headed? They are going back toward the waterspout. The waterspout is leaning to the left. This may lead our eye forward to the distant ship or backward to the smack boat.

If we start with the sharks or the boat, our eye is most likely to be attracted to the direction the boat is headed. Notice that Homer has the boat headed back into the picture. If we follow that line, we will be attracted to the sailing ship, which is facing the waterspout.

If you can, imagine you have never seen *The Gulf Stream* before. Perhaps, at first glance, your eye is attracted to the man *and* his boat. What pattern do they make? Together, they form a "V" shape which, again, leads us back into the painting. One side of the "V" points toward the sailing ship and the other to the waterspout. As we noted, either of these two forms will lead your eye to the other.

Do you see how Homer keeps us looking around and around in his painting? He carefully placed all objects to keep our eyes *in* the picture. It is actually hard to look off his canvas.

In the visual arts, **rhythm** is movement created by repetition of an element. The artist repeats the same element, such as color or form, to hold the attention of the viewer. You can almost feel the rhythm of the waves in *The Gulf Stream*. Many other excellent examples of rhythm in painting appear in the reproductions in this text. A less obvious but very important use is the rhythm in architecture. Look, for example, at Jorn Utzon's Sydney Opera House on page 137. Now look at the familiar Empire State Building (Figure 34). Can you see the rhythmic patterns in these buildings?

Proportion

The size of one part of an artwork in relation to its other parts is called **proportion.** Artists use proportion to show emphasis, distance, space, and balance. In *The Gulf Stream*, notice the size of the man and the smack boat in relation to the rest of the painting. The man and the smack boat are larger than everything except the waves and the large shark in front. The other sharks are about the same size as the man. The man is tall enough to reach from one side of the deck to the other. Are they all in proportion to the story?

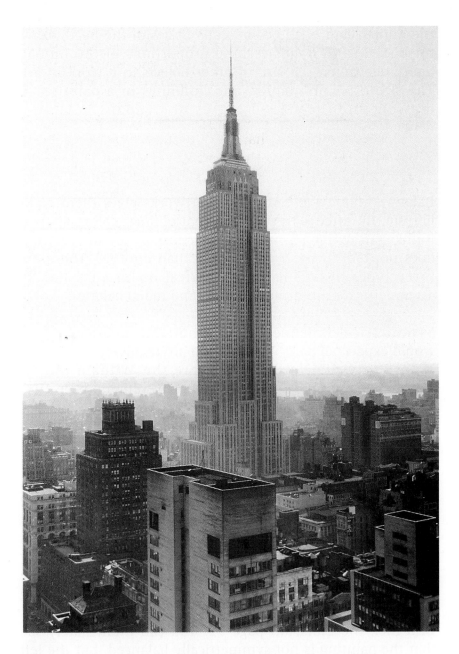

Figure 34. Look for rhythm in other skyscrapers. *The Empire State Building*, New York. Completed in 1932. AP/Wide World Photos, Inc.

How important is the size of the ship and the waterspout to the story of the painting? If they were larger they would look closer. If they were smaller, they would seem farther away. Do their closeness and size seem right to you? Imagine them smaller, then larger. Would that change their relationship to the man in the boat and the total design?

In your other creative work in this course, you will be working with proportion, for example, the proportions of

the human figure (the comparative sizes of the head, arms, torso, legs, and hands). These proportions of the human figure determine the size of other objects in a work of art. The size of chairs, tables, and buildings in a painting or drawing and the size of horses or weapons in statues depend upon the human presence.

Balance

Balance among the elements in artworks gives them equilibrium. **Balance** is the arrangement of lines, colors, shapes, forms, and textures so that one section or side of the work does not look heavier or stronger than another. There are three types of balance: symmetrical or formal balance, asymmetrical or informal balance, and radial balance.

Symmetrical Balance In **symmetrical balance,** as you would expect, all parts of the design are relatively equal. This is easy to visualize. Examples are the William Morris wallpaper on page 143, and the Egyptian coffin on page 198.

Asymmetrical Balance When an *a* appears at the beginning of a familiar word, it changes the meaning of that word to its opposite. Thus, *asymmetrical* means "not balanced." How can something be said to have "asymmetrical balance"? In art, **asymmetrical balance** means that the elements may not *actually* balance, but the artist has arranged them in such a way that they *seem* to be balanced. On a see-saw, a lighter person might balance a heavier person by putting more board on his or her side. The same principle may be used in visual compositions. An interesting example is the painting *Hunters in the Snow* by Peter Brueghel, the Elder, on page 92. You can immediately see that the painting is not symmetrically balanced, but the left

Figure 35A. Symmetrical balance.

Figure 35B. Asymmetrical balance.

and right sides give us a feeling of balance and satisfaction with the arrangement. Now look at the photograph by Eadweard Muybridge of *Mirror Lake—Valley of the Yosemite* (page 131). The left and right sides of the photograph have asymmetrical balance. The larger size of the paler, distant mountain balances the smaller portion of the darker, closer mountain. Now turn the book sideways and look at the photograph. What kind of balance do you have now?

Radial Balance In **radial balance** the most important part of the visual composition lies in the center. Other components radiate from, or move around, the center. Homer's *The Gulf Stream* is an example of radial balance in the history of art. The smack boat and the brave sailor are the center. The sharks, flying fish, the distant sailing ship, the waterspout, and all of the elements of the sea set up movements and counter-movements around the smack boat and the sailor.

Unity

Unity in a work of art is the result of all of the elements and the principles working together. If a work of art has unity, it holds together as a story and as a design. It is not enough that Homer placed his sailor on a boat with a broken mast in the middle of some water with a few sharks and flying fish, a waterspout and a distant ship. Homer organized his composition to tell a story within a 28-inch by 49-inch rectangular shape. He also created a mystery—one of the great unanswered questions asked by a work of art: Will this man survive this threatening environment? Try to imagine changing the arrangement, location, size, color, value, or direction of any object in the painting. Can you do it and still have the same story and unity? If you decide you cannot, you have found a unified work of art.

This concludes our formal introduction to the visual elements of art and compositional principles of design. You will be using the elements and principles throughout this course to help you with your own creative efforts. You also will use them to help you understand and evaluate the work of your classmates and that of master artists.

In the section that follows we will discuss art criticism. You will see that the visual elements and compositional principles play a vital role in helping you make judgments about art.

INTRODUCTION TO ART CRITICISM

Art criticism is a fundamental part of the art course. It is a process which will help you make informed personal judgments on works of art. It is also a skill that you will be developing and sharpening for the rest of your life. Everything you know and learn will be of value to you in art criticism.

An excellent example of this is the development of your own creative skills in art. There is no substitute for experience. Your own art creations will help you evaluate the problems that an artist faced in the creation of his or her work.

As you learn more and more about the world's history, you will become better equipped to critique art. You will be able to study an artwork in relation to the *time* in which it was created. Remember that in the long history of art, the museum is a relatively recent thing. To properly evaluate an ancient piece of sculpture, for example, it is necessary to understand the purpose for which it was created. In looking at modern abstract art, you will benefit greatly if you can relate the work to important works in the past.

So, the more deeply you are involved in art, the more satisfaction you will get from art criticism. As you practice and progress in using your skill, the authors hope that you will remember your first formal experience in criticism with *The Gulf Stream.* Now let's investigate the four-step process of art criticism, which includes description, analysis, interpretation, and judgment.

Four Steps of Art Criticism

Description Description is a detailed statement of exactly what you see when you closely examine a work of art. It is not an interpretation of what you think the artist may have wanted you to see. Rather, it is a listing of everything you observe as you look at the work. You may recall that we looked at *The Gulf Stream*, then looked again, and again. We questioned ourselves about just exactly what we saw in

order to gather precise details. Here are a few of those questions.

- What colors did Homer use?
- How many sharks are there?
- What is that "red stuff" in the water?
- Is the waterspout approaching the smack boat and the sailor?
- What is the angle of the sun?
- What is the sailor looking at?
- Which way is the sailing ship headed?
- What might the sailor have stored below the deck?
- Is there significance to the rope in the water?

You had a good deal of coaching from your teacher and the text in taking this first step in art criticism. Although you will not have the same coaching with all the examples, you should apply the same questioning technique. The mere fact that you practice will greatly sharpen your skills of observation. Such skill should help you in all areas of schoolwork.

Analysis In the preceding section you were introduced to the visual elements of art and the compositional principles of design. To analyze an artwork, you must note how these elements and principles are used. You may need to review the preceding section to see how Homer used the elements and principles in *The Gulf Stream*. We note again how valuable your own creative work will be in practicing art criticism. Talking about art is valuable; *using* the elements and principles is indispensible.

Interpretation Interpretation of an artwork is based upon description and analysis. An **interpretation** explains the meaning of the work. It is time to make your own interpretation about our example, *The Gulf Stream*. What does this painting mean to you? How does it relate to you and your life? What is the artist's "statement" in this work? Your interpretation may be quite different from your classmates'. That is perfectly all right. In fact, your interpretation has to be based upon your own experiences and reactions to the work of art. If you based the interpretation on solid evidence from the first two steps, your interpretation is just as valid as the artist's own. If you have the opportunity to

discuss interpretations in class, listen very carefully to interpretations which differ from your own. There is much to be gained in this type of discussion.

Judgment After careful observation, analysis, and interpretation of an artwork, you are ready to make your own judgment. Your **judgment** of an artwork is your own evaluation based on your understanding of it. No one can do this for you. You may have noticed that the authors do not try to pre-judge works of art for you. Be honest with yourself. Do you feel that your experiences in the first three steps are sufficient to make a personal judgment? A great many people make hasty judgments of an artwork based on their own personal tastes and prejudices. Try to avoid this.

Your final judgment may be based on the *realistic* aspects of the piece of art, especially in a work such as *The Gulf Stream.* You may decide that you like it very much because it is an excellent imitation of the actual appearance of the scene portrayed. If this is, in fact, the most important thing influencing your judgment, then it is called a judgment based on **imitationalism.**

Your judgment may be based on how well you think the artist used the elements of art and the principles of design. The more you study art and the more you practice criticism, the more you will come to appreciate success in using the elements and principles. If your judgment is primarily based on these aspects of an artwork, then your judgment is based on **formalism.**

Your judgment may also be based on the emotional impact that the work has on you. Do not ever be afraid to express this type of judgment. Many great works of art have a profound emotional effect on the sensitive, intelligent viewer. Such a judgment is said to be based on **emotionalism.**

Are you thinking, "But how can I sort these three types out in this particular evaluation? How can I say that one is more important than the other? Is it all right to make a judgment based on more than one of these reasons?" The answer is that it is perfectly all right. Most judgments are a combination of two or even all three of these reasons.

You will have more formal practice as we progress through the course. Don't let that be all that you do. Practice the process on a well-known work of art that has no appeal to you at first glance. See if you can discover why

the artist produced the work, and why it is considered significant. You just might change your mind about it. On the other hand, you may find that you like it even less than you did at first glance. Whatever you decide, you will find the satisfaction that comes from an intellectual exercise.

THE ILLUSION OF SPACE

When artists create works of art, they very often must solve problems. The problem may deal with how to draw a particular way, paint a certain apple, or carve a body bending over. These are problems of representing something real, something that we can see.

Other problems may deal with how to express anger, or love, or sadness, or joy. Artists solve problems such as these by the way they show people's faces, posture, and gestures.

Artists also try to solve problems of design. They either try to work within the principles of design or to see how far they can break the rules of design and still make successful works of art. When we analyze works of art using the principles of design, we are really playing a game with the artist. We are trying to see how well the artist solved those particular design problems.

Representation, emotion, and design are all art problems that you may have tried to solve in your art classes or at home. These are all problems which artists have tried to solve for thousands of years. Every student of art must learn to solve them for himself or herself.

The history of art is the history of how artists in different centuries, in different countries, and in different cultures solved the same problems. Even so, a nose in ancient Egyptian art is not greatly different from a nose in Chinese art. An apple by a Dutch painter of the fifteenth century is not totally unlike one by an American still-life painter of the nineteenth century. Although some differences of style, brushstrokes, or use of color exist, the differences are not complex.

The Problem of Space

However, there is one age-old problem which artists have solved in a variety of ways over thousands of years. Ancient Egyptian artists approached it one way, while Greek artists, almost two thousand years later, looked at it quite differently. Third-century Romans solved it differently than did fifteenth-century Romans. Artisans in medieval Germany came up with solutions different from the ones used by artists living in the same century in China or Japan. Do you know what the problem is? It is the problem of space! It has been one of the hardest problems to solve in art.

How do you paint or draw something you can't see? Space is something you can walk through or reach out into but cannot touch. We can only perceive space because of the objects in space and the distance between them. For example, we can see how far apart houses are or how close trees are to houses. We see space in distance. Space may be perceived in the distance a road takes to disappear in the landscape, the distance across a room or swimming pool, or the distance from the front corner of a building to the back corner. The problem of showing space is really one of showing distance as it goes away from us. This is called the third dimension. It means depth in space.

The first two dimensions are height and width, the third is depth, and the fourth is time. In reality we can measure the dimensions, but in art they are illusions. An **illusion** is a mistaken idea of reality. Perhaps the most magical of these illusions is space, or distance. A painting can give the illusion of distance so forcefully we think we can see for miles and miles, and yet the surface of the canvas is less than an eighth of an inch thick.

Creating the Illusion of Space

The first attempts to create the illusion of space date back to cave painters 15,000 years ago. To show a group of reindeer in a herd, these painters arranged the animals so that they overlapped one another. Ancient Egyptian artists used the same overlapping device to show groups of warriors. The Egyptian soldiers march on a straight line which represents the earth. In the following three examples, we can see this line.

Using a Baseline In Figure 36 we see a row of lance-bearers. Their bodies are twisted flat. Their left legs are all

Figure 36. Ancient Egyptian lancebearers in stone relief show an overlapping perspective. *Egyptian Lancebearers,* stone relief carving. 2850 B.C. Erich Lessing, Magnum Photographs.

forward in a regular pattern, but only the right leg of the first lancebearer has been included. There is no real space between them. The straight line representing the ground, is called a **baseline.**

In the second example, the sand painting of a Navaho (Figure 37), the baseline is below the four figures, but they are not standing directly on it. The four dancers stand above the baseline. Their long, thin bodies are bordered by an even longer figure. The head of this figure is on the left, and its feet and legs are on the right.

The third example (Figure 38) is a drawing by a first grader. The student has used the same baseline idea as the

Figure 37. This is a reproduction of the Big Godway sandpainting which depicts the four figures of the first dancers on the last night of the Navaho Nightway ceremony. Each figure sings to a different kind of bird—a line of corn pollen connects the bird to the figure. Below their feet are lines representing yellow evening, white dawn, and darkness. Courtesy of the Wheelwright Museum of the American Indian.

ancient Egyptian artisan and the Navaho sand painter. This is a very natural way to draw the earth. By the time most boys and girls are seven years old, they have begun representing the world in their art with a line at the bottom of the page.

The Egyptians used a similar baseline to show distance. They merely repeated the same symbol for earth. In Figure 39, there are two rows of wheat gatherers, or farmers. In reality the top or second row would be *behind* the first row, but the artist painted the second row *above* the first. Also, although the artist may have seen that the wheat gatherers in the second row appeared smaller than those up close, he knew they were really the same size. So he drew them as he knew them to be, rather than as he actually saw them.

Figure 38. Drawing by a first grader.

Figure 39. Egyptian wall painting from an ancient tomb in Thebes. *Egyptian wall painting,* c. 1450 B.C. The Granger Collection, New York.

Figure 40. Child's painting illustrating a double baseline.

If one such line is called a baseline in art, what do you suppose two of them are called? Yes, a *double baseline,* of course. Perhaps you have a younger brother or sister who draws people and objects on double baselines. (Figure 40 is an example of a double baseline drawing by a first-grade student. Notice how the figures and objects are lined up on one row or the other.)

In each of the examples so far, the artists drew what they knew about the objects, not what they saw. They were drawing from imagination and memory. This is more clearly shown in the next two examples.

Establishing a Point of View In the picture shown in Figure 41A we see a garden pool in an Egyptian tomb in Thebes. Notice how the pool is drawn as if the artist saw it directly from above. The fish and water lotus on the other hand, are shown as they look from the side. In yet another contrast, the trees are flat. They are laid out around the pool

Figure 41A. A pond, as illustrated by an ancient Egyptian artist, from a tomb painting. Egyptian tomb painting: *Pond.* The British Museum, London.

upright on top, laid out left and right on each side, and upside down at the bottom.

The artist drew a concept or idea of the fish and the pool. The concept was what the artist knew of a pool and what he knew a fish looked like as it is usually seen. Such art is drawn from a mental concept, rather than what the artist really saw.

The next example (Figure 41B) shows a swimming pool by a British artist, David Hockney. Hockney has been painting a series of works on swimming pools. In the drawing below, we are looking at the pool from one end. What do you notice? There are wiggly lines for water. You

Figure 41B. *Swimming Pool* **by David Hockney.** David Hockney, *Bedford Pool Study*, 1978. Pen and ink on paper. 11 1/4" x 8 1/4". ©David Hockney.

can see the edge of the pool, the water line, the walk around the pool, and bushes beyond it. But also notice that the pool is narrower at the back end than in front. The left and right sides of the pool slant toward one another near the far end of the pool. This gives the illusion of space, or distance, which actually exists in the view of the real swimming pool. In this picture, Hockney drew what he saw, not what he knew.

66

Is this pool the same shape as the one in the Egyptian painting? Yes, both pools are rectangular, but how differently the artists have treated them.

Notice also that there is no front edge to Hockney's pool. We see the pool through the eyes of the artist. He is looking at the pool. Where might he be? He might be standing on the edge of the pool, or perhaps out on a diving board, or even sitting on the board. Somehow, we know that the artist is there.

Now look at the Egyptian pool again. Where is the artist? To draw the pool as he did, he would have to be directly above it. However, to draw the trees as he did, he must change position. To draw the trees above the pool, he must be below it. Where must he be to draw the trees at the near end of the pool? Where must he be to draw the trees on the right side? The left? The artist must have visualized five different places to show us the Egyptian pool. These positions or standpoints from which the artist views a subject, are called **points of view.** In the drawing by Hockney, the artist is standing in a single place with one point of view.

Have you ever drawn a picture like one of these? Think back. You may have without realizing it. It's a very popular way of solving the problem of three-dimensional space.

A detail from *Backyards, Greenwich Village.*

U N I T

FORMS OF
EXPRESSION

The Artist and Nature

There are many forms of creative expression in the visual arts. The forms we will study in this unit are drawing, painting, sculpture, photography, architecture, and crafts.

Artists choose forms that best express what they see and want you to see. In this part of the book, the artists have selected forms for creative expression to express their vision of nature.

You also will have the opportunity to express yourself in each of these forms of expression in the unit.

This book is about the visual arts. The visual arts represent various ways of seeing, that is, what the artist sees, and what the viewer sees. Talking about what we see in an artwork, and why we see it, helps us to make interpretations, and each of us may have a different interpretation of the same work of art.

The French painter Henri Matisse had this to say about seeing: "The artist has to look at everything as though he saw it for the first time: he has to look at life as he did when he was a child and, if he loses that faculty, he cannot express himself in an original, that is, a personal way."

Another painter, an American named Charles Burchfield, recalls: "I saw a sketch this evening that gave me the same savage thrill that I felt when as a boy I sighted a new butterfly or moth."

DRAWING

For many artists a drawing is a starting place, the first expression of an idea. For other artists a drawing is the idea, a finished work of art. Often, artists paint pictures based on their drawings. The artist Vincent van Gogh (van-go´) made drawings based on his paintings. Whatever purpose an artist has in making a drawing, this form of expression has a power of its own.

The two drawings *Rocks in the Sea* (Figure 42) and *Sea Forms* (Figure 43) present very different approaches to the seascape. Drawing can be more than working with a pencil or pen. For example, the artist Karl Schrag used a brush and black ink to create *Rocks in the Sea*. The strong, energetic strokes in this drawing suggest the power of both the rocks and the swirling sea.

Karl Schrag must have had an intense response to what he saw when he looked at the rocks in the sea. His powerful brushstrokes reveal that he almost "attacked" the paper in his excitement. So strong is the drawing that it almost appears that the sea is flexing its rocklike muscles. The sea and the rocks are one—a great weight of mighty rhythms.

The artist William Baziotes (bah-zee-oh´-tase) approaches the sea in another way in his drawing *Sea Forms*. He has chosen for his medium pastels, or colored chalks. *Sea Forms* goes under the water to look at a world we normally do not

Figure 42. Karl Schrag used bold lines and natural forms in *Rocks in the Sea* (1963). Karl Schrag, *Rocks in the Sea*, 1963. Brush and India ink. 25 7/8"x 39 5/8". Kraushaar Galleries, New York. (photograph by G. Clements.)

see. Strange images float about in mysterious space. Unlike *Rocks in the Sea,* which suggests that we keep our distance, *Sea Forms* invites us to come close and peer at its interesting forms.

Although both Schrag and Baziotes use flowing lines, Baziotes does so with entirely different effect. With the edge of his chalk he draws out the fine lines that flow from a nucleus-like center at the top left of the drawing. Because the particles of chalk spread slightly on contact with the texture or "tooth" of the paper, the line has both a sharp and slightly soft appearance. This adds to the mystery of the image. Baziotes' lines are fine, fluid, soft, and somewhat controlled. Compare them to Schrag's lines. Do you see that Schrag's lines are broader and have a splashier look?

The artist Theodore Rousseau (roo-so´) uses a pen and brown ink to draw *Landscape with Farmers' Huts* (Figure 44). Crisp, short strokes with the pen build up his drawing. It presents a landscape of solidity and endurance. The movement in this drawing is calmer than that in *Rocks in the Sea.* Why is this so? For one thing, Rousseau's drawing does not show the restless sea, but the unmoving land. We can look

71

Figure 43. William Baziotes depicts a strange and delicate world in *Sea Forms*. William Baziotes, *Sea Forms*, 1951. Pastel on paper on masonite. 38 1/8″ x 25 1/8″. Collection of the Whitney Museum of American Art, New York.

at it without fear that it will change before our eyes. *Rocks in the Sea* is so full of motion that we might hesitate to turn our backs on it.

Rousseau probably used brown ink rather than black in order to soften the effect of his landscape. Brown, a color found widely in nature, gives the picture a more lively organic appearance than black.

Figure 44. *Landscape with Farmers' Huts* **by Theodore Rousseau gives a feeling of solidity to the countryside.** Theodore Rousseau, *Landscape with Farmers' Huts*. c. 1840. Pen and brown ink on paper. Museum Boymans van Beuningen, Rotterdam, The Netherlands.

Rousseau and Schrag looked at land and sea, two very different natural scenes. Yet both saw solidity and complexity, power and movement. Each expressed his vision in a different way. The choice of different materials, techniques, approaches, and arrangements of forms enabled each artist to communicate his vision successfully.

Orchard at Trottiscliffe (Figure 45) was drawn by the English artist Graham Sutherland. The drawing portrays his garden during the years that he was serving as a war artist in World War II. He began producing nature studies in the 1930s and observed, "...all my paintings are based on a sudden and personal meeting with some part of nature." Do you believe him?

Although the word *orchard* implies many trees, the artist has focused on only two in this drawing. They seem to be fighting one another. The artist seems to have expressed the

73

Figure 45. Sutherland's trees seem to be in conflict. Graham Sutherland (1903-1980), *Orchard at Trottiscliffe.* 1943. London. Ink, pencil and gouache on ivory rough pulp, heavyweight paper mounted on cardboard. 8" x 6 1/4". Collection of the Santa Barbara Museum of Art and gift of the Buchholz Gallery.

Figure 46. Do these trees seem more serene? Titian (properly Tiziano Vecellio) (c. 1488-1576), *Group of Trees.* (16th century) Pen and ink on beige paper. 8 1/2" x 12 1/2" Inscription in darker brown ink at lower margin: Giorgione. The Metropolitan Museum of Art, The Rogers Fund, 1908.

conflict witnessed as a war recorder in his orchard drawing, but Sutherland tells us this is not the case.

The gentle pen and ink drawing by the sixteenth century Italian artist, Titian (tee´shun), *A Group of Trees* (Figure 46), conveys a very different image of trees from *Orchard at Trottiscliffe.* Yet both drawings communicate a sense of movement and mystery. If you put sound effects to each drawing, what might they be? *Orchard at Trottiscliffe* might howl and shriek; *A Group of Trees* might make a rushing or whispering sound. Both drawings are strong statements. One is a powerful shriek; the other, a powerful whisper.

Let's look at the techniques used by each of these artists to achieve movement. In *Orchard at Trottiscliffe,* the splashy, thick lines, and the dramatic use of white against gray

Figure 47. Think carefully about the compositional design of this drawing. Ellsworth Kelly (American, b. 1923), *Briar*, 1963. Graphite on paper. 22 3/8" x 28 3/8". Collection of the Whitney Museum of American Art, New York. Purchased with funds from the Neysa McMein Purchase Award.

washes of ink give a strong feeling of animation. The tree limbs seem to gesture restlessly, adding to this sense of animation. By contrast, the movement in *A Group of Trees* is suggested by a complex network of pen strokes. If you look closely at the build-up of lines, it appears almost like a weaving. *A Group of Trees* offers a more inviting experience. We approach a wood thick with many trees and soft, billowing foliage. It beckons to us. Whether we enter this woods or not is our choice. On the other hand *Orchard at Trottiscliffe* appears to bear down upon us and to clutch at us. It directly confronts us and allows us no escape.

The elegant line-drawing *Briar* (Figure 47), by the American artist Ellsworth Kelly, is a thoughtful composition of great simplicity. The line moves about the page with a lyrical rhythm, as if executed by a figure skater. Ellsworth Kelly greatly simplifies his drawings of plants to make us see as he sees. Kelly is not interested in the exact scientific representation of plants, but rather in spatial effects, proportion, scale, and design.

At first glance the weight of the line may appear the same throughout *Briar*. Actually the line varies from thick to

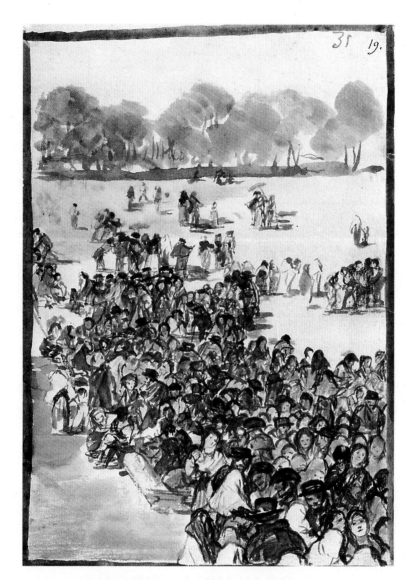

Figure 48. How can you tell this is a happy crowd?
Francisco de Goya (1746-1828), *Crowd in a Park*. Brush and brown wash. 8 1/8″ x 5 5/8″. The Metropolitan Museum of Art, New York. Harris Brisbane Dick Fund.

thin and light to dark. In a line-drawing, such as *Briar*, the line defines edges, establishing both positive and negative space on a flat plane. Variations in the weight of the line make the drawing more interesting. A line can swell with excitement or hold its breath, slide over the page or stop and think, hug itself or try to hide. Look closely at *Briar* and see if you can determine what the line is doing.

Crowd in a Park (Figure 48) is one of more than a thousand drawings made by the nineteenth century Spanish

master Francisco Goya (goy´-uh). The park is probably located in the capital city of Madrid. Judging from the bright light and the full trees in the background, it appears to be a glorious summer day. We sense that the citizens have poured from their homes and cafés into the open air. The crowd is dense, but Goya's deft balance of dark brown, light brown, and white faces, hats and shawls creates an appearance of bobbing and bubbling froth. It is not easy to portray a compact mass of people as animated activity rather than as a lump of shapes stuck together.

The artist also conveys to us that this is a congenial, happy crowd. What changes in the drawing might suggest a more subdued crowd? An angry crowd? A frightened crowd? Drawing a crowd involves much more than arranging little circles to suggest heads. How many actual expressions can you find among these faces? *Crowd in a Park* is filled with clues that we may not see at first, but which shape our initial response. As we discover these clues, we take even greater pleasure in the drawing.

In the section that follows you will be rendering your own drawings. Consider the techniques of the artists above as you develop your drawing skills.

DRAWING ACTIVITIES

1. A drawing should do more than merely record. A good drawing expresses visually on a two-dimensional surface what a person feels, thinks, dreams, or sees.

As you prepare to make a drawing, try to think of the whole idea of your drawing and visualize this idea as a completed work. Select and place the center of interest (main subject or idea) first. Then place the other images in your composition in relation to the main subject or idea. Step back and evaluate the placement. Think about the balance of the shapes and the emphasis that you want to show. Make any necessary changes in the placement of parts.

Start to define the shapes or forms by the use of dark and light shading or the use of thick or thin lines, or both. Leave the fine details until later. Work all over the drawing

surface. Step back from time to time to evaluate the movement, emphasis, and unity of your drawing.

When you are satisfied with the overall composition, begin to add details.

2. Artists use the visual elements of art and the compositional principles of design to create their works of art. To help you see what the artist does when he or she makes an artwork, you are going to diagram different artists' use of one of these elements, line.

Place a clear piece of plastic or tracing paper over a work of art, and diagram the artist's use of line. Do not be concerned with anything else in the work except the different kinds of lines that you can see. What do you find? Are the lines repeated anywhere else in the work? Which of the following terms best describe the various lines you have diagramed?

short	vertical	flowing
restful	horizontal	converging
active	long	

Add other terms of description to the list.

3. In this exercise, you will deal with two of the visual elements of art, line and shape, as you make a drawing. Take an object from your pocket or purse. Anything will do, but select something with fairly simple lines. Place the object that you have selected on a blank sheet of paper. Now study it carefully, as if you had never seen it before. Turn it over, look at it from all angles and all sides (all points of view). Select the point of view that you wish to use for your drawing. Draw only what you *see, not what you think it looks like.* Use only lines at this time until you are satisfied with the shape of the object.

4. In activity 3, you worked with line and shape to create a picture of an item from your pocket or purse. Enlarge one of your drawings of this item so that it fits comfortably on a 9- by 12-inch sheet of paper. Shade the drawing to make it look three-dimensional. In other words, give **form** to your object.

5. Bring a small toy animal to class. Those that come with toy farms or circus sets are ideal for this activity.

Spend a few minutes just looking at your animal. Turn it in all directions. An artist's point of view is very important. Look at the relationships that each part of the animal has to its other parts. For example, are the legs longer than the back? Do the knees bend as yours do? Is the head small in relation

to the body? Where are the eyes in relation to the nose? If it has horns, relate the horns to the position of the ears.

Position your animal in front of you. On a piece of paper, and using a felt-tipped marker, make a large outline drawing of its shape, with no details. Now, carefully turn the animal a quarter turn in one direction. Use another color of marker this time, and make another large outline drawing over the top of the first one. Repeat this step two or three more times. Each time you turn the animal, use a different color of marker.

6. Although you may make many quick sketches of the people and places you want to draw later, your sketches may not record all of the details you want to remember. Sometimes your memory can be the best "sketchbook" of all. However, your memory must have practice in observing and recording.

Try these practice exercises. Begin with a large sheet of newsprint. Divide it into four boxes. Then try four visual memory tasks. Look at one part of the classroom for a minute or more. Observe the details of this segment of the classroom carefully. Try to remember as many details as you can. Then turn away from the scene and draw it in the first box on the paper. Try to sketch as many details as your memory can retrieve. Number the box 1. The one rule is that you cannot look back at the scene.

Repeat the exercise three more times. Each time, observe a different part of the room, turn away and draw, and then number the box. When you finish the four exercises, examine your drawings. Could you remember more details by the time you got to the fourth drawing?

7. Whether it is dim or bright, faraway or near, natural or artificial, light can affect the way an object or scene looks. Observe how. Place an object on the model stand so that it can be viewed from many different perspectives. Next, turn a spotlight on it and look at it with this change of light. Does the object appear changed? In what ways?

Select a piece of white drawing paper. Use a drawing pencil to make an outline sketch of the object.

Move the spotlight to a different location in the room or change the light source. Repeat the outline drawing, placing this one on top of the first. How do they differ?

Use oil base crayons to add color to each of the outline drawings. Look at each drawing and plan an interesting color combination. Add texture or pattern to the background.

8. Practice the use of light and shadow in drawing. Take a piece of white paper and crumple it gently in your hand. That is, crumple it only enough to put a few different planes, or flat surfaces, on it. You may have to try this several times to get the result you want—one that is not too

Figure 49A. Student art.

Figure 49B. Student art.

difficult to draw. Place this form in front of you. Draw the figure, paying special attention to the different planes (flat surfaces). Draw the lines and the shape of the form. Some of the planes will look light gray and some will look slightly darker. Try to get at least four degrees of gray.

9. An object on the model stand can be viewed from many different directions and angles. As a matter of fact, each of you will see it from a slightly different point of view. Select a piece of white drawing paper of the size and shape that best fits the object being displayed *and* your point of view of it. Select a wax crayon, and sketch the shape of the object. Don't try to shade this drawing. Just draw the outline.

When you and your classmates are ready, the teacher will turn the model stand one quarter turn. This gives you a different view and also a different shape. Select another value of the same color of crayon you started with, and make a second outline drawing. Overlap this one on top of the first. As each sketch is completed, the model stand will be turned two or more quarter turns. You will, each time, repeat the process, using a wax crayon of a different value. To add interest, try to use values of the color you selected in order from dark to light or light to dark.

PAINTINGS

Nature offers the artist a wide range of possibilities for expression. Marc Chagall said, "Art picks up where nature ends." He meant that the artist's vision gives us a new look at nature. The artist can celebrate nature, record it exactly, or distort it. The artwork may show that nature is ideal, romantic, comforting, frightening, or fantastic. The artist can, through images, attempt to control nature or show the relationships between people and nature.

Joseph Mallord William Turner (1775–1851) said, "I paint what I see, not what I know." Study Turner's seascape, *Snowstorm: Steamboat Off Harbor's Mouth* (Figure 50). Did Turner ever really see such a sight on the ocean? When Turner speaks of seeing, he means more than just seeing with our eyes. He wants the viewer to feel the drama of the scene as well. To show this in his painting, he uses dazzling lights, color, and motion. He gives us only an impression of a ship with a dark hull and a flag flying bravely from the

Figure 50. *Snowstorm: Steamboat Off Harbor's Mouth* by J.M.W. Turner depicts the awesome forces of nature. J.M.W. Turner, *Snowstorm: Steamboat Off Harbor's Mouth.* 1842. Approx. 35 1/4" x 46 3/4". Courtesy of The Tate Gallery, London/Art Resource, New York.

mast. He uses fantastic colors and the sun's reflection to contrast with the helpless ship.

During storms at sea, Turner had sailors tie him to the mast so that he could study the effects of wind and rain on the water. What Turner saw was how weak people are before the destructive power of nature.

Let's turn now to the works of other painters to see how they can open our eyes to nature.

Landscapes:
Scenery with a Statement

Sidney Goodman, an American artist from Philadelphia, painted a picture called *Landscape with Four Towers* (Figure 51). A landscape shows a view of the scenery on the land. Goodman's painting reflects his concern about the changes people cause in landscapes. "*Landscape with Four Towers* was not any specific locale," Goodman says. "It is a composite

Figure 51. *Landscape with Four Towers* **expresses Sidney Goodman's feeling about the way people alter the natural landscape.** Sidney Goodman, *Landscape with Four Towers,* 1970. Oil on canvas. 55" x 66". Courtesy of Terry Dintenfass, Inc., New York.

growing out of observation of the landscape approaching New York City on the New Jersey Turnpike. . . . I have been interested in the way manmade structures too often violate a place or the landscape. I both recoil at this intrusion, and find myself drawn to it."

Look carefully at *Landscape with Four Towers*. What do you see in this painting? There are four passages from bottom to top in the landscape. The bottom third shows ravaged hillsides with a sprinkling of surviving trees. Just above is a community of farms and houses, appearing cozy and peaceful. Above and beyond this section is a gray, cold-looking section of what appear to be industrial plants and office buildings. At the top, weighing down the other three sections like massive paperweights, are the four towers. Why do they sit poised and waiting over the city and the land? Why do they look so threatening? Even the artist said he felt he was witnessing something horrible.

The four towers look as if they are perched on the edge of the world. Perhaps the artist meant to show they are on the edge of modern history. Notice that there is light falling on one side of the towers and darkness on the other. Was the artist thinking of good versus evil?

Here, then, is a landscape with four different stories, each showing an aspect of people and nature. Our eye is led up and out of the painting by the bright sky and pointing towers. The artist might be asking us to provide the fifth story. What do you think it might be?

We are discovering that artists see and record their responses to nature in many different ways. Let us look at another example.

Close your eyes and imagine a starry night. What do the night stars look like in your mind's eye? Now look at the painting *The Starry Night* by the Dutch painter Vincent van Gogh (Figure 52). Have you ever seen a starry night like this? How does it differ from the one you saw when you closed your eyes?

Does van Gogh's landscape look real? To van Gogh it did. He had a great imagination and a very individual view of reality. The hills in this painting swell like ocean waves. The stars whirl and explode. A huge poplar tree weaves and points to the heavens. Yet while the night leaps like flames from the canvas, the little town and its church sleep quietly. Van Gogh painted his visions in an unforgettable way.

Look again at *The Starry Night*. How does van Gogh create such a powerful landscape? The village appears distant

Figure 52. In *The Starry Night*, Vincent van Gogh portrayed the world in a new and imaginative way. Vincent van Gogh, *The Starry Night.* 1889. Oil on canvas. 29" x 36 1/4". The Museum of Modern Art, New York. Acquired through the Lillie P. Bliss Bequest.

because of the dark colors and the gentle brushstrokes. The dark tree pulls your eye to the sky, and there the bright color and the stabbing brushstrokes almost envelop you. If your eye escapes for a moment back to the village, it is swept by the weaving tree into the whirling sky again. So you are twirled around and around in this painting. It is a disquieting picture.

To add to the sense of vibration, van Gogh has used mostly blue, violet, and yellow. Violet and yellow are complementary colors which, when placed next to each other, tend to create a sense of excitement in the eyes of the viewer.

Figure 53. *Travelers in Autumn Mountains* **by Sheng Mou. The tiny figures are overwhelmed by the grandeur of nature.** Sheng Mou (active c. 1310-1350), *Travelers in Autumn Mountains.* Chinese, Yuan Dynasty. Ink on silk. 9 5/8" x 10 9/16". The Cleveland Museum of Art. Gift of Severance and Greta Millikin.

Artists use many different ways to make a landscape interesting to the viewer. In *The Starry Night,* the whirling stars almost suck us into the picture. Through intense color, strong brushstrokes, and powerful rhythms, the artist has communicated to us an amazing landscape.

What ways can you think of to attract the attention of a viewer? How would you get a viewer into your landscape?

Look now at the painting called *Travelers in Autumn Mountains* (Figure 53). This ink painting on silk was done about A.D. 1350 by the Chinese artist Sheng Mou (shing moo). It makes a strong statement about the relationship of

87

people and nature. In the painting travelers move unhurriedly along a gentle road. We join the travelers on the road, but at the same time we have an overview of the entire landscape. Nature looms and stretches before our eyes in this beautiful painting. We are encouraged by the breathtaking mountains, the lovely waterfall, the pleasant trees, and interesting curves in the hills. We move about the landscape slowly and think about what we are seeing. Sheng Mou is telling us that mankind is not the most important element in the scheme of things, but merely a traveler passing through the universe.

Early Chinese landscapes, such as *Travelers in Autumn Mountains,* (Figure 53), do not tell us where the viewer stands in relation to the view. The Chinese artist assumes that we place ourselves in the landscape and do not simply look at it from the outside.

The fantastic mountain peaks we are looking at may seem unreal. Yet such scenery is actually to be found in parts of China. The artist reveals it to us by painting a landscape both of boundless views and close, detailed description.

When you look at *Travelers in Autumn Mountains,* what do you see first? Mountains? Trees? Waterfall? Travelers? Everything at once? In this painting the human figures are as much a part of nature as the trees or the mountains.

What does *Travelers in Autumn Mountains* have in common with van Gogh's *The Starry Night?* The first is a gentle but powerful landscape; the second is an exciting and powerful landscape. Both portray human beings as just part of a larger natural force. Both say some similar things in different ways.

Brushstrokes

There is yet another interesting similarity between these two works. The brushstroke is very important in creating the "look" of both paintings. We find gentleness and calm in *Travelers in Autumn Mountains* and anxiety and movement in *The Starry Night.* Although paintings are often thought of as two-dimensional, they are in fact not flat. The paint or ink is applied, usually with a brush, on a surface such as paper or canvas or wood. The impression left on the surface by the stroke of the brush is like the artist's handwriting or imprint. This is often called a *texture stroke.* When we visit an art museum we can look closely at original paintings and study the brushstrokes. They help us to better understand the artist's intentions.

The brushstroke is very important in Chinese and Japanese painting. Artists of the Orient express the forms of living nature through the energy and discipline of the brushstroke. The stroke itself can be carefully controlled or bold and free. It must express the spirit of the artist as well as an awareness of the life of nature.

The technique of the Chinese landscape painter has four basic elements: the line, varying tones of gray called the *ink wash*, the texture stroke, and the dot. The last two are used to give texture and accent to rocks and mountains. Can you find examples of all four of these elements in Sheng Mou's painting? Vincent van Gogh admired Japanese art. Do you think this might have influenced his use of broken lines and strong texture strokes in *The Starry Night?*

Chinese and Japanese painters traditionally copy the work of the old masters, carefully studying their brushwork. In this way they train their hands while learning both the techniques of painting and respect for the tradition.

Figures 54 and 55 show two paintings by the Chinese artist Tao Chi (döw-chi) (1642–1707). One is in the style of another artist, Ni Tsan (nee-tsan). The other is an original. Look carefully at both of them. Can you tell which has the copied style and which is in Tao Chi's own style? In the copy the lines and brushstrokes are stiff and heavy, but in the original they are free and alive.

The copy is the painting on the left. Each painting has different subject matter, but both picture bamboo. Look at the way the bamboo in each picture is painted. In the original, the brushstroke is more natural and relaxed. The lines for the pumpkin and squash are free and have feeling. In the copy, the brushstrokes are stiff and in some places painted over. They lack directness. The copy does not express as well as the original the aliveness of nature.

The superb tethered horse (Figure 56) is attributed to Han Gan, an artist who was the greatest painter of horses China has produced. The many seals we see on this work and others are of the collectors who have owned the painting through the years. It is unfortunate that so many have been stamped onto this masterpiece.

Placing People in the Picture

Two more paintings show how artists see people in nature. *Hunters in the Snow* (Figure 57) is by the Flemish painter Pieter Brueghel, the Elder. Flemish people live in a

Figure 54. *Landscape in Style of Ni Tsan* by Tao-Chi. Tao-Chi, Chinese (1642-1707), *Landscape in Style of Ni Tsan*. 1697. Ink on paper. 18 9/16" x 12 11/16". The Art Museum, Princeton University. Carl Otto von Kienbusch, Jr. Memorial Collection.

Figure 55. *Bamboo, Vegetables, and Fruit*, by Tao-Chi. Tao-Chi, Chinese (1642-1707), *Bamboo, Vegetables, and Fruit*, 1705. Hanging scroll, ink and light color on paper. 41 11/16" x 18". The Art Museum, Princeton University. Gift of Arthur M. Sackler Foundation.

Figure 56. Notice that the Chinese artists often wrote poems on their paintings.
Han Gan (Han Kan) (Active A.D. 742-756). *Night-Shining White Steed.* Ink on paper. 13 3/8″ x 12 1/8″. China, Tang Dynasty. The Metropolitan Museum of Art, New York. The Dillon Fund 1977.

part of northern Europe called Flanders. Most of Flanders lies in the countries of Belgium and France. Compare the subject matter in the following pictures. *View of Toledo* (Figure 58) is by a painter known as El Greco ("The Greek") who was born in Crete but did most of his work in Spain in the late 1500s. In what ways are *Hunters in the Snow* and *Travelers in Autumn Mountains* alike? In what ways are *View of Toledo* and *The Starry Night* alike?

Many art historians regard Chi-chuan Wang (wong) (b. 1907) as the most important Chinese landscape painter in three hundred years. Wang has lived in New York City since 1949. He has the most important private collection of Chinese painting in the world. His work continues the great tradition in Chinese art. This is so because he uses his knowledge of traditional Chinese painting in the creation of new works. Look closely at Figure 59, and compare it with the examples we have studied on the past few pages.

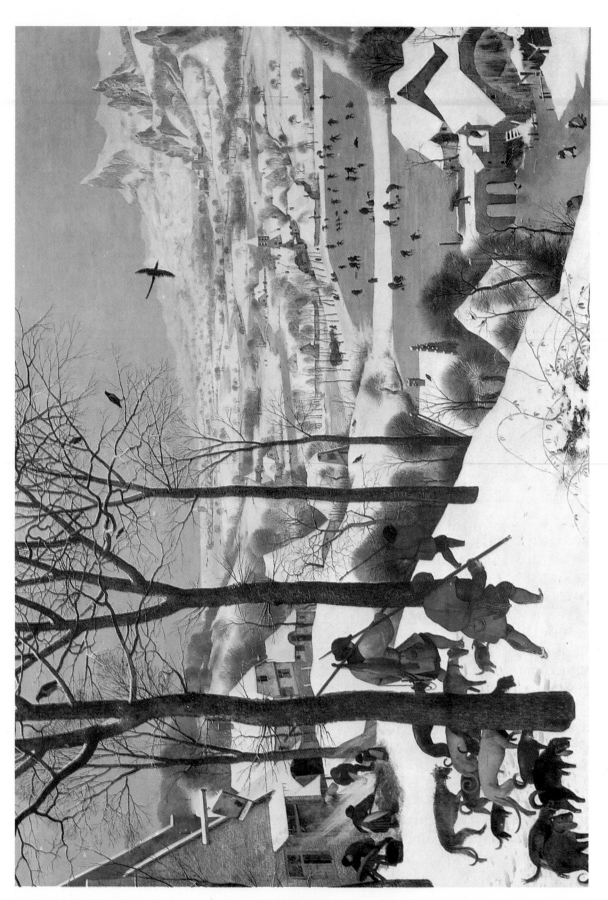

Figure 57 Pieter Brueghel, the Elder, showed the life and landscape of sixteenth-century Flanders in *Hunters in the Snow*. Pieter Brueghel the Elder, *Hunters in the Snow*. 1565. Oil on canvas. Approx. 46″ x 64″. Kunsthistorisches Museum, Vienna, Austria.

Figure 58. El Greco's highly imaginative *View of Toledo*. El Greco (Domenicos
Theotocopolos), *View of Toledo*. 1608. Oil on canvas. 47 3/4" x 42 3/4". The Metropolitan Museum of Art, New
York. Bequest of Mrs. H.O. Havemeyer, 1929. The H.O. Havemeyer Collection, 1929.

Figure 59. Wang keeps the great traditions and adds his own style.
C.C. Wang, *Landscape #720700, 1972.* Ink and watercolor on paper. 24" x 30". Private Collection. Courtesy of the artist.

In all four of these paintings nature is more than a setting for human activities. It is the main subject of the picture. The people and buildings in these works are not as important as the natural world. All the paintings provide a view that almost takes our breath away. All demonstrate the power of nature.

Captured Seasons

Many artists have looked at nature in terms of the seasons. *Hunters in the Snow* shows the seasonal work of a Flemish artist in the 1500s. Let's look at three other paintings showing seasons in more recent times.

Backyards, Greenwich Village (Figure 60) is by the American artist John Sloan. Here is a city landscape where we would least expect to find it—in a small backyard. The backyard has been changed for the moment into a snowy

Figure 60. John Sloan presents an intimate view of modern city life in *Backyards, Greenwich Village.* John Sloan, *Backyards, Greenwich Village* 1914. Oil on canvas. 26" x 32". The Whitney Museum of American Art, New York. Purchase.

wonderland for children and cats. Even the laundry seems to be flapping happily in the wind and sunshine.

John Sloan was a newspaper staff artist who reported the passing scene in illustrations for magazines and newspapers. He knew and loved the life of the city. His pictures show a warm caring for people and often a good sense of humor. Look at the expression of the cat curled up in the foreground. How does the little girl who is watching feel? Sloan seems to be saying that we don't need the big countryside when it snows. There is much pleasure to be found even in a little box of a yard.

Alma Thomas (1891–1978) dearly loved two things— teaching and painting. Her passion and energy found expression in a vibrant use of color in her painting. In thirty-five years of teaching, she established community action programs and art galleries in public schools in order to promote art education. Thomas was the first African-American woman to have a solo showing at the Whitney Museum of American Art.

Figure 61. Thomas sees flowers as pure color.
Alma Thomas (American, 1891-1978), *Iris, Tulips, Jonquils, and Crocuses*. 1969. Acrylic on canvas. 60"x 50". The National Museum of Women in the Arts, Washington, D.C. Gift of Wallace and Wilhelmina Holladay.

She believed that color and energy were essential to life, and looked for evidence of both in all that she did, whether teaching, painting, or simply taking a walk. Her *Iris, Tulips, Jonquils and Crocuses* (Figure 61) reflects her colorful style. The flat patches of color seem saturated with sunlight. The pattern arrangement is almost like musical notes and conveys an ecstatic rhythm, a bright song. For Thomas the spring flowers were a riot of pure color and energy. She challenges us to forget the actual shapes and names of the individual flowers in order to join her in celebrating this color and energy.

"Monet only has an eye, but what an eye!" Paul Cézanne (say-zahn´) said describing his fellow artist Claude Oscar Monet. Look at Monet's (moh-ney´) *Haystack at Sunset* (Figure 62). What did his masterful eye capture here?

Figure 62. Monet's eye not only saw nature, but experienced it as well. Claude Monet, *Haystack at Sunset*. 1891. Oil on canvas. 28 3/4" x 36 1/4". The Boston Museum of Fine Arts, Boston. Juliana Cheney Edwards Collection. Bequest of Robert J. Edwards in memory of his mother.

In front is a large stack. On the top, dark purple tones are set off against a color opposite—the yellows of the sky. An orange-red sunset reflects glorious color on the ground hitting the tomato-red bottom of the stack. The choppy brush strokes create rhythms of a ballet where the grass sways and the stack shimmers.

But Monet's eye saw more. This painting is one of a series showing stacks at different times of day and seasons of the year. "The title *Haystack* is wrong. They are wheat stacks," said Monet. And he knew the difference since he had grown up in farm country. Wheat stacks are tied and thatched to keep the rain out. Wheat is the wealth of the farmer, and he watches over it like his own house. Notice how the stack carefully repeats the shape of the houses in back. This stack is so powerful it beams an image of a dwelling. Monet's poetic statement reminds us of the human bond with life-giving nature.

97

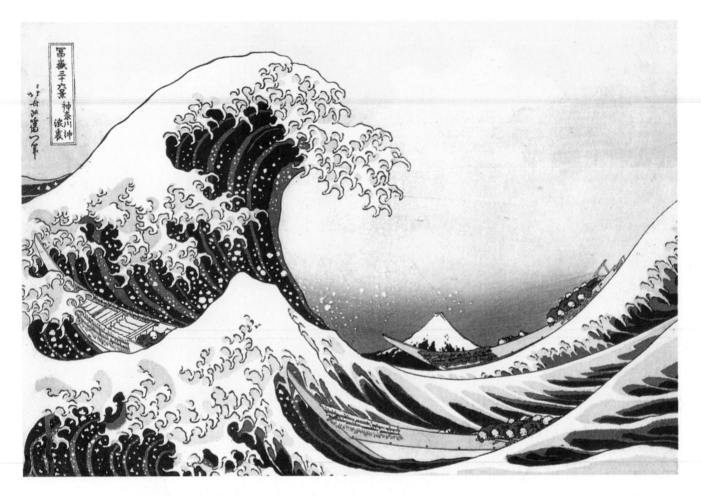

Figure 63. *The Great Wave Off Kanagawa,* **by Hokusai has influenced many artists.**
Katsushika Hokusai, *The Great Wave Off Kanagawa (Fuji Seen From the Bottom of a Wave).* 1824. Block print on paper.
15″ x 10″. The Metropolitan Museum of Art, New York, NY. Rogers fund, 1914.

Focus on the Sea

The seas have provided artists with a sometimes spectacular form of nature—the wave. Let's look at two works of art using waves as a central focus. In both, fingerlike projections of white foam reach out. You are already familiar with *The Great Wave Off Kanagawa* (Figure 63) by the Japanese artist Hokusai (discussed earlier on page 25). The wave in this picture rises from the sea. Its huge, dark form is lifted by frothy fingers of foam grasping the little men in their boats. So large is the wave that even Mount Fuji is dwarfed. *The Great Wave Off Kanagawa* suggests tremendous weight and sheer physical power.

Figure 64. In *Waves* by Ogata Korin, the huge waves rise up to haunt the viewer.
Ogata Korin, *Waves*. 1716. Two-fold paper screen: wave design in colors on gold ground. 58 7/8″ x 65 1/8″. The Metropolitan Museum of Art, New York. Fletcher Fund, 1926.

The print *Waves* (Figure 64) by Ogata Korin, is more mysterious than *The Great Wave Off Kanagawa*. It is filled with lovely, flowing shapes that look something like ghosts. Nature, in the form of these waves, appears to be alive. Can you see eyes looking out at you? *Waves* is a print one can look at for a long time and discover many surprises. Its power lies in its ability to hold our attention, as well as its rhythms.

PAINTING ACTIVITIES

Introduction

To create a painting, an artist needs three things: paint, a tool, and a support surface. **Paint** is pigment held together by a binder. Artists use many different kinds of paint: watercolors, oils, tempera, lacquer, inks, and even house paint. Paint is made of very finely ground material—natural or synthetic pigment. The pigment is mixed with a **binder** which makes the pigment hold together, makes it workable, and makes it adhere to the support surface.

Various **tools** are used to apply the paint to that support surface. At an early age you may have used your fingers, but there are many more effective tools, such as brushes, palette knives, and sticks. Can you add more tools to this list?

Have you ever wondered how many different sizes and shapes of brushes are available? Some are made especially for one kind of paint, while others are called multi-purpose. The "paint" can also be the "tool" when the pigment and binder are compressed or packaged into mediums like chalk, pastels, or crayons. Look through an art supply catalog and note the variety of tools.

The **support surface,** or **ground** is the surface to which you apply the paint. There are as many types of support surfaces as there are different kinds of brushes. Paintings can be done on paper, canvas, wood, walls, and floors. These surfaces can take an infinite number of different sizes and shapes.

For centuries, artists have sought ways to make their artworks last. They have tried to combine new pigments with the right kind of binders and apply them to the right surfaces to make them last for the longest possible time. Some have succeeded better than others. Certain cave paintings have lasted many thousands of years. An ancient Egyptian portrait in wax of a mummy looks as fresh today as in the second century A.D. when it was painted.

Still, even the greatest artists have sometimes failed to solve this problem. Leonardo da Vinci (lee´-oh-nar´-doh duh vin´-chee) painted *The Last Supper* over the years 1495 to

Figure 65. *The Last Supper* **by Leonardo da Vinci, must constantly be repaired.**
Leonardo da Vinci, *The Last Supper*. 1495-98. Fresco. 15′ x 1 1/8″ x 28′ 10 1/2″. Santa Maria della Grazie, Milan, Italy. The Granger Collection, New York.

1498 (see Figure 65). The painting, located in Milan, Italy, is constantly undergoing repairs because Leonardo's experiments with pigments and binders were not successful. The problem of making artworks last is important to the art community. An important profession in the art world today is restoring and conserving works of art.

1. A **still life** is a painting or drawing of nonmoving objects. When you are learning to paint a still life, you must develop the skills of looking at the parts rather than just at the whole. You must be able to translate the parts into shapes and forms, and then arrange the shapes and forms into a composition.

Look carefully at the model. Observe the arrangement, keeping the visual elements in mind. Consider the general shapes of the items. Look at the size and placement relationships of the shapes and forms. Think about how you will use the compositional principles to develop the composition.

101

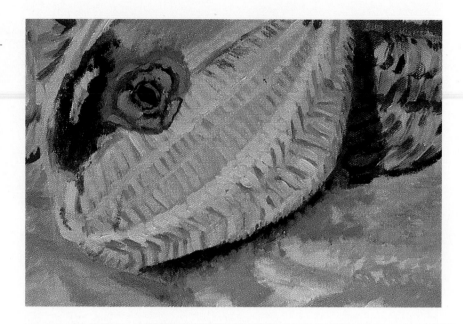

Figure 66. Student art.

Next, prepare a series of sketches. Your beginning sketches should include only the shapes and their placement on the page. Leave out all details and shading at this point. They will be added as you paint the total composition.

Select the sketch that you wish to use as the basis for your painting, and transfer it to the support surface (paper or cardboard) that you will use for your finished painting. Select your colors. Pay very close attention to your teacher's instructions as you begin to paint.

2. In this still-life assignment you will:
 a. Observe in order to see the parts of the whole.
 b. Translate the parts into shapes and forms.
 c. Select and arrange the parts into a composition.
 d. Use a color scheme of one hue and its values for your painting. This is called a **monochromatic** color scheme.

In this composition, extend the shapes and forms to the edge or over the edges of the ground (paper or cardboard) you are using. Also, overlap the objects in this still life. While doing your preliminary sketches, concentrate on the shapes that are formed by the overlapping as well as the shape of the whole subject. Select one of your sketches and transfer it to the support surface.

Begin the painting process by selecting one color and white and black. Mix the shades and tints that you will use. Remember, the entire support surface will be covered in this assignment.

WATERCOLOR ACTIVITIES

Introduction

It has been suggested that the medium of watercolor is one of the most difficult to handle or control. There are really just three things that you must do to become competent in any medium:

1. Learn to see and draw.
2. Think in terms of the visual qualities you are using.
3. Work hard at the craft and practice, practice, practice!

As you prepare to use watercolor, remember your experiences. You have already had experiences in seeing, drawing, and using the visual qualities in a piece of artwork. You have discussed ways different artists combined the visual qualities, subject matter, and their media to produce master works of art. You have completed drawing and painting activities designed to develop skill in rendering ideas and images.

Every artist has his or her special way of preparing the media and tools to be used. The following ideas and guidelines may help you to develop your own way of working with watercolor.

■ Sketches. Always carry a small sketch book or pad of paper. You never know when you will see something that might motivate you to produce a painting. Make notes about the color and location of the items you sketch.
■ Paint. At some point in your painting career, you should acquire your own set of paints and tools. Good materials

Figure 67A. Student art.

Figure 67B. Student art.

Figure 68. Student art.

generally produce better results. Watercolor is packaged in cakes (in pans) and tubes. There are advantages to both. The watercolor pans offer a convenient, portable way to sketch outdoors. The watercolor sold in tubes is usually of a finer quality. In addition, the tubes offer a wider range of color possibilities. However, the tubes generally cost much more than the pans. Excellent watercolor painting can be produced using either pans or tubes.

■ Palettes. The pan type watercolor trays offer a limited mixing area when opened out flat. An advantage is that you also have an attached top for the tray. Commercially produced mixing trays are available, and these offer larger sections for holding paint and more space for mixing. Plain white dinner plates or divided aluminum food trays can also serve as acceptable palettes.

■ Brushes. A poor brush could be compared to a dull saw. You cannot do the job well with poor tools. To choose your brushes for watercolor, you need some guidelines. Typical watercolor brushes are made from soft, flexible hair such as pony hair. Many brushes are made of a combination of types of hair, which lowers their cost without diminishing their workability. Other brushes are made from synthetic fibers.

Aside from the choice of materials in the brushes, there is the choice of appropriate sizes. Watercolor brushes are produced in a confusing array of sizes. The beginner should have a base of three sizes: a large flat or oval brush (for washes), a medium-sized round pointed brush, and a small round pointed brush (for detail work). To this base add several different sizes of bamboo brushes with a quill pin point on one and at least one large utility brush (one and a half to two inches).

As your skills develop and your interest increases, add other specialized soft brushes and a few bristle brushes. But buy quality rather than quantity. The masters use as few as three brushes.

■ Easel, Backboards, and Paper. You can paint a lifetime without an easel. In fact, much of your painting will be done on a table or even on your knees. Easels are convenient if you plan to do a great deal of outdoor work. They can be simple or elaborate. Above all else, the easel should be portable.

You also need a backboard to hold the watercolor paper. If you are going to use tape or pins to fasten the paper to the backboard, the board should be several inches larger than your paper. If clips are used to hold the paper, the backboard should be only slightly larger than the paper so that the clamps will grasp the paper's edges.

Watercolor paper comes in blocks—a pad of paper glued at the edge. Sheets of watercolor paper are available in different sizes (22 by 30 inches, 25 by 40 inches, and some larger sizes), weights (90-, 140-, 300-, and 400-pound paper), and textures. The heavier the weight, the more expensive the paper is the general rule. Texture varies from very smooth to very rough.

CAUTION

Always discuss the selection and use of any tool with your teacher for specific safety advice. Do not attempt to use any of these tools without your teacher's guidance.

■ Tools and Miscellaneous Equipment. Tools (other than brushes) can be various kinds of knives, scissors, small pliers, or any other gadget that will make a mark on wet watercolor paper. You will also need old rags, paper towels, facial tissues, sponges, and water containers (some with tight-fitting tops for field use). Finally, you will need drawing tools, such as pencils (number 2 pencil, or better yet, carpenter pencils), pen and ink, and plastic or gum erasers.

■ Techniques. There are four techniques for applying watercolor. The four differ in the amount of water you use on the brush and paper. You should learn to control all four techniques.

a. *Dry on dry:* This technique involves using a dry brush to pick up the color and to place it on dry paper.

b. *Wet on dry:* This technique is the use of a wet brush to apply color to dry paper.

c. *Dry on wet:* This technique means working with a dry brush on wet paper.

d. *Wet on wet:* The last technique, and probably the most difficult to control, is that of applying color from a wet brush to a wet surface.

Each of these techniques has a wide range, from very dry to very wet. Many factors affect your choice within this range. The quality and size of the brush affects the amount of water that it is able to hold. The same is true for the weight and quality of the paper. Where will you be painting? Indoors or outdoors? How humid is the climate on the particular day? These are large factors in your control of the wetness and dryness of the brush and paper. These variables are ones you will learn to control with practice.

3. In this assignment you will paint a still-life in watercolor. Look carefully at the still-life arrangement. With a pencil, very lightly block in the general placement of the objects and the background. Leave the white areas, and begin putting down the next lightest color. Continue this process, working to darker and darker colors. Remember that the places that you plan to overlay with a wash should be dry to prevent the color from running or bleeding. At this point, it is good to stop, perhaps for the day.

When you resume, begin by critiquing the piece at this point of development. Study the arrangement of visual elements and compositional principles. Decide if your painting

Figure 69A. Student art.

Figure 69B. Student art.

will hold together, or if some adjustment is needed. Be satisfied that you have a well-balanced composition that leads the eye over the entire painting. Then continue to develop the color and make adjustments by adding more intense color and texture.

4. Let's now approach the painting of landscapes in watercolor. Look in the text for examples of landscape painting. Note how various artists have interpreted landscapes. Compare and contrast van Gogh's *The Starry Night* (page 86), Sheng Mou's *Travelers in Autumn Mountains* (page 87), and Brueghel's *Hunters in the Snow* (page 92). Discuss the similarities of *The Starry Night* and El Greco's *View of Toledo* (page

Figure 70. Student art.

93) if you have not already done so. Each of these artists has used a personal interpretation of the subject matter. Your own landscape should stress your own personal interpretation through mood, arrangement of line and shape, and space relationships.

Spend the time to make a good selection of a subject. You should sketch some scenes that seem appropriate in your own neighborhood. Use either new sketches or ones you have previously made for your landscape painting. You may use cityscapes or seascapes, if such scenes are nearby and if they fit your objectives.

5. In *The Gulf Stream,* Homer used camouflage to fool the viewer about the number of sharks in the painting. Camouflage is a technique that many artists use.

Select an animal, bird, or insect that camouflages itself in its environment. Design the creature, using materials suggested by your teacher. On a separate sheet of paper, create the camouflage environment using the same colors, patterns, line, and texture found in the animal. Then place your creature in or on the drawing so that the camouflage is apparent to a viewer.

Figure 71. Student art.

6. This action-oriented activity draws on Homer's *The Gulf Stream,* and asks that you work with the human form. You have not had a formal introduction to drawing and painting the human figure. That will come in the next major section. So simply have some fun with this one.

The Gulf Stream portrays a man struggling against natural forces. Imagine you are a lone survivor struggling against nature. Select an environment which places you outdoors (for example, hiking, mountain climbing, swimming, sailing, or driving a car in the desert). Then imagine a disaster that occurs to threaten your survival (such as a hurricane, snowstorm, avalanche, animal, or car breakdown). Divide a sheet of paper into six or eight sections. Sketch your struggle against nature, showing what took place before, during, and after the catastrophe.

After completing the sketches, select the one frame that contains the most action or reveals the most information about the disaster. Using tempera or watercolor, paint an enlarged version of that frame titled *The Lone Survivor.*

SCULPTURE

You have learned how nature has affected the work of many different artists who paint or draw. You have also seen how these artists use nature, or some part of it, to express their visions. Many artists express themselves in other media. Some work in wood, clay, stone, or other materials. These artists carve, mold, weld, and sometimes hammer. These artists are sculptors. Like painters, sculptors are affected by nature. They, too, have a vision to share.

The Sculptor as the Landscape

Sculptor Barbara Hepworth remembers drives with her father in the countryside of Yorkshire, England. She remembers how deeply affected she was. "And the country—the unspoiled country there—was so magnificently shaped that the roads became, as it were, contours over a sculpture."

Ideas that began to form in her mind during those childhood trips, Hepworth claims, shaped her whole life.

Figure 72. British sculptress Barbara Hepworth translated her sensations of traveling over the land in her *Figure in a Landscape.* Barbara Hepworth (British, 1903-1975), *Figure in a Landscape* (trencrom). 1952. Alabaster, 5 1/4" x 10" x 2 1/4". Smith College Museum of Art, Northampton, Massachusetts. Purchased 1953.

The hills were sculptures; the roads defined the form. Above all, there was the sensation of moving physically over the contours of fullnesses and concavities, through hollows and over peaks—feeling, touching, seeing, through mind and hand and eye. This sensation has never left me. I, the sculptor, am the landscape. I am the form and I am the hollow, the thrust and the contour.

Look at Hepworth's *Figure in a Landscape* (Figure 72). What do you see? Where is the figure? Where, for that matter, is the landscape? Hepworth says, "I, the sculptor, am the landscape." In this work could the two holes be her own eyes? Could the form itself represent a mask through which she views nature? Such forms are called "pure" forms. They capture the essence of a mountain or a wave or a tree. Still, in Hepworth's work, there is a power in the form that makes us look longer at it and wonder if it has some special meaning.

Hepworth called her sculpture *Figure in a Landscape*. The name demands that we make the effort to see what she had in mind when she carved it. The sculpture itself appears to be looking at us to capture our attention.

Early in her life, Hepworth wondered how a dirty industrial town such as Wakefield, her hometown, could grow out of the beautiful countryside surrounding it. To Hepworth, this seemed a conflict between people and nature. Yet she also saw that the town and countryside were part of the same landscape, and this suggested to her a unity between people and nature. Hepworth's sculpture represents her efforts at expressing both this conflict and this unity.

Why did Barbara Hepworth choose to work in stone? She tells us in her own words:

> I so love carving. It seems to me the most rhythmical and marvelous way of working on live and sensuous material because, even if one has two pieces of the same stone, they have another nature. Every piece of wood and every piece of stone has its own particular live quality of growth, crystal structure, and one becomes utterly absorbed . . . as one tries to make the forms and contours which will express oneself. . . . Being a carver, I do have a complete conception in my mind of the form I'm making before I start carving or, indeed, making any work.

Capturing Nature in Sculpture

The very earliest sculptures found in China include the jade bird pictured in Figure 73. This sculpture was made during the Neolithic period of the Stone Age, which lasted from about 3000 to about 1600 B.C. Pottery of the Neolithic period decorated with plant forms, birds, animals, and human figures has also been found in China.

Do you think this figure is a bird? If not, what might it be? What is it doing? The "bird" appears to be resting but, at the same time, alert. Its neck thrusts upward, suggesting that it is aware and prepared to fly if necessary. The artist must have been extremely observant to create a feeling of both rest and alertness in one figure.

Now look at the marble sculpture of the powerful sitting bear (Figure 74). It was carved during the Shang Dynasty in China, which lasted from about 1600 to 1027 B.C. Carvings and paintings of such animals have been found in tombs of the Shang kings. These animals were placed there partly to protect the tombs. They were also there for their decorative

Figure 73. The abstract bird carved in jade is among the earliest known known sculptures from China. Artist unknown, *Abstract Bird*. Shang Dynasty. (About 1500 B.C.) Jade carving. (Approx. 6″ in height.) The Asian Art Museum of San Francisco. The Avery Brundage Collection.

value. In other words, their shapes and designs were just pleasurable to look at.

The bear makes a striking and attractive decoration. We can enjoy looking at it simply as an ornament. However, look at the bear more closely. Does it appear to be protective? Is it ferocious? Calm? Or is it proud and self-confident as a creature might be that is aware of its strength and power? This bear holds itself almost like a king. With its feet planted squarely on the ground and its head and chest raised, it seems to be saying, "I am a bear to reckon with!" Perhaps, then, the bear is protecting the spirit of the dead king. As did the "bird," the sculpture of the bear reveals careful thought and observation by the artist.

Finally, look at the small bird carved in jade (Figure 75). It was meant to be a pendant, worn on a chain around someone's neck. This bird was made by a Chinese artist sometime between 1027 and 249 B.C. The simple design expresses motion.

Now compare the early Chinese bird sculptures—the Neolithic "bird" and the bird pendant—to another sculpture, *Bird in Space* (Figure 76). *Bird in Space* was created in 1925

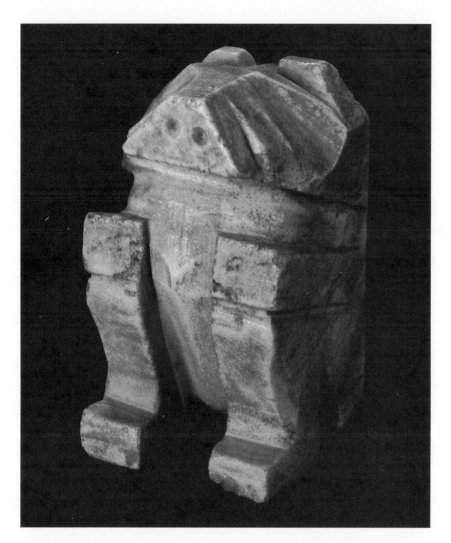

Figure 74. This sitting bear carved in marble is another fine example of very early Chinese sculpture. (About 1500 B.C.) Artist unknown, *Sitting Bear.* Shang Dynasty. Jade carved in marble. Height 4 1/16″. The Seattle Art Museum, Seattle, Washington.

by the Romanian sculptor Constantin Brancusi. All three sculptures are abstractions. This means that their forms represent or suggest an idea or concept, but they do not show it just as our eye usually sees it. For instance, the form of the Neolithic "bird" merely suggests a bird; it does not show an exact bird.

The other two sculptures suggest a movement we associate with birds—flight. The outstretched wings of the bird pendant tell us that it is flying. How does the Brancusi sculpture suggest flight? What is the form doing? Does it look as if it is standing still or as if it is moving? In what direction is it moving?

Figure 75. The simple design of the small jade bird expresses the feeling of flight. Artist unknown, *Jade Bird*. Zhou Dynasty 1027-249 B.C. Jade carving. Height 5". The Asian Art Museum of San Francisco, The Avery Brundage Collection.

◄ **Figure 76. The modern sculptor Constantin Brancusi expresses the essence of flight in *Bird in Space*.** Constantin Brancusi, *Bird in Space*. 1925. Polished bronze. Height: 4' 1 3/4". Philadelphia Museum of Art. Louise and Walter Arensburg Collection.

Brancusi wanted to remove as many details as possible from the bird form and still give us a sense of flying. He said, "All my life I have sought the essence of flight. Don't look for mysteries. I give you pure joy. Look at the sculptures until you see them." Well, then, let's look at *Bird in Space* until we see it. What details has Brancusi completely eliminated from the bird? What is still birdlike about the form?

Brancusi explored bird forms in many sculptures, until he finally saw the image of the bird as just the *idea* of flight. In fact, he repeated the theme of *Bird in Space* between the years 1924 and 1949 in a series of works that were increasingly simplified.

He was always looking for basic forms that appear over and over again in nature. A basic shape is one that cannot be simplified any further. One of Brancusi's favorite basic shapes was the oval. In nature we find it as an embryo, a nucleus, and an egg, for example. What do all three have in common? They are all beginnings of life.

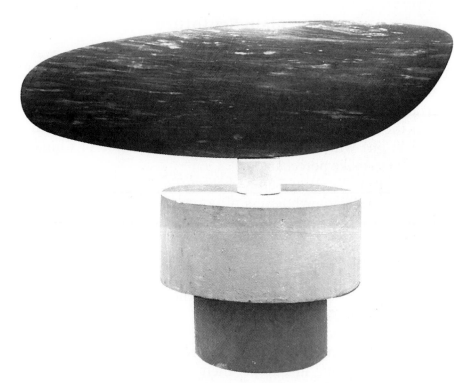

Figure 77. *Fish* **by Constantin Brancusi seems ready to dart away.**
Constantin Bransusi, *Fish*. 1930. Grey marble. 21″ x 71″. On three-part pedestal of one marble and two limestone cylinders 29 1/8″ high. Collection of the Museum of Modern Art, New York. Acquired through the Lillie P. Bliss Bequest.

Brancusi used the basic oval shape for beginnings too—beginnings of sculptures. Look again at the sculpture *Bird in Space* and then at Brancusi's sculpture *Fish* (Figure 77). Both are basically an oval shape. *Bird in Space* is an oval that has been stretched upward as if soaring into the sky. It is an oval that stands for flight. Because it has no special details, it represents not one particular bird but all birds, and all flight. *Fish* is an oval that has been flattened and stretched out horizontally. It hovers motionlessly the way fish do when they are still. However, like the Neolithic "bird," it looks ready to dart away in a moment.

Since Brancusi made his sculptures so stark and simple in form, he cared a great deal about their finish. The artist polished and repolished their surfaces and contours until they seemed to glow with the ideas they contained within.

There are other unusual types of sculpture to consider. Let's look at a very fine example of porcelain and then the highly original woven sculpture of Magdalena Abakanowicz.

Porcelain Sculpture

Porcelain, a hard and fine-grained form of pottery, was produced in China more than twelve hundred years ago. It was harder than other kinds of pottery and so could be made thinner and molded into delicate shapes and forms. It could be given the most brilliant glazes. A special clay, called **kaolin** (kay´-oh-lin) which had remained a secret outside of China, was used to make porcelain.

Pottery produced in Europe before the eighteenth century lacked the brilliant whiteness of porcelain and the beautiful enamel glazes of color. The pieces also chipped more easily than porcelain. Pieces of porcelain had found their way into Europe from the Far East over the years. By the early eighteenth century, the wealthy of Europe had become obsessed with the desire for porcelain pieces. These became popularly known as "china."

It appeared that a fortune awaited the one who could rival the Chinese. Many tried to make porcelain but were unsuccessful. At this time in Europe, there were many people who were known as alchemists. Alchemists tried to change base metals (such as iron) into gold. One of these, Johann Friedrich Bottger (bot´-grr), believed that if he could only make porcelain, it would be more valuable than gold. He teamed up with a respected scientist, Walther von Tschirnhausen (churn´-how-sen). They found the most important ingredient of porcelain, kaolin, near the town of Meissen, in Saxony, in what is now part of Germany. By 1710 they had produced a china so hard that it could be cut and polished like a jewel.

A factory which was sponsored by Augustus the Physically Strong, king of Poland, was established at Meissen. Soon its wares were sought throughout Europe. Augustus commissioned Johann Kirchner (kurch´-ner) and Johann Kaendler (kaned´-ler) to produce porcelain zoo animals and birds for the decoration of the Dutch and Japanese palaces in Dresden, a city in Saxony. Many were life-sized or nearly so. Few of them were so richly decorated as the one depicted in Figure 78, entitled *A Pair of Goats.*

Woven Sculpture

The woven sculpture *Abakan 27* shown in Figure 79 was created by the Polish artist Magdalena Abakanowicz (ah-bah-kan´-oh-witz). The "abakan" is a woven free-hanging, three-

Figure 78. The impact of Kaendler's *Pair of Goats*, created in dazzling all-white porcelain, lies in the sensitivity and delicacy of the forms and details. Johann Joachim Kaendler (German, 1706-1775), *A Pair of Goats.* c. 1732. Made at Koniglich Sachsische Porzellanmanufaktur, Meissen. Hard-paste porcelain. Female: H: 18 3/4″, L: 27 1/4″, W: 14″. Male: H: 21 3/4″, L: 28″, W: 13 1/4″. The Philadelphia Museum of Art. Bequest of John T. Dorrance, Jr.

dimensional work. Why do you think the artist calls her work "abakans?"

Abakanowicz' first woven works were flat, but in the mid-1960s she began to work in three dimensions. Many of her materials are cast-offs from factories. The artist does not like to work with artificial fibers, only natural ones, such as wool, sisal, flax, horsehair, and hemp. These materials are not only organic, but also traditional. Their use places Abakanowicz in touch with nature and the past.

Although artists respect and learn from tradition, many also enjoy the challenge of discovering new ways of expression with traditional materials. Abakanowicz says that rules and prescriptions are "the enemies of inspiration." In other words, she does not use traditional materials in traditional ways. She sees relationships among things of which others are unaware. Her sculpture expresses these relationships in new ways.

119

Figure 79. Abakanowicz uses only natural fibers. Magdalena Abakanowicz, *Abakan 27.* 1967. Woven sculpture. Sisal weaving on brown. 57 3/8" x 71 3/4" x 5 3/4". The Detroit Institute of Arts, Detroit, Michigan. Gift of Jack Lenor Larson.

SCULPTURE ACTIVITIES

120

1. Sculpture gives the artist and the audience three dimensions to be concerned with. Instead of looking at the work from one point of view or direction, the viewer can walk around the work and view it from many directions. Your first sculpting

experience will be with a soft, rather flexible wire. You will be able to manipulate it easily. Look back at any sketches you may have kept from drawing activities. If you need to, make a few new ones. The sketch you choose will be your subject for this sculpture. In moving from drawing to sculpture, remember that you now have more than a line on a flat surface to consider. You now must also consider the third dimension—space. Experiment with bending and curving the wire. Consider how the image you are creating will look from all directions, even from the top down. The finished piece should give a light, airy feeling and should express the subject's attitude and mood.

2. Use your imagination to invent and produce a new animal form. Pretend that you were caught in a storm at sea and the waves that washed over your boat brought aboard a strange new form of sea life.

Select materials from which you will make the image of this new form. You may wish to use firing clay or plastic molding clay to produce a model of your strange new find. Then you may want to enlarge the idea. Consider making a papier-mâché enlargement beginning with sheets of rolled newspaper taped into a basic form. (You may need to add some anchors with wire coat hangers.) Wads of newspaper can then be added to give the animal more form. Last, you can apply pieces of newspaper soaked in papier-mâché paste.

3. New forms can be invented from various objects you may find. In art, these are often referred to as **found objects.** Collect buttons, fabric, plastic parts from packing materials, foil, odd machine parts, and so on. Glue or paste them to one basic shape such as a box, cylinder, or ball. Try several variations before you decide on the final grouping. Several finishing processes may be considered, such as covering all with papier-mâché, or painting the whole sculpture one color and adding accent colors.

Work with found objects will test your creative skills. Be sure you continually keep the compositional principles in mind as you work.

Figure 80. Student art.

PHOTOGRAPHY

Still another form in which artists explore nature is the photograph. In this medium the artist works with images on film. Like other artists, the photographer must have a vision, and must find a way to express it through the lens of a camera focused on the outside world.

Human Marks on the Landscape

Robert Frank's photograph *U.S. 285, New Mexico 1958* (Figure 81) is one of many from his book *The Americans.* Frank traveled throughout America photographing the commonplace. He wanted to show us America as he saw it, a plain landscape, filled with plain people going about their business.

Figure 81. *U.S. 285, New Mexico 1958,* **a photograph of commonplace objects by Robert Frank, gives a thought-provoking image.** Robert Frank, *U.S. 285, New Mexico, 1958.* Courtesy Pace-MacGill Gallery, New York.

He wanted to make us notice places and events we might tend to overlook. He wanted to make us see new meanings in everyday events.

U.S. 285, New Mexico 1958 can be seen as a powerful comment on people and nature. Five little gas pumps stand on a landscape. They might have arrived moments ago from outer space. They stand at attention, their little round heads all turned in the same direction, as if awaiting a command; their hoses ready at their sides. Where did they come from? What are they doing?

The gas pumps, of course, were made by people to serve people with a product taken from the land. In a way, they are indeed invaders. For centuries before their arrival, nothing disturbed the flat stretches of land. Only a few junipers and piñons punctuated the landscape.

Why did the photographer make the sign, SAVE, such an important part of the picture? What did it actually mean? Probably that gas was sold for less at that station. What did the photographer want the viewer to think about? To save the landscape from such intruders? To save us all from too much progress? The photograph *Santa Fe, New Mexico* appears to be straightforward. Yet we might say there is more to it than meets the eye. It is a powerful photograph that surprises us. Like Barbara Hepworth's sculpture, it looks back at us, holding our attention, forcing us to think about it.

Two additional photographs show how other artists saw created forms interrupting the natural landscape. One is

Figure 82. Charles Sheeler's *Fuel Tanks, Wisconsin* **shows how manufactured objects can dominate a landscape.** Charles Sheeler, *Fuel Tanks, Wisconsin.* 1931. The Library of Congress, Washington, D.C.

Charles Sheeler's *Fuel Tanks, Wisconsin* (Figure 82). The other photograph is Barry Brukoff's *Stonehenge* (Figure 83).

Special Techniques

Sometimes a work of art appears to be almost an exact copy of nature. If so, we say, "Why, that is just like a photograph!" However, we would not be talking about a photograph such as the one called *Boojum II* (Figure 84) by Richard Misrach (miz´-rock). Look closely at this photograph. What is it about?

Dramatic lighting and special darkroom techniques were used in *Boojum II*. The resulting product is a highly subjective, or personal, view of the subject. *Boojum II* shocks us into seeing in this landscape something that Misrach saw. The trees thrust up from the earth, reaching out with clawlike limbs. Where are they coming from? What time of day is it?

Figure 83. *Stonehenge* **by Barry Brukoff focuses on the weighty presence of this ancient subject.** Barry Brukoff, *Stonehenge*. 1980. 8" x 10" gelatin silver print. ©Barry Brukoff, 1980.

Figure 84. Richard Misrach produced an eerie landscape in his photograph *Boojum II*. Richard Misrach, *Boojum II*. 1977. Photograph. The San Francisco Museum of Modern Art. Mrs. Ferdinand C. Smith Fund purchase.

What do you think this photograph is about? Is it an exciting or a frightening picture? What does the title, *Boojum II* suggest about this landscape?

Compare *Boojum II* to the photograph *Oak Tree in Winter, Lacock Abbey Estate* (Figure 85) by William Henry Fox Talbot. *Oak Tree in Winter* is a more traditional photograph. It was made in the mid-nineteenth century and looks exactly like what it is—an oak tree. Which photograph is more interesting? Which do you prefer? Why?

Photography's Growth as an Art Form

Photography was invented in the early part of the nineteenth century. Painters, as well as the general public, admired the camera's ability to record nature in exact detail.

Figure 85. William Henry Fox Talbot's *Oak Tree in Winter, Lacock Abbey Estate,* shows a natural object as it really appears (1840).
William Henry Fox Talbot, *Oak Tree in Winter, Lacock Abbey Estate*. c. 1843 Photograph. Salt paper print from a calotype negative. Approx. 6 5/8" x 8 3/8". The Fox Talbot Museum, England. The Lacock Collection.

However, most people regarded photography as the work of a machine and not as an art form.

Since most early photographers were interested in commercial or scientific success, they did not even consider the issue. The miracle of a life-like image was enough reward in itself.

Only gradually did the camera come to be used to record the vision of the human being behind it. In the next four photographs, we will look at the works of four pioneering photographic artists: the American photographers Edward Steichen, Edward Weston, and Gertrude Kasebier, and British photographer Eadweard Muybridge. The ways they used their cameras to record nature transformed photography into an art form. The public could now see and under-

stand the mastery of the photographer-artist over the machine.

Edward Steichen Edward Steichen (1879–1973) was a leader in the movement away from the camera's use as a mere machine for copying nature. He was a painter with a keen interest in making artistic photographs. Steichen experimented with exposure times in printing to give different effects to his photographs. Sometimes, accidents lead him to discover new effects. When his camera lens got wet in a downpour, the image he shot was blurred—to great effect!

Around 1904 Steichen did an art series that expressed the mysterious atmosphere of moonlit landscapes. His photograph *The Pond—Moonrise* (Figure 86) was shot that year. It is one of the most beautiful and important photographs ever made. It has the feel of a painting. The mist has a haunting and dramatic effect. The eerie moon creates a moody atmosphere over the long shadows of the trees in the water.

Edward Weston Edward Weston (1886–1958) began his career by making artistic photographs. The kind of visual images he created was known as *pictorialism*. Pictorialism meant that a photograph should look as much like a painting as possible.

Weston developed camera techniques that enabled him to produce photographs with absolute sharpness. He felt that the photographer must see clearly in the mind's eye the desired final result of the photograph before shooting it. This mental image must include the light and dark areas. Unlike a painting, the print could not be changed!

Weston looked for the "grand design" of the universe in the world around him. His photographs reveal many abstract patterns in nature. Look at the cool design of nature in his photograph *Iceberg Lake* (Figure 87). You are experiencing this abstract wonderland through the lens of a modern artist.

Eadweard Muybridge Eadweard Muybridge (1830–1904) worked in his native Britain and the United States. He was a brilliant artist and quite inventive. His incredible shot *Mirror Lake—Valley of the Yosemite* (Figure 88) was made over a hundred years ago. The double image he created here is a perfect description of the lake's name—Mirror Lake. Where did Muybridge stand when he took this photograph? How was he able to record that kind of reflection? Note the trees in the background are also reflected in the water. This is a marvelous composition created by an ingenious photographer.

Figure 86. *The Pond—Moonrise*, by Edward Steichen has a haunting effect. Edward Steichen, *The Pond—Moonrise*. Platinum toned with yellow and blue-green. 15 5/8″ x 19″. The Metropolitan Museum of Art, New York. Gift of Alfred Steiglitz, 1933.

Figure 87. *Iceberg Lake* **by Edward Weston reveals patterns in nature.** Edward Weston, *Iceberg Lake*. 1937. Silver gelatin print. 7 1/2″ x 9 1/2″. Photograph coutesy the Art Institute of Chicago. Gift of Max McGraw, 1959.

Gertrude Kasebier Gertrude Kasebier (1852–1934) was born to a pioneer family that traveled to Colorado in a covered wagon. She revolutionized portraiture by placing her subjects in everyday light in natural settings. Gertrude Kasebier's photograph, *The Sketch* (Figure 89) portrays a young woman standing in the shade of trees on a bright, sunny day. She appears to be sketching the surrounding gentle fields. Her face expresses concentration and peace. Her posture implies self-confidence. The sketcher holds her materials securely. She blends naturally with the landscape she is studying. The image is a quiet and serene one.

We can almost feel the slight breeze stirring the sketcher's hair and long skirts. So intently does she appear to be con-

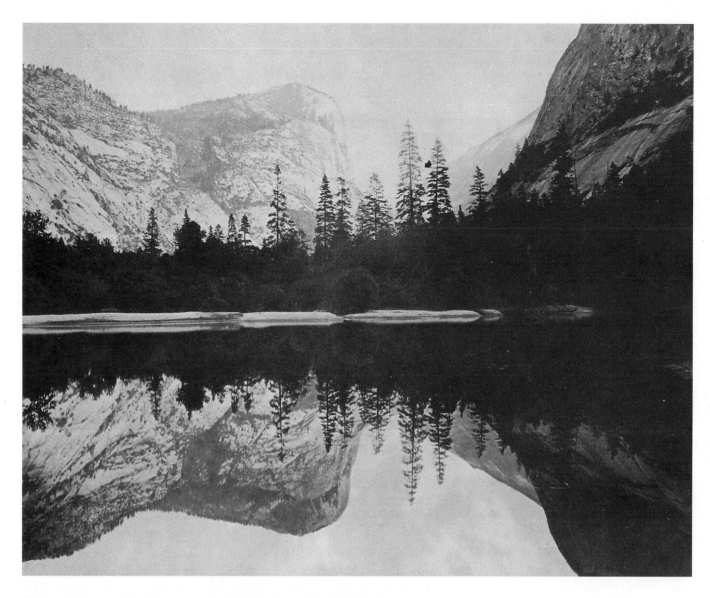

Figure 88. Consider the care that Eadweard Muybridge took to get a perfect image of the mirror lake. Eadweard James Muybridge, *Mirror Lake—Valley of the Yosemite.* 1868. Albumin print. The Metropolitan Museum of Art, New York. David Hunter McAlpin Fund, 1966.

centrating that we have the sensation that we have come upon her unnoticed. We pass her in the midst of a lovely, private moment, and we can walk on, leaving her to her communication with the countryside.

In this photograph Kasebier evokes a strong mood through the effective use of chiaroscuro. **Chiaroscuro** is a technique that involves use of light and shade to create an effect. You will come upon this basic art term in studying other forms of expression. In this case, the shadows of the

131

Figure 89. Study the effects of light and shadow.
Gertrude Kasebier, *The Sketch*. 1902. Photograph. International Museum of Photography at George Eastman House, Rochester, N.Y.

trees, the pale sky, the dark head, and the light skirts of the sketcher work together, making her look almost like a piece of sculpture. However, the soft focus of the entire image balances the strong lighting effects. The overall result is an image that is strong and gentle at the same time.

PHOTOGRAPHY ACTIVITIES

1. The essentials of photography are light and light-sensitive materials called emulsions. A camera is not required to make a photographic image. Interesting prints called **pho-**

Figure 90. Photogram. Student art.

tograms can be made using short exposures with a light bulb and found objects in contact with an emulsion (photograph paper or blueprint paper). Two examples of photographic art by students are shown in Figures 90 and 91. Make a photogram. Begin by collecting some manufactured objects such as cut glass dishes, jewelry, net, lace, transparent projector bulbs, small crystals, dry pasta, textured glass, string, or paper stars. In a pitch-dark closet or room, place these objects on light-sensitive photographic paper. Turn on the light for a few seconds. Next, follow your teacher's specific directions. Develop, fix, and wash the paper with Dektol. Ask your teacher for more information about these processes.

What effect did you achieve in your photogram? Try a similar photographic experiment using natural objects such as leaves, weeds, flowers, seashells, fan coral, or feathers. How do the two photograms differ?

 CAUTION Your teacher will give you specific directions in photo processing.

133

Figure 91. Photogram. Student art.

If photographic equipment is not available, you might try a similar experiment on a copying machine. Place your objects on the glass of the copier. Push the print button. What kind of image appears? How do you think it differs from a photograph?

2. In the early days of photography, emulsions were slow (not as sensitive to light), and the shutter had to stay open for a long time. People had to pose very still for a photographic portrait to be made. The pinhole camera you will make in this activity will also require the photographic subject to remain very still during the photographing process.

For a pinhole camera you will need a shoe box, an oatmeal box, or a cigar box. Paint the inside of the box flat black. Use a fine sewing needle to poke a pinhole in a piece of aluminum foil. (A more durable and uniformly round pinhole can be made by *almost* piercing a piece of aluminum pie tin with a needle and then sanding it on the reverse side until a hole appears.) Cut a 1- by 1-inch opening in the box and tape the foil over it so that the pinhole is in the middle of the opening. This serves as your lens and aperture. Devise a shutter or cover for the pinhole which can be

Be very careful using the needle.

CAUTION

Figure 92. How can you tell this is stop-action? Student art.

held in place after the exposure. For your light sensitive emulsion, tape photographic paper or sheet film opposite the pinhole, inside the box. You must be in a dark place such as a darkroom or closet to do this. Then use black tape to make sure the box is light tight at the seams.

To take a picture, go outdoors. Find a subject, and focus the camera on it. Remove the shutter to expose the emulsion. Exposure time varies with time of day and emulsion type. It will be a few seconds for film and about ten minutes for paper. Cover the pinhole with the shutter until you are ready to develop your shot.

3. Winslow Homer's painting *The Gulf Stream* has as its subject an individual struggling against nature. Can you take a photograph dealing with this theme? You might try taking a photograph of someone surfing, riding horseback, skiing, climbing, sailing, or weathering a storm. You may need to use a fast shutter speed to stop the action. Or, you might try a *slow* shutter speed to get an interesting blurred effect.

4. Many of the paintings you have studied are shown as a moment of action frozen in time. Use your camera to stop action or freeze motion. Shoot at least twenty frames. Find

subjects that have foreground movement and stationary backgrounds. Some ideas are: falling water, dancers, vehicles, games or athletics, playgrounds, or flags in the wind.

When using automatic shutter speed-preferred cameras, choose larger apertures (smaller numbers) which will, in bright light situations, cause the camera to "choose" a fast shutter speed to stop action. Listen to the difference in the sounds of the various shutter speeds as you use them.

Carefully examine your finished photographs. Is the foreground action in each shot clear? Is the stationary background clear? Which of the photographs look like a moment of action "frozen" in time? Explain why.

ARCHITECTURE

Earlier in this unit you read that things that are essentially different can be related. How different a building is from a painting! Yet these two types of works of art can be related.

Look at the Sydney Opera House shown in Figure 93. A Danish architect, Jorn Utzon, won first prize in competition for designing this building in 1956. His design was thought to be daring, dramatic, and original. The huge shells rising above the opera house help make it a modern-looking and dazzling building.

Look again at the paintings *The Great Wave Off Kanagawa* and *Waves* on pages 98 and 99. Do you find any similarities in the forms represented in those paintings and those in the opera house? It is known that Utzon, the architect, was influenced by Japanese culture.

The house called *Falling Water* (Figure 94) was designed by another architect who admired Japanese culture and the Japanese respect for nature. Frank Lloyd Wright (1867–1959) grew up in a small town in Wisconsin. The countryside around it was filled with meadows, cliffs, and wooded hills. As a young boy he found time between farm chores and school to play at designing buildings. Later in his life he asked his wife: "Can you see me there . . . a curly-headed boy, all alone, sculpting, playing in the sand, constructing a building with branches and rocks, then planting grass around it, making a little garden of flowers—can you see me there?"

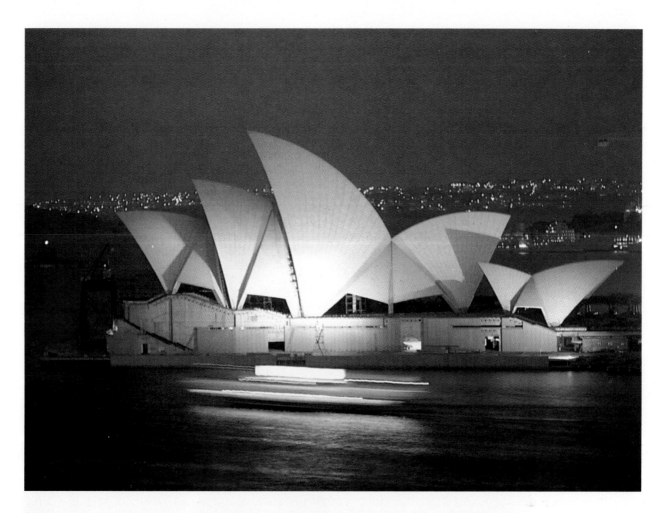

Figure 93. *The Opera House* **in Sydney, Australia, was designed by Jorn Utzon. What compositional principles can you identify?** Jorn Utzon, *The Opera House, Sydney, Australia.* 1956. Magnum Photos, New York.

Frank Lloyd Wright was interested in the integration of people and nature. He felt that a home should blend with its surroundings so that the atmosphere, the light, and the view all worked with the building. Wright believed that a house is a place where people live, not just where they sleep. In order to live, people must have a sense of privacy and a feeling that nature is alive around them.

Falling Water blends with its natural environment in just this way. For Wright, the beauty of architecture was in how it harmonized with its surroundings.

Wright used many modern materials to achieve his stylistic and personal ideals. *Falling Water* is built largely of reinforced concrete. Wright avoided purely decorative styles of architecture, because he believed that form follows func-

137

Figure 94. *Falling Water*, **designed by Frank Lloyd Wright, blends perfectly with its natural setting.** Frank Lloyd Wright, *Falling Water*. 1937. Uniphoto, Inc., Washington, D.C.

tion. In other words, the shape of a building flows from the way it is to be used.

Falling Water was designed in 1936 and completed in 1937 for Mr. and Mrs. Edgar Kaufmann. It is located at Bear Run near Pittsburgh, Pennsylvania. When he was asked years later how he related the site to the house, Wright replied:

"There in a beautiful forest was a solid high rock-ledge rising beside a waterfall and the natural thing seemed to be to cantilever [project outward] the house from the rock-bank over the falling water. . . Then came Mr. Kaufmann's love for the beautiful site. He loved the site where the house was built and loved to listen to the waterfall. So that was the prime motive in the design. I think you can hear the waterfall when you look at the design. At least it is there and he lives intimately with the thing he loves."

The public did not accept Frank Lloyd Wright's ideas quickly, but years later Mr. Kaufmann said to Wright: "Frank Lloyd Wright, I have spent much money in my life but I never got anything so worthwhile for it as this house. Thank you."

Antoni Gaudi (gow´dee) loved nature and believed strongly in the sacredness of handwork. A handsome and popular man, he became the favorite architect of the wealthy in the city of Barcelona, Spain. In 1910, he began to devote himself entirely to the construction of an immense church, the *Sagrada Familia* (sah-grah´-dah fah-muh-leé-yah) or the *Church of the Sagrada Familia*. Although Gaudi had worked on this project off and on for twenty-six years, it now became his all consuming focus. He became a hermit and lived on the church grounds. When construction money was low, he went to the streets to beg. On June 7, 1926, just before his seventy-fourth birthday, he was struck by a streetcar and died three days later on a pauper's bed in a hospital.

Work on the *Church of the Sagrada Familia* had begun in 1882 under another architect, but Gaudi had taken over the commission in 1884. More than one hundred years later, it towers unfinished over Barcelona (Figure 95). One critic described it as "looking like a medieval cathedral half-melted in the sun." Another called it "the greatest ecclesiastical [church-related] monument of the last hundred years." What do you think?

We have seen a wide range of architectural examples from around the world. Now let's explore some architecture in your community.

Figure 95. Gaudi literally devoted his life to this project. Antoni Gaudi, Architect, *Church of the Sagrada Family*, 1884-1926. Barcelona, Spain. The Granger Collection, New York.

ARCHITECTURE ACTIVITIES

1. Take a visual tour of your community. Look for interesting buildings, especially examples of architecture inspired by natural forms. Take pictures or make sketches of one building and its setting. Notice how the building relates to its setting. Does it fit in well with the environment around it, or does it stand out because it is so unlike its setting? What impact does the building have on its surroundings? Make notes on your observations. Also note the materials used to make the building, its windows, and doors.

If possible, go inside the building and observe how the style of the interior relates to the exterior. How is the interior space utilized? What materials are used? What is the function or purpose of the building? How does its design relate to this function? Write a paragraph to summarize your observations on the design of the building.

2. Try your hand at sketching a design for a building that is inspired by natural forms. Choose a setting for your building. Is it a small plot on a busy city street? In a shopping mall? On several wooded acres? How will the setting affect the forms you use?

Decide what the function of your building is. Who will use it? What for? How many people should it accommodate? Will it be used at night as well as during the day?

Make one sketch to show the outside and another to show the inside of your building. How do they relate to one another? To the building's setting? To the building's function?

Make notes to go with your sketches. Tell what materials you propose to use and why. Explain what you are trying to accomplish with your design.

CRAFTS

Nature has long been a source of inspiration to the craftsperson. **Crafts** are forms of expression that are both beautiful and useful. Some examples of crafts are ceramics,

glass objects, and masks. In this section we will look at several examples of beautiful and useful objects which derive their form and meaning from nature.

Toward the end of the nineteenth century, an arts and crafts movement developed in England. This movement was formed to show that art should be both beautiful and useful. Its members worried that the world of the artist-craftsperson was being destroyed by industrialization. They fought for a return to standards of beauty and craftsmanship that had existed in earlier times, particularly during the Middle Ages.

The Pimpernel wallpaper (Figure 96) was produced by William Morris, one of the leaders of the English arts and crafts movement. It is a repeating pattern of leaves and blossoms. The forms appear to dance about one another. If you stand far away from the pattern, it appears to be just shapes and colors. Imagine the delight of someone approaching a wall papered with Pimpernel and discovering that it is almost alive with plant forms.

The glass vase made by Louis Comfort Tiffany (Figure 97) looks like a flower. Forms invented by Tiffany were sometimes strange and fantastic, sometimes elegant and simple. Which words would you say describe the vase in the illustration? From a small base a narrow stem rises, then opens out broadly into a flower. What kind of flower is shaped like this? A morning glory? A petunia?

The exquisite color and texture of this flower are not to be found in any garden. Tiffany developed a process that would give his glass pieces a glowing luster. This sheen was like that found on long-buried objects worked upon for centuries by erosion and mineral salts. During blowing, Tiffany's glass was exposed to metallic vapors and other chemicals. These gave the finished pieces unusual streaks and textures. Tiffany's glass objects often take graceful flowerlike forms, as does the vase shown.

The English arts and crafts movement developed into a broader movement which produced arts and crafts with a new look. This movement was called Art Nouveau (noo´-voh), which means new art. Art Nouveau was popular in the early part of this century.

Objects created during the Art Nouveau period display fantastic combinations of forms and function. For example, look at the hood ornament shown in Figure 98. The design, called *5 Chevaux (Five Horses)* was for a 1925 French automobile. The designer, René Lalique (lah-leek´), created a mythological animal built to fly. This car emblem defined

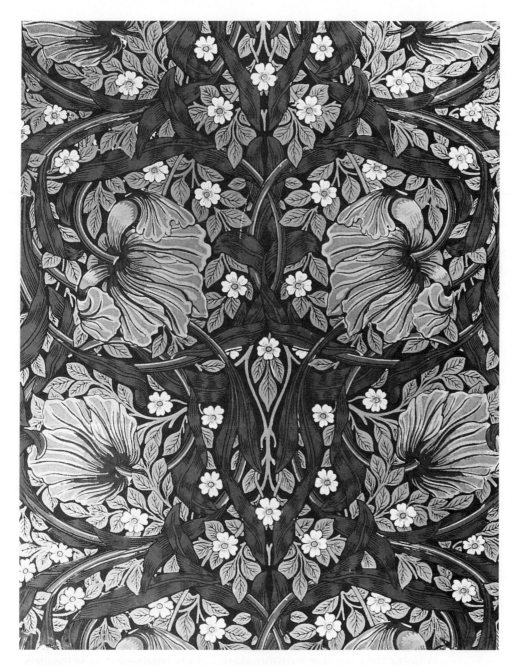

Figure 96. Notice the intricate detail of wallpaper by the British designer William Morris. William Morris, *Detail from Wallpaper*. 1876. "Pimpernel." The Victoria and Albert Museum, London/Art Resource, New York.

the function of the high-flying automobile. Sometimes Lalique used colored glass as material for the emblems for car hoods (see Figure 99). It must have been quite a sight to have seen a little watery-green frog disappear into the night on the hood of one of most outrageous cars ever designed, the Bugatti Royale.

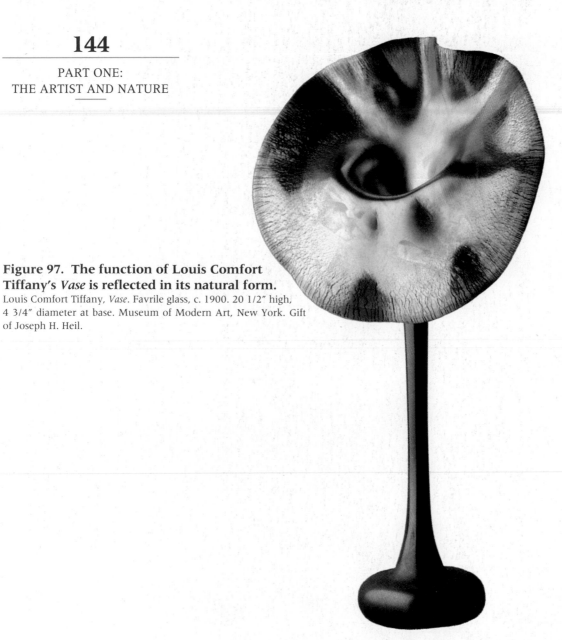

Figure 97. The function of Louis Comfort Tiffany's *Vase* is reflected in its natural form.
Louis Comfort Tiffany, *Vase*. Favrile glass, c. 1900. 20 1/2" high, 4 3/4" diameter at base. Museum of Modern Art, New York. Gift of Joseph H. Heil.

This terrifying but beautifully colored mask (Figure 100) was formed from a human skull. Then turquoise, a semi-precious stone, and other pieces of mineral were applied. It is believed to be a work of the fourteenth century. The mask was part of a collection of Aztec ceremonial objects that Montezuma II, the last Aztec ruler, gave to Cortez at the time of the Spanish conquest of Mexico in 1519–1520. The collection was sent to Spain and presented to the Emperor Charles V.

What makes this mask so frightening? The polished iron in the eye sockets makes the eyes appear wide-open and alive. What other choices made by the artist add to the

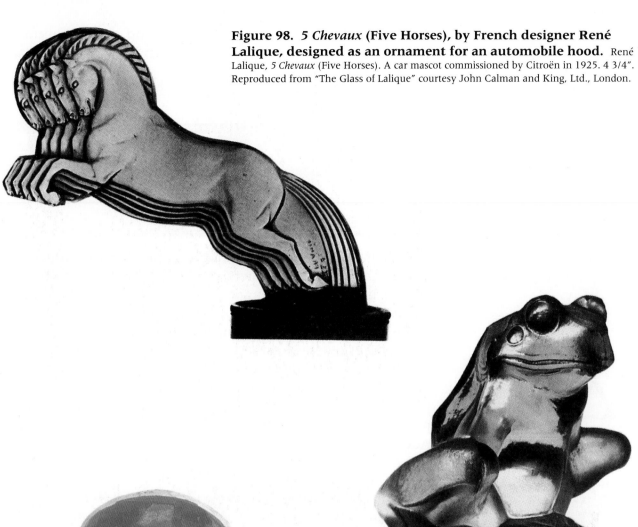

Figure 98. *5 Chevaux* **(Five Horses), by French designer René Lalique, designed as an ornament for an automobile hood.** René Lalique, *5 Chevaux* (Five Horses). A car mascot commissioned by Citroën in 1925. 4 3/4". Reproduced from "The Glass of Lalique" courtesy John Calman and King, Ltd., London.

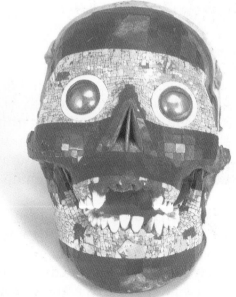

Figure 99. Lalique's *Glass Frog.* **Also designed as an ornament for the hood of an automobile.** René Lalique, *Grenouille*. Car mascot on its original chromium-plate base (engraved Breves Gallery) in clear glass with satin and polished finish. 6 5/16". Reproduced from "The Glass of Lalique" courtesy, John Calman and King, Ltd., London.

Figure 100. This mask was part of Aztec ritual. *Mask of Tezcatlipoca.* Aztec, 14th century. Human skull with mosaics. Height approx. 10". Courtesy of the Trustees of the British Museum.

ferocity of this image? Beautiful color and design contrast with the frightening image to help make *Mask of Tezcatlipoca* an interesting object.

CRAFT ACTIVITIES

Be careful with needles. Pay close attention to your teachers demonstration

CAUTION

1. Gather a collection of photographs of many different kinds of animals. Study them carefully with the idea of creating a large wall hanging with your classmates. Put away the photographs and refer to them only if you need information about the general anatomical structure of an animal. Do several sketches for the class project. Display the sketches for discussion purposes. Decide with the class which images will work best in the project. Each class member will plan to produce a part of the whole picture. Cut out all the parts from cloth and apply them to the background cloth. Add interest by using a variety of decorative stitches. To add still more interest, the animal forms may be padded lightly to achieve a slightly raised effect.

2. Create a composition on burlap using colored yarn and different types of stitches. Choose a theme for your composition such as fish, faces, buildings, or birds. Or, you might want to create an abstract design or allover pattern. To begin, make a sketch of your idea. Color the sketch. Now you will have a plan from which to work. Of course, you can change the plan as you begin to stitch. Before starting on your stitchery, you might want to experiment with kinds of stitches. Make a stitching sampler on burlap. Next draw your idea on the burlap with a magic marker and then fill it in with colored yarns.

3. Over the years, masks have been used to cover people's faces. In some cases, a mask covers all or most of the body. Masks have been a well-developed form of art in African, Oceanic, and Native American cultures. In this activity, you will create a mask. First, select a face to use as a guide. Your mask will be built on a base made from a strip of newspaper folded and fastened into a ring. Fill the ring with small pieces of crumpled newspaper. Cover the base with strips of papier-mâché (made from newspaper and liquid paste).

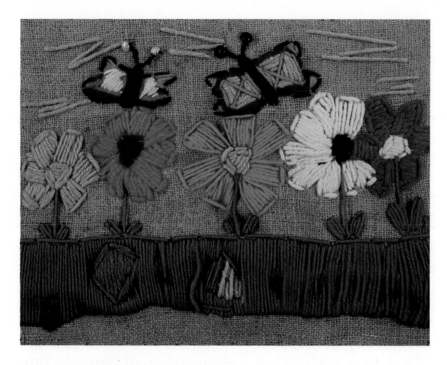

Figure 101. Student art, stitchery.

Build up at least two layers and allow them to dry before you build up the features of your face. You can use parts of egg cartons, folded pieces of light cardboard, and any other material that will serve as a base for your features. Add ears,

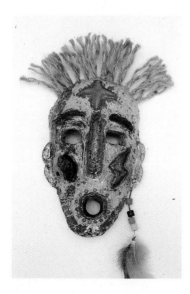

Figure 102. Student art, mask.

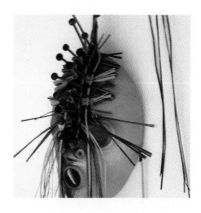

Figure 103. Student art, mask.

nose and eyes, and cover the entire face with additional layers of papier-mâché. Allow the mask to dry thoroughly. Now you are ready to paint. Add your own original touches. Add yarn for hair and beards.

4. We have seen that the alchemist, Johann Bottger and the scientist, Walther von Tschirnhausen finally discovered the clay that had been the secret of Chinese porcelain for centuries. In this activity, you will have your first experience in clay by making what is called a **handy.** This means a shape that is pleasing to hold, as a smooth rock is. Begin with a piece of clay about one-half the size of a golf ball. Shape this piece into an oval or round shape that is personally pleasing to your touch. Work with the clay form as it hardens to the stage which is called "leather hard" to make it as smooth as possible. Your teacher will then fire the piece. Every detail that you have in your handy will remain the same after the firing process.

5. This is your second opportunity to work with clay. You will make a textured tile with an overall pattern. Your teacher will give you detailed instructions in this activity. Press the clay that your teacher provides flat on the surface and then roll it smooth with a rolling pin. You will use a dull knife to cut the clay into a tile size square.

The next step is to experiment in creating textures on the tile. Use your thumb and fingers to make impressions. Try other objects to make different kinds of impressions, such as a spool, a pencil, rubber bands, paper clips or the decorative handle of a spoon.

Be careful cutting the clay.

CAUTION

UNIT

3

SPECIAL PROJECTS

The Artist and Nature

ART HISTORY

1. Compare Homer's *The Gulf Stream* (pages 4-5) with Turner's *Snowstorm: Steamboat Off Harbor's Mouth* (page 83). Analyze the treatment of the sea, the weather, and the breaking waves. Discuss the style, the use of color and light, each artist's message, and the impact of each painting on you.

2. *Travelers in the Autumn Mountains* (page 87) by Sheng Mou was painted in the fourteenth century. C. C. Wang's *Landscape* (page 94) was painted in 1972. Study both works, looking for similarities in technique. How has Wang retained the traditions of Chinese painting but at the same time expressed his own vision? Look closely at the brushwork and perspective as part of your analysis.

3. John Sloan, who painted *Backyards, Greenwich Village* (page 75), was a member of the Ashcan School of artists. The **Ashcan School** took this name because they supported realism in American art. Members of this group painted ordinary people in urban settings—in shops, at their windows, and on rooftops of their tenement buildings.

There are several important visual artists in the Ashcan School. Study the works of this group during the early part of the twentieth century through the period of the Great Depression (the 1930s) in America.

During this period photo-realism and realistic novels became very important. If you are to make a report on the Ashcan School, you will make it more interesting by including examples of photo-realism and realistic novels of the time.

4. We have seen how *The Great Wave Off Kanagawa* by Hokusai influenced Winslow Homer's treatment of the sea in *The Gulf Stream*. Hokusai lived from 1760 to 1849. He was a master of the Japanese wood block print. In addition to influencing Homer, these prints had a major effect on the art of western Europe. This was especially true of the art of the French Impressionist painters such as Claude Monet. You will recall that his *Haystack at Sunset* appears on page 97. *The Great Wave* also influenced Impressionist composers of music. Claude Debussy was one of the most significant Impressionist composers. What does Impressionism mean in music? *The Great Wave* inspired Debussy to write his musical tone poem entitled *La Mer (The Sea)*. Listen to a recording of *La Mer*. Describe what you "see" in your mind as you listen to various passages. Do you understand why Debussy is called an impressionist composer? Can you see why this selection is called a tone poem? Listen again, and sketch what you visualize as you listen to *La Mer*.

5. Look again at El Greco's powerful painting *View of Toledo* (page 93). He has painted a city of nightmares. It was the headquarters of the infamous and terrifying Spanish Inquisition.

If someone could have photographed the city of Toledo during this period in its history, it would not appear as it does in El Greco's painting. El Greco moved the tower to the other side of the castle, changed the bridge towers, and added another imaginary bridge.

The sky in this painting seems to be boiling with dark flames. The shadows are like menacing hands spread out across the hills. What light there is has turned this place into a ghost city. One critic has said that El Greco gave the city "a burning soul akin to his own."

El Greco was trained in classical art, and had all the knowledge and experience this implies. However, he "saw" with his imagination. Three hundred years after his death he was proclaimed a heroic forerunner of modern art by modern artists. Look closely at *View of Toledo*.

a. Identify those features which seem realistic.

b. Suggest reasons why El Greco moved the cathedral to the left of the palace.

c. Suggest why he added an imaginary gate and changed the towers.

d. Look for and identify three expressive techniques that the artist used: elongation, distortion, and the emotional use of color.

e. Discuss the changes El Greco made in the subject of the painting for the effect he desired. Relate this work to some of the modern work you have seen. Why do you think that El Greco is so revered by this group?

APPRECIATION AND AESTHETIC GROWTH

1. Ernest Hemingway said that he learned to describe nature by studying painting. This is his description of the Gulf Stream from his novel *The Old Man and the Sea:*

> The clouds over the land now rose like mountains and the coast was only a long green line with the gray blue hills behind it. The water was a dark blue now, so dark that it was almost purple. As he looked down into it he saw the red sifting of the plankton in the dark water and the strange light the sun made now. He watched his lines to see them go straight down out of sight into the water and he was happy to see so much plankton because it meant fish.
>
> The strange light the sun made in the water, now that the sun was higher, meant good weather and so did the shape of the clouds over the land. But the bird was almost out of sight now and nothing showed on the surface of the water but some patches of yellow, sun-bleached Sargasso weed and the purple, formalized, iridescent, gelatinous bladder of a Portuguese man-of-war floating close beside the boat. It turned on its side and then righted itself. It floated cheerfully as a bubble with its long deadly purple filaments trailing a yard behind it in the water.*

Compare Hemingway's description of the "river of blue" to Homer's painting. Create an illustration for this portion of *The Old Man and the Sea* by using Hemingway's description of the water of the Gulf Stream as a guide.

2. *The Starry Night* (page 86) expresses the brilliance of color at night as Vincent van Gogh's eyes saw it. Colors in van Gogh's daytime paintings achieved a brilliance never before experienced in art. Yet he wrote, "The night is more

alive, more richly colored than the day." At night he left his studio and went into the village streets to paint, sometimes with candles stuck around the brim of his hat for added light. As you look at *The Starry Night:*

a. Write down words which you feel describe his brushstrokes.

b. Compare the long and the short brushstrokes. Which add most to the feeling of anxiety, or uneasiness? Why?

c. Explain how the *direction* of the brushstrokes creates movement in and around the painting.

d. Note the way van Gogh achieved *intensity* by placing complementary colors close to each other. This is a very good example of how intensity is achieved by an artist. You may want to review the color section (pages 39-44).

e. The text describes *The Starry Night* as "disquieting." It also says that the painting creates excitement in the eyes of the viewer.

While recognizing this, it is also important to respect the *control* the artist has displayed. As you look closer at this painting, apply the steps of art criticism discussed on pages 56-59. Discuss your conclusions with other class members.

3. Sheng Mou used three types of points of view (perspective) common to Chinese landscape paintings in his *Travelers in the Autumn Mountains* (page 87). The first is *kao yuan* or *high distance.* This means that we can see the mountains from base to top. The second type of perspective is *shen yuan*, which means we see the mountains from the vantage point of a mountain in the foreground. The artist places us on this mountain, from which we view the painting. The third type is *p'ing yuan* or *level distance* which shows us the mountains in the distance across those in the flat foreground.

Study the use of each of these types of perspective in this painting.

4. Certain cities have inspired many tales, poems, legends, and dramas. Some of these cities are real, some pure legend. Many of them have great elements of mystery and romance. Examples are Xanadu, Oz, Timbucktu, and the lost city of Atlantis. Select one of these cities, read about it, and use your imagination to draw or paint a scene set in your chosen city.

PART

II

THE ARTIST IN
THE COMMUNITY

A detail from *American Gothic*.

UNIT

LET'S GET LOST IN A PAINTING

American Gothic

by Grant Wood

"The land was ours before we were the land's."
Robert Frost

In 1930 an unknown artist submitted a painting to the annual exhibit of new art works at the Art Institute of Chicago. The work caused a sensation and brought him fame overnight. People who never went to museums waited in line to see it. Critics from around the country came to hail "a modern Columbus who had discovered the soul of America." The name of that unknown artist was Grant Wood; the title of his painting was *American Gothic* (Figure 104).

FIRST FAMILY IN ART

Sixty years later, everyone recognizes the couple in *American Gothic* as our first family in art. But the agreement ends there. No one agrees why they like it. No one is quite sure what it means. The mystery that surrounds *American Gothic* is one of its fascinations. While we all look at the same painting, we may each see it very differently. Some see comedy, others tragedy, and still others both comedy and tragedy. Some see charm, others ridicule, and some even see contempt. The argument goes on and on . . .

What do you see when you look at this American classic? As you begin the journey to the Midwest (Iowa), take a close look. Can you identify the couple? Are they husband and wife? What are they doing? Thinking? Feeling? Is the picture beautiful? Humorous? Sad? Threatening? Do you see something else? Before you reach any conclusion, keep in mind the strange window and the title, *American Gothic.*

Who does not know these two! Who does not recognize this couple, who say nothing but tell everything about their tastes, their ways, and their beliefs. They are standing in front of their farmhouse as if posing for a picture. The artist-photographer has placed them with objects telling of their work and roles. A pitchfork is in the man's hand, and to the woman's left are houseplants. Behind them a lightning rod juts up from a freshly painted farmhouse. In the far background a church spire rises over neatly trimmed trees.

The scene is charming, but the mood is grim. The long faces show the couple's uneasiness. What are they thinking about? They won't tell. Their lips are sealed, closed shut like the blinds of their house. The pitchfork in the man's hand seems to be a warning: Stranger, keep away! Neither of

Figure 104. *American Gothic* **by Grant Wood.** Grant Wood, *American* ➤ *Gothic.* 1930. Oil on beaver board. Approx. 29 1/4" x 24 1/3". The Art Institute of Chicago, Friends of American Art Collection, 1930. Photograph ©1990 The Art Institute of Chicago.

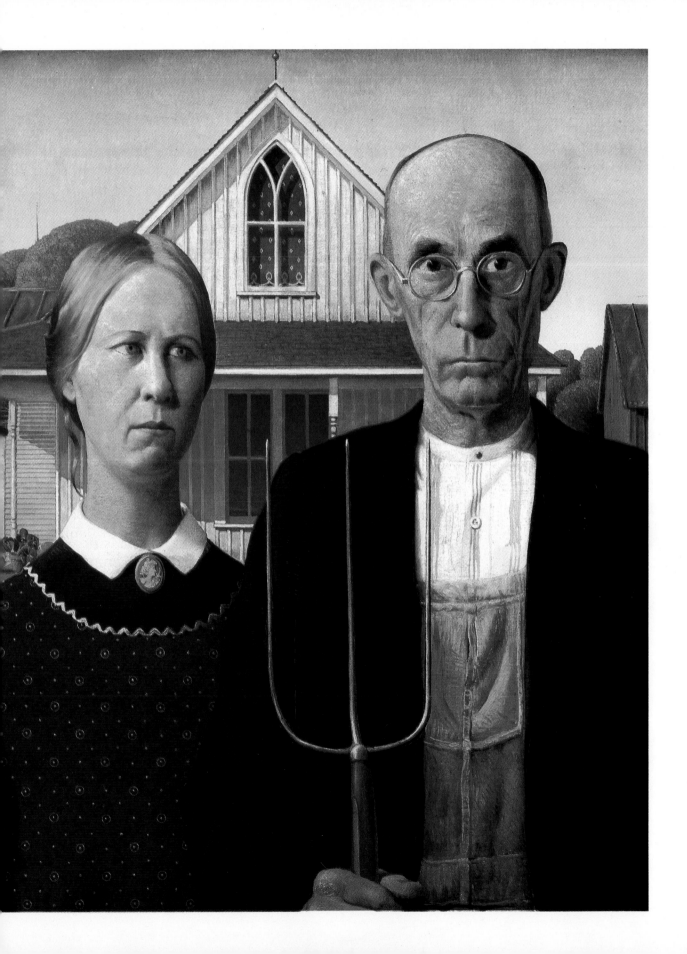

them focuses on the viewer. Their eyes reveal distance. He stares blankly ahead, while she looks to the side. Who are these two? Study their faces closely.

Most viewers assume they are husband and wife: Mr. and Mrs. American Farmer who carried their Puritan roots from the soil of New England into the rich Midwest farm country. In the portrait the artist-photographer has told a story: Their work is long and hard, their tastes are simple, and their religion is strict. There is no glamour in their labor and no joy in their lives. The public has always taken them to be husband and wife. Look again and decide for yourself.

The woman is much younger than the man. Her yellow-green hair and the soft texture of her skin contrast with his bald head and the hard lines of his wrinkled face. Perhaps she is his daughter or younger sister, but what difference does it make?

To the Iowans in 1930 it made a great deal of difference. Their reaction is part of the strange history of the painting. By mistake, a local newspaper had introduced the work with the title *Iowa Farmer and His Wife,* and the Iowans were furious. They thought the artist was ridiculing them. The housewives were angry: "God pity the American farmer if his wife resembled that woman." Wood received so many threats that his mother was afraid to answer the telephone. One local suggested that the painting be placed in a cheese factory "because the woman's face could absolutely sour the milk." Was Wood mocking life on the farm? It is not a happy portrait, nor is it "pretty." The clothing is immaculately clean but drab. In his Sunday best, he is a sorry figure, and she is not elegant. The clothes hide her body, and her figure has been flattened out. Is life on the farm so joyless? Are the good, old-fashioned virtues as dull as this couple appear to be?

THE ARTIST'S VISION

If Grant Wood intended this as a portrait of a husband and wife, the Iowans were absolutely right. The painting could be understood as an attack against a way of life, even against the institution of marriage. If these two were a typical farm couple, the artist was indeed making fun of rural life. Their relationship became important. When asked, Wood never explained. But his sister did. It was she, Nan

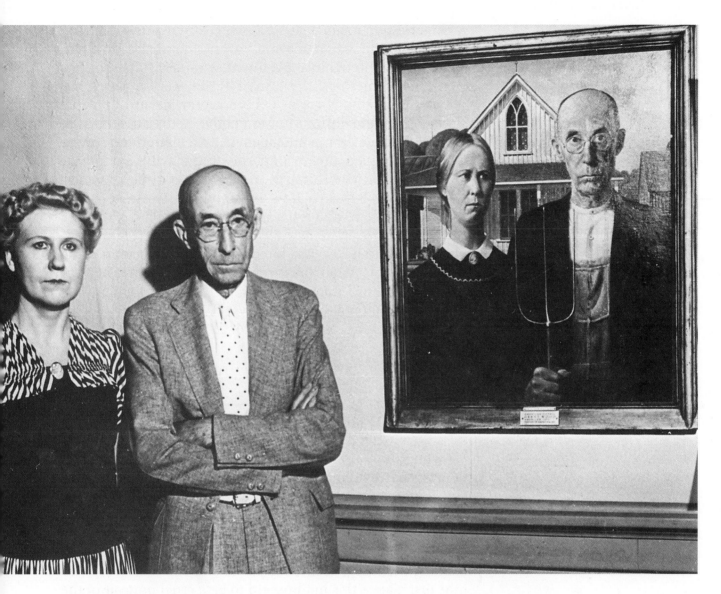

Figure 105. Photograph taken in 1942 of Nan Wood Graham and Dr. McKeebe, the models for *American Gothic*. Joan Liffring-Zug, Photograph of Nan Wood and Dr. McKeebe. 1942. Copyright, Joan Liffring-Zug.

Wood Graham, who had posed as the model for the woman. And it was a local dentist, Dr. McKeebe, who had posed for the man. At the time, Nan was thirty-two and the dentist sixty-two. The photograph of these two standing next to the painting (Figure 105) was made in 1942. Here they do not look like husband and wife.

As you look at the photograph and the painting, how much likeness do you see between them? If you had been one of the models, would you have been satisfied? Is there enough likeness for the painting to be called a **portrait?**

159

The question is not easy to answer, for what is a portrait? Should it be the artist's attempt at an exact likeness of the model, like a photograph taken with a camera? Or should a portrait say something the artist has detected in a person's character? Great portraits reveal character. The art of portrait painting involves constant tension between the artist and the model. The model wants the likeness to be flattering. But the artist is looking for a truth underneath the skin—something the model might be hiding. In making the portrait there is a constant battle between how the models themselves want others to see them, and what the artist sees. When the work is finished, if the client is not happy, what next? This constant pressure to please can force an artist away from portrait painting. Grant Wood once remarked, "If I paint them as they are, what will they think of me? If I paint them as they want to be, what will I think of myself?"

In this case there was no customer, but the good citizens of Iowa mistook *American Gothic* for a portrait of themselves.

WHAT THE PUBLIC SAW

Through no fault of his own, Grant Wood's future in his native state was almost ruined. When the wrong title was published in a local newspaper the people were insulted. Had the artist used the models to reveal some terrible confession hidden in the closets of Iowa? Look at the painting again. Look at the people and the objects. Was the artist ridiculing them and their beliefs?

At first glance this might seem to be a cruel portrait of the "Bible Belt"—deeply religious people who live in the small towns of rural America. The artist included many religious symbols: (1) the man's shirt suggests the collar of a preacher; (2) the woman's face resembles that of a Madonna in a Renaissance painting; (3) the window of the house is a church window; and (4) in the background is a church spire. If this is a religious painting the question becomes: What kind of religious belief is the artist showing? The old dress hints at an "old-fashioned" religion. But what do the people actually believe? One writer looked at the painting and thought it meant devotion to a belief in a person's God-given right to own property. Look at the positions of the people and the objects as they are outlined in Figure 106.

Figure 106. The outline shows how the forms in the painting are related to each other.

The man dominates the space. His placement overlaps the woman, the house, and the trees. If the woman is his wife, she is not his equal but his possession. She is related to the rest of his property. The pattern of her dress is similar to the curtains in the window. Her dark brown dress is similar to the color of the land, and the round shape of her head is repeated in the plants and trees. Notice these pattern repetitions as they are outlined in Figure 107.

The man is the dominant person, and the pitchfork is the dominant object. The pitchfork is a farm tool, and it is also an instrument of violence. As he holds it in front in his long bony hand, the pitchfork creates tension. The hard look behind the cold steel glasses could be a warning. His eyes could be fixed on any trespasser threatening him, his beliefs, or his property.

The pitchfork has still another, more sinister meaning. By tradition in art, a pitchfork is sometimes considered a

Figure 107. This outline shows how Wood used patterns to integrate different areas of the painting.

sign of evil. Some critics have read the painting in the following manner:

> Although this man may go to church—he might even be a Sunday preacher—he is capable of harm. The painting is an attack against people who believe in one thing and practice another. The careful arrangement by the artist is his judgment. The couple seem innocent but they are not. These are people who in the name of virtue do more harm than good. This man's attitude puts the pitchfork in front and the church spire in back. What is this attitude? His belief that everything in his space is his possession. The accumulation of possessions—the material things in life—is more important to him than the Christian values he preaches. Once he defined the pitchfork, the artist played with the tines to complete his effect. The pitchfork has three tines, but Wood deliberately added two more points in the painting: the lightning rod and the church spire. If the pitchfork protects the couple from intruders, the lightning rod protects them from the elements, and the church spire guards against modern ideas.

American Gothic has been read as a brutal painting by some critics, who feel the couple might be characters from a

Figure 108. Wood emphasized the pitchfork by repeating its outline.
Detail from *American Gothic* (Figure 104).

Gothic story by Edgar Allan Poe. Poe's Gothic stories take place in old settings and are filled with horror and mysterious events. Haunted by some curse of the past, the couple in the painting are doomed in the present. The dreary atmosphere is so stifling that more than one critic wondered how Wood must have suffered at the hands of these people as a young man.

No wonder the Iowans were upset by what they assumed was a portrait of "Iowa Farmer and His Wife." Strangely enough, their anger was directed against his portrait of the woman, not the man. If she was miserable and unhappy, no one questioned why. Wood only exaggerated her features. But look what he did to the man. To some critics he made him monstrous. No wonder some artists avoid portraits. The local audience hated what they saw, but for the wrong rea-

son! If the artist had intended only to mock them, how would they have reacted to the true title of the painting?

Once they learned the correct title and identities of the couple, the Iowans went back to look at *American Gothic* again. This time some chuckled, others were deeply moved, but they all saw something that gave them pleasure and pride. What did they see? Take another look at the house. What does it tell about the painting? The title? And if your eye is really sharp, about Iowa?

IOWA GOTHIC

Wood painted the house in 1929 long before he added the occupants. He saw that particular house on an outing in Eldon, Iowa, and it inspired him. He said later that he could imagine the people inside, with stretched-out faces long enough to match the vertical board and batten (a vertical strip of wood used to nail down two boards) lines of the house (Figure 109).

What the artist saw also was the history of a state. For many years what Wood called that "rickety house" had survived the cold of Iowa's winters and its searing hot summers. In the 1860s, when Iowa was first being settled, this was the most popular type of farmhouse in the Midwest. It was called "Iowa colonial" because of its features. The porch was large, and it had a large gable on the roof. The house was made popular by the leading designer of country homes and rural estates, Alexander Jackson Davis. Davis had studied in England and introduced a style called "neo-Gothic" (*neo-*

Figure 109. The lines on the house emphasize the vertical movement in the painting.
Detail from *American Gothic* (Figure 104).

meaning "new"). The word *Gothic* has its own fascinating history. The fifteenth-century Italian writer Vasari first coined it as an insult.

In the late Middle Ages stonemasons found a new way to build arches for cathedrals. The Gothic arch (Figure 110A) inspired architects to build churches higher and higher, as if they were reaching toward the sky. Vasari had been used to the more graceful structures of the Roman arch (Figure 110B). When he first saw the medieval churches with their arches and gables, he found them barbaric. He described them as "Gothic," as if built by the Goths, those savage nomadic tribes who brought ruin to Roman civilization. In time Gothic architecture was accepted as an important advance.

Hundreds of years later, the Gothic style became popular in building country homes. Since country architects usually used timber instead of stone, a new term emerged—*carpenter Gothic*. Davis first made carpenter Gothic popular in America (Figure 111). He and Andrew Downing, an expert on gar-

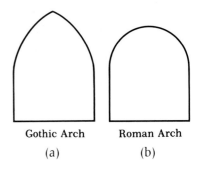

Gothic Arch Roman Arch

(a) (b)

Figure 110. The Gothic and Roman Arches.

Figure 111. This lithograph shows an example of "carpenter Gothic," a style made popular by Alexander Jackson Davis. Artist unknown, *Carpenter Gothic.* c. 1890. Collection of the author.

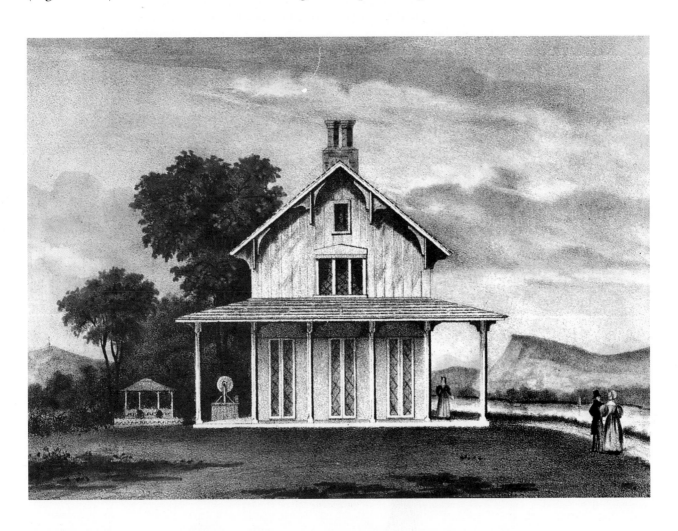

FARMER'S HOUSE.

FIRST FLOOR. SECOND FLOOR.

KITCHEN

LIVING ROOM.
18 by 20

BED BED

CHAMBER

"This design is simple, economical and adapted to the American climate. It is two stories high with a garret loft. The porch may continue or stop at the dotted line. The bold gable is an essential part of the design."

Figure 112. Floor plan for carpenter Gothic house. This floor plan was taken from a Davis and Downing catalogue. Artist unknown, *Floor Plan for Carpenter Gothic.* c. 1890. Collection of the author.

dening, published a series of house designs which they hoped would improve and beautify the American landscape. The drawings were sent out in a catalog and the farmer could select a design and build a house from the plan. The cost was approximately $1,500 for the plan.

A floor plan for one such house is shown in Figure 112. Although the one in the plan is not exactly like the house Wood saw in Eldon, Iowa, it is the same type of house. He also saw something else, the window. Notice the Gothic shape of the window (Figure 113). How strange! How did a Gothic monstrosity, this relic from the Middle Ages, suddenly show up in an Iowa farmhouse? What was it doing here in the American Midwest?

THE ARTIST'S PLAN

Wood photographed the Eldon house and returned a few weeks later to do an oil painting of it. Shortly thereafter

**Figure 113. Detail shows
Gothic window in Wood's
painting.**
Detail from *American Gothic*
(Figure 104).

he made a pencil sketch for *American Gothic* with a couple
standing in front. Within a few months he finished the
painting as we know it. By looking closely at the photo-
graph (Figure 114), the first painting of the house, and the
sketch (Figure 115) you can follow the artist's plan from
first idea to the finished work.

**Figure 114. Photograph shows the house in Eldon, Iowa, which Wood used in his
painting.** Carl E. Smith, *Photograph of the Eldon House*. c. 1931. Collection of the author.

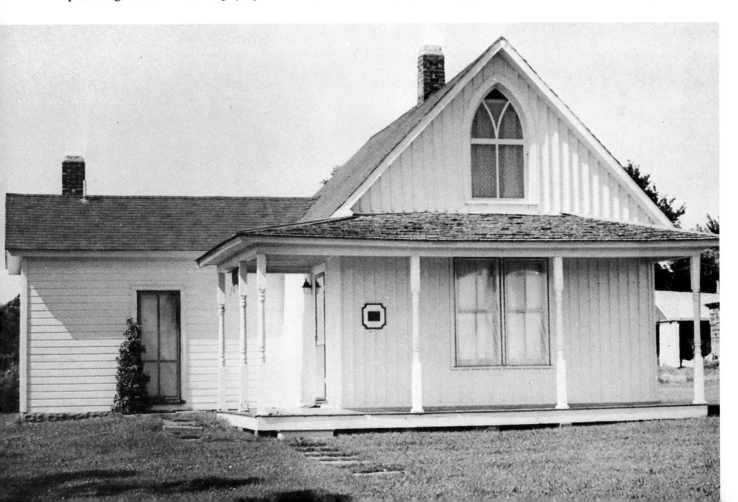

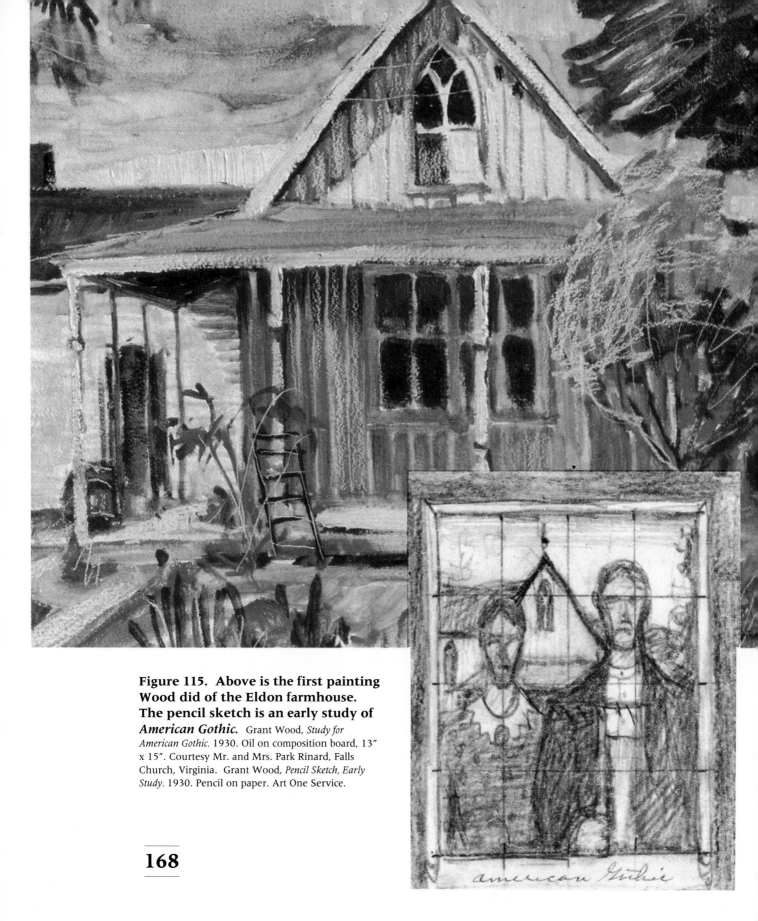

Figure 115. Above is the first painting Wood did of the Eldon farmhouse. The pencil sketch is an early study of *American Gothic.* Grant Wood, *Study for American Gothic.* 1930. Oil on composition board, 13" x 15". Courtesy Mr. and Mrs. Park Rinard, Falls Church, Virginia. Grant Wood, *Pencil Sketch, Early Study.* 1930. Pencil on paper. Art One Service.

Can you see any difference between the house in the photograph and the one in the painting? Did you notice how Wood heightened the gable to get his "Gothic" effect? In the first painting, he made the gable a little higher and more steeply angled to suggest the Gothic feeling of height. This first effort is the beginning of the artist's exaggeration. Before he stretched the faces of the couple in *American Gothic,* he stretched the house, narrowed the gable, and made the window taller and more prominent.

In his first pencil sketch he included a man and a woman in a grid. Here the hard angles of their faces and their sloping shoulders begin to repeat the angles of the gable. The artist again changed the length of the gable and the window. To the left he added another Gothic arch in what might be another window or doorway. The man is holding a rake. In the final painting the rake became a pitchfork. What does the pitchfork add to the design? Go back again and compare the sketch with the final work (pictured again in Figure 116). Try to decide why Wood changed the rake to a pitchfork.

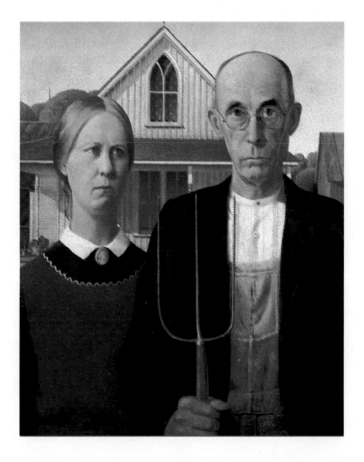

Figure 116. The finished version of *American Gothic.* Grant Wood, *American Gothic.* 1930. Oil on beaver board. Approx. 29 1/4" x 24 1/3". The Art Institute of Chicago, Friends of American Art Collection, 1930.

**Figure 117. The upside—
down Gothic window.**
Detail from *American Gothic*
(Figure 104).

**Figure 118. The shape of
the pitchfork is repeated in
the Gothic window.**

You might say the pitchfork is a stronger image for the farmer. It belongs in his hand. But the pitchfork also strengthens the design of the painting.

Wood understood the importance of repeating shapes, and the addition of the pitchfork completed the design. The idea for the final design was for the lines of the Gothic window to repeat in the faces. When the Gothic arch is turned upside down, it has the shape of the pitchfork (Figures 117 and 118). Before going on, return to the painting and find where the shapes of the Gothic arch and pitchfork repeat.

The diagram (Figure 119) shows how the pitchfork repeats in the bib of the overalls and in the man's face. The three tines of the pitchfork repeat in the window, the hand, and on the sides of the barn and house. The Gothic arch repeats in the woman's hairline.

The vertical pitchfork creates the illusion of height. Follow the left tine of the pitchfork. It points upward, directing the eye to the lightning rod and the steeple. The overall design has the feel of Gothic architecture: tall and somber. It is an architectural painting made up of vertical and horizontal lines. It is a static composition, that is, it requires very little eye movement. As the lines meet, they form right angles and slow down the eye. The diagram in Figure 120 shows the vertical and horizontal lines of *American Gothic.*

For contrast, and to avoid monotony, Wood used circles, semi-circles, and ovals (the cameo, the woman's dress, the

Figure 119. Drawing shows the many pitchfork shapes repeated in the painting.

curtains). The circles form diagonal lines which meet at angles.

The pitchfork is the dividing line at the center of the painting. On the man's side, the artist emphasized vertical lines. The woman's side of the painting has softer, rounder lines. Study the shapes in Figure 121. He brings them together (1) by overlapping the bodies, (2) by the horizontal lines of the porch roof, and (3) by having her glance sideways. He then locks them into position by using the gable as the frame. Whatever meaning the pitchfork has, it must be there for the purpose of Wood's design.

Figure 120. Wood used vertical and horizontal lines throughout his painting.

The design of *American Gothic* is a visual joke—a humorous play of Gothic shapes repeating in people, objects, and landscape. But was the artist laughing at the models or with them?

IDEAS FROM THE PAST

Wood was often asked to explain the couple in *American Gothic.* He said he wanted an "elderly spinster type" for the female model, but could not find one. He never said that he intended them to be husband and wife. He did, however,

Figure 121. The drawing shows the lines, patterns, and circular shapes in *American Gothic.*

have much to say about "Gothic." In the vocabulary of art, **Gothic** refers to an historical painting style. Gothic art flourished in Europe between the thirteenth and sixteenth centuries. It began when artists started to paint copies of sculpture from Gothic cathedrals. The angular faces and sharp folds of the dress in Gothic paintings were inspired by the sculptor's chisel. According to Wood, Gothic art was the major influence on his work. When he spoke about *American Gothic,* he often referred to the fifteenth-century Gothic master, Hans Memling. Look at the two Memling portraits shown in Figures 122 and 123. Can you find similarities to *American Gothic?*

Figure 122. Hans Memling (active c. 1465-1494), *Portrait of a Lady with a Pink.* Tempera and oil on wood. 17" x 7 1/4". The Metropolitan Museum of Art, New York. The Jules S. Bache Collection, 1949.

Figure 123. Hans Memling, *Portrait of a Young Man.*
Hans Memling, *Portrait of a Young Man.* Oil on wood. 15 1/4" x 11 1/8". The Metropolitan Museum of Art, New York. The Robert Lehman Collection, 1975.

174

Although only a few of his works survive, Hans Memling's greatness remains unquestioned. His portraits do not show the beauty of the human body. Instead they celebrate the soul of the quiet, pious, and hard-working people of Flanders. Memling was a devout Christian, and his paintings are religious statements. They are meant to move the believers to humility before God and to courage in life. His people have the "Gothic look"—bony faces, severe poses, hard lines, and intense, staring eyes. The hands are important and prominent, clasped as if in prayer. The background landscapes are dreamy pieces of nature hidden in corners of

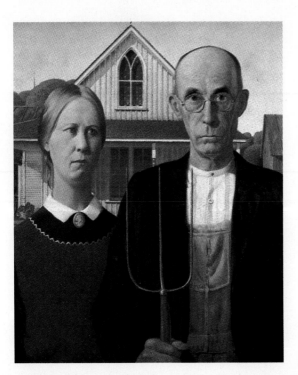

1. The severe expression of the faces.
2. The oval shapes in the landscape—repeating the shape of the woman's head.
3. The prominent hands.
4. The straight lines of the clothes used to frame the face.
5. The similar use of color.

Figure 124. Compare *American Gothic* **with the two portraits by Hans Memling.** Detail from *American Gothic* (Figure 104).

the painting. Figure 124 shows some traces of Memling in *American Gothic.*

As in Memling's work, the color values of *American Gothic* go from light at the top to dark at the bottom (Compare Figures 125 and 126). Since the couple is outside, the colors are natural. The sky and the sun are lightest. The couple's flesh, the man's bald head, and his white shirt are also light. Wood places the woman's dark apron and the man's dark coat at the bottom. This weighs the painting down and gives it a firm base. The gray values—the shadows between light and dark—make a slow change rather than a series of contrasts. If the dark colors were at the top, the painting would be top-heavy. They would press down on the couple and the house, thus changing the mood of the painting.

Memling painted three-quarter portraits, that is, portraits halfway between a profile (or side view) and the full

Figure 125. In the Hans Memling portrait, the lighter tones appear at the top, and darker shades appear nearer the bottom.
Hans Memling, *Portrait of a Young Man* (Figure 123).

face. In his works the subjects do not look at the viewer, because their thoughts are elsewhere. It is almost impossible to read feelings and emotions in their faces; they are distant. Their eyes do not focus on the real world, because they reflect some inner drama of the soul. The portraits are votive. "Votive" refers to the fulfillment of a religious vow.

The faces of Wood's couple have this feeling and, like Memling's portraits, suggest a votive painting. You are looking at them, but they do not see you. Their thoughts are elsewhere. They are removed from us. These two are fulfill-

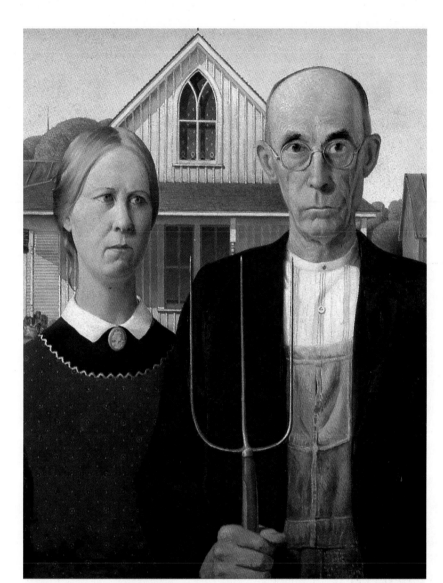

Figure 126. Compare Grant Wood's use of color tone with the Memling portrait. Grant Wood, *American Gothic* (Figure 104).

ing a vow. But to what? To the Church? To the house? To each other? Or to the most prominent object—the pitchfork? The answer to the question is as mysterious as the faces of the couple. It lies elsewhere in Wood's life and work.

THE ARTIST'S BACKGROUND

Grant Wood was born in 1891 on a farm in Anamosa, Iowa. When he was ten his father died, the farm was taken

away, and his family then moved to Cedar Rapids, Iowa. He did odd jobs to support them and taught himself to paint at night. After high school he studied art and design in Minneapolis and Chicago and served as a soldier in World War I. After the war he taught art for seven years in the Cedar Rapids schools. During this time he made several short trips to Europe to study art and to paint. In 1927 he received a commission to make a veterans' war memorial for Cedar Rapids. The stained glass windows were too difficult to make in the United States, so he went to Munich, Germany, to work with craftsmen long skilled in the art of stained glass.

His time in Munich marked the turning point in Wood's life. It was there that he came under the influence of Gothic artists, especially Hans Memling. The stony looks of Memling's subjects reminded him of the faces of Iowa farmers he had known. The lovely clothes suggested the patterns of his mother's old dresses. The delightful shapes of Memling's landscape recalled the rolling hills and neatly planned cornfields of home. Here he was, thousands of miles from home, looking at the work of a Gothic master, separated by hundreds of years in time, and what did he see? Iowa!

The Munich trip had become a voyage of self-discovery. Wood had solved for himself a problem that had long bothered the American artists—the need to go to Europe. Of course, they had to visit the art capitals of Europe. Here, in the great museums, hung the paintings of the masters. But, as Wood learned, one did not have to stay there for inspiration to paint. For almost forty years he had lived as an obscure artist, earning hardly enough money to support himself and his art. Although he would live only twelve years after his Munich stay (he died in 1942), he produced, in that short period of time, a series of outstanding paintings that live on.

CHANGES IN STYLE

The visit to Munich hastened something that probably would have happened anyway. We cannot know what goes on inside the mind of the artist. But there is the evidence—his work. In 1928 there was a dramatic change in Wood's style. A typical example of his earlier work is *The Yellow*

Figure 127. *The Yellow Doorway, St. Émilion* **by Grant Wood is an early work.** Grant Wood, *The Yellow Doorway, St. Émilion.* 1926. Oil on composition board, 16 1/2″ x 13″. Cedar Rapids Museum of Art, Cedar Rapids, Iowa. Gift of Happy Young and John B. Turner, II, 1972.

Doorway (Figure 127). This work shows the influence of European art, especially Wood's knowledge of the technique of Impressionism. The thickness of his paints suggests the blazing sun hitting the rough surface of the stonework. This is an important work, but its style is very different from his approach to art after his return from Munich. Compare this with his 1929 painting *Woman with Plant* (Figure 128) done after his return from Munich.

The woman is the artist's seventy-year-old mother. This work is probably his most Gothic painting. Notice the bony hands holding the flowerpot and the face turned to the side. Below, a small winding road, a dreamy corner of nature,

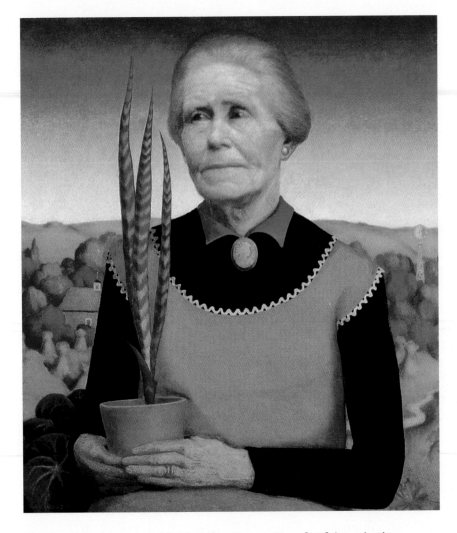

Figure 128. *Woman with Plant* **by Grant Wood. This painting
shows the influence of the Gothic portrait artists.** Grant Wood,
Woman with Plant. 1929. Oil on upsom board. 20 1/2″ x 17 7/8″. ©Cedar Rapids Museum
of Art 1990, Cedar Rapids, Art Association Purchase.

leads to corn shocks and a little schoolhouse. Behind the
schoolhouse, delicate, round-shaped trees lead to a wind-
mill in the distance. The landscape tells the story of the sub-
ject's accomplishments and contrasts with her severe fea-
tures. The history of the American pioneer is in the
woman's face. She is much larger than the land. Her portrait
speaks of years of sweat and toil, hard winters, summer
heat, disappointment, survival, and most of all, courage.

The snake plant in her hand follows another Gothic con-
vention. Gothic artists paid attention to the smallest detail.
Everything in their paintings expressed human character

and the glory of God. In Memling's time the story behind *The Lady with Pink* (page 174) needed no explanation. The "pink" in her hand is a carnation. It was a Flemish custom for the bride to wear a carnation on her wedding day. The pink expressed the purity of the woman's love. In Wood's portrait the snake plant is an important part of her story. The tropical snake plant is one of the hardiest plants. Its will to survive the Iowa climate reveals the character of the woman. A snake plant and begonias also appear in *American Gothic*.

In 1930 Wood completed *American Gothic*. It is strange that this painting is almost impossible to date. It has the feel of another time. Go back to the work again (page 157). Is there any way to identify the date of the painting? There are some clues. Wood had given specific instructions to his sister to wear an apron trimmed with rick-rack braid. When she tried to buy it, she was told that the stores hadn't carried it for years. She had to tear the rick-rack from one of her mother's old dresses and sew it on the apron, while underneath she wore an old dress. By 1930, even a three-tined pitchfork was becoming obsolete. Her clothes and the pitchfork are from another time. The artist had a specific idea in mind; to make a living image of the past.

Again we can imagine Wood facing Memling. After a while Memling's portraits have a strange and wonderful effect. His people belong either in a convent or a monastery. No matter when they might have lived, there is the feeling that time passed them by. Wood's couple have that same feeling. Although they live in the present, they belong to the past—the artist's own past. Had he not spent the happiest years of his life on a small farm in rural Iowa?

Wood had strong ties with the art and history of the Midwest, and he always had a passionate interest in early American folk art. He loved the solid furniture of early American craftsmen and often furnished and decorated houses in the older style. He collected and studied historical maps and atlases. He loved the pattern of his old family china and the landscapes of Currier & Ives (Figure 129). The charm of these earlier styles appeared in Wood's later works.

He spent hours looking at early pioneer photographs. That led him once to explain that the couple in *American Gothic* were "tintypes from an old family album." The critic Wanda Corn has shown how the arrangement of the couple in *American Gothic* was actually suggested by the nineteenth-century photographer Solomon Butcher.

HOME TO THANKSGIVING.

Figure 129. Wood was influenced by the landscapes of Currier & Ives, such as this lithograph titled *Home to Thanksgiving.* Currier & Ives, *Home to Thanksgiving.* Lithograph. The Museum of the City of New York.

The photograph of John Curry's sod house in Figure 130 could easily have served as a model for Wood's piece of history. Traveling photographers of that century usually posed a couple in front of their house. The painting has other similarities to the photograph—the dress, the stiffness of the bodies, and the staring eyes of the couple. Notice also the plants potted in cans. The indoor plants were a source of pride to settlers, since it was hard to keep plants alive during the long winter. A pitchfork identifies the man as a farmer, but it also kept him steady during the long time necessary for photographic exposure.

OTHER PAINTINGS

When Wood looks into the past, he reveals his feelings about the present. What does *American Gothic* tell about

Figure 130. This early photograph by Solomon Butcher titled *John Curry Sod House* **may have influenced Wood.** Solomon D. Butcher, *John Curry Sod House near West Union in Custer County, Nebraska.* c. 1886. Solomon D. Butcher Collection, Nebraska State Historical Society, Lincoln, Nebraska.

1930? Is it, after all, a joke—a spoof about people who lived in the past and are ridiculed in the present? Is it one artist's statement against his community of uncultured American Goths? Or were these outdated folks who struggled to keep the plants alive telling us something beautiful and true about a vanishing America? Which definition of Gothic— story, art, or architecture—applies to the painting? Maybe they all fit. Other works by Wood on the following pages show him to be capable of ridicule *(Daughters of Revolution)*, humor *(Victorian Survival)* anger, *(The Appraisal)*, and tender sympathy *(Fall Ploughing)*.

Daughters of Revolution (1932) shown in Figure 131 created a storm of protest. The artist previously had had trouble with a patriotic organization, the Daughters of the American Revolution (DAR). Members of the DAR objected to his visit to Germany to finish the stained glass window for the war memorial. They complained that an American war memorial should have been made in America and not in Germany, the former enemy in World War I. The painting is a good-natured slap at the DAR. In the background is Emanuel Leutze's classic painting *Washington Crossing the Delaware.*

Figure 131. This painting created another uproar among Grant Wood's public.
Grant Wood, *Daughters of Revolution*. 1932. (Oil on board.) 20" x 40". Cincinnati Art Museum. The Edwin and Virginia Irwin Memorial. ©Grant Wood/VAGA, New York, 1990.

This time the artist's visual joke is to repeat the prow of the boat in the mouths of this prim and proper threesome. They are celebrating an historic occasion: Washington's 200th birthday in 1932. Wood's idea for the celebration was to place a bony hand making a "dry" toast with a cup of tea.

Wood's model for *Victorian Survival* (Figure 132) was a tintype photograph of his aunt, Matilda Peet, from his own family album (Figure 133). It is another visual joke. A long-necked woman sits next to a long-necked, old-fashioned telephone. The woman comes from the 1880s—the time of Queen Victoria. The telephone comes from the 1920s. The telephone and the twentieth century have come and times have changed, but like the couple in *American Gothic*, she hasn't. The discomfort is in her face. She *resembles a chicken!*

The Appraisal, originally titled *Clothes*, is a lesser-known work, but one with a message (Figure 134). Two women meet to discuss the value of a hen. The woman on the right comes from the big city and is elegantly clothed in the furs of a dead animal. Her vicious double chin shaped in the form of a second pair of lips suggests her huge appetite. On

Figure 132. *Victorian Survival* **by Grant Wood.**
Grant Wood, *Victorian Survival* (portrait of the artist's aunt).
1931. Oil on composition board. 32 1/2″ x 26 1/2″. The
Carnegie–Stout Public Library, Dubuque, Iowa. ©1990.

**Figure 133. The photograph that
served as a model for the painting,**
Victorian Survival. Grant Wood Family
Photograph Album, *Matilda Peet.* c. 1880. Tintype pho-
tograph. 3 1/2″ x 2 1/8″. Grant Wood Collection,
Davenport Museum of Art, Davenport, Iowa.

the other side a wholesome farm woman embraces the hen.
Her clothing is simple, and she is at one with the animal,
holding it proudly and close to her. The fat hen has a thick,
elegant coat—the most luxurious of the three. The hen's
look of concern is justified, for it will end up on the table of
the city woman.

While there is humor in this harmless scene, it is actual-
ly a fierce painting. *The Appraisal* deals with the price of a
hen, but the artist is also making an appraisal of country life
versus city life. The solid farmhouse in the background,
with its flowering potato patch, is life. The city woman is
out of place here. *The Appraisal* is full of an artist's venom,
ridicule, and contempt. Its statement is clear: the farm pro-
vides, the city takes. It tells much about the meaning of
American Gothic.

In many of his works Wood celebrated the virtues of the
American farm. One of his best is *Fall Ploughing* (Figure

185

Figure 134. In *The Appraisal*, Wood contrasted farm people and city people. Grant Wood, *The Appraisal.* 1931. Oil on composition board. 29 1/2" x 35 1/4". The Carnegie–Stout Public Library, Dubuque, Iowa.

135). Hints of this work appear in *American Gothic.* There the eye, disappointed by the grim faces of the couple, wanders into Wood's dreamy corners of nature—the landscape. Here is food for the dreamer. The rounded shapes of the plants and three trees rising up like toy balloons are so inviting that we are tempted to remove the people to see what else is there. The artist accomplished this in *Fall Ploughing.* The work is Wood's tribute to a nineteenth-century American invention, John Deere's walking plow. With this marvelous invention, farmers no longer had to stop every few yards to clean the moist topsoil from the blade. It was the "plow that conquered the soil" and made big harvests possible. In the painting the plow stands alone. The clean curve of the blade repeats in the lines of the landscape. You can feel the lift and sweep of the ground. The corn shocks march in formation, and the rolling hills glide off into the distance. It is an earthly paradise made by man and his plow.

Like *American Gothic, Fall Ploughing* speaks of another time. But could these works have been painted at another time? Go back once more to *American Gothic* and *Fall*

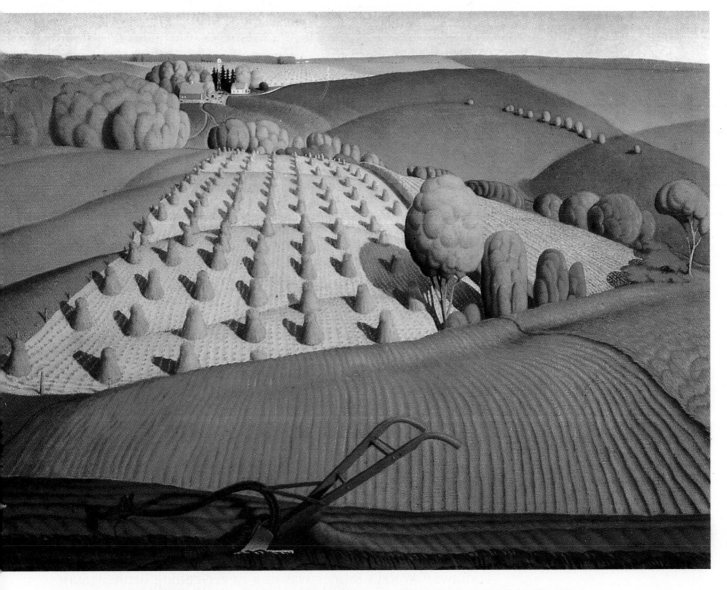

Figure 135. *Fall Ploughing* **is Grant Wood's tribute to the Iowa farmland he loved.**
Grant Wood, *Fall Ploughing.* 1931. Oil on board. 30" x 40 3/4". Courtesy of the John Deere Company, Moline, Illinois, The John Deere Collection.

Ploughing. Can you determine whether they are nineteenth- or twentieth-century works?

Grant Wood's paintings always began as abstract designs. He once said: "All my pictures are first planned as abstract shapes and only then do I put the clothes on." The exaggerations in *American Gothic* fit Wood's design. In *Fall Ploughing* the corn shocks are all the same size and line up in even rows. To explain the importance of repetition in his design, Wood used to show a photograph of corn shocks which were of different sizes and sagged lifeless to the ground.

187

This insistence on shapes, lines, color, design—what are known in art as the "formal" aspects of a painting—dates him as a modern artist. Although his objects are recognizable, his technique is modern. His fields, his houses, and his people are abstract shapes in the mind before they become objects in his paintings. He is just a brushstroke away from unrecognizable objects—one step away from abstract art. His design changed the landscape into geometric patterns with dazzling repetitions of line and shape. The style is part of the new visual experience that is modern art.

Wood's style does not explain *American Gothic,* but it leads to an intriguing question. Why did this modern, sophisticated artist who traveled and studied in the art capitals of America and Europe go back to the past? Why do his 1930 paintings have people dressed in Victorian clothes with long-outdated tools? By 1930 many American farms had become mechanized. Why is there no modern equipment in his world—no giant harvesters, tractors, or mechanized plows? His farms, like his people, are relics of the past. They existed long before the bulldozer destroyed the American landscape for the expanding cities, long before highways brought the automobile. These paintings are his judgments. His farmers have seen the progress but have not yielded to it. They seem uncomfortable and ridiculous, and their manner might baffle the modern viewer. The artist did not reveal them, but their faces reveal Grant Wood.

Years later Wood wrote about himself and his commitment to the farmer. In his essay "Revolt Against the City" he wrote about the reserved farmer who is ridiculed by city people: "When the gentle farmer is called a hick he withdraws." Wood's farmer was in a never-ending battle against drought, famine, dust storms, heat, and floods. He dealt with the constant threat of losing his farm to the bank. He had no time for idle chatter or posing for slow-speed cameras. Grant Wood's art interpreted the drama of that life. *American Gothic* is a votive work, with two vows fulfilled: the farmer's to the land and the artist's to the farmer.

REGIONAL PAINTERS

With the early thirties came a time of crisis and upheaval in American history. The Great Depression, when millions of Americans were out of work and standing in breadlines, put

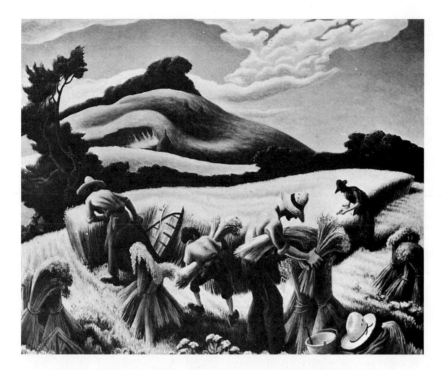

Figure 136. Thomas Hart Benton, another regionalist painter, shows his attraction to the American way of life in *Cradling Wheat.* Thomas Hart Benton, *Cradling Wheat.* 1938. Oil and tempera on board. 31" x 38". The Saint Louis Art Museum, St. Louis, Missouri. Museum purchase.

that look on their faces. Something had gone wrong with the American dream. Most of the art of the Great Depression expresses the fear, suffering, and disappointment of the time. While most American artists were questioning their country, others had been rediscovering their roots. These artists, called Regionalists, had gone back to the soil, the strength of America's past. They left the art capitals of the Western world and went back home: John Curry to Kansas, Thomas Hart Benton to Missouri, and Grant Wood to Iowa. (See Figures 136 and 137 for works by Benton and Curry.) These three took their inspiration from an America that was and is no more.

That's not quite true! The couple in *American Gothic* is alive and well. The passage of time has only added to their stature. Although most people have not seen the painting at the Art Institute of Chicago, everyone recognizes it. The couple appear in posters, advertisements, and jokes on the presidential family. They are so much a part of us that cartoons need no explanation.

American Gothic has become America's self-portrait. It remains a large success because a portrait involves three

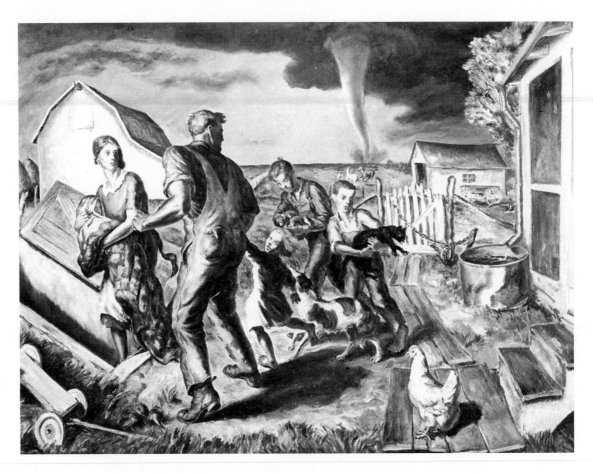

Figure 137. John S. Curry depicted scenes from life in Kansas in painting such as this one titled *Tornado Over Kansas.* John Steuart Curry. *Tornado Over Kansas.* 1929. Oil on canvas. 46 1/2" x 60 1/2". Courtesy of the Muskegon Museum of Art, Muskegon, Michigan. Hackley Picture Fund.

people—the artist, the model, and the viewer. The models say, "The picture does not resemble us." The artist responds, "What do you see when you look at yourselves?" The viewer adds, "What difference will it make a thousand years from now?" The models ask, "Is it us or a picture of us?" The artist says, "Yes." The viewer asks the critics. The models ask, "Who are we? What does the painting mean?" The artist responds, "You are characters from a Gothic novel, living in a Gothic structure as parts of a Gothic painting." You the viewer, still not sure, must go back to the painting one more time. Is the picture beautiful? Humorous? Sad? Threatening? Something else? The obvious answer is yes! It is beautiful because the artist has opened to us a new way of seeing life. It is humorous, sad, yes, even threatening, because these words represent essential truths of life.

"If these are truths of life," say the models, "how about the landscape? We never saw such exaggerations." The artist

responds, "God made the trees, I can only make paintings." The viewer agrees with both. The models say, "But our clothing is so old." The artist responds, "Your clothing, like you, is timeless!" The viewer sees the first and eventually recognizes the second.

The models ask their last question: "Are we husband and wife?" The artist just smiles but does not answer. He lets you, the viewer, decide. Now what? The joke is on the viewer. At first the Iowans hated the painting because they thought the two were husband and wife. Now it is universally liked for the same reason. We cannot ask because the artist locked the couple inside the design. We cannot get in, and they have no intention of coming out.

Are we any closer to the meaning of the painting? Although we have not solved the mystery of *American Gothic,* we have come closer to its truth. The enormous popularity gives the couple a living presence—a life beyond the picture frame. "Some life!" mutters the cynic. The couple leap outside the painting and respond, "Look at yourself! What are your vows? Where is your integrity? Your conscience?" The viewers look again, this time not at the painting but at themselves. And the disagreements continue. . . . Some see charm, some ridicule, and others comedy; for some there is tragedy, for they see nothing.

We wanted to discuss these matters with the artist. By then he had gone on to his next work. . . .

If his later paintings shed light on *American Gothic,* this painting tells everything about Grant Wood. *American Gothic* stands alone among his works. Whether it is a masterpiece remains an open question. It is certainly his centerpiece. All his genius and talent were expressed here. Its style and meaning stamp the other paintings with his vision of America. What was that vision? In 1961 the Vermont poet Robert Frost spoke at the inauguration of President John F. Kennedy. Quoting from his poem "The Gift Outright" he described the American people with the mighty line, "The land was ours before we were the land's." Grant Wood's farmers belonged to the land. They built it so it could be ours.

Summary Questions

1. People and what they do have been favorite subjects of artists since prehistoric times. Portraits have also been a

favorite subject matter. Portraits differ from other paintings about people because in a portrait people are usually not doing anything except posing. Usually a portrait title simply names the people in the picture. The title does not tell a story or describe something else. In what ways would you say that Grant Wood's painting *American Gothic* differs from the usual portrait?

2. In Part I of this book you read about the ways in which artists have solved the problem of representing distance and space. One solution was overlapping. Find an example in Wood's paintings in which he used overlapping. Look at the painting *Fall Ploughing* on page 187. How did Wood solve the problems of space and distance in that picture?

3. Artists get their ideas for paintings from many sources. Name three sources Grant Wood used.

4. What are some of the ways in which *American Gothic* is similar to Hans Memling's *Portrait of a Young Man* (page 174)?

5. How would you describe the colors of *American Gothic?* How do they affect the impact of the painting?

6. In what way does *American Gothic* reflect Gothic architecture? How do you think it reflects a Gothic novel or film?

7. In Part I you read about artists and nature. Study *Fall Ploughing* on page 187. How does Grant Wood portray nature in this painting? What relationship does he imply exists between people and nature?

REVIEW, THE VISUAL ELEMENTS OF ART

In Part I you learned about the elements of design—color, form, line, texture, space and value. Let's see how Grant Wood used these elements in *American Gothic*.

Color

The colors in *American Gothic* are mostly dark and somber. Notice how much black and gray Wood used. The lighter colors in the background make the figures seem even starker. There is, however, a triangle of reds in Wood's painting. Can you find it? Start at the red barn on the right side, then move your eye to the woman's brooch. The third angle of the triangle is in the reddish browns of the man's hand. Close your eyes for a moment and try to imagine how Wood's painting would look without this red triangle. Would it be as effective?

The artist also used many values of gray and brown in *American Gothic*. How do these help give unity to the painting?

Line

The diagram on page 172 shows how Wood repeated vertical and horizontal lines over and over again throughout the painting. These lines help to give the painting a sense of stability. When we feel that stability, we sense that these people will never move; they are on their land forever.

Shape and Form

The preceding section discussed the various shapes, such as the Gothic arch, that Wood used. The diagram on page 162 shows how circles were repeated in many parts of the painting. Look again at the painting. Locate the pointed V-shape of the roof. How many similar shapes can you find in the painting? Don't forget the rick-rack on the woman's apron!

The heads of the two characters are excellent examples of the way shape can be transformed into the illusion of form. You will be drawing and painting the human figure in this part of the text. You may want to refer to Wood's work as you practice.

Space

Compare *American Gothic* to Wood's *Fall Ploughing* (page 187). Which of these paintings gives a more vast sense of distance and space? Why is this? What devices does Wood use to achieve this? What device does Wood use in *American Gothic* to show the man is slightly nearer to the viewer than the woman?

Texture

American Gothic appears smooth to the eye. Wood did not use the heavy brushstrokes as Homer did in *The Gulf Stream.* The small, refined brushstrokes of Wood have created the natural textures in the trees and the smooth appearance of the man's overalls.

REVIEW, THE COMPOSITIONAL PRINCIPLES OF DESIGN

You will recall that the compositional principles of design are repetition, variety or contrast, emphasis, movement and rhythm, proportion, balance, and unity. Let's look at how these principles are used in *American Gothic*.

Repetition

The repetition of forms such as the Gothic shape, circles, and lines is diagramed in the section on the painting. You may want to review the illustrations of the repetitions (pages 162–172), since *American Gothic* is a good example of the effective use of repetition in design.

Variety and Contrast

Think about what you have read about color, line, and shape in this work. Make a list of features that show variety or contrast in this painting.

Emphasis

What did Grant Wood emphasize in *American Gothic?* Do you recall how he changed a rake in an early sketch to the pitchfork we see in the finished painting? Wood used the pitchfork to strengthen the design of this painting. He also used it to emphasize the faces of the man and woman.

Movement and Rhythm

What principle of design is quite strong in *The Gulf Stream* but appears to be almost missing in *American Gothic?* You are right, it is movement. Whereas in *The Gulf Stream*, everything is in motion, in *American Gothic*, everything is still. In Wood's painting the people do not move. There is no evidence of a wind moving the trees, and the curtains do not flutter in the breeze. The composition itself, with all of its verticals and horizontals, is still. And yet, your eye moves around the picture. How does Wood make this happen? Your eye is directed up by the pitchfork and vertical lines. It is carried from side to side by the white edge of the porch roof. Devices such as the triangle of red also help to move your eye from one part of the picture to another. The woman's face and attention are turned to the right and into the painting, but your eye stops at the man who looks back at you.

Look for examples of rhythm in the illustrations throughout the section on *American Gothic.* You will recall that rhythm is the movement created in an artwork by repeating an element, such as line. Note the examples you find and discuss them in class.

Proportion

Review the discussion of proportion on pages 52–54. How has Wood used this compositional principle to show dominance in *American Gothic?*

Balance

Recall the three types of balance: symmetrical, asymmetrical, and radial. Which kind of balance do we have in this painting?

Unity

A number of the elements of art and compositional principles work together to give this painting unity. Discuss this in class.

UNIT

FORMS OF EXPRESSION

The Artist in the Community

Earlier in the study of *American Gothic,* the question was raised about likeness in a portrait. For some artists likeness is most important—the portrait is like a mirror. Others only use likeness to reveal character. Still others use the model to tell something about everyone, including the artist. (Most great portraits include all three.)

There is no one simple answer to this question of the ages. Since earliest times artists have been making images of people. In ancient Egypt, portraits of kings were part of their immortality. These were supposed to be so lifelike that there would be no mistaken identity in the next world. Figure 138 shows a king's coffin molded into a dazzling human likeness. Looking at these exquisite works today, we can only wonder whether the artists were capturing human likeness or creating beauty.

Thousands of years later, we no longer share the beliefs of the ancient Egyptians, but have feelings about the human image changed? Does a picture have life? If you have any doubts, think of a parent holding a photograph of a child, or of our feelings for photographs of loved ones no longer

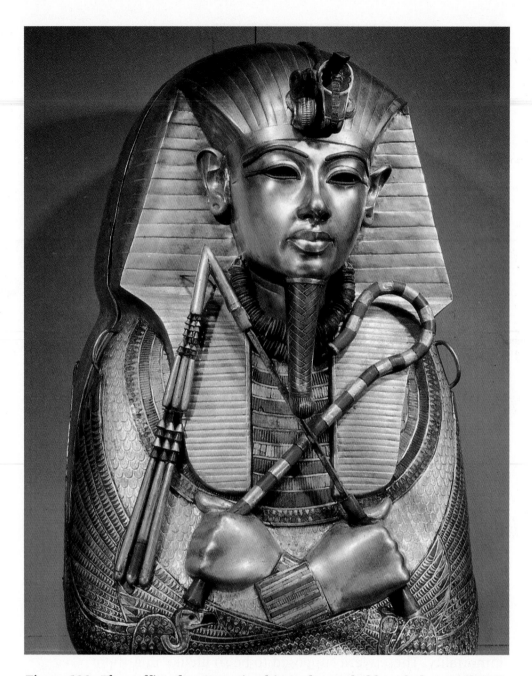

Figure 138. The coffin of an Egyptian king who probably ruled around 1350 B.C. *King Tutankhamen's Coffin*, upper portion, New Kingdom. c. 1350 B.C. Gold, enamel and precious stones. Approx. 73" high. The Egyptian Museum, Cairo. Photo courtesy F.L. Kennett. Copyright George Rainbird, Robert Harding Associates, London.

alive. Although only images of people, these photographs are treated with love and respect, as if they were alive.

Each civilization has had its own purpose and style for portrait painting. Nonetheless, the problem for the artist remains the same: How do I give life to a human image? The

198

Figure 139. *Women Winding Wool,* **a 1949 drawing by English artist Henry Moore.**
Henry Moore, *Women Winding Wool,* 1949. Crayon and watercolor. 13 3/4″ x 25″. Collection The Museum of Modern Art, New York. Gift of Mr. and Mrs. John Rope in honor of Paul J. Sachs.

artist can find it anywhere—in the subject's face, character, or work. Different artists have seen the world in very different ways. There is no one answer to why or how artists make portraits—except perhaps that artists have to support themselves!

DRAWING

Sometimes people's hands can tell us more about them than their faces. In Henry Moore's crayon and watercolor drawing *Women Winding Wool* (Figure 139), the hands tell the story. The figures of the two women strike us as great, solid forms resting in place like two continents. They are connected by a moving "sea" of wool. They communicate through the tensions created as they move the wool to keep it taut between them. They do not have to talk. We do not have to see their faces to know that they are communicating.

The tension we see in the threads of wool is repeated by a larger theme—the tension between two strong figures,

199

Figure 140. In Yasuo Kuniyoshi's *Girl Thinking*, the viewer learns about the girl by looking at her hand. Yasuo Kuniyoshi, *Girl Thinking*. Ink on paper. Courtesy, Christie's N.Y.

separate and connected at the same time. It is their hands that bring them together. The tension in this picture is further shown by the technique with which it has been recorded. Short, nervous strokes of the crayon create an impression of flowing energy. Winding wool becomes a lively dialogue.

In the ink drawing *Girl Thinking* (Figure 140), by Yasuo Kuniyoshi (koo-nee-oh´-she) the hand is important to the mood of contemplation. It is likely that Kuniyoshi meant us

to focus on the hand. Our eye is drawn to its white shape, which contrasts with the dark areas of the face and hair. Look more closely at the hand; you will see that it presses into the lips, showing that they are loose and flexible rather than set. The girl's eyes appear to be gazing into herself as well as out of the picture. Whatever she is thinking about, the girl does not seem to have made up her mind yet. The loose, sketchy brushwork corresponds to her thoughts; she is musing, letting her mind drift.

The Artist Captures Loneliness and Suffering

New York Movie by Edward Hopper (Figure 141) shows human presence in a nearly deserted space—a motion picture theater. The two customers are faceless. They are only a few feet apart, but as much apart from each other as the usher is from them. The usher is a part of this society also, although she is separated from it. She appears bored, tired, troubled, or perhaps just lost in thought. This sense of human isolation may be the element that gives the feeling of such loneliness to this picture. Each of the characters is placed in a situation that calls for companionship or comfort, but none of them is capable of offering it.

Compare the preparatory sketches Hopper made of the two women he considered (Figure 142). Of the two, do you agree with the choice he selected? How does the woman in the fur collar and the larger hat create a different atmosphere than the woman in the less expensive clothing would? Does this make a difference in your thinking? Why? If Hopper had eliminated the man and depicted two women in the audience, would the message of the painting have been different?

What time of day or night do you think that this scene is taking place? Why?

As you can see from the study sketch (Figure 143), the theater's interior was changed in the final version. What changes do you see? Consider why Hopper made these changes. Did the changes help the painting?

The artist Arshile Gorky was born in Turkish Armenia to a peasant family. The family suffered great hardships and poverty, and in 1919, when Arshile was fifteen years old, his mother died of starvation. The next year he and a sister immigrated to the United States.

Figure 141. Edward Hopper's *New York Movie*. Edward Hopper, *New York Movie*. (1939) Oil on canvas. 32 1/4" x 40 1/8". Collection, The Museum of Modern Art, New York. Given anonymously.

Arshile thought about his mother often and, from a photograph taken of her in Armenia in 1912, he made many sketches and drawings. Look at Gorky's charcoal drawing *The Artist's Mother* (Figure 144). Despite her suffering, this woman conveys an image of inner strength and dignity. The solid form with which her figure is represented gives her a massive appearance.

The Artist's Mother is a very skillful drawing. The woman's eyes are penetrating, and her torso and cap appear almost as dense as armor. Although the forms appear solid, the charcoal is applied in such a way as to suggest that they are

202

Figure 142. A free-hand sketch by Hopper prior to his painting *New York Movie.* Edward Hopper, *Studies of Seated Woman.* Conte on paper, 15 1/8" x 7 3/4". Collection of the Whitney Museum of American Art, New York. Bequest of Josephine N. Hopper.

Figure 143. Study by Hopper for his painting, *New York Movie.* Edward Hopper. Palace: drawing for painting *New York Movie.* Detail. 1939. Conte on paper. 8 7/8" x 11 7/8". Collection of Whitney Museum of American Art. Bequest of Josephine N. Hopper.

**Figure 144. The drawing was made from a photograph of
Gorky's mother.** Arshile Gorky, American, 1904-48, *The Artist's Mother*, 1936. 24" x
19". Worchester Sketch Fund, 1965. © 1990 The Art Institute of Chicago, All Rights
Reserved.

made of smoke. Dreams and memories often seem to be as
wispy as smoke. Which part of this drawing do you find to
be the most memorable and meaningful?

Charcoal is one of the oldest drawing materials. Charred
sticks were used in early cave paintings. Various kinds of
wood are used to produce charcoal for drawing. Willow and
beech produce brittle sticks; vine twigs make the blackest
and softest charcoal. Completed drawings are fixed with a
protective coating to prevent smearing.

DRAWING ACTIVITIES

Introduction

People are one of the most interesting and often used subjects for the artist. Posing the model you are going to draw or paint is most important. You may be asked to pose or to arrange poses from time to time. Here are several considerations:

- Have the model hold some convenient object, such as a book or mirror.
- Costume the model in some fashion—cowboy or cowgirl boots, chaps, firefighter's gear, police clothes, etc.
- Pose the model where everyone can have a good view.
- Pose models with weight centered on one leg to avoid stiffness or static positions.
- Drape lengths of brightly printed cloth behind the model(s).
- Add other props to heighten interest and vary the composition.

1. Drawing people is a skill which can be learned, but it requires a great deal of concentration and practice. You should practice drawing the human form each week.

Before you actually start a figure drawing, make an imaginary line from the top of the head down through the neck, backbone, thighs, calves and feet. Now, using your pencil, lightly draw a line representing the attitude (or central line) of the figure on your paper.

Next divide the line you have drawn into segments that closely relate to proportions of the head, torso, and legs. Look at the shoulders and arms. Are the arms both hanging straight down from the shoulders? Are the shoulders parallel to the floor? Are the legs together or crossed or bent backward? Pay attention to the relative length of the arms and legs. This may not be their *real* length, but what *appears* to be their length. Continue this method of comparative observation, drawing and adding details as you go.

Don't spend too much time on each drawing; fifteen minutes for each is plenty. Complete at least three drawings during one class period. The idea is to capture the attitude and positioning of the figure.

2. Do at least five quick sketches of the model on large sheets of newsprint. Each sketch should take only five to ten minutes. The objective is to get a feeling for the stance of the model and for the whole composition. Pay close attention to the relationships of the parts of the composition to the whole. Stop at this point and select your best sketch. Your teacher may put everyone's chosen sketch up around the room for a class critique.

3. This activity will test your observation skills. One of your classmates will model in a costume. Before you begin drawing, observe the details of the costume. Try to remember every part of the costume *and* how it fits the model. Close your eyes and try to remember how the different parts of the costume are made. Now look again to see if you remembered correctly.

The model will now leave the room. After the model has gone, take out your pencil and draw the costumed model from memory. Your main objective is to record the costume as accurately as possible. When the drawing is complete, the model will return and you can compare your drawing with the real costume.

This kind of drawing from memory is called **reportage** (rep-ur-tahzh´) **drawing**. Practicing this skill several times a week will help you develop skills of observation. You can practice this alone. At first, use a simple object such as a rock, a cup, or a hat as a subject. Look at the object for a short time, then put it out of sight and try to draw it accurately. As you gain skill, draw more complex objects from memory.

4. In this activity you will make several contour drawings. A **contour drawing** is one in which the artist uses one continuous line to draw an object or figure while keeping his or her eyes on the subject. The **contour line** follows the outer edge of the form as the eye flows around and through the subject. Your pencil should move in concert with your eye. Concentrate on the object or figure that you are drawing. Don't take your eyes off the line you are following as you look at the subject. Sometimes that line will move into the center of the subject. Sometimes the line will run into another line that stops it. Sometimes that line will cross over another line. When your eye runs into a likely place to stop, pick up your pencil and select another starting place.

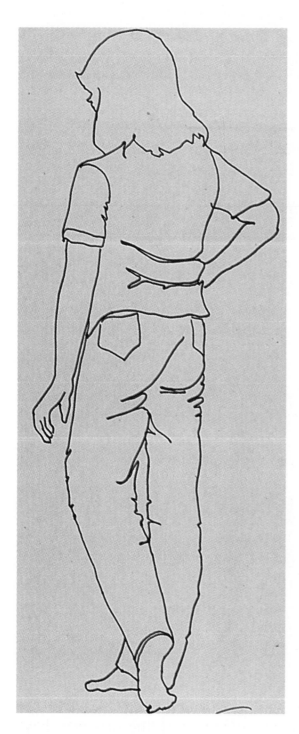

Figure 145A. Student art.

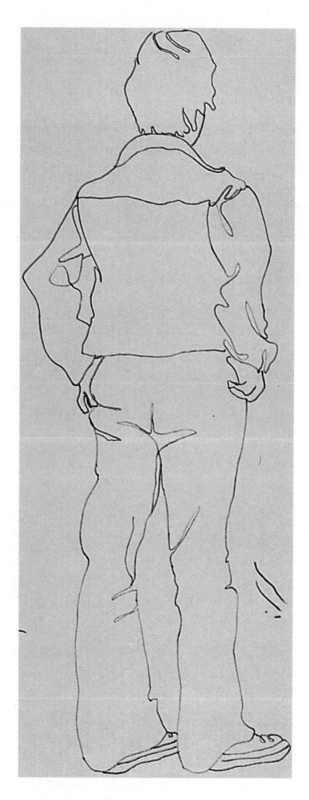

Figure 145B. Student art.

207

Figure 146A. Student art.

Figure 146B. Student art.

Try this technique using a draped figure. Don't be discouraged with your first attempts. By the time you have completed ten or twelve contour drawings, you will observe a big difference in your skill.

5. A **gesture drawing** is a small, quick sketch which expresses the attitude, movement, and major characteristics of a subject. In this activity you will use gesture drawing to help you see and feel the entire scope of your subject. Most people, when they first begin to draw, have a great deal of

trouble seeing the whole, or the overall composition of the subject. Your eyes may wander from detail to detail, slowly forming an aggregate picture of the many small parts that you see. If this happens, you may remain unaware of the attitude and movement within the boundaries of the subject.

Using a dark crayon, make a very quick sketch of the essential moving lines in the figure. Go over and over these lines as fast as you can, forcing yourself to concentrate on the whole figure. Omit superfluous detail, putting down only the essential attitude and movement. These small, very quick sketches may look like a line drawing of a tightly wound wire sculpture. When you think you have completed one gesture drawing, or wish to start over, move to another space on the paper and continue.

6. So far, the emphasis in drawing has been on line, drawing what you can actually see, drawing from memory, figure drawing, contour drawing, and gesture drawing. There is one more basic skill that you need. Mass drawing, as it is called, will allow you to produce not only what you see but also what you think and feel about it.

In this activity, you will use a large sheet of newsprint, and the side of a small piece of crayon or charcoal.

Mass drawing deals with the weight, balance, and movement of the full subject. Concentrate on the bulk and movement. Work very loosely. Don't think in terms of a line, but only the *tone* and *mass*. Avoid all elaborate or unnecessary tones. You achieve tone by varying the pressure on the tool you are using. Complete at least five or six mass drawings. Date and save a few for later reference.

7. Not everyone you draw will be sitting or standing in the relaxed position of a model. Often you will want to draw someone whose face and body express happiness, surprise, anger, or fright. Practice observing and then drawing these emotions expressed in the face and the body.

First, the model should express fear. Observe what the body does. What position and attitude does it take? How does the face appear? Next try to capture the general position of the body, the attitude of the body parts, and the basic expression on the face. What kind of lines will you use? Will they be sharp or rounded? Repeat the exercise several times. Each time the model should express a different feeling, such as surprise, joy, or sadness. Make quick sketches for each exercise.

Produce a series of four finished drawings of this model utilizing the techniques of contour, overlapping contour,

Figure 147. Student art.

209

Figure 148. Student art.

gesture, and mass. It may take several attempts at each of these for you to achieve what you would like to keep. Select four finished pieces. Mat and date each piece, and prepare them for an exhibition.

PAINTING

In an interview, Pablo Picasso was asked about the importance he gave to likeness in portraits. His reply was, "None. ... It is not important. The work can be beautiful even if it does not have likeness. What is a face really? Its own photo? Its make up? Or is it a face as painted by such and such painter? Is it that which is in front? Inside? Behind? Doesn't everyone look at himself in a particular way?"

Think about Picasso's statement and look closely at his portrait of the *Weeping Woman, 1937* (Figure 149). Could it

Figure 149. In Pablo Picasso's *Weeping Woman, 1937*, we see the agony caused by war.
Pablo Ruiz y Picasso, *Weeping Woman, 1937.* Oil on canvas. 23 5/8" x 10 1/4". The Tate Gallery, London/Art Resource, New York.

possibly resemble anyone? This is a face made from the shapes of broken glass with jagged edges, and from colors that clash like flashing lights. Nothing, at first glance, is where it should be. The eyes are out of their sockets. Are the eyes little "shipwrecked boats" or are they polished diamonds? Look again. What we see is not the typical portrait of a woman, but what happens to her face when she weeps. There are pain and weeping in every part of the face, while each color tries to scream louder than the others.

Why all this weeping? The reason for her weeping is suggested by part of the title. In 1937, Spain, Piccasso's native land, was in the grip of a savage civil war. In the portrait, the woman **is** Spain, a country torn apart.

As this painting is considered a masterpiece, we can see that likeness may or may not be important in portraiture.

Figure 150. Rembrandt. Rembrandt van Rijn. Drawing.
Undated. Rembrandt House, Amsterdam

Self-Portraits

The self-portraits of Rembrandt van Rijn (rem´ brant-
von-rine) invite us to look at the artist as he looked at him-
self. Self-portraits receive no commissions—the artist is free
to paint whatever he chooses to express. Study two of
Rembrandt's self-portraits (Figures 151A and 152B).

In the first, the young artist was twenty-three years old
and on the verge of success. The look is self-assured; light
falls on the zig-zag of the eyebrows, the cocky nose, and the
slight bulge of the mouth. Rembrandt used no props and
revealed himself through the play of light on his face.

The second portrait is Rembrandt at the age of fifty. Look
closely and compare these two works. In the years between
(1629 to 1656), Rembrandt had gone through much suffer-
ing. The young man of the first self-portrait was famous,

Figure 151A. *Self-Portrait* **by Rembrandt at age 23. (1629)**
Rembrandt van Rijn. *Self-Portrait* at age 23, 1629. Oil on wood. 14 3/4" x 11 1/2".
Mauritshuis, The Hague. ➤

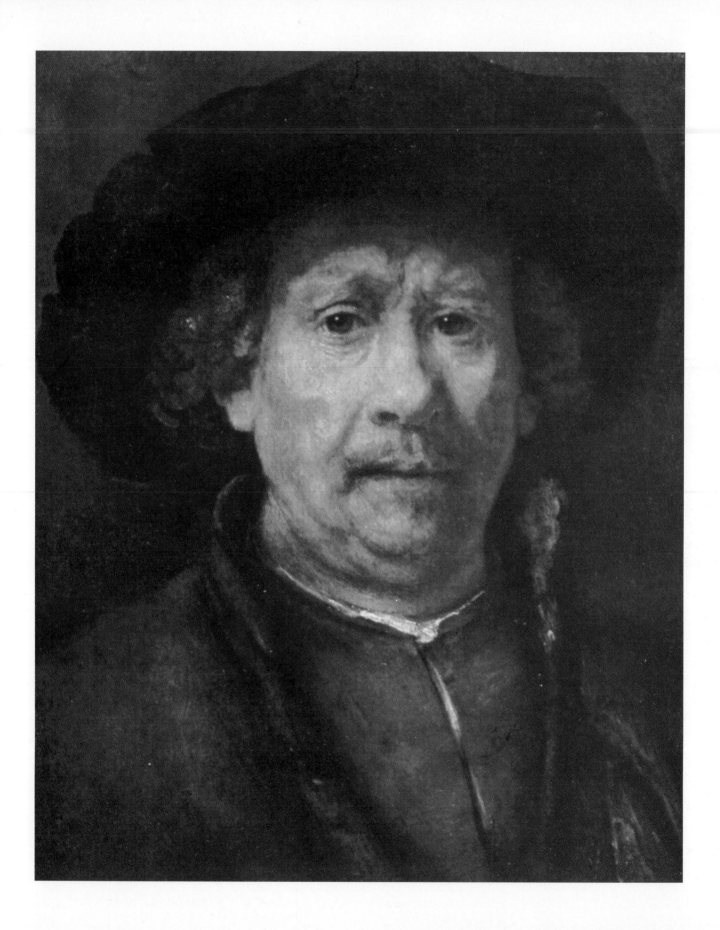

wealthy, and happily married. But the fates were not kind. By 1656 his beloved wife, Saskia, and most of his children, had died. His spendthrift ways had ruined him financially. Here, in this masterpiece, we see him at fifty. The grieving eyes peer out at the world in mystery and pain; his expression reveals his anguish. The puffy face reflects the red of the lips and his painter's coat. That coat tells much of Rembrandt's commitment to his art.

Judith Leyster's (lie´ stur) *Self-Portrait* looks directly at us (Figure 152). Her self-portrait, like the figure compositions in which she specialized, is painted in a lively and loose style.

Leyster was born and lived in Holland during the seventeenth century. She was a pupil of the painter Frans Hals, who influenced her work. Leyster enjoyed wide acclaim during her lifetime and was honored by her native city of Haarlem. Although the pose and costume in the painting appear somewhat stiff and uncomfortable, her face as she works is relaxed and engaging. This painting is really a double portrait because it shows the artist working on a portrait of a musician. Both figures in this portrait within a portrait seem to be saying, "Hi! Join us, won't you?"

Compare Judith Leyster's *Self-Portrait* with Adelaide Labille-Guiard's *Portrait of the Artist with Two Pupils* (Figure 153). Labille-Guiard (lah-bee´-gee-ar) lived and painted in France during the eighteenth century. Her greatest gifts lay in her portraits, which were painted with strength. In fact, some critics even doubted that she painted her own pictures, believing that a woman could not have created them.

Labille-Guiard was an independent woman of noble birth, and thus her life was in danger during the time of the French Revolution (1789–1799). Nonetheless, she remained in Paris after the Revolution and taught young women who wished to become artists. She challenged the rule that only men could be professors at the art academies. In *Portrait of the Artist with Two Pupils,* she portrays herself not only as a painter but also as a teacher.

Of particular interest in this painting are the two pupils. One is watching the teacher demonstrate techniques of painting. The other is watching the painter at work on the portrait. Which is which? The directions of the gazes of the young woman underscore the portrait's statement that

◄ **Figure 151B.** *Self-Portrait* **by Rembrandt at age 50. (1656)** Rembrandt van Rijn. *Self-Portrait* at age 50. 1656-1658. Oil on wood. 20″ x 16″. Kunsthistorisches Museum, Vienna.

Figure 152. Judith Leyster's *Self-Portrait* portrays the artist in direct contact with the viewer. Judith Leyster, *Self-Portrait*, c. 1635. Oil on canvas. 29 3/4" x 25 5/8". National Gallery of Art, Washington, Gift of Mr. and Mrs Robert Woods Bliss.

Labille-Guiard is both artist and teacher. The expressions on the students' faces indicate admiration and enthusiasm. Labille-Guiard appears comfortable, self-confident, and kindly.

The teacher and two pupils are joined together through their love of art. Their figures form a triangle (Figure 154).

Figure 153. In *Portrait of the Artist with Two Pupils* (1792), Adelaide Labille-Guiard shows us the artist as both subject and teacher. Adelaide Labille-Guiard. *Portrait of the Artist with Two Pupils,* 1792. Oil on canvas. 83″ x 59 1/2″. The Metropolitan Museum of Art, New York. Gift of Julia A. Berwind, 1953.

Figure 154. Triangular designs create a strong sense of unity in Labille-Guiard's painting.

The three heads are at the apex. Their full skirts are at the bottom, pointing toward (notice the artist's toe) the strong diagonal of the large canvas. We are looking at a powerful comment about women and art—each forcefully represented. There is yet another important triangle in the picture. Can you find it?

Within the large triangle made up of the three women is a smaller one. To define it, begin with the hair of the pupil farther back. Continue along the shoulder of the pupil next to her, stopping at the hand about her waist. Now follow the left forearm of the pupil closer to the viewer and continue along the forearm of the teacher. Follow the brush in the right hand of the teacher, which points back to the pupil we began with. This triangle, like the larger one, is directed toward the painting by the palette and the brushes held in the artist's left hand. There is still another triangle to be found by connecting the eyes of the three women. The women—teacher and pupils—are united, and their focus is art.

Labille-Guiard chose to portray herself as an artist and teacher. That is, she wished to be seen for the things she did. Many portraits show people engaged in their daily routines. This is a way of telling us more about a person than might be possible by just presenting a face and torso.

Royal Portraits

Francisco Goya said, "Painting selects what is suitable for its purpose. It brings together qualities from different people

Figure 155. The very regal King Henry VIII in formal pose.
Hans Holbein, the Younger, *King Henry VIII*. c. 1549. Oil on panel. 34 3/4" x 29 1/2". Courtesy of the Board of the National Museums and Galleries on Merseyside. (Walker Art Gallery, Liverpool).

Figure 156. *King Louis XIV*
by Hyacinthe Rigaud
depicts the majesty of the
French king.
Hyacinthe Rigaud. *King Louis XIV*,
1701. Oil on canvas. 9'2" x 7'10 3/4".
The Louvre, Paris. (Cliché des Musées
Nationaux, Paris.) © Photo R.M.N.

and concentrates them on one single *fantastic being*. The creator is no mere copyist but acquires the title of inventor."

In 1798, the Spanish artist Francisco Goya received a commission for a group portrait of the royal family of Spain—the family of King Charles IV. Paintings of kings have their own place in the history of portrait painting. These works, known as "regal portraits," show royalty as human monuments. Two good examples of the regal portrait are those of Henry VIII of England by Hans Holbein, the Younger (Figure 155), and Louis XIV of France by Hyacinthe Rigaud (Figure 156).

Figure 157. The royal family is painted by Francisco Goya. Francisco Goya, *The Family of Charles IV*, 1800. Oil on canvas. 9'2" x 11'. The Granger Collection, New York.

In these regal portraits the artists give to the royal sitters the majesty and glory of their position. Dressed in all their finery, these figures are what they are supposed to be—kings. They are larger than life, with a divine right of kingship, and their portraits dominate the artists' canvases just as they rule their lands. This type of picture is probably what Charles IV had in mind; but it is not what he got from Francisco Goya.

Look at Goya's *The Family of Charles IV* (Figure 157). These people are not regal. They are monsters. A famous French writer described them as "the country baker and his wife after they won the lottery." But the writer was not being fair to bakers. What he meant, of course, was the way the artist had put fancy clothes on crude, vulgar people. Goya had taken honor out of a king's position and replaced

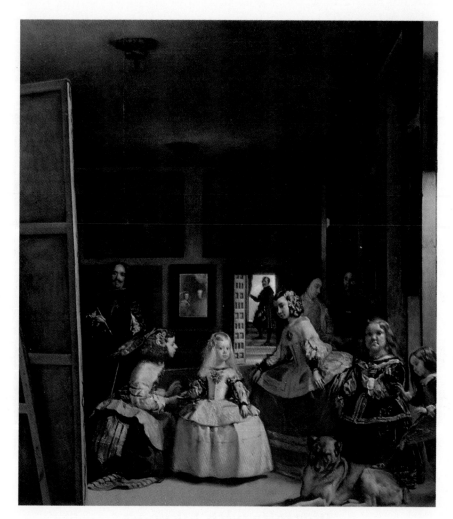

Figure 158. Diego Velásquez's delightful scene of court life, *The Maids of Honor* **(1656), contrasts with Goya's unpleasant vision.**
Diego Velásquez, *The Maids of Honor* (Las Meninas), 1656. Oil on canvas. 10′5 1/4″ x 9′ 3/4″. The Prado Museum, Madrid.

it with contempt. Unlike every court painter before him, instead of paying homage, Goya was brutally honest in his portrayal of this royal family.

Without mercy, he chose not to protect these highborn people from their inner selves. For what do we have here? According to one writer, "a collection of ghosts!"—frightened children, a bloated vulture of a king, and a crude, nasty queen.

Goya could have lost his job as court painter, or even his head. That the royal family permitted, and even liked, this work is amazing. Perhaps it was the fine clothes; or perhaps it was the artist's reference to an earlier, glorious portrait of Spanish royalty—*The Maids of Honor* by Diego Velásquez (vuh-lahs´ kes). Look closely at *The Maids of Honor* (Figure 158). How would you compare the two paintings?

The setting for *The Maids of Honor* is the artist's studio. At the left is the artist himself working on a painting. In the

center is the Princess Margarita with her friends and maids of honor. Her parents, the king and queen, have just entered the room, and we see only their reflection in the mirror. It is a happy scene full of light and majesty.

In Goya's work, the artist is also in his studio, but he is behind the group. Instead of Velásquez's happy princess, Goya placed the strange-looking queen at the center, causing the light to fall on the fat part of her arm. There is a mirror hidden in Goya's work. Can you find it? That's right, the painting is the mirror. Those people are posing in front of a mirror. Notice how in *The Maids of Honor* the people happily look at each other. In Goya's work they are too busy posing, looking at themselves in the mirror. If the mirror cannot hide the truth, neither will the artist.

This unkingly portrait also revealed a personal truth about the artist: Goya's hatred of this royal family and probably of all royalty. Goya lived in a time of revolution and change. A few years before, both America and France had gotten rid of kings. In Spain, revolution was in the air, and Goya was part of it. This work was a statement of revolution.

In *The Family of Charles IV*, Goya invented a series of "fantastic beings." Like the queen in *Snow White and the Seven Dwarfs*, the family spoke to the mirror and expected flattery. The Spanish master gave them the bitter truth.

Portraits with Likeness

Mary Stevenson Cassatt was born in Allegheny City, Pennsylvania, in 1845. She was raised in a comfortable environment and aroused the disapproval of her family when she decided to become a serious artist. Nevertheless, she settled in Paris, France, where she devoted her life to her work. She is best known for her paintings of mothers and children.

Look at Cassatt's painting *Mother and Child* (Figure 159). The mother and child are tenderly unified through the placement and gestures of their hands and heads. The mother's hands securely hold the child to her, while the child reassuringly touches the mother's face and hand. The mother's skirt forms a strong broad base at the bottom of the painting to add to the sense of security and contentment. The harmonious colors and the broad brushstrokes also support the focus of this painting, which is the mother-child relationship.

Figure 159. Mary Cassatt's
Mother and Child **depicts a**
scene of warmth and har-
mony.
Mary Cassatt, *Mother and Child*. 1890.
Oil on canvas. 35 3/8″ x 25 3/8″.
Wichita Art Museum, Wichita, Kansas,
The Roland P. Murdock Collection.
Henry Nelson, photography.

Children's Doctor is a tempera painting by the American artist Andrew Wyeth (Figure 160). It shows two sides of a physician—Dr. Margaret Handy—front and back. As you can see, a person's back can project a strong statement. We see Dr. Handy in the foreground presented in a classic head-and-shoulders portrait. At the same time, we see her walking away to make her rounds to the sick. It is almost as if to say that she is too busy to sit very long for a portrait. Her patients are waiting, and she must be off.

Figure 160. Two views by Andrew Wyeth of his children's doctor. Andrew Wyeth, *Children's Doctor* (1949). Oil on canvas. 26″ x 25″. © Andrew Wyeth 1991. Collection of the Brandywine River Museum, Pennsylvania.

The doctor's face, with hand raised to cheek, appears thoughtful and pleasant. Her expression indicates that even as she sits for the portrait, her mind is on other things. The squared-off shape of her back suggests solidity and responsibility. She is a woman in whom many parents and children have placed their trust.

In reality, Dr. Handy was a woman of strong determination. She shocked her mother by choosing a career in medicine and was one of the first women to graduate from Johns Hopkins Medical School. She took care of Andrew Wyeth's children as well as those of many of his friends.

Figure 161. How is Johnston's painting carefully balanced?
Joshua Johnston, *Mrs. Hugh McCurdy and Her Daughters*. c. 1804. Oil on canvas. 44" x 38 3/4". The Corcoran Gallery of Art. Museum purchase through the Gifts of William Wilson Corcoran, Elizabeth Donner Norment, Francis Biddle, Erich Cohn, Hardinge Scholle, and the William Al Clark Fund, 1982.

Wyeth's portrait *Children's Doctor* shows his fondness and respect for her.

Joshua Johnston was one of the earliest known African-American painters in the United States. He is best known for his portraits of the upper-middle class society in Baltimore. Johnston often embellished these portraits with decorative props to make them more appealing to his clients.

What props did Johnston add to the portrait of *Mrs. Hugh McCurdy and Her Daughters* (Figure 161) in order to brighten it? Around what two complementary colors is this painting developed? In *Mrs. Hugh McCurdy and Her Daughters* the reds and greens have been tinted with white and grayed (slightly dulled and softened). The resultant pinks and olive greens provide a pleasant and flattering image. The three figures look like porcelain dolls, which probably pleased the sitters.

Carefully examine the composition. This painting has been thoughtfully developed to establish a balance in forms as well as in color. Johnston needed to provide visual relief from the three strong vertical forms of Mrs. McCurdy and the daughters, but did not want the horizontal element to compete with them in importance. He achieved this end by outlining the top of the sofa in metal brads that flow softly in a definite diagonal line behind the three figures. To bal-

ance the tall form of the mother at the left, the painter has added a bright basket of fruit in the hand of the daughter at the right side. In what other ways has Johnston added a sense of balance in an asymmetrical composition?

An Animal Portrait

Animals are also a part of our community. Perhaps the unknown artist who painted *The Cat* (Figure 162) was imagining the way a cat might appear to birds. It is not a cute pet, but a huge, terrifying head stalking through the grass. The cat in the painting has already caught a bird, and the other birds seem to hide in the trees. Where is the cat's gaze aimed? It is looking up toward those birds in the trees. The bird in the tree on the left looks away, perhaps hoping the cat will not see it. However, it is clear from the expression on the cat's face, that it certainly does see the two birds. This cat is a symbol of danger.

Why do the birds stay there? Why do they not fly away? Have you ever been "scared stiff," that is, so frightened that you are unable to move? The birds are painted as rigid, perhaps frozen in fear.

There are many ways an artist could illustrate a cat hunting birds. What makes this particular painting so original and interesting is that it shows the sense of terror that birds must feel when they are being hunted. Again, the artist has shared a vision. He or she has made you see something in a way you do not ordinarily see it.

We have just studied portraiture as an expression of the community. Now let us consider how a mural reflects the community spirit.

Muralismo

Between 1920 and 1930 an art movement emerged in Mexico called *Muralismo* (myoo-rul-ees´-moh). During this time, hundreds of artists participated in the creation of **murals,** artworks painted on public walls and ceilings. How and why an art movement comes about at a particular time and place are very complex questions. The work of Diego

Figure 162. *The Cat* by an anonymous folk artist, from the point ➤ of view of the birds. Anonymous American, 19th century, *The Cat*. Probably 1850-1899. Oil on canvas. 16″ x 20″. National Gallery of Art, Washington D.C. Gift of Edgar William and Bernice Chrysler Garbisch.

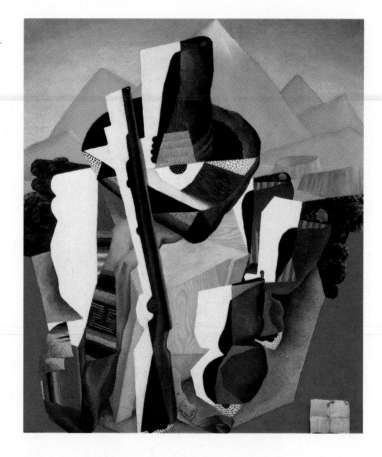

Figure 163. *Zapatista Landscape—The Guerilla,* **was painted while Rivera was studying in Europe.**
Diego Rivera, *Zapatista Landscape—The Guerilla,* 1915. Oil on canvas. Detroit Institute of Art.

Rivera provides us with insights into the Muralismo movement in Mexico.

Rivera was born in 1886 in Guanajuato (gwan-uh-whot´-oh), Mexico. When he was six, his family moved to Mexico City, where he had the good fortune to study with Jose Guadalupe Posada (poh-sah´-dah). Posada was an impassioned artist whose drawings stirred the conscience of the nation. Fifty years earlier the Mexican Revolution had promised democracy and reforms. These promises had never been fulfilled. The land was held by only a few very wealthy families. The nation was in turmoil, and revolution was again in the air. Posada's work reflected the spirit of the times, and ignited the two passions that would burn in Rivera for the rest of his life—justice for the peon (peasant) and the mastery of Muralismo.

Rivera went to Europe to study modern art. He kept in touch with events in Mexico through the visits of fellow artists. In 1915 he painted a small masterpiece, *Zapatista Landscape—The Guerilla* (Figure 163). The subject, Emiliano Zapata (sah-pah´-tah) was a peasant revolutionary general at the time. In the five-sided geometric pattern of the paint-

ing, the guerilla's sombrero, his serape (blanket), his gun, and the Mexican flag are arranged against the backdrop of mountains, volcanoes, and ocean-blue sky. This modern work was so impressive that critics mistook it for that of Rivera's close friend Pablo Picasso.

Rivera was unique among the Mexican muralists. When the government began to commission murals for public buildings, Rivera had acquired the technical skills required of a great muralist. He had even gone to Italy (1916–1918) to study the Italian masters from the fifteenth through the early seventeenth century, the period commonly known as the Italian Renaissance. He had spent two years making drawings of murals and early sculptures. Why did he suddenly abandon modern styles to go deep into the past? Rivera was convinced that it would be possible to approach the peasant in Mexico through his art, and he wanted a language in art that would be very clear to this audience. The language he chose was Muralismo.

Upon his return to Mexico, he painted his first mural, *Creation*, for the National Preparatory School. A mural begins with the muralist's singular ability to look at a wall as a point of departure. The wall is the support surface for the design. *Creation* reflects the many hours Rivera studied that particular wall. It also reflects the countless hours he spent studying the Sistine Chapel at the Vatican in Rome. Notice Rivera's studies for the hands of "Wisdom" and "Science" (Figures 164A and 164B). They fill the space with graceful

Figure 164A. Rivera spent countless hours preparing for his murals. Diego Rivera, Untitled (*Hand*) c. 1921-1922. Conte crayon and charcoal on paper. 26 5/8" x 19 1/8". San Francisco Museum of Modern Art. Gift of Albert M. Bender through the San Francisco Art Institute.

Figure 164B. Rivera's study for the hands of "Science." Diego Rivera, Untitled (*Hands, Palms Up*), 1922. Conte crayon and charcoal on paper. 18 3/16" x 25 7/26". San Francisco Museum of Modern Art. Albert M. Bender Collection. Gift of Albert M. Bender through the San Francisco Art Institute.

Figure 165. *Detail of Creation of Adam* **from the ceiling of the Sistine Chapel. 1511.**
Michelangelo. *Detail of Creation of Adam*, 1511. Fresco. Ceiling of the Sistine Chapel. 44' x128'. The Vatican, Rome. Courtesy SCALA/Art Resource, New York.

gestures, linking the figures. Their rhythmical movements recall the exquisite hand movements in Michaelangelo's "Birth of Adam" segment of the Sistine Chapel ceiling (Figure 165).

Rivera's link with the Italian masters is subtle and interesting. In the city of Sienna he studied one of the most memorable scenes from the Italian Renaissance, *The Journey of Aeneas Piccolomini* by the Italian master Pinturicchio (peen-too-rick´-ee-oh) (Figure 166). In Rivera's mural at the Palace of Cortez in Cuernavaca there is a brilliantly painted, heartbreaking scene of the tortures that Indians suffered at the hands of the Spanish Conquistadors. But our eyes don't focus on this part of the scene at first. In the foreground Rivera has painted the figure of Zapata standing by his magnificent white horse (Figure 167). This horse demands our first attention. Now look closely at the Pinturicchio painting. In the background a storm is ending. In the middle ground is action and activity, but the horse and the young man in the foreground attract our attention. This young man's obvious well-being contrasts with the heavy bearing of the other plodding travelers and their beasts. The artist wanted us to rejoice in young Aeneas' voyage and his future. The horse is so delicately drawn that for hundreds of years critics have

Figure 166. *The Journey of Aeneas Piccolomini,* **by Pinturicchio, and perhaps Raphael.** Bernardino di Betto Pinturicchio, Umbrian. c. 1454-1513. *The Journey of Aeneas Piccolomini.* Fresco, from *Scenes from the Life of Aeneas Sylvius Piccolomini,* in the Piccolomini Library of Siena Cathedral. Alinari/Art Resource/New York.

claimed that it could only have been done by the great artist Raphael. Actually, as a young man Raphael went to Sienna as an apprentice to Pinturicchio, and it is highly likely that this horse *was* painted by Raphael.

231

Figure 167. *Emiliano Zapata*, **lithographed detail from mural at the Palace of Cortez at Cuernavaca by Diego Rivera.** Diego Rivera, *Emiliano Zapata*, 1932. Lithograph. Giraudon/Art Resource, New York.

The young man in the Pinturicchio-Raphael painting was beginning a blessed voyage to Rome where he would later become Pope Pius II. Consider the similar composition in Rivera's mural and Rivera's knowledge of Italian art. What does the similarity tell us about Rivera's feelings about Emiliano Zapata?

Throughout his life Rivera spent thousands of hours studying, collecting, and making drawings of ancient Mexican art objects. In fact, Rivera and his fellow Mexican muralists helped the country rediscover its soul and take great pride in the history of its art.

Figure 168. Mural at the National Palace in Mexico City, by Rivera.
Diego Rivera, *History of Mexico*, 1935. Fresco. Mural in the Presidential Palace, National Palace, Mexico City. Bryant/Art Resource, New York.

Rivera's murals for the National Palace in Mexico City (Figure 168) reconstruct the history of Mexico from the ancient civilizations to his time. Critics agree that this is Rivera's outstanding achievement. These murals present a rich picture of the Mexican land and its people—their labors, festivals, lifestyles, struggles, aspirations, and dreams. The work is so monumental that it is impossible to reproduce its effect on paper. We can appreciate this terribly difficult achievement best by the description of the work Rivera did to accomplish this project. The following description summarizes the reactions of a friend who daily watched Rivera put all of Mexico on a wall at the National Palace.

The work is done in **fresco.** Fresco is one of the most exacting methods of painting. Powdered pigments are mixed with water and painted onto fresh-laid plaster *while the plaster is still wet.* Because of this method, the fresco becomes a part of the wall itself, and in dry climates will endure as long as the wall stands.

After perfecting his sketches on paper, Rivera put them on the great surface of the wall with red chalk or charcoal. Assistants traced this sketch on transparent tracing paper and ran a perforating wheel over these lines to make a stencil. Each morning, after the new plaster had dried to its proper degree of wetness, the assistants would awaken Rivera—usually around dawn. The new plaster would remain at the proper degree of wetness for a period of from six to twelve hours, depending on the humidity of the day. During that limited time Rivera had to complete the portion his assistants had prepared for him. So each day he would mount his scaffold, start with black for the modeling of the figures, then paint the fresh brush strokes of color, following the requirements of the design. He changed and recomposed as he went along. He worked all day if the conditions permitted. He strained his eyes into the fading early evening light, not daring to use artificial light for fear his color values would change. At last he would descend from his scaffold. Did he go home? No. He then would stand squinting, straining his eyes in the approaching darkness. What could he possibly see? His friend, observing, could no longer make anything out. Rivera would again advance to the scaffold—a stroke here, a deepening of color there, a slight alteration of line or form. Down and up he would go, for there would be no tomorrow for Rivera with that portion of the mural.

What motivates an artist to work with such passion? In the words of Rivera's fellow muralist José Clemente Orozco (Oh-rose´-koh), "Mural painting is the highest form of painting. It is also the least selfish, for it cannot be turned into an object of personal gain or be hidden for the enjoyment of the privileged few. It is for the people. It is for everyone."

PAINTING ACTIVITIES

1. You have drawn a posed figure from observation. Painting a posed figure offers another challenge.

As you begin your sketches of the posed figure, remember to look for the positioning of the weight and the movement of line through the figure. Select your best sketch. Use

a soft brush and thinned paint to block in the selected pose. Select your colors, and begin painting. Work all over the composition, putting a thin wash of color down first. Study the arrangement of the basic color placement and decide if it holds together or needs some adjustment. When you are satisfied that you have a well-balanced composition that leads your eye over the entire painting, continue to develop the color, forms, and textures.

2. Daily sketching can provide constant practice in drawing and a rich source of ideas for landscapes. Take a small sketchbook with you as you walk. When you observe interesting places or scenes in community take rapid "visual" notes (sketches) and keep notes on color and mood.

You may wish to diagram the compositional features of *American Gothic* as you did in studying *The Gulf Stream*. (See page 157) Notice that one has deeper space than the other, and both reflect a personal interpretation of their subject using visual qualities and compositional principles. Search your sketchbook for ideas for a landscape. Select, combine, or rearrange ideas and images. Create a composite design on the support surface (paper or cardboard, for example). Render your design in color. Keep the mood or expressive quality you wish to achieve in mind as you work.

Figure 169. Student art.

3. Watercolor is an excellent choice for achieving expressive qualities of a posed figure. In this activity you will use watercolor to paint a posed figure which expresses a definitive mood. Return to your file of drawings of posed figures. Study the different poses and attitudes you have gathered.

a. Make quick interpretations of figures in active poses using one color. Work toward achieving form by varying the intensity of color. Try two colors on the same brush.

b. Repeat activity **a** using different techniques for applying watercolor.

c. Do a complete painting of a posed figure in watercolor. Include the suggestion of a background.

Remember that you put the lighter tints down first and work toward darker ones. Don't forget that to achieve clarity you may have to let one wash dry before applying the next.

4. We have studied the painting of an important mural by Diego Rivera. In this activity you will participate in painting a mural. One of the basic ways that very large paintings

Figure 170. Student art.

such as murals are begun is first to prepare what is known as a cartoon. This is not the kind of cartoon you find on the comic pages of your newspaper. **Cartoon,** in this context, means a small scale drawing or rendering of what the larger picture is to look like when it is completed.

Murals usually tell a story, sometimes a story with social significance. Discuss some issues in class that concern your community, your state, or even the nation. Before going further, look again at the illustrations of Rivera's work and other examples of murals your teacher may show to the class. Notice that artists have to fit all of the parts together, even if they have to go around a door or windows. If the area to be covered is very large, the artist may not be able to work on one section and see the whole painting at the same time. However, this problem can be solved.

■ *Step 1.* Select a real or imaginary location for your mural and measure its dimensions carefully in feet or yards.

■ *Step 2.* Reproduce the shape (area) that your mural is to fit on a reduced scale. The scale should be small enough to cut from a sheet of drawing paper or craft paper. For example, if the wall for the mural is 20 feet long by 10 feet high, reduce the measurement to 20 inches by 10 inches. In this example, one inch equals one foot.

■ *Step 3.* Do your sketches as black line drawings on the paper you have cut. Continue until you are satisfied with the sketch you wish to use.

■ *Step 4.* Draw a one-inch grid on the sketch you have selected, and a one-foot grid on the wall to be painted.

At this point, the class should select the sketch that will be used for the actual mural. Keep in mind these points:

 a. The sketch must have a well-defined linear quality.

 b. The image must fit the space selected—square, rectangular, round, etc.

 c. The image should fill the space with very little, if any, background showing.

■ *Step 5.* With your teacher's approval and under her or his supervision, transfer the lines that appear in each one-inch space of the cartoon to the corresponding one-foot space on the wall. This should give you the enlargement of the cartoon. Next, paint the cartoon sketch. Finally, paint the mural, using the same color palette as was used in the cartoon.

5. Rembrandt often used his own image as the subject of a portrait. Use yourself as your subject. Decide how you want to dress for your self-portrait. As you pose before a mirror,

Figure 171A. Student art.　　　Figure 171B. Student art.

make a series of sketches of yourself using a light wash, a large piece of chalk, or a water marker. Overlap a series of these sketches. You might paint the shapes and spaces as they are created by the overlapping. Add the final details of clothing and background after your composition is blocked in with color.

SCULPTURE

Ancient Mexican Sculpture

Sculpture, because of the materials used, has generally survived longer than any other form of expression. Sculpted objects are the most ancient relics we have. We can therefore learn more about historical communities by studying their sculpture than any other source.

Almost three thousand years ago, Mexican artists of the Tlatilco (tla-teel´koh) culture created a host of charming and often humorous figures. Women played an important role in

238

Figure 172. This figure by an unknown Tlatilco artist may have had a religious function.
Tlatilco, North America. Middle America, Mexico, Federal District (Valley of Mexico). *Female Figure*. 1150–550 B.C. Ceramic, paint. Dallas Museum of Art, General Acquistions Fund.

Figure 173. The "jaguar mouth" is seen in many Olmec works. Olmec. North America. Middle America, Mexico, Veracruz, Arroyo Pesquero. Mask. 800-400 B.C. Jadeite. Height 7 1/8", width 6 9/16" diameter 4". Dallas Museum of Art. Gift of Mr. and Mrs Eugene McDermott, the McDermott Foundation and Mr. and Mrs. Algur H. Meadows and the Meadows Foundation, Inc.

Tlatilco society. Female figures, such as Figure 172, greatly outnumber the images made of males. They often wear elaborate hair styles or jewelry. These sculptures may have been created to be buried with deceased relatives.

The sculpture of the Olmecs runs the gamut from small, dwarflike figures to giant heads. While these figures have an abstract quality, the Olmec *Mask* (Figure 173) is intense and powerful. The "jaguar mouth" is characteristic of Olmec

239

Figure 174. An ancient figurine of an infant crawling (Mexico, Central Highlands).
Olmec style, Middle Preclassic, 1000-500 B.C. *Hollow Crawling Baby*. Buff earthenware with red paint and traces of white slip. Height: 6 1/4″. Length: 8 1/4″. The Saint Louis Art Museum. Gift of Morton D. May.

sculpture—the upper teeth are bared; the corners of the mouth are drawn downward. This same mouth can be found on the fascinating and mysterious Olmec giant heads which you can read about on page A-6 in the history appendix. In their man-child figures (Figure 174), the artist combined the real with the mysterious. These little men with chubby, babylike bodies and poses are the product of a highly imaginative people.

Ancient Egyptian Sculpture

Queen and Hairdresser (Figure 175) is a sunk relief sculpture from Egypt dating back to about 2050 B.C. In raised relief the background is cut away and the figure stands out. In **sunk relief** the figure is "sunk" into the background, which is left untouched. In the brilliant light of Egypt, sunk relief had a more dramatic effect than raised relief.

Queen and Hairdresser is a fragment. It came from the underground tomb chamber of Queen Neferu at Thebes. In the sculpture the queen is attended by her hair dresser, who is attaching an artificial braid. Just in front of the braid being attached is another lock, which is pinned up out of the way until the new braid is in place. Notice that the profiles of both the queen and her hairdresser are almost identical. That is because they are not meant to represent real individuals. Instead, they represent

Figure 175. This fragment of a carving from the tomb of an Egyptian queen is about 4000 years old. *Queen and Hairdresser.* Thebes, Early Middle Kingdom, Eleventh Dynasty. c. 2050 B.C. Limestone with traces of paint. Height 7 1/2″. The Brooklyn Museum, Charles Edwin Wilbur Fund.

the female face considered to be the ideal at the time. The women have full lips, a prominent nose with strong nostrils, slanting ears, and dramatic eyes.

Which portrait tells you more about its subject, the Wyeth painting *Children's Doctor* or the *Queen and Hairdresser* sculpture? Or do these works tell you different things?

The Great Sphinx (sfinks) appears mighty and solid, immovable and calm (Figure 176). It is taller than a twenty-story building. Its size is truly awesome and communicates to the Egyptians that their rulers were great and powerful gods. Try to imagine its impact.

The *Great Sphinx* is a sculptured mountain which guards the pyramids at Giza (gee´-za, with a hard "g"). It was formed from a natural rocky outcrop that remained from a quarry. That quarry was used to create the great pyramid of Cheops (key´-ops). The constructors, who wanted to honor King Cephron (sef´-ron), decided to use this huge remaining outcropping as something different from the standard pyramid. They also created a huge pyramid in which Cephron is entombed nearby.

Figure 176. *The Great Sphinx* **at Giza, Egypt.** Egypt: Old Kingdom. *The Great Sphinx*. c. 2600 B.C. Quarry rock. 66′ x 240′ x 13 1/2′. Giza, Egypt. Courtesy The Granger Collection, New York.

The human-headed lion represents Cephron as both king and sun-god. The face was intended to resemble the face of Cephron. The body was covered with painted plaster and gilded to make it look like the coat of a lion. The paws were carved separately and added on. Nestled between these gigantic paws is a small temple dedicated to—guess who?

African Sculpture

African sculpture often served important functions. Many examples related to a society's beliefs and customs and reminded people of society's values.

Look at the Baluba-Shankadi (bah-looh´-bah shahn-kah´dee) figure (Figure 177). It is a wood carving of a man

Figure 177. Wood carving, *Baluba-Shankadi Figure*, with the cascade hairstyle. Artist unknown. *Baluba-Shankadi Figure: Man Holding a Pipe*. Wood carving. 6 1/2″ high. Courtesy of the Trustees of the British Museum, The Museum of Mankind.

holding a pipe made from a gourd. What feature of this work is most intriguing? Perhaps it is the exaggerated cascading hairstyle. In many parts of Africa, hairstyles indicated a person's status or role in society. Sometimes these hairstyles were so elaborate that pieces of thin wood or reed were woven into them to help support them. Intricate combs and pins might also be used.

Small wooden pillows or neck rests were created to be used when sleeping or resting in order to protect these elaborate hairstyles. The Baluba-Shankadi carvings that show the cascade hairstyle are famous for their sculptural quality.

SCULPTURE ACTIVITIES

1. In this activity you will create a wire sculpture based on one of your gesture drawing sketches. Look back at your gesture drawing sketches or do additional sketches of people or animals in action poses. Select one sketch. Think of the lines of the gesture drawing becoming a strand of wire. Try to imagine what the finished product will look like from all sides. Think of the flow of movement within the figure, its balance and attitude. The coils of wire should be fairly dense so that you get the feeling of a solid form without details.

Figure 178. Student art.

This will take more time and concentration to complete than your previous effort with wire sculpture. You may find that you need a supporting piece to hold the coils of the wire. If you do need this support, carefully consider how the support piece could be fashioned so that it adds to the overall design, or so that it detracts the least from the design.

2. The term **subtractive method** in sculpture means that the artist takes away material from a solid block. For your first experience in this method, you will use a composite material that your teacher supplies. Of course it will not have the gleam and texture of stone or metal, but the actual design problems it presents are the same. Look at some photographs of sculpture in this book. Photographs cannot give you the overall impact that you would get if you actually could view the sculpture. Can you imagine from the photographs how each piece might look from another angle? Which examples in the text are not carved? Of these, can you determine what tools the artist may have used? Select a piece. Does the piece serve a purpose other than introducing beauty? If so, what do you think it may have been?

Look at the block of material in front of you. Does its shape or color suggest an image to you? Turn it around and upside down several times as you look at it. Do the size or the physical properties of the material suggest any limitations on your subject?

Figure 179. Student art.

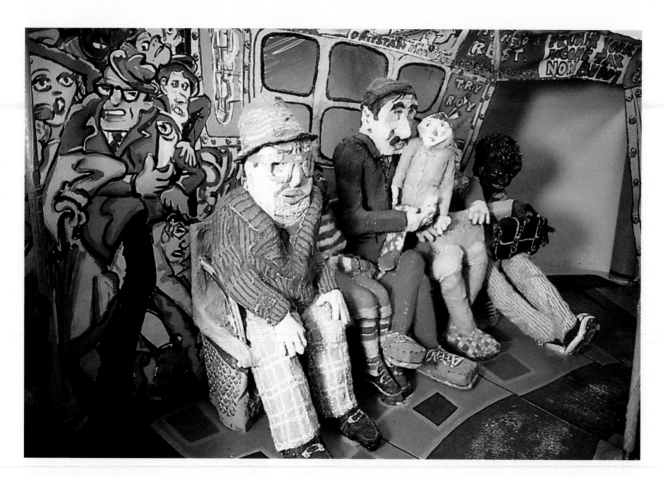

Figure 180. A detail from Red Grooms' *Ruckus Manhattan Subway.*
Red Grooms' *Ruckus Manhattan Subway* (detail), 1975-76. Mixed media, 9' x 18'7" x 37 1/2'. Courtesy Marlborough Gallery, New York.

On a large sheet of paper draw several views of your block. Try sketching what the finished sculpture might look like from several viewpoints. Remember that you cannot add to this block; you can only take parts of it away. Sketch the general outline of what you want to do directly on all sides of the block. As you begin to carve the parts away, turn the block often so that you are working and thinking about the whole form. Take only a small amount away at a time. When you have sculpted the basic form, think about details and textures. The wise sculptor knows when to stop.

3. Some contemporary artists use unusual material for their sculpture. Take a look at a work by Red Grooms (Figure 180) and notice that he uses *very* different materials. He has used, adapted, and changed objects such as pre-made forms, old wood, cardboard, and barrel tops. This artist has used *additive methods* in most of his three-dimensional work. That is, he has created his composition by adding material.

Grooms depends a great deal on the use of color and texture to assist the movement, balance, and unity of his work.

Figure 181. Student art.

It is alive with color and wildly celebrates the everyday life of people. His work is painted in bright, sometimes fluorescent colors and often moves to the sound of recorded sound effects.

The entire class will contribute to this sculpture, which is based on found objects. It may be as large or as small as the group wishes. Decide on a theme and size first. Then collect some forms that will suit the planned theme and size. Try several arrangements of the forms. Do quick sketches of each arrangement to determine the most satisfactory one. Consider what you might need to add to give the composition an exciting, expressive quality. Remember to think about the visual qualities that will contribute to the balance and unity of the whole.

4. Louise Nevelson is an important artist who uses pieces of wood in many shapes and sizes to create beautiful relief sculpture. Her sculpture entitled *Dawn's Wedding Feast* (Figure 182) is one example of Nevelson's work. Look at it closely, and see the variety of pieces she used. Does she use exactly the same shape more than once? Sketch some of the unusual things she has done. Your sketches may help you to remember possibilities when you are out collecting wood pieces for your own sculpture. First, take a look around your own home for old wooden things that are no longer used, such as toys, blocks, picture frames, and dowels. What other sources can you think of? Is there a cabinet shop or furniture manufacturer nearby? Is someone constructing a house or building nearby? If pieces are too large, they might be cut into small pieces for your project.

You may want to make a free-standing piece or to attach your pieces of wood to a backboard. Your design will be like

CAUTION Be very careful in carving and pay close attention to your teacher's demonstration.

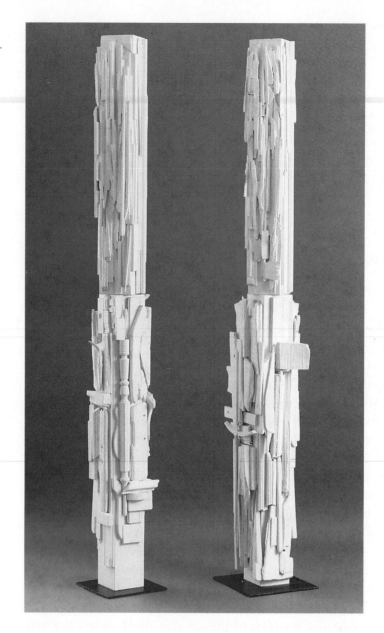

Figure 182. *Dawn's Wedding Feast,* **by Louise Nevelson.** Louise Nelson, *Dawn's Wedding Feast,* 1959. Painted wood. 94 1/8″ x 18″ and 94 3/8″ x 11″. The Menil Collection, Houston, Texas. Hickey-Robertson photograph.

a puzzle, but there are clues for putting it together. The practice activities you had on the compositional principles will help you now.

PHOTOGRAPHY

You have seen how painters and sculptors portray people. Now let us look at how photographers capture portraits on film.

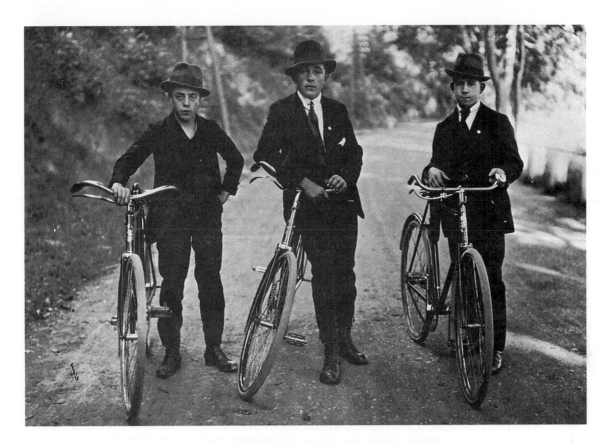

Figure 183. The three subjects in August Sander's *Bicyclists* confront the viewer.

August Sander. *Bicyclists, Westerwald*. 1922. Photograph. Copyright © by Aperture, a division of Silver Mountain Foundation, Inc., as published in *August Sander/The Aperture History of Photography Series*. Aperture, New York, N.Y., 1977.

August Sander's Universal Types

The photograph, *Bicyclists* (Figure 183), brings us abruptly face to face with three young men on a country road. The artist, August Sander, traveled around his country, Germany, looking for faces to photograph. His photographs skillfully unveil the private person in the public face. He has brought us up close to the bicyclists by cropping (cutting off) the photograph so that there is very little foreground between them and us. We are forced to confront them.

What are these three bicyclists telling us about themselves as they stop to pose for a picture? Is there a leader in the group? Who is he and why do you think he is the leader?

What do you learn from observing the attitudes of the bodies? The positions of the hands? The hats? And, of course, the facial expressions?

These young men are trying to convince us that they are self-assured and persons to be reckoned with. Although

249

they are dressed as grown men, they are trying too hard. The expression on each face is similar. As we look at the photograph, the three faces begin to merge into one personality.

Do you think each bicyclist would have the same expression on his face if he were traveling alone? Sander has created a tension between the subjects of the photograph and the viewer. The three boys seem to be daring us to take on their group. As viewers we try to separate the boys from the security of their "threeness" so that each stands alone.

The sharp detail in such Sander photographs as *Bicyclists* and *Unemployed* (Figure 184) encourages us to approach the subjects with an almost scientific curiosity. Indeed, Sander was seeking to photograph universal "types" of people. Therefore, he never listed the names of his subjects but rather their activities or occupations. What "type" of person is the man shown in *Unemployed?* Unlike the cocky youths portrayed in *Bicyclists,* he holds his hat humbly and low before him. He does not stand boldly in the middle of the road but off to the side of the street. He is out of the mainstream, no longer a part of the daily traffic. Compare his posture and facial expression to those of the young men. What differences do you find?

Imogen Cunningham
Breaks through the Mask

When Imogen Cunningham died at the age of ninety-three, she was still working, still taking photographs. Encouraged by her father to develop her talent, she became a portrait photographer at a time when there were few women in the profession.

As a photographer, Cunningham developed the art of "breaking through the mask" to portray the real person underneath. While working, she posed questions to her sitters about their lives in order to get the right expression. Suddenly came the moment of truth—the snap of the shutter reflected the moment of the artist's greatest concentration. The resulting unforgettable portraits are now a large collection.

In the 1970s she began a series of portraits of people over ninety years old. The photographs have much to tell about the tragedy and the triumph of the elderly. Take a look at four photographs from her remarkable collection.

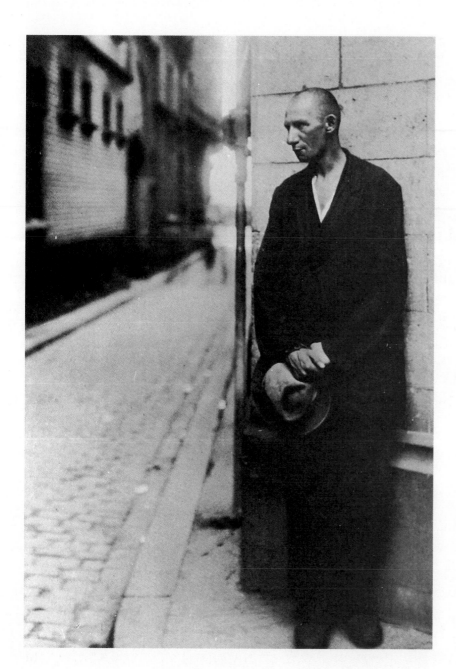

Figure 184. By contrast, the subject in Sander's *Unemployed* stands alone looking away from the viewer.
August Sander, *Unemployed,* Cologne, 1928. Photograph. Copyright © by Aperture, a division of Silver Mountain Foundation, Inc., as published in *August Sander/The Aperture History of Photography Series.* Aperture, New York, N.Y., 1977.

The first two photographs are of the sculptor John Roeder (Figures 185A and 185B). His hands tell everything. This man worked in an oil refinery, but as Cunningham said, "He was really an artist." Notice how the strong character is revealed in the lines of his hands and face. The second photograph of the two shows the sculptor standing beside one of his creations. Here the hands gently touch his proud upright child in a fatherly way.

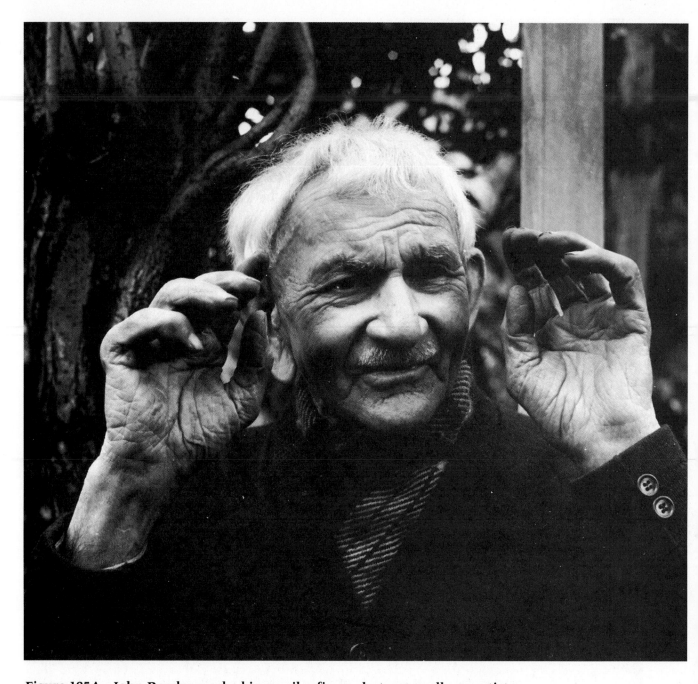

Figure 185A. John Roeder worked in an oil refinery, but was really an artist.
Imogen Cunningham. *John Roeder*. Photograph, 1975. Courtesy the Imogen Cunningham trust. Photograph. © 1977, Imogen Cunningham.

Figure 185C is a woman in a senior-citizens home. The world has forgotten about her, but she has seen much and has survived. Her face tells us she will continue to survive.

The title of Figure 185D is *The Three Ages of Woman, on Fillmore Street*. In this photograph are childhood innocence,

Figure 185B. Here is Roeder with one of his sculptures. Imogen Cunningham. *John Roeder with One of His Sculptures*. Photograph, 1975. Courtesy the Imogen Cunningham trust. Photograph. © 1977, Imogen Cunningham.

Figure 185C. *She said to me, "When you come here, nobody knows where you are."*
Imogen Cunningham. *She said to me, "When you come here, nobody knows where you are."* Photograph, 1975. Courtesy the Imogen Cunningham trust. Photograph. © 1977, Imogen Cunningham.

Figure 185D. *The Three Ages of Woman, on Fillmore Street.* **Which age dominates the composition?** Imogen Cunningham. *The Three Ages of Woman, on Fillmore Street*. Photograph, 1975. Courtesy the Imogen Cunningham trust. Photograph. © 1977, Imogen Cunningham.

motherhood, and old age. In front a frail elderly woman, still full of life, dominates the scene. The lines on her face, her powerful gaze into the lens, and the background tree command our respect and attention. The pleasant mother and child, perhaps her daughter and granddaughter, are in the background, like an achievement that is behind her.

PHOTOGRAPHY ACTIVITIES

1. Water can be an interesting photographic subject. Water can reflect, magnify, reduce, and distort. Try to take a photograph that has water as the main component. Look for water in various locations in your community—on your window or windshield, on the street in a puddle, in a sprinkler, in a fishbowl or aquarium, in a pool, on the shore, on a leaf, or on a person wearing a shiny raincoat.

Try a variety of shots. For example, you might try shooting a droplet of water up close or reflections in a puddle of water. Show your photographs to the class. Discuss your reactions to photographing water. Did you find it interesting? Difficult? Explain why. From your experience, do you have some idea of why artists like Winslow Homer often use water in their paintings?

2. Sometimes a film negative looks more dramatic and interesting than its positive paper print. An example appears as Figure 186. To make a print of a negative image you must make a reverse or **negative print.** For this process you use a normal prewashed positive print as a paper negative, contact printing it to a fresh (unexposed) wet sheet of photographic paper.

Place the wet positive print face up on a sheet of glass (with the glass edges taped for safety). Next, place the wet unexposed sheet of enlarging paper on top of the positive print, face to face, or emulsion to emulsion. Hold papers with one hand and with your other hand quickly squeegee the two together with a window squeegee to force out air bubbles and therefore make better contact.

Figure 186. This is a negative print. Student art.

Have the enlarger set up for contact printing (using its largest aperture at a higher height). If you do not have an enlarger, a light bulb will work. Quickly place the glass and paper "sandwich," glass side up, on the baseboard of the enlarger (or on the table under the light source). Do not use an easel. Wipe off the glass with a towel. Work quickly, as prints tend to separate. Expose the "sandwich" from one to six seconds. The light passes through the positive print, exposing the negative one. Peel apart and process normally the reversed or negative image.

3. Grant Wood photographed his Gothic house before he painted it. He had captured something special. Take a series of photographs of buildings with "character" in your community. Look for buildings with unusual details such as Gothic windows. These details can serve as a theme. Figure 187 shows one student's photograph of such a building.

Figure 187. Remember you are to photograph buildings of character; look for details. Student art.

On a separate piece of paper, prepare a series of sketches of the buildings you photographed. Make a drawing by selecting several components from your sketches. Repeat shapes as Wood did in the sloping shoulders of his farmer and slanted gables of the house. Do the styles of the buildings in your photos suggest anything about the people who inhabit them or anything about your community?

4. Set up and take a photographic portrait. Plan this portrait to show as much as possible about the subject. For example, what is the subject's special interest? Is the person gentle, active, serious? What is the typical body language of your subject? Create a portrait that will reflect the individuality and capture the personality of your subject. Move your model around to see the face from different angles.

The background can also tell about a person. Experiment with different backgrounds, such as a landscape, windows, or

Figure 188. *Portrait Without Face*. **Student art.**

sky. As an alternative you might choose a simple background such as white cloth or cardboard covered with foil. Try taking outdoor and indoor exposures. Expose at least one roll of film on your portrait subject.

Examine your portrait prints. Which portrait do you like best? Why? Which portrait does your subject like best? Why?

5. Many painted and photographic portraits have a face as the center of interest, but in this assignment no faces will be visible. Your subjects will wear masks, helmets, umbrellas, or hats. Be sure that you don't photograph the person's face or reveal his or her identity.

This assignment can also be accomplished by lighting the subject from behind or in silhouette (as in Figure 188). Set up and take an interesting portrait without relying on the face to create the interest for the composition.

ARCHITECTURE

Shelter is one of the basic needs. For ancient civilizations the problem was a serious one—to find and invent ways to

"put a roof over their heads." Shelter took many forms and depended a great deal on the materials available close by. Through the centuries, as small communities became increasingly larger, architecture became an art form.

Gothic Architecture

In our study of Grant Wood's *American Gothic* we found the Gothic arch of great importance in the painting. The story of Gothic architecture is one of the most interesting and important stories in art history.

For many centuries walls were the sole support of roofs. Thick pillars were hidden in walls to help support heavier and heavier roofs as people created larger and taller buildings. In general, the rule was that the larger the building, the thicker and sturdier the supporting walls had to be. It is easy to see that windows and doors subtracted from the support a wall could give a roof, so there were few of these. As a result, large buildings were quite dark, and long expanses of wall space were common. In great public buildings such as churches, these long wall expanses were perfect places for decoration, and the huge walls were filled with murals or other forms of decoration.

In the twelfth century architecture was revolutionized. Architects achieved remarkable advances which literally opened buildings up to light and allowed them to soar to breathtaking heights. This seemingly miraculous development was due to the invention of the ribbed vault, the pointed arch, and the flying buttress. The combination of these three innovations meant that the load of the roof was lightened. Furthermore, the load was redistributed from the walls themselves to piers, which were located *outside* the buildings. The resulting churches seemed a miracle—walls were mostly glass, and soaring vaults of roof seemed to be suspended in air. The old decorated dark walls gave way to stained glass. The beauty of the sun filtering into the church buildings through the stained glass was awe-inspiring.

You can see the **ribbed vaults** in Figure 189. The ribs distributed the roof's downward thrust evenly and also allowed the architects to use lighter material for the roof.

A simple way to think of buttresses is to imagine a run-down shed or barn learning heavily to one side. How would you prop (buttress) the building to keep it from collapsing in on its weakest wall? Buttresses had been used for centuries,

**Figure 189. View of the
Nave, *Chartres Cathedral*.
Note the ribbed vaults
above.**
Chartres Cathedral. c. 1194-1220. The
nave and the great organ. Chartres,
France. Courtesy The Granger
Collection, New York.

but they had always been pillars *inside* the walls. The **flying
buttress** is actually a half arch of stone that takes the pres-
sure of the downward thrust of the weight of the roof away
from and *over* the interior of the building. It places the load
on *outside* pier buttresses. With increasingly wider spans of
the flying buttresses, increasingly higher roofs became possi-
ble. Look at Figure 190 of the Cathedral of Notre Dame. The
flying buttresses are easy to see from this angle.

The engineering and the mathematics on which Gothic
architecture is based are as fascinating as the results are
stunning. Much has been written on Gothic architecture,
and you may want to research this field. If you do, and you
enjoy it, you might consider architecture as a possible
career.

Figure 190. *Notre Dame Cathedral* **from the southeast. Note the flying buttresses.**
Notre Dame Cathedral, Paris. c. 1200-1250. Scala/Art Resource.

As Gothic architecture began to flourish in northern Europe, Buddist and Hindu artists were shaping temples in the Far East.

The Great Temple

The great temple of Angkor Vat (ang´-kore watt) in the jungle of northwest Cambodia is one of the most remarkable achievements of architecture and sculpture in the world. Look at Figure 191, which is a view of the complex. You will have to use your "mind's eye" to envision the immense size of Angkor Vat. The area enclosed by the moat is rectangular. One side of this rectangle is 5,000 feet long, and the other is 8,000 feet. The rectangle encloses an area of over 900 acres.

Figure 191. *Angkor Vat* **lay deserted and forgotten in the jungle for four hundred years.**
The Great Temple of Angkor Vat, 12th century. Cambodia. Courtesy The Granger Collection, New York.

This monumental project was created in the twelfth century by a people known as the Khmer (kuh-mer´). The temple flourished as the heart of its community and the home of the Hindu god Vishnu until it was sacked by enemies in the middle of the fifteenth century. After that, this forgotten masterpiece sat in its lonely splendor for four centuries, isolated in the vast Cambodian jungle. It was rediscovered by the French in 1861.

The principal building which you can see in the background is made up of a system of elaborate terraces. These terraces are approached by steep stairways opening onto sunken courtyards. The front of the building is 787 feet long. It is perfectly symmetrical. The superb handling of proportion gives it a feeling of grandeur. Every inch of space on the vast walls is covered with delicate, shallow relief carving. The outside walls are decorated with carvings of over 1,700 life-sized celestial dancers covering a space of over 7,000 feet. Unsurpassed for gracefulness, each displays what is now universally known as the "Angkor smile" which you can see in Figure 192.

This achievement, like the temple itself, is colossal. It is impossible to do it justice in photographs, diagrams, or writ-

263

**Figure 192. The serene "Angkor smile" is used throughout
Cambodian art.** *Detail of Central Towers of the Bayon*, Angkor Thom, Cambodia. Late
12th-early 13th century. Courtesy The Granger Collection, New York.

ten descriptions. Angkor Vat exists, and yet it is "the stuff
that dreams are made on."

Two Exposition Halls

The Crystal Palace was built in 1851 to celebrate the first
World Fair, the great exhibition in London. It was to be the
largest building in the world. At that time standard building
materials were stone and brick. It did not seem possible to
build such an immense structure, given the short time allot-
ted for completion and the building materials and construc-
tion methods then in use.

The architect who accepted this challenge was Joseph
Paxton, a man who had begun his career as a gardener.
Paxton became a self-taught architect, famous for his large,
airy greenhouses. Paxton was excited about the opportunity

Figure 193. Paxton had been famous for building greenhouses.
Joseph Paxton, architect. *The Crystal Palace*. Built in Hyde Park, London, 1851. Re-erected in Sydenham, 1852-1853. Destroyed by fire November 30, 1936. Late 19th century photograph. Courtesy The Granger Collection, New York.

to design the largest building in the world. He proposed a new assembly system to create the structure. In the construction he would use cast-iron posts, which were more fire resistant and took up less space than wooden posts. Paxton designed a huge cast-iron skeleton made from prefabricated elements. This held the glass panels, which were of standard four-foot lengths. It was an enormous transparent box, like a giant greenhouse over 1,600 feet long, and was, indeed, the largest building ever built (Figure 193).

In such a structure, there would be unforeseen problems. One of interest was the problem of the English sparrows. The building contained trees and attracted the sparrows, who were not housebroken. It was really no laughing matter, as the birds obviously could not be shot in the Crystal Palace. Finally, the queen herself was consulted, and she said, "Send for the Duke of Wellington!" Wellington had defeated Napoleon at Waterloo. When informed of the problem, the Duke said, "Send for the sparrowhawks, Ma'am." Once more Wellington was victorious.

The success of the Crystal Palace was of great significance. It was the first broad use of standardized, prefabricated parts and marked the beginning of modern building tech-

nologies. Equally important was the fact that construction took only six months.

Sophia Hayden was only twenty-two years old when she entered the competition to design the Women's Building for the *Chicago World's* Columbian Exposition which was held in 1893. Hayden was the first female graduate of the Massachusetts Institute of Technology's school of architecture. The competition was limited to women, for the sponsors believed that this building should be entirely a women's project. Hayden won the competition.

Until that time, architecture had been an exclusively male domain. There was a great deal of hostility from male architects toward any woman who aspired to excel in the field. Such hostility was especially noticeable in the case of young Sophia Hayden. She received the smallest amount of money allocated for any project at the exposition, and faced constant quibbling and interference from the all-male board of architects who oversaw the entire project.

Despite these distractions, Hayden's building was the first one completed for the exposition. She received an artist's medal for the classical architecture of the building. You may note the harmony of the Greek columns, the Roman arches, and the implied arch of the glass enclosure. Figure 194 shows an interior view. It proved to be Hayden's first and only work. She died shortly after its completion.

Figure 194. *Interior View of Woman's Building,* **World's Columbian Exposition, 1893. The far wall held Cassatt's mural.**
Sophia Hayden, architect. *Interior View of Woman's Building,* World's Columbian Exposition, 1893; looking south to tympanum decorated by Mary Cassatt. Courtesy of the Chicago Historical Society.

A Warrior Fortress—The White Heron

A warrior class called **samurai** existed in Japan in the sixteenth century. The samurai were proud men who lived by a strict code. They served the feudal lords who ruled the various regions of Japan. Samurai served their master to the death if necessary; to die in battle was the greatest honor samurai could achieve.

Himeji Castle was a fortress inhabited by a feudal lord named Daimyo of the small town Himeji (hi-meh´-gee), near the city of Osaka (Figure 195). It is the largest and best preserved example of military architecture in Japan today. Construction started in 1346, and the castle has been altered several times over the centuries. Today, there remain thirty-seven buildings dispersed within four enclosures. Himeji Castle is of wood construction reinforced by masonry on a massive stone foundation. The buildings rise several stories with a series of diminishing roof orders. Four towers are joined by narrow passages with turrets, and sixteen gates control movement in and out of various areas of the complex.

Figure 195. *Himeji Castle.* **Can you see why it is known as "White Heron"?**
Himeji Castle, in southern Honshu, Japan. Begun in 1346. Ogawa Taisuke, Shinkenchiku-sha, Tokyo. Courtesy The Granger Collection, New York.

Himeji Castle is known as the "White Heron" because its shape appears to resemble a huge white heron about to take flight. Such a dramatic shape hovering over a town would serve to remind potential enemies that the Daimyo and his samurai warriors were constantly alert.

ARCHITECTURE ACTIVITY

1. Look closely at the photograph (page 167) of the house Grant Wood used as a model for the house in *American Gothic*. Compare this house to the "Carpenter Gothic" in the lithograph on page 165. What do you notice about the upstairs window treatment? That's right, one has a Gothic style window and the other a rectangular style. The Gothic pointed arch here serves no purpose other than that of a decorative touch. In fact, the Gothic style window may have a drawback compared to the standard window that we see in the lithograph. Can you think of what this drawback might be?

Now, look again at Frank Lloyd Wright's *Falling Water* (page 138). Wright believed, as you will recall, that "form follows function," and a building's design should flow naturally from its use or purpose.

For this activity, adopt Wright's view that form should strictly follow function. Study several buildings in your community and elsewhere, evaluating how well their form suits their function. Keep a written record of what you observe over a period of a week. Decide which examples you believe do have a form that follows function and those that you think do not.

After you have made your collection, analyze each example. Think carefully about the use and purpose of each of the buildings in your collection. A bank building, for example, may look much like a Greek or Roman public building. Why? A comparatively new church may be built in the Gothic style, but without flying buttresses or other construction features of the Gothic period. Why was it designed to look Gothic? Why do you think the architects (and those who commissioned them) chose these styles? If

you think carefully about this, some of your initial reactions may change. Discuss your findings with other class members who have done the same exercise.

CRAFTS

In Part I you studied examples of several craft media inspired by nature. This Part, "The Artist and the Community," discusses a number of crafts which are either useful to the community or created as community projects (for example, quiltmaking).

Baskets for Food Gatherers

Our first example is a type of basket generally considered to be among the finest ever produced. These baskets were produced by Native Americans in California. There were several small groups known collectively as the Mission Indians because they settled around the Spanish missions. West of the desert and the Sierra Nevada mountains, they were protected from violent weather changes. This locale also kept them isolated from outside influences for a long time.

Because of the mild climate and abundant food, the Mission Indians did not practice agriculture, but gathered their food, for which they needed baskets of many shapes and sizes.

The image of the snake looks real in *Shallow Coiled Basket* (Figure 196). The artist has strengthened the design by emphasizing the geometric shapes of the diamonds along the back of the snake. Notice that the snake does not make a complete circle. This is not a sleeping snake. Its head, with eyes wide open, moves toward the center of the basket; the tail has its rattles raised. Might the snake be viewing a small creature scurrying downwards from the center of the circle as a meal?

Quilts

One craft at which Americans excel is quiltmaking. The dictionary defines the word *quilt* as "a bed cover of two layers filled with down, cotton or wool and held in place by stitched designs." The Egyptians, Chinese, and Turkish used quilted materials for warmth. In the fifteenth century,

Figure 196. *Shallow Coiled Basket*, **created by Mission Indians in California.** Mission Indians, California. *Shallow Coiled Basket*. c. 1000 A.D. Native plant fiber. Diameter 14 1/2″. Denver Art Museum, Colorado.

Europeans used quilted undergarments. Although quilting is found in many areas of the world, Americans developed the art of quilting.

The American tradition of quilting began in the early eighteenth century as pioneer women sought ways to keep their families warm. Later, particular groups of people and specific areas of the country have become well known for certain quilt patterns. Some of these are the log cabin, the double ring, the nine-square, the Texas Star, and the crazy quilt. People, such as those portrayed in *American Gothic,* were hardworking and thrifty. They saved many things to be used over and over again. Scraps from dressmaking, usable parts of worn clothing, and flour sacks are among the fabric pieces they saved to turn into quilts or throw rugs. When a quilt was designed, one motif was often repeated many times until the quilt became the desired size. Generally, the

Figure 197. As in most handmade pieces, there are slight variations in length and width.
The *George W. Yarrall Spectrum Quilt*. c. 1935. 78 1/2" x 90 3/4". Courtesy the Kentucky Museum, Western Kentucky University, Bowling Green, Kentucky.

top of the quilt (the decorated side) was placed over a backing of combed cotton and a solid colored bottom was attached. Then the whole thing was sewn through with an intricate pattern of very small stitches. This operation sometimes took months and was usually done in the winter, when other chores were completed, or at night after work.

Until recently, quilting was almost exclusively a female pursuit. Today, however, both men and women enjoy quilting.

The quilt *Spectrum* (Figure 197) is made of pieced percale, a fine, smooth, closely woven cotton cloth, by George W. Yarrall in 1935. Yarrall was an engraver for a jewelry company. It is believed that he worked on the quilt to keep his fingers nimble and limber for working on the delicate jewelry he produced. The quilt became an obsession with Yarrall. It took him two and a half years to complete it, and he used 66,153 pieces of percale fabric.

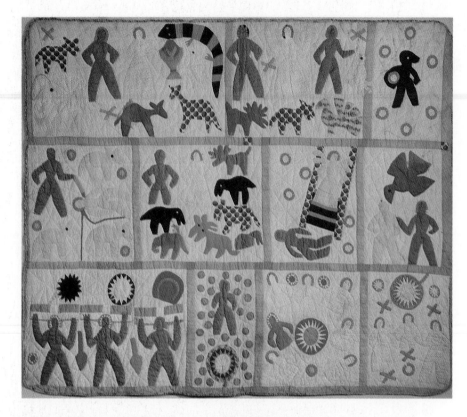

Figure 198. A remarkable example of fine detail work. Harriet Powers, *Biblical Themes Quilt*. c. 1886. Appliqué and piece work. 70" x 64". National Museum of American History, Smithsonian Institution, Washington, D.C.

The arrangement of colors in *Spectrum* creates an illusion of movement and vibration. This effect is achieved by the use of complementary color combinations distributed in small touches throughout the surface of the quilt.

The *Biblical Themes* quilt was made by Harriet Powers, an ex-slave from Georgia (Figure 198). It was made about 1886 of applique (ap- li- kay') and piece work. **Appliqué** is cutout decoration of a material laid out on, and fastened to, a larger piece of material. The fine detail work makes the quilt one of museum quality. *Biblical Themes* quilt depicts a number of scenes from biblical stories.

Puppets for Entertainment

Puppetry has provided pleasure and entertainment in America since Colonial days. This is, however, a very broad art form which has a heritage of more than 5,000 years. From ancient masks and dolls used in ceremonies to computerized, and even computer-generated creatures used in

recent movies, puppets come in many sizes and are made from many materials. The art of **puppetry** is the creation and manipulation of nonliving objects which give the illusion of life, in order to entertain an audience.

A common type of puppet is the hand puppet. Punch and Judy are classic European and American hand puppets. The bodies are generally made of cloth, and the heads are carved of wood, or molded of papier-mâché, plastic wood, or exotic—and toxic—materials including celastic and fiberglass. The puppeteer manipulates the figure by putting his hand inside the puppet.

There are many other types of puppets. Some are worked by strings from above or by rods from below. Other puppets may be worked on wheels, under water, or from a computer console. Some puppets the audience never even sees—only their shadows are seen through translucent screens.

Puppets are not limited to Europe and America. A popular form of Japanese puppetry is Bunraku (bun´-ra-koo), used to tell traditional tales of warriors (Figure 199), princesses, and magical creatures. While we generally think of puppeteers being concealed behind, below or above their puppet stages, the Bunraku puppeteers are not hidden. The audience can see them standing behind their puppets to manipulate them. In this traditional art form, three puppeteers work one puppet. The master puppeteer works the head and an arm. The other puppeteers manipulate the other arm and the feet. They are dressed in black, and two junior puppeteers wear black hoods. As a sign of his accomplishment, the master puppeteer goes without a hood. Musicians and narrators are placed at the side of the stage and perform their parts along with the puppets.

One unique form of this art is shadow puppetry. The audience never sees the puppets, only their shadows through a translucent screen. Shadow puppetry had its start in Asia and India, where it is still popular. A traditional Javanese puppet show tells epic tales and features adventure, battles, and even comedy. It can last twelve hours, from dusk until sunrise. Performed outdoors, it becomes a festive event. The audience often goes behind the screen to watch the show from backstage, or goes to visit with other audience members. The puppets (Figure 200) are made of tanned leather so thin that light (traditionally from an oil lamp) passes through the puppet and onto the screen. The puppeteers paint their puppets in beautiful colors in order to make colored shadows on the screen.

Figure 199. This warrior puppet is over four feet in height. Anonymous Japanese artist. *Bunraku Puppet*. 20th century. Wood with gold brocaded costume. 50" high. The Detroit Institute of Arts. Gift of Marjorie Batchelder McPharlin.

Figure 200. *Javanese Wajang Kulit Shadow Figure.* **The puppets are seen only in shadow.** *Male Figure Shadow Puppet.* Wayang Purva, Javanese. Late 19th century. Carved leather. Height: 23", including rod; width: 6". © The Detroit Institute of Art, 1990. Founders Society purchase, Paul McPharlin Memorial Fund.

Because the audience sees only light and shadow, shadow puppeteers can use many optical effects more common to the movies than to live theatre. Shadows can float above the "floor" of the screen. They can fade in and fade out for dream sequences of fantasy scenes. The shadows can grow big to fill the screen or so tiny as to almost disappear. Puppeteers achieve these effects by playing with the distances among the light source, the puppet, and the screen onto which the shadow is reflected.

CRAFT ACTIVITIES

1. Grant Wood told you something about the characters in *American Gothic* by dressing them as he did. Create people who tell a story through the kinds of clothes they wear. One way to do this is to make people collages. Obtain a supply of magazines, wallpaper, gift wrapping papers, doilies, and other kinds of interesting papers. On a large sheet of paper, draw an outline of a person. Continue by "dressing" the figure. Use the paper supply you have to cut out clothes for it. Think carefully about the person you are "dressing." Does this person like fancy, colorful clothes, or have simple taste? Might the person live on a farm and wear work clothes or work in an office and wear business clothes? Does the person like hats, boots, gloves? What will your choices tell about the person? Cut out clothes for this person and paste them on the outline figure. You might then want to add details such as facial features to the figure. When you are finished, you may play a guessing game with classmates. Ask them to guess what kind of person your figure is, based on what the person is wearing.

Be very care-
ful in cutting

CAUTION

2. Some artworks emphasize all-over pattern. An *all-over pattern* is one that covers an entire surface. In this case your surface will be fabric. One of the most important uses of pattern is in the designing of fabric. After you have reviewed with your teacher the idea of all-over pattern, experiment with ways of altering the weave of a small piece of burlap. Begin by using a pointed instrument. Alter the weave of the

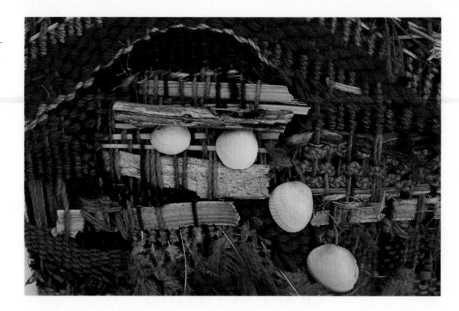

Figure 201. Student art.

Caution in using your pointed instrument.

fabric by pulling out threads and reinserting them in different places to produce an all-over pattern.

3. In this activity you will create a decorative woven wall hanging. The basic principle of weaving is the combining of linear materials using an over-under method. In other words, a linear material (such as yarn) is held in a vertical position while other linear materials are woven through it. The process you will use is known as **off-the-loom** weaving. (See Figure 201 for an example.) It is a process that can give beautiful results.

First you should determine the size of your finished piece. The project should be easy for you to handle and store, not more than about two feet in length and one foot in width.

Select a piece of wood such as a bar, a slat, a dowel, or a tree branch. Support it at a height that is comfortable for you to work with. Next, attach a series of threads to this wooden piece. The threads should all be of the same length as they hang down. These threads will be the **warp,** or the vertical strands, of your weaving.

The next step is to select the materials for weaving through the warp threads from one side to the other. These materials, which will comprise the horizontal part of the weaving, are called the **weft.** For weft materials you might consider yarns of various colors and textures, reeds, grasses, fabric torn in strips, or even paper. If your warp threads are

attached to a tree branch, other tree branches might make an especially attractive weft. In addition to these linear materials, you may want to add decorative items such as feathers, shells, buttons, or any found material that has a color and texture to complement your wall hanging. Such items can be tied to your warp threads. Tie the end of your weft yarn back into the warp whenever you wish to change your weft materials.

The handling of the weft material may become difficult as you are weaving, for the warp threads are loose. You may want to attach some form of weight to each warp thread at the bottom, or attach all of the warp threads to another wooden piece at the bottom.

Before you get close to the end of your weaving, plan how you will finish off the bottom. You may decide to leave a fringe, add another branch or wooden piece, or knot the warp thread into bundles. Choose whatever finishing touch you think makes your weaving interesting and attractive.

4. In this activity you will design and make a quilt from paper. It will be rather like putting a puzzle together. Decide on a geometric shape—square, triangle, rectangle, or trapezoid, for example—and draw a small one on cardboard. Cut it out. Using this as a pattern, cut 10 to 15 pieces each from several colors of construction paper.

Next, arrange these pieces in a formal design on a 10 by 10-inch square. You may not need all of the pieces, but each placed piece should be dealt with as if it were to be sewn to the next and placed on the background. When your square is arranged to your satisfaction, carefully glue each piece to the 10 by 10-inch background. You have now designed a quilt pattern. If you repeat this process 149 times, using cloth, and sew all the pieces together, you will have the top portion of your quilt.

5. Jewelry can be thought of as a form of sculpture that can be worn. To illustrate this concept, find a supply of art, craft, and museum magazines and mail order catalogs. (Your teacher may have collected a number.) Work with two or three classmates. Choose a kind of jewelry that interests you. It could be silver, ceramic, beaded, gold, or another type. Cut out pictures of jewelry made from your chosen medium. Make a collage of these pictures. When they are completed, discuss the collages with classmates. Are some pieces of jewelry more like sculpture than others? Why? What are some of the characteristics of sculpture?

Figure 202. Student art.

6. Make a piece of ceramic jewelry. Begin by making sketches of the piece you'd like to make. For ideas refer to illustrations of jewelry in craft magazines, mail order catalogs, and other sources.

Next, prepare a piece of firing clay about the size of an orange. Look at your sketches. Decide how many parts your piece of jewelry will have. How will you connect them? On a wire? On a string? On leather? What size holes are needed? (Plan for some shrinkage when the clay is fired.) Could you use different colors of clay? How about stains? You might want to paint the pieces with tempera or acrylic paints. You might even consider incorporating other types of materials after the firing, such as feathers, string, wooden beads, plastic pieces, or found objects.

Finish forming and connecting the clay pieces for firing. Then collect all the components of your piece of jewelry and assemble them. Model your jewelry or get someone else to put it on so that you can see how it looks.

PRINTMAKING

Many artists are printmakers. A **print** is a work of art that can be produced in multiple copies by stamping, pressing, or squeezing paint or ink through a stenciled shape.

Figure 203. *Poverty*, **a lithograph by Kaethe Kollwitz, dramatized the problems of weavers in the Industrial Revolution.** Kaethe Kollwitz, *Poverty*, 1897. Lithograph. 6″ x 6″. The Philadelphia Museum of Art, Philadelphia, PA. Gift of Lessing J. Rosenwald.

Some types of prints are etchings, woodcuts, engravings, silkscreens, and lithographs.

A Study of Despair

Let us look first at a lithograph by the artist Kaethe Kollwitz. This print, *Poverty,* shows a mother and child (Figure 203).

As in the painting *Mother and Child* by Mary Cassatt (page 223), the placement of the hands is important. The child's hands are drawn together under the sheets. The mother's hands hold her head in grief. Again as in Cassatt's painting, the background is subordinated so that our attention focuses

279

on the mother and child. And Kollwitz's mother and child form a triangle, just as they do in Cassatt's painting. However, the triangle in *Mother and Child* suggests stability and perhaps contentment. The triangle in *Poverty* suggests despair.

Look at the triangle formed by the mother's head (at the top), arms and elbows (at the sides), and baby in bed (at the base). The weight of the mother (and her sorrow) appears to be concentrated at her elbows. They seem to reach for a base on which to rest. Her physical weight and her hopes as a mother are about to collapse as her child lies dying.

Although Kollwitz studied painting and drawing, print-making was her major interest. She was more interested in line than color, and her drawings were always a means to an end. They were studies for a print. Kollwitz was also attracted to the graphic arts because she believed in making original works widely available at low cost.

Poverty is an example of Kollwitz's interest in social drama. She was concerned with the plight of workers and their struggle to improve their position. *Poverty* is one of a series of prints dramatizing the problems of weavers. In the mid-nineteenth century the Industrial Revolution was sweeping through Europe. The invention of power looms meant that weavers who worked by hand were no longer needed. Thus, *Poverty* represents, not only the death of a child, but also the death of a way of life for these hand weavers. Their weaving equipment rests idly in the background of the picture, as do the woman and child to the viewer's left. The artist presents us with a powerful statement about the effects of social change.

Studies of Loneliness

Artists record their responses to the people and activities in their communities in a variety of ways. One way is through art which shows scenes from everyday life. Remember, for example, how John Sloan in *Backyards, Greenwich Village* (page 95), showed us a scene from everyday life in which children are simply having a good time in the snow. Pieter Brueghel's *Hunters in the Snow* (page 92), also, shows people involved in the commonplace activities of another time.

Small-scale works of art showing scenes from everyday life are called **genre** (zhon´-ruh) **art.** Italian and Flemish artists began to produce such work in the fourteenth and fif-

teenth centuries. It emerged as a distinct art form in the seventeenth century in the work of the Dutch and Flemish masters. In the twentieth century many Impressionists and Post-impressionists took it up. *Genre* is a French word meaning "sort" or "variety."

The following two graphic prints by the American artist Edward Hopper are examples of genre art. Hopper spent most of his life in New York City. His work portrays everyday scenes of the city and often stresses the loneliness that is felt in a big city.

House Tops and *Night in the Park* (Figures 204 and 205) both show a human presence in a nearly deserted space—a train and a park. The geometric character of these places is emphasized by harshly revealing light. These everyday scenes have been simplified so that they are emotionally charged and appear almost unearthly. The solid forms give a

Figure 204. *House Tops*, **an etching by Edward Hopper, is an example of "genre" art.**
Edward Hopper, *House Tops*. Etching. The Philadelphia Museum of Art, Philadelphia. Purchase, the Harrison Fund.

Figure 205. Hopper's *Night in the Park* depicts the solitude possible even in the city. Edward Hopper, *Night in the Park*, 1921. Etching. 7″ x 8 3/8″. The Philadelphia Museum of Art, Philadelphia. Purchase, the Harrison Fund.

somewhat sculptural feeling to both pictures. Although these prints have genre subjects, their true meaning goes beyond observation of everyday activity.

The person in each of these prints is faceless. The artist was less concerned with individuals than with the image of people alone with their thoughts. Because we do not see anything particular or unique about the person, we can concentrate on understanding what it is about people the figure in each of these settings represents.

In *Night in the Park,* a man reads about the lives and events of other people in the newspaper. He too is alone. The spotlight in both pictures is on a world of other people beyond the central figure—those in the house tops and in the newspaper. The subjects are in deep shadow—physically outside that world, but connected to it by their thoughts.

A Supreme Satirist

Lithographer Mabel Dwight's powerful satire described the absurd aspects of the human condition. Her drawing is

Figure 206. Mabel Dwight enjoyed depicting the absurd in everyday life. Mabel Dwight, *Queer Fish*, 1936. Lithograph. 10 5/8" x 13". The Philadelphia Museum of Art, Philadelphia. Purchase, the Harrison Fund.

satirical, that is, it ridicules human vices or weaknesses. She captures the tragicomic moment encountered by people caught up in modern urban life. She was trained at the Hopkins Art School in San Francisco. After collaborating on some lithographs in Paris in 1927, she devoted herself to lithography. Following her return to the United States in 1928, Dwight became well known for her comic lithographs about city life. Her subjects were the many urban character types and the peculiar situations in which they often found themselves. By the time she began to work for the Federal Art Project in the late 1930s, she was an established artist with a major show in New York.

Dwight objected to arbitrary distortion. That is, she felt it was unnecessary to distort the shapes and scenes she observed in order to show truth. In her view, modern life itself was so ridiculous that the artist only had to observe it closely for the resulting work to seem twisted.

In *Queer Fish* (Figure 206), Dwight plays curved forms against diagonals. Her controlled, velvety crayon technique and the unity of the dark shapes against white show her concern for technique and the organization of her subject.

Dwight silhouettes an almost dream-like group of people against the light of the fish tank. The big fish stares at the fat man with an oddly human anger. The fat man returns the hostile glare of the fish, just for an instant, before each swims off. Is there a hint of mutual recognition? Both of them, the artist seems to say, are "queer fish."

PRINTMAKING ACTIVITIES

1. A **collograph** is a type of print which can be made using cardboard surfaces; the process is easy and can give excellent results. You will need two pieces of corrugated cardboard to make your collograph. One will be used as a backing, and one will be cut into shapes and glued to the backing to form the printing surface. Cut simple shapes of varying sizes. Try several arrangements before you glue the pieces to the backing. Think about the effective use of the compositional principles. Pay special attention to the negative spaces created as you paste the shapes on the backing.

Texture can be created by peeling off the surface layer from some of the shapes or by gluing string to the tops of others. Be careful that the final printing surface does not get so busy that you lose the effect of your original design. When you have finished this step, you now have a **printing plate.**

Before you print your collograph, check the thickness of the printing plate for consistency. If the thickness varies too much, the plate will not print evenly. Try a number of different ways of positioning the print plate:

- Make rows with sides touching.
- Turn the plate a half-turn on each printing.
- Alternate the print with open spaces, "checkerboard" style.
- Place each row off-center to create a diagonal pattern.
- Use two colors, alternating prints.

There is an almost endless number of possibilities.

Figure 207A. Student art.

Figure 207B. Student art.

Figure 208. Student art.

2. The **silkscreen** process uses a stencil technique to selectively block out areas of a screen. Ink is then pushed through the screen to the print paper. Artists use several ways to block out areas on printing screens. You are going to use a simple but effective stencil method. This method lends itself to making exciting designs, for the same screen can be overprinted with a second or third color or value.

Cut shapes will become the part of the screen that will be used as the "block out." This means that the ink will go through the screen around the shapes. The reverse process can also be accomplished. If you save your negative and use this part, the ink will go through the screen only where the cut shapes were.

Next, arrange the screen, with its design called a **stencil,** on top of the sheet of the print paper as you wish your finished screened print to look. Lay the screen frame on top of the design. Force a small amount of ink through the screen using a squeegee. Lift the screen. Your stencil is now pressed to the bottom of the screen. It will remain attached for a number of printings. You may wish to change the design in some way by removing the stencil. If so, wash the ink from the screen and allow it to dry before attaching a new stencil.

UNIT

SPECIAL PROJECTS

The Artist in the Community

ART HISTORY

1. In our discussion of *American Gothic,* we saw that during the Great Depression of the 1930s, many artists, whom we now call Regionalists, went "back to the soil." They rediscovered the strengths of America's past during the troubling times of that period of history. John Stuart Curry went back to Kansas, Thomas Hart Benton went back to Missouri, Grant Wood returned to Iowa. Choose one of these Regionalist painters, and report on regional influences on this artist. If you wish, you may choose another artist whose work is strongly associated with a particular section of the United States. In your report, support your views with examples of the artist's work and comments from the artist, the artist's acquaintances, art critics, and historians.

2. Thomas Eakins's *Max Schmitt in a Single Scull* communicates the artist's passion for visual truth in his art. Eakins's preparation was painstaking. He began with mechanical scale drawings of the boat, the oars, and bridges. Then, using a mathematical process he devised, he placed them in proper perspective and proportion.

Eakins was an artist who set out written rules for drawing perspective and for showing reflections and shadow. For example, Eakins defined specific principles for painting reflections on water. He said that the angle of reflection was equal to the angle at which the object enters the water. Look at the photographs by Weston and Muybridge which appear on pages 130 and 131. Do you see what Eakins meant? Leonardo da Vinci also wrote on perspective. Research the views of Leonardo, Eakins, and other artists you may find who have written on perspective. Write a short essay based on your research.

3. Pablo Picasso painted *Weeping Woman* (page 211) during the Spanish Civil War. The year was 1937, and within another two years war would envelop all of Europe. In the same year, Picasso painted his most famous mural, *Guernica* (gurr-nee´-kah). The town of Guernica was the capital of the province of Basque (bask) in Northern Spain. Picasso was devastated by the destruction that was taking place in his native Spain. *Weeping Woman* originated from one of many drawings he made in preparation for *Guernica.* The agony of this woman is greatly intensified by Picasso's use of color. Note the treatment of the eyes and mouth—the eyes with color, the mouth without color.

To Picasso, the eye was the center of interest for his portraits. Picasso's own eyes, black and piercing, fascinated those who knew him. Gertrude Stein said he had the power to see around corners. Her brother Leo feared that Picasso's eyes could burn holes in whatever he viewed. Look at Picasso's eyes in his self-portrait (Figure 209).

Even in Picasso's most abstract paintings, he never lost contact with his subject matter. He said, "… the head remains a head." Picasso's work is represented in books more often than that of any other artist of the twentieth century. Locate a few of these books. Look at some of the reproductions of Picasso's abstract paintings of people, and see how he treats the head. Do you see how the features are painted? Do you agree with him that "a head remains a head?" Discuss with other classmates who have researched Picasso.

4. Trace the changing attitudes about war as it is depicted in art such as monuments of classical heroes, emperors, and other great conquerors, and such as paintings and statuary commemorating great battles in history. Consider Picasso's *Guernica* and other anti–war art.

5. The portrait of Charles IV of Spain and his family by Goya (page 220) and Velásquez's *Maids of Honor* (page 221)

Figure 209. Pablo Picasso. *Self-Portrait*, 1907. Pablo
Picasso, *Self Portrait*. Oil on canvas. 22″ x 18 1/8″. The National Gallery,
Prague. SPADEM/Art Resource.

are two of the most famous portraits of family groups in the
history of art.

Notice that the artist himself appears in both of these
paintings. Velásquez had been dead for more than eighty
years when Goya was born. Goya was quoted as saying that
he acknowledged three masters: Velásquez, Rembrandt, and
Nature. His painting is a "line-up" of thoroughly unattrac-
tive and disagreeable people. It is difficult to understand
how Goya got away with such a devastating family portrait,
but it was said that Charles IV was as stupid as he looks in
the painting. Goya was, of course, very much aware of

Velásquez's *Maids of Honor,* a charming scene. Do you think that Goya included himself in his painting of the royal family to intensify the parody of this dismal looking group? His presence makes even more obvious the comparison with the Spanish royal family Velásquez had painted 100 years before. Look for other examples of artists including themselves in their paintings. Find at least one other example, and write a report. Include why you feel the artist included himself or herself.

6. Mary Cassatt, whose *Mother and Child* appears on page 223, is recognized as one of the United States' most important painters. However, she achieved no fame in her native country until after her death in 1926. At the very height of her powers, in 1899, the *Philadelphia Public Ledger* commented, in a brief social note, "Mary Cassatt, sister of Mister Cassatt, President of the Pennsylvania Railroad, returned from Europe yesterday. She has been studying painting in France, and owns the smallest Pekingese dog in the world."

Adelaide Labille-Guiard was a very strong personality, as well as a strong artist and teacher. Her *Portrait of an Artist with Two Pupils* on page 217 is as close to a self-promoting commercial as was possible in the eighteenth century. It is reported that she painted her portrait as a challenge to those who questioned her ability because she was a woman.

These two incidents illustrate the prejudiced attitudes about women artists which persisted for centuries. Trace the acceptance of women artists from Labille-Guiard's time to the present. Note events which mark milestones in changing attitudes. As an example, now no one questions the greatness of Mary Cassatt. However, as time passes, it is more and more difficult to find any reference to her brother (the railroad president). The *Philadelphia Public Ledger* is but a memory, and, for that matter, so is the Pennsylvania Railroad. Make a record of the examples you find.

7. On page 202 the painting *New York Movie* by Edward Hopper appears with a preliminary sketch Hopper made for the painting. The details in the sketch have been simplified in the painting to unify the architectural elements and create a balance between the shallow space (with the usher) and the deeper space (inside the theater). Compare Hopper's use of shallow and deep space in this painting with:

 a. Velásquez's *Maids of Honor* (page 221).

 b. Brueghel's *Hunters in the Snow* (page 92).

c. Picasso's *Weeping Woman* (page 211).
In what ways have these artists treated space differently?

APPRECIATION AND
AESTHETIC GROWTH

1. *American Gothic,* as we have seen, is a statement by Grant Wood about Iowa and the Midwest. As you look at this painting again:

a. Discuss its static organization as a comment on the community and region.

b. Discuss the role of social comment and social satire in the arts and their effects on the community.

c. Look at the political cartoons on the editorial pages of your favorite newspaper for several consecutive days. Select one cartoon which you think makes a valid point about a local, state, or national problem, or select one which you believe makes an unfair statement. Discuss your reasoning with your classmates.

d. Decide upon a controversial issue (local, state, or national) which is receiving considerable attention in the public media, and draw your own political cartoon about this issue. Take a strong stand on the issue. Your cartoon should be designed to make people think and perhaps see an issue from a new perspective. The social studies teachers in your school may have some good examples of particularly persuasive political cartoons of the past for your reference in this project.

2. There are two self-portraits of Rembrandt on pages 213 and 214. Rembrandt used himself as a model sixty-two times during his lifetime, often because he could not afford a model. He was always very honest in recording what he saw in the mirror. Research his self-portraits. Find as many as you can in art history books and encyclopedias in the library, taking notes on each and recording its date. Write a short biography of Rembrandt, using only the physical evidence you find in his self-portraits. Keep in mind that he was born in 1606 and died in 1669 at the age of 63. Which paintings seem to record sad times in his life? Do you find paintings indicating happy times? After you have completed your short biography based solely on the visual evidence, read about his life in an encyclopedia or other library

source. Compare this biographical information with your thoughts about Rembrandt's life. Do the two agree?

3. In a critical analysis of a work of art, the first step is to make a careful description of the work. We have learned to make a listing of just exactly what we see as we look closely. Let's take a very close look at a painting we have briefly discussed, a painting which can really stretch your powers of observation.

The painting is Velásquez's *Maids of Honor*. Look at your classroom reproduction of this work. You may ask. "What more could we possibly get from this painting?" We have only scratched the surface of this painting; there is always more.

For example, on page 222, the text says that the Queen and King have just entered the room for a visit. Assuming this is so, what is the subject of the artist's painting? (The artist on the canvas is Velásquez himself.) He is, you will probably say, painting the princess who is shown posing in her beautiful white dress. Following this line of reasoning, Velásquez may be looking in a mirror at the princess, and we can see this mirror in front of the artist. We know that the King and Queen are there, for we can see their reflections in the mirror on the wall at the back of the room. Be sure you have located all of these elements in the painting before we proceed.

This is a standard interpretation of *Maids of Honor*. However, there are other ways to interpret what is going on in this painting. Other Velásquez experts believe that Velásquez is not painting the princess. Before you read on, think, "If this is so, then who *is* he painting? In this interpretation, Velásquez is painting the Queen and King. They are posing, standing about where we, the viewers, see the painting. They are reflected in the mirror at the rear. This interpretation means that all of the children, the servants, the two dwarfs, and the sleeping dog are not a part of the artist's work.

Either interpretation demands that we use our eyes very carefully for clues. Study the details. Look at the eyes of the artist and the eyes of the Princess. Look at the dress, the posture, and the attitude of every character in the room, including the reflection in the mirror. The man at the back of the room seems to be pulling a curtain back. Is more light needed? Would each person in the room be doing whatever he or she is doing if the King and Queen had just stepped into the room? Use the visual evidence to support any conclusion you may reach. There are other possible interpretations. Can you think what they might be?

4. Mary Cassatt's *Mother and Child* (page 223) contains two styles of painting. The first is called **alla prima** (ah-lah-preé-mah). This is a technique in which colors are laid down in one application, at one sitting. There is little or no preliminary drawing and underpainting. This technique has been utilized since the seventeenth century, but improvements in the quality of paints made this technique much more popular in the nineteenth century.

Cassatt also used the finished style in parts of this painting. Notice the treatment of the flowers in the dress, and consider the effect of this unfinished area on the overall work. Do you see that Cassatt, by combining two techniques in this painting, has moved our attention to the faces and hands of her subjects?

A detail from *Circus*.

PART

III

ART
APPLICATIONS

UNIT

THE ART MUSEUM EXPERIENCE

Soon after the American Revolution, Charles Willson Peale founded America's first art museum in Philadelphia. Peale was famous for his portraits of George Washington. He was an inventor-scientist and a man interested in practically everything. In his painting *The Artist in His Museum* (Figure 210) he is standing in front of a curtain near some stuffed birds. Inside, spectators look at boxes of stuffed animals, insects, and fish beneath portraits of American patriots.

A story about Peale's museum illustrates the possibilities of such institutions. According to the story, two rival Indian chiefs came to visit the museum at the same time. These two men had met before only on the field of battle. They were sworn enemies. Would there be trouble in the museum? Not at all. Interpreters explained the exhibits to the visitors. As the two chiefs marveled at the wonders of art and science, they came to the same conclusion: The abilities of human beings were so great, wouldn't it be better to work together in peace than apart as enemies? So these men buried the hatchet and became brothers.

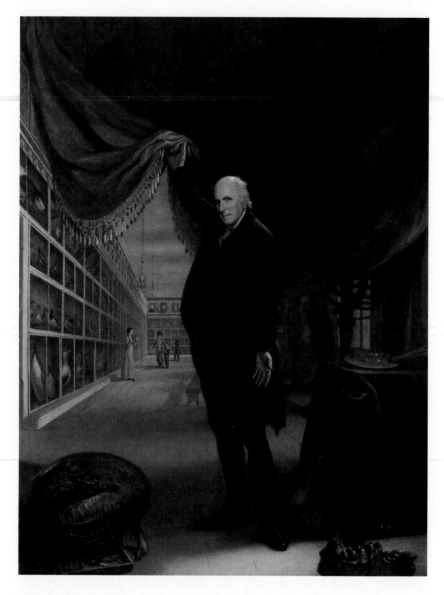

Figure 210. *The Artist in His Museum* **by Charles Willson Peale.**
Charles Willson Peale. *The Artist in His Museum.* 1822. Oil on canvas. 103 1/2″ x 80″. The
Pennsylvania Academy of Fine Arts, Joseph and Sarah Harrison Collection.

What is the purpose of this story? First, museums do reflect the achievements of people. And second, these particular visitors had what is known as a museum experience. There is a difference between a visit and an experience. When you merely visit a museum, you look at art but don't really see it. A museum experience can change your life, because it changes your understanding of something.

What happens when you enter an art museum? Suddenly you are in front of several paintings on the walls or art objects on the floor. On the first visit, time does not

permit you to see everything. So you find a painting you like and stay with it. Why do you like this particular work? It may take some time before you can answer that question. Over a period of time you will select favorite works and from looking, thinking, and discussing, you will understand what makes them so appealing to you.

Perhaps you have selected, with the class or your teacher, one particular original work to examine. If you have previously seen a copy of this work, you can immediately tell the difference. People can make very good copies of art works, and we can learn much from them. Still, there is no substitute for the original colors of a painting or the textures of a sculpture. This is the most important reason to visit a museum, but it is only the beginning.

An art museum is a living record of the past and present. You may go to a museum to see a great painting that is considered by many to be a masterpiece. You may also visit museums to see many other kinds of art. All have their own beauty, power, and message.

THE PEOPLE BEHIND THE ART

Let's look behind the artworks and see who makes a museum run. The *director* (Figure 211) is in charge of everything that goes on in an art museum. The director's duties include raising money for the museum, purchasing new works of art for the museum's collection, and planning special exhibits.

Figure 211. A museum director (right) discusses a piece for a special exhibition.
Photographer David Hanover.

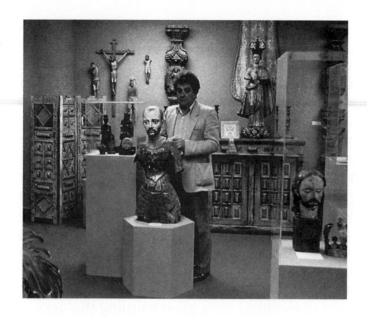

Figure 212. A museum curator.

A Museum Curator. Photograph courtesy of Monkmeyer Photo Service. (Anderson)

Many large museums have libraries. The *librarian* at such a museum helps people find information about artists and works of art. The librarian keeps the museum library up-to-date, ordering new books, magazines, slides, and videos.

The *curator* (Figure 212) recommends art works which the museum might purchase, selects objects for exhibits, decides on how paintings should be hung, and maintains the museum's collections.

A museum *lecturer* (Figure 213) must be well-trained in both art history and public speaking. It is the lecturer's job to conduct tours through the art museum, informing people about individual paintings and artists. He or she may also prepare special brochures to accompany the tours.

Figure 213. A museum lecturer.

A Museum Lecturer. Photograph courtesy of the Metropolitan Museum of Art, New York.

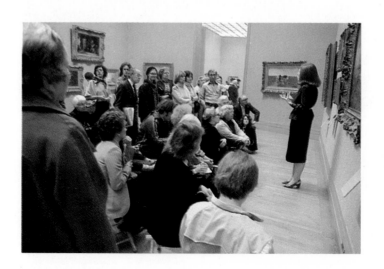

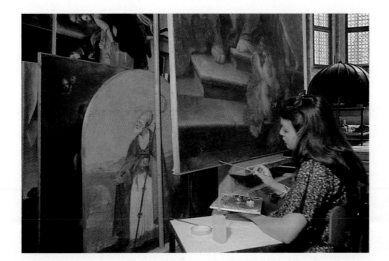

Figure 214. A museum conservator.
A Museum Conservator. Photo Researchers, Inc., New York.

The *conservator* (Figure 214) sees that the paintings, sculptures, and other valuable objects in the museum are cared for properly. Paintings that have centuries of soot, dirt, or varnish on them or that have been damaged by fire or floods must be restored.

The museum *guard* (Figure 215) makes sure visitors do not touch or damage the works of art. Guards are available to give directions to anyone needing help to find a particular painting or gallery.

Figure 215. A museum guard.
Photo Researchers, Inc., New York.

Figure 216. *The Temple of Dendur* **from ancient Egypt now stands at the Metropolitan Museum of Art in New York City.** Ancient Egypt. *The Temple of Dendur.* Courtesy of the Metropolitan Museum of Art, New York. Given to the United States by Egypt in 1965; awarded to the Metropolitan Museum of Art in 1967; installed in the Museum's Sackler wing in 1978.

Look at the reproductions of museum pieces shown in Figures 216, 217, and 218. The first is an Egyptian temple; the second, medieval armor; the third, an evening gown made by the House of Worth. These are all important works of art from our earliest history to our recent past. Each piece expresses values, ideals, and beliefs of different civilizations. As we study them, we come closer to our past and to ourselves.

The museum experience can change your life by affecting how you see yourself or how you look at the world. For example, as you look at the art objects from everyday life

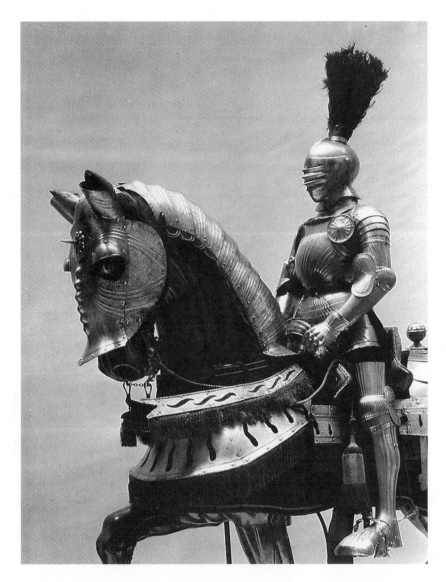

Figure 217. Armor for man and horse from medieval Europe was a symbol of the age of chivalry. *Maximilian Armor for Man and Horse.* (German, 1515) Courtesy of the Metropolitan Museum of Art, New York. Bashford Dean Memorial Collection. Funds from various donors, 1929. Gift of William H. Riggs, 1913.

(the dress, the armor) the question arises: Which objects in your life will someday be in a museum—and why? Could you find an object such as a favorite chair, cup, or bike and look at it through the eyes of an artist? Winslow Homer taught us how to see colors. Now try looking at your own room as if it were a painting. In your community find an old automobile or a house with a Gothic shape. From your museum experience could you determine what those relics of the past have to do with you? That's the challenge—because once you have been to the museum, you can have the museum experience anywhere. Art is everywhere.

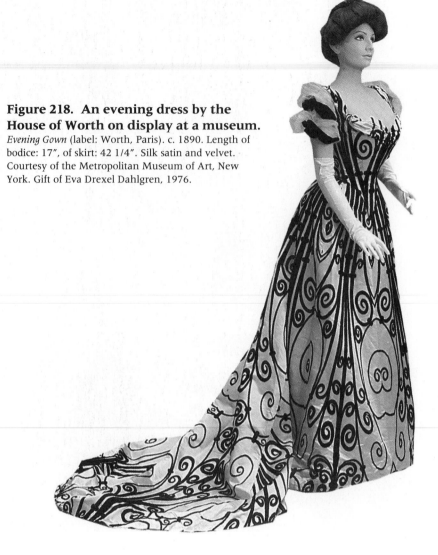

**Figure 218. An evening dress by the
House of Worth on display at a museum.**
Evening Gown (label: Worth, Paris). c. 1890. Length of
bodice: 17", of skirt: 42 1/4". Silk satin and velvet.
Courtesy of the Metropolitan Museum of Art, New
York. Gift of Eva Drexel Dahlgren, 1976.

U N I T

COMPUTERS AND ART

A computer is an electronic device that processes data and develops information resources. The computer follows instructions (called **programs**) from the person using it, who is called the **user,** or the **operator.** It also stores this information and produces it when the operator calls for it. This is often called **output.** The computer cannot do anything unless you give it instructions first. Therefore, the computer does not create an image, but **generates,** or produces it, according to data you **input** into it.

The entire computer unit, (Figure 219) consists of a **monitor** (screen for viewing data and images), a **keyboard** for typing messages to the computer, a **disk drive** for reading your **disk** and sending the message to the computer, and a **printer** which produces a copy of your work on paper. Along with the keyboard, you can also use a **mouse** (a device on a ball-wheel) to point out directions on the screen without using the keyboard. All of this equipment—the monitor, disk drive, printer, keyboard, and mouse—is called **hardware.**

Preparing information for the computer is called **programming.** Some programs are already prepared by computer manufacturers for their machines. You can also write your own program to perform specific tasks or buy one of the many hundreds of different commercial programs that

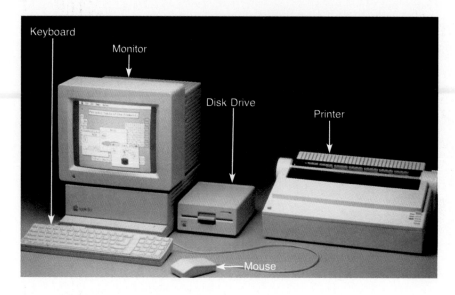

Figure 219. A computer unit. Courtesy of Apple Computers, Inc.

are available. All programs are stored on two types of **disks: floppy disks** or **hard disks.** The programs are called **software.**

In this course, we are concerned with the computer's capabilities to produce visual images, called **computer graphics** or **computer art.** Computer graphics (Figure 220)

Figure 220. Many commercial illustrators now use computers to produce drawings like the one shown on the monitor. Courtesy of Hewlett-Packard.

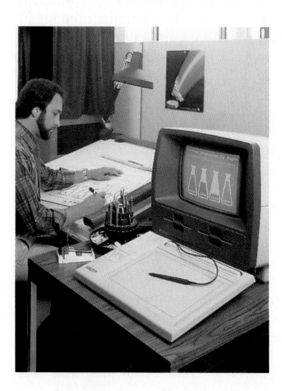

Figure 221. The same principles used to paint a picture were used to create this computer-generated work of art. Courtesy of Time Art, Inc.

may be used to produce charts and diagrams, reports, and layouts for commercial designs and architecture. The term is also used when referring to computer art, but computer art is more concerned with *computer generated imagery* (which can embody the representational, symbolic, imaginative, expressive, and abstract aspects of art) than with graphs, charts, or commercial and architectural design (Figure 221).

Several software packages have been developed (and more are currently being developed) which allow the user to generate and display images that can be considered an art form. The computer artists can now use graphics software as a painting device which produces immediate results on the screen. The greatest advantage of the medium is its flexibility; these images can be quickly and easily changed.

Computer artists must invest time studying, experimenting, and practicing with drawing or painting software, just as other artists and craftspersons explore watercolors, clay, or other media to discover their advantages and disadvantages. In addition to its flexibility, computer art also features the advantage of easy clean-up. You don't have brushes to clean or specially mixed colors of paint to save from one painting session to the next. All you need to do is save the image on your disk, then print it, and put the disk away. One difficulty

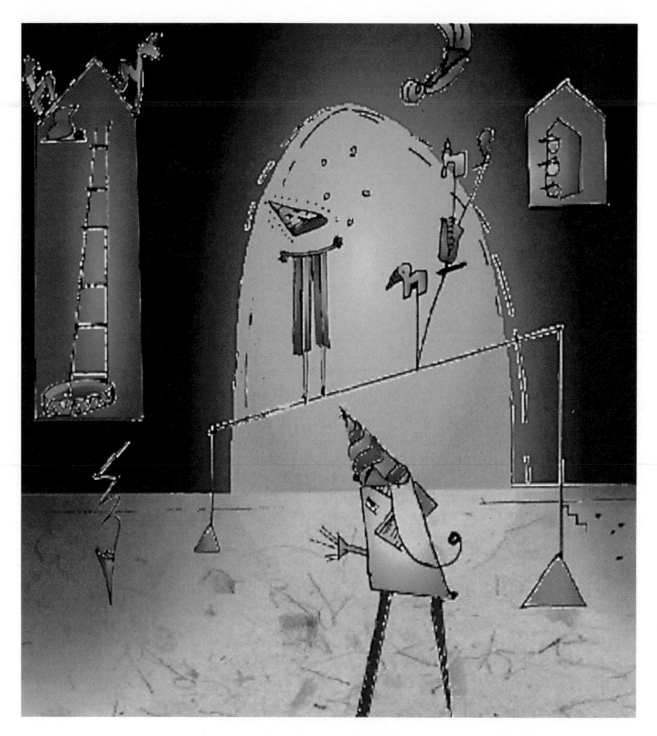

Figure 222. Some computer artists are becoming so skillful that they can produce art that does not look computer-generated. No. 57. Barbara Joffe. *Circus.* Cibachrome print. 30 x 37 in. 1989. Collaborator: Computer Arts Institute. Scans.

in computer art is generating an image which does not look mechanical and automatic, but natural and inspired.

Many design functions have been revolutionized by the computer's ability to store images and retrieve them instant-

Figure 223. Many magazines and newspapers are designed and put together on computers. Courtesy of Claris Corporation.

ly. Some of these uses are the creation of TV graphics, the retouching of photographs, and the design and production of illustrations for publications. Much of the design of this book was done by artists skillfully using the capabilities of the computer. A computer can greatly speed up the process of designing a book, magazine, newspaper or brochure. Pictures can be cut, reduced or enlarged, and properly placed electronically rather than manually. Page and chapter layouts can be shifted and stored in the computer for retrieval and minor adjustments (Figure 223). These functions are all completed by a single process on the computer. When done by hand, they require several different processes and take much more time. Computer capabilities allow for continuous, slight improvements that could not be made manually, because of the time involved. Moreover, the speed and efficiency of the computer allows the designer more freedom to concentrate on the excellence of the design. The computer has almost instant flexibility. Changes, additions, and subtractions are comparatively simple to make by scanning a computer video system.

Another important artistic use of the computer is in the design of three-dimensional works. Three-dimensional models may be viewed on screen in the form of animated images before the actual item is created. This provides a guide for shaping the image of a three dimensional object, such as a sculpture or clay pot, before working on the actual piece.

If you are considering a career in graphic design, you should take specialized courses in art and get as much computer experience as possible while you are in high school. The graphic designer of today combines the successful use of traditional design and commercial art skills with the extraordinary power of the computer. The result is a unique form of visual expression and communication.

THE COMPUTER AS A MEDIUM

Elements of Art, Principles of Design

The computer will not replace paints and crayons, or other art media; but it is a versatile addition to the art media we already use. It also has limitations. As you learn to use the computer to create art, think of it as another medium, just as you think of pencils, crayons, paint, chalk, clay or other tools. Each medium has special advantages, but each has limitations. The artist, in learning to use a new medium, experiments with it to find out what it can and cannot do.

Some of you may have had experience with computers and perhaps have made some computer graphics or computer-generated art. Others may not have had such opportunities.

Regardless of your experience, however, it is important to remember that you will use the computer to produce the visual elements of art. Your knowledge of the compositional principles of design will be important in organizing your images on the screen just as they are important in using other media. Admittedly, however, the computer is a sophisticated medium that requires some additional knowledge on the part of a beginner.

As simple as this sounds, the first thing you will need to know is how to turn on the computer. You also need to know how to access the proper software. You will need to know how to use the computer hardware such as the drawing device. Depending on which computer system you use, the drawing device might be a **mouse,** a **koala pad,** a **joystick,** or a **light pen.** You also need to know how to save your art onto a disk for filing, and how to print your art.

There are many different art software packages available, such as Paintworks Plus art graphics software, which works on the Apple IIGS computer, MacPaint art graphics soft-

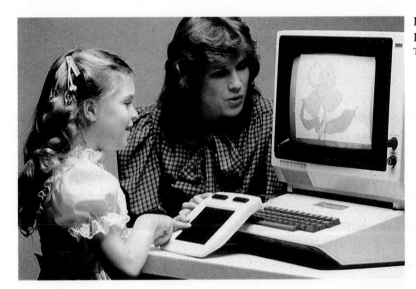

Figure 224. A student using a Koala pad. Courtesy of Koala Technologies Corporation–San Jose, CA.

Figure 225. The mouse is rolled across a flat surface and the cursor on the monitor moves accordingly. Courtesy of Revue.

Figure 226. By moving the stick of a joystick side to side, the cursor moves across the monitor. Courtesy of Morris, Inc.

ware, which works on Macintosh computers, and Full Paint and PC Paint, which work on IBM and IBM compatible computers. If you are not familiar with the computer or art software, you should learn the basic computer skills before attempting to produce computer art. You might learn these skills through computer instruction offered by your school, or you might learn these skills through taking a private course in computers. Many computer retailers offer such courses. You might also learn these skills through the use of the computer manual and available tutorial programs.

You will also need to learn computer art terms. Although they have slightly different meanings from those you have already learned, you will probably find that the

311

terms used in computer art software are familiar to you. Computer art terminology includes terms such as the easel and the palette. The **easel** is the opening frame of your software package. It contains the menu bar, the toolbox (or icons), the border color and pattern palettes, and the window upon which you create your images. The **palette** includes examples of patterns and colors which you select to fill in your images. The **icons** are small pictures which represent objects in the toolbox such as a paint brush, spray can, eraser, and various shapes and lines. You might look these terms up in the glossary to see how their use in computer art differs from similar terms in general art.

Read the special manual for your art software package. It describes how to open the program you want, how to use the **cursor** (the pointer arrow or + sign), and how to read the easel (the display of menu bars and palettes) to identify the icons in the toolbox. It also explains the procedures for shifting from the toolbox to the menu bar or to the color and pattern line, or border palettes. It will tell you how to erase and begin again or how to use the file for saving and printing. The manual will also give you instructions for making pictures.

Once you have the proper computer knowledge, you can begin to apply your knowledge of the visual elements and compositional principles to produce computer-generated art. As the novelty of this new medium wears off, you will probably find that you are faced with many of the same challenges and rewards you have found in using other media.

UNIT

9

CARTOONS, ANIMATION AND ENTERTAINMENT

CARTOONS AND ANIMATION

If you were to look up the term *cartoon* in a dictionary of art, you would find it defined as "a full-sized drawing made for the purpose of transferring a design to a mural, a tapestry, or stained glass." Cartoons originated as patterns used in the process of completion of a serious work of art. This is still a valid definition, since this method is still used.

The cartoon as we think of it today, however, is an outgrowth of illustrations for newspapers and magazines, such as the drawings Frederic Remington did for *Harper's Weekly*. Beginnings of this sort of cartooning go much further back than that. The balloon over a character's head containing his or her thoughts or spoken words was used by the British engraver and artist William Hogarth, who lived from 1697 to 1764.

Figure 227. Charles Schulz's *Peanuts* is an example of a daily strip read by thousands of readers everyday. © 1990 United Feature Syndicate, Inc.

In 1843 the first "modern" cartoons appeared. In that year, frescoes were commissioned to decorate the walls of Parliament in London. While artists were preparing the cartoons as patterns for the frescoes, the British humor magazine *Punch* published its own satirical "cartoons" ridiculing the members of Parliament. A modern cartoon may be defined as a drawing, often accompanied by a caption, which transmits its message without the need for further explanation.

There are many categories of cartoons today:

1. *One panel, humorous.* These cartoons either have a typeset caption outside of the drawing, hand-lettered balloons with dialogue, or no dialogue at all.

2. *The daily strip.* This is a multipanel cartoon, usually with hand-lettered dialogue in balloons. Some have continuity from day to day; some do not. Some are humorous (Figure 227), some are serious. Extended versions often appear in color in Sunday supplements.

3. *Editorial (political) cartoons.* Generally these are one panel with a typeset caption or no caption at all. Political cartoons deal with current events or situations and usually express a strong point of view through caricature (Figure 228).

4. *Comic books.* Comic books present a multipage story (humorous or serious) in pictures, with dialogue in balloons and narration above or below pictures.

5. *Television storyboards for commercials.* A television storyboard is not for putting on the air but is a multipanel series of illustrations with explanatory notes outlining a sequence for a commercial.

Figure 228. This political cartoon by Bill Mauldin appeared in the Chicago Sun Times on November 23, 1963, the day after the assassination of President John F. Kennedy.
Bill Mauldin. Political Cartoon, Saturday, November 23, 1963, Chicago Sun Times. Courtesy United Features Syndicate.

6. *Animated cartoons.* **Animation** is the illusion of movement given by a sequence of images. Before the computerization of animation, images were drawn and then painted on celluloid panels. One thousand four hundred and forty panels were required to produce one minute of film. The process was a slow one for several reasons. The first was the sheer number of images required. All background layouts, dialogue, and sound effects had to be completed before the animation of the characters. The animator then had to be very careful that the characters did not bump into trees or furniture or other objects painted in the background. The drawing of lip movements and associated body movements had to match exactly with the spoken words on the sound track. If it took forty frames for a character to say, "What's up, Doc?" on the sound track, the animator had to make the character's mouth and body motion match the sound in exactly forty frames.

This painstaking procedure was workable at the time of the first full-length animated motion pictures in the 1930s, a period of widespread unemployment and very low wages. However, the cost of using this method became prohibitive in the late 1950s. The use of computers was to revolutionize this art form.

Figure 229. Computers are used to edit animated films.
Courtesy of Sullivan Bluth Studios.

The first success with computer animation came in television commercials. In computer animation images may be rotated in any direction. Characters and background can be created and stored in the computer and matched instantly with sound tracks. We now have software that can generate sequences of movement for characters and objects (Figure 229). Live action and animation can be blended. Full-length animated cartoons have returned.

Cartoonists seem to have one thing in common—a lifelong ambition to be a cartoonist. Rube Goldberg (1883–1970), one of the greatest, describes it this way:

> No one but a born cartoonist can understand the isolation of a young hopeful with nobody close to him who really sympathizes with his hopes and ambitions. He must literally wallow in the work of established cartoonists to find vicarious companionship. His friends are the cartoon figures he can find on the printed page.*

If you are a cartoon addict yourself, successful cartoonists will tell you to constantly sketch and study the masters in the field. Translating a concept into an effective cartoon requires close attention to the compositional principles of design, a sense of humor, and an inquiring nature.

*Stephen Becker. Comic Art in America 1959. Simon and Schuster. New York, p. 259.

Activity 1—Cartooning Study the various styles of the artists of cartoons you especially admire. What drawing techniques have been used to create those styles? Stay with a particular style you like, and practice. Your own style will develop, but it will take time and patience.

Begin by considering some humorous event that might be translated into a cartoon. Could you best represent the event in a one-panel cartoon or in a multipanel strip? Try several sketches. Carefully consider the words you need to convey the idea. Use as few words as possible. Transfer your best sketch to drawing paper, and complete the cartoon with pen and ink.

ENTERTAINMENT

All forms of popular entertainment media, such as movies, stage plays, opera, and ballet, combine many different disciplines or subject areas including art in order to provide a stimulating and enjoyable experience for the audience.

When you watch a movie, you do more than watch the writer's words brought to life. You look at images, just as you look at images in a painting. For example, just as the principles of design must be applied to a painting or a piece of sculpture, so too must they be applied to the design of a set for a stage play, opera or ballet. Repetition and contrast; symmetrical, asymmetrical and radial balance; emphasis, dominance and subordination; movement; and unity of composition—all are applied in the creation of successful entertainment. In the case of film or video, for example, an art director will work to control the movement of the viewer's eyes. He or she will work with other members of the creative and technical staff, such as lighting technicians, camera operators, scene designers, and the director, to create visual images that enhance the dramatic effect.

You might try watching a movie at home with the sound turned off. Spend some time judging the strengths and the weaknesses of the visual images provided. Apply what you have learned in your study of art to what you are seeing on television or in the theater. You will probably find that just as there are successful and not-so-successful paintings and

sculptures, so too are there good and not-so-good movies and stage plays.

One area where the world of art and artists has crossed over into the world of entertainment in a major way is in the field of special effects. **Special effects** add to the visual impact of a film. They are any images or sound content added through special filming, film editing, or other work that takes place after the basic filming work has been completed. Early special effects were as simple as fading images between the scenes, or creating the illusion on screen that the character was riding in a car or plane, when the actor was actually sitting in a motionless prop. This type of special effect is almost as old as the movies themselves and is still in use today. Such effects were accomplished by manipulating cameras and projectors. The advent of computer technology, however, has revolutionized the possibilities for special effects.

Today, through the use of both computer technology and the skills of very accomplished motion picture artists, exciting and fantastic scenes can be created through the use of background paintings called **matte paintings.** This type of special effect was employed frequently in such films as the *Indiana Jones* movies as well as the *Star Wars* films. Software has been developed that makes it possible for the computer to control several video-tape recorders automatically. Many recent movies have used this process to produce dazzling special effects. In some cases special effects that have been around for a long time have been improved through the use of computers. For instance, live action involving actual actors has been blended with animated characters in several films, but never as successfully or as realistically as in the Disney movie, *Who Framed Roger Rabbit.* The difference between past attempts at this special effect and the success of *Roger Rabbit* was the use of sophisticated computer hardware and software.

Computerized special effects have also become an important part of another form of popular entertainment—the theme park. For instance, a system called audio-animatronics is used to make life-like characters actually move around a stage and deliver appropriate dialogue.

Whether at the movies, in a theatre, or at the theme park, it is important to remember that art and design play an important part in all forms of entertainment, not just those that use special effects. What you have learned and

Figure 230. *Who Framed Roger Rabbit* **successfully blended live actors with animated characters.** Courtesy of Gamma-Liaison. Photo by Christopher Lloyd.

what you will learn as you continue to study art will help you get the most enjoyment from any form of entertainment. Additionally, if you seek a career in an entertainment field you will probably find your knowledge of the basic elements and principles of art to be of immense value.

Activity 2—Special Effects In this activity you will research the history of special effects in motion pictures and make a videotape report to the class. This can be an individual or a group project. You will prepare a short script which will accompany several motion picture examples on videotape. You will pre-set the various films to the segments you want to use to make your points, before copying the relevant portions.

Many early special effects appear ridiculous to us today, but they will add interest to your presentation. In the early part of the twentieth century audiences would scream in horror if they saw a train coming directly at them on the screen. You might want to use one early example of special effects in silent films such as Douglas Fairbanks wrestling with a giant rubber squid in *The Thief of Baghdad.*

Figure 231. A scene from *King Kong* which broke new ground in special effects in 1933. *King Kong.* 1933. RKO Radio Pictures (Merian C. Cooper). Courtesy of the Museum of Modern Art/Film Stills Archive.

MGM's 1952 musical entitled *Singin' in the Rain* is a spoof of movie-making techniques in the 1920s. A useful scene in the first half of the film shows the two principal characters walking through several sets. In one of these you can see an early special effects man hand-cranking scenery which rolls by two men fighting on top of a train. If possible, show a segment from *King Kong* (RKO 1933), the movie in which modern special effects were born (see Figure 231). Disney's *Fantasia* (1940) was a landmark for several reasons. In the history of special effects it is important because Mickey Mouse shook hands with a live character, the famous conductor Leopold Stokowski. It was the first time live action was combined with animation.

Bring this last point up to date with a short segment of *Roger Rabbit* to illustrate modern techniques for interaction of animation with live action. Continue with particularly

good examples of spectacular special effects from today's films.

The films selected above are excellent examples, but they are only suggestions. You should begin your research by reading an article about motion pictures in a good encyclopedia and go on to the many books on motion picture history.

APPENDIX

A BRIEF HISTORY OF ART

ANCIENT ART

The history of art begins approximately 30,000 years ago, during a period called the **Paleolithic** (pay-lee-oh-lith'-ic) Age. *Paleo* comes from a Greek word which means "ancient," and *lithic* means "stone" in the Greek language. In this age, human beings made pictures deep in caves, and many of these pictures survived (Figure A-1). Thus part of that ancient world was captured for posterity.

Cave paintings were not discovered until late in the nineteenth century. There was much speculation about what they were, who painted them, and when they were painted. In these paintings, animals were rendered in great detail, while people were represented as stick figures, such as a pre-school child might draw. Powerfully rendered animals dominated the pictures, and many believe that the pictures were part of the ritual of the hunt for the nomadic people of the Paleolithic Age.

The **Mesolithic** (meh-zoh-lith'-ic) Age (8000 B.C. to 3000 B.C. followed the Paleolithic. *Meso* means "middle" or "between" in Greek. During this period, people began congregating in areas where food gathering was possible. This simplified their lives, and led to the first efforts to raise crops.

The **Neolithic** (nee-oh-lith'-ic) Age (3000 B.C. to 1500 B.C.) followed the Mesolithic. As you might guess, *neo* means "new'. In this age, there was steady progress in many cultural areas. The Stone Age ends in this period, as the people in four fertile river basins of the ancient world began what is now termed a "civilization". We will look at the culture of these four river civilizations, and then look at the beginnings of art in Africa and the Western Hemisphere.

Mesopotamia—The Tigris and Euphrates River Civilizations

The Greek word for "between rivers" is *Mesopotamia* (mess-uh-poh-tay'me-uh). The settlement of the land between the river valleys of the Tigris and Euphrates Rivers consisted of many villages. As the people learned to control the flooding in the area, their way of life was greatly improved. The small villages prospered and grew. The people were thankful for their prosperity and believed they were blessed by gods who made their crops grow. They worshipped the sun god, the water god, the earth god, the moon god, and others.

Figure A-1. Cave painting.
Group of Stags. Caves at Lascaux. c.
15,000-13,000 B.C. Dordogne, France.
Art Resource, N.Y.

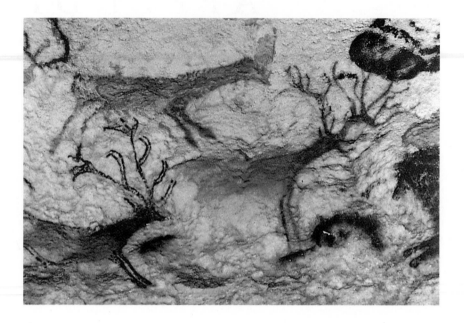

Their art reflected these religious beliefs. The Mesopotamians built enormous temples called **ziggurats** (zig'-uh-rats) (Figure A-2). Dedicated to a god, these mud brick temples could be seen for many miles over the flat plains between the two rivers. Inside, these structures were lavishly decorated with fresco paintings and sculptures.

The history of this civilization was a bloody one. It was in constant danger of being overrun by invaders who lived under harsh conditions in the surrounding desert. Many remaining Mesopotamian relief carvings depict battle scenes.

The Nile River Civilization

The vast desert which surrounded the Nile provided a fair measure of protection from invasion for the area and for the Nile's life-giving water. So, along this long valley of the Nile, many quite similar settlements began. The entire Nile valley gradually became one large community. The need for dams and levees for flood control led to the rise of powerful leaders who could organize such large projects. This unification occurred around 3000 B.C. High priests of the Nile dictated the religious art of the region. Later, the art also became political, much of it dedicated to celebrating the achievements of the great monarchs. Most of the art was created for the tombs of these

monarchs. We have seen examples of Egyptian tomb painting and relief sculpture in Book One on pages 61, 63, and 241. An enormous amount of labor was required to construct these tombs, which we know as the Pyramids of Egypt.

The Indus Valley Civilization

The Indus Valley civilization began around 3000 B.C. and flourished in Southwest Asia for many hundreds of years. About 1800 B.C. it was overrun by invaders from nomadic tribes. During the time of this civilization there were truly great civic accomplishments, such as wide thoroughfares, piped fresh water, elaborately decorated public pools, and drains for waste removal and flood control. Brick homes were common, and these were built with fired brick rather than the sun-dried bricks used in Mesopotamia.

The scale of the art was smaller and of a more personal nature than that of the other river civilizations. Gold, silver, and semiprecious stones were commonly used. Two distinct types of sculpture are evident. One was formal and rather stiff in design and execution. It is generally believed that the subjects depicted in this style were the holy men of the Indus civilization. In total contrast, the other style was quite informal, with natural, lifelike poses. The informal style was an important

Figure A-2.
A Mesopotamian Ziggurat.
View from the southeast of the partially restored Third Sumerian Dynasty Ziggurat at Ur. c. 2100 B.C. The Granger Collection, New York.

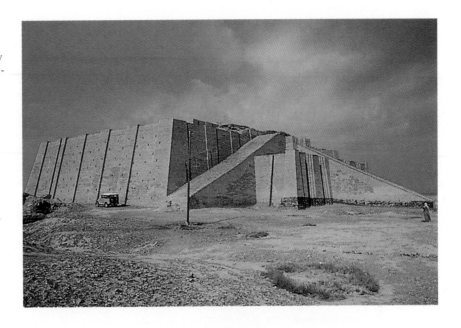

influence on the sculpture of India for many centuries to follow.

The Yellow River Civilization

The development of the Yellow River basin cultures was somewhat different. Neolithic artisans had made fine pottery and carved jade since approximately 4000 B.C. The Bronze Age began in China around 2200 B.C.

Dynastic rule began on the Yellow River. A **dynasty** is a succession of rulers of the same line of descent. Chinese art is classified by the dynasty in which it was produced. The oldest surviving artifacts in bronze come from the Shang Dynasty. This is the first dynasty about which a great deal is known. It began around 1700 B.C. The bronze casting of the Shang Dynasty is unsurpassed (Figure A-3). Shang artists also worked in jade and marble. There are some excellent examples in Book One on pages 114 through 116.

Chinese civilization is unique in that a clear path can be traced almost as far back as the earliest use of bronze in China (2200 B.C.) to the present. For nearly 4,000 years, Chinese art has survived and kept many of the virtues which we see in the Shang Dynasty. It has survived because of its ability to absorb the new while honoring the traditions of the past. It has a unique flexibility. Consider, for

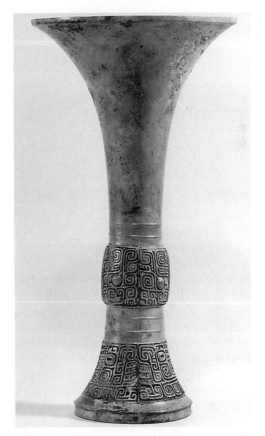

Figure A-3. Bronze vase from the Shang Dynasty. *Ku: Wine Beaker,* late Shang period, China. 13th - 12th century B.C. Bronze. Height 10 9/16". The Cleveland Museum of Art. John L. Severance Fund.

Understanding and Creating Art—Timeline 1

	Paleolithic		**Mesolithic Period**	
	30,000 B.C.	8000 B.C.	4500 B.C.	4000 B.C.
Cultural, Political Events		● Agriculture begins in Mesopotamia ● *Nomadic Tribes* Dog domesticated (8400) Earliest remains of towns	● Agriculture begins in China, Africa	● Rice farming in China (4000)
Scientific Technological Events	● Sahara Desert is Green ·〉		● First date in Egyptian calendar (4236)	● Earliest date in Jewish calendar (3760) Earliest known ● numerals in Egypt (c. 3200) ● Period of terrible flooding in Mesopotamia
Visual Arts	● Decorated Utensils ● Cave Art			● Chinese Pottery and Jade Carving Begin

example, the Chinese sages who simultaneously admire the bamboo for its ability to bend without breaking, and jade for breaking without bending.

The Beginnings of Art in Africa

The first art in Africa was that of cave dwellers. Thousands of years later, the great Nok culture developed in Northern Nigeria. With the Nok culture began the long tradition of sculpture in Africa. The Nok culture is unusual in that it bypassed the Bronze Age entirely. Iron smelting had developed fully in the Nok culture by 1000 B.C. Nok artists made terra cotta figures of monkeys, snakes, and many other animals of the region. These figures are generally found with iron-working equipment. The Nok created human images that are particularly significant for their individuality. The personality of each subject is communicated powerfully. The quality of the work of the Nok artists indicates that there must have been a long tradition of sculpture. In the third century B.C., the Nok culture vanished, leaving few traces. However, the style and individuality of Nok art influ-

Figure A-4. This is a fragment; only the nose and mouth remain. Fragment of the face of a tubular head. Tonga Nok. c. 500 - 400 B.C. Terracota. Height 6 1/4". Jos Museum, Nigeria. Courtesy Nat'l. Comm., of Museums and Monuments, Lagos.

Neolithic Period

| 3000 B.C. | 2500 B.C. | 2000 B.C. | 1500 B.C. | 1000 B.C. |

- Old Kingdom begins in Egypt (2850)
- Ancient Yao dynasty in China (ends in 2300) replaced by By Shun (2300 to 2205) and Hsai (2205–1760)
- Indus Valley Civilization wiped out (1850)
- Olmec civilization begins in Mexico (1150)
- Shang dynasty begins (1760)
- Nok civilization in Nigeria (1000)
- Early Greeks migrate westward to Mediterranean
- Troy destroyed by Greeks (1193)

- Potter's wheel used in Mesopotamia (c. 3000)
- First calendar of 365 days in Egypt (c. 2772)
- Equinoxes and solstices determined in China (c. 2200)
- Egyptians use right angles
- Sundials in Egypt
- Horses used to pull vehicles
- Iron smelting (Nok civilization in Africa, Syria, Palestine)
- River civilizations well organized, running water, fired brick
- Floods in Egypt used for irrigation (c. 1800)
- First dictionary (China) (1100)
- Bronze (alloy of copper and tin)
- Flood control in river civilizations

- King Zoser's pyramid (2800)
- Great Ziggurat at Ur (2100)
- Stonehenge built in Britain (1860)
- King Tut's pyramid (1361)
- Bronze Age begins in China and Europe (c. 2200)
- Temple at Karnak in Egypt (1280)
- Shang bronze and pottery period begins (1700)
- Fresco, sculpture in Egypt, Indus valley, Mesopotamia
- Silk fabrics in China
- Tapestries in Egypt

enced all African art to come (Figure A-4) and, as we will see, had an important role to play in twentieth century art.

The Beginnings of Art in the Western Hemisphere

In what is now Central America, a culture based on hunting and foraging was slowly replaced by a culture based on the raising of a form of corn called maize. This process began around 7000 B.C. By 1500 B.C. there were settled agricultural villages in the region known today as Mexico.

The Olmec civilization evolved in southwestern Mexico. It is considered the "mother culture" of the pre-Columbian world. (The term *pre-Columbian* refers to the New World before the coming of the Europeans.) During the six hundred year period from 1150 to 500 B.C. the Olmec culture thrived. Its influence was felt throughout the large area now known as Mexico.

Olmec images that survive today are almost all of human beings, and most particularly of the human head. The astonishing size of these pieces,

and the extreme hardness of the stone used to create them, make the Olmec artists seem almost superhuman. We can only speculate about the purpose of these enormous carved heads which the Olmec people somehow transported sixty miles from their quarries.

Heads, such as the one you see in Figure A-5, are the best known Olmec works, but there are many fine smaller pieces of Olmec art in museums around the world. If you can remember what this head looks like, you will probably be able to recognize Olmec pieces wherever you encounter them.

INTERLUDE

Histories of the visual arts have traditionally concentrated on European (or what is often called Western) art, tracing its traditions from ancient Egypt to Greece, then Rome, the Middle Ages, the Renaissance, and on to the latter part of the nineteenth century. By that time, outside influences on Western art become too important to ignore, but before the late 1800s non-Western art is often

Figure A-5. A giant Olmec head.
Colossal *Olmec Head* c. 800-600 B.C. Mexico. Basalt. Height approximately 6 feet. San Juan, Teotihaucan. Museo Jalapa. Foto Films/Art Resource, N.Y.

ignored. There are two problems with taking such an approach to the history of art. The first is that without some appreciation of non-Western traditions in art it is hard to understand why they had such an impact on Western art. Second, this approach assumes that the traditions of non-Western art are of less importance than Western traditions, that they are too hard to understand or are, in some way, inferior. As you will discover, this is not so.

We will now look briefly at Western art traditions from the time of the ancient Egyptians to the last part of the nineteenth century. Then we will study the art traditions of non-Western civilizations for the same period. During this long period, there was contact among the many great world civilizations. However, the results of the contact were much more important in the fields of commerce than in art. The artistic traditions of European, African, Asian, and Native American art were the result of the genius of the people in these various cultures. The traditions were developed within the separate cultures without highly significant outside influences. Important exceptions will be noted.

In the final section, we will weave all of the threads together, and explore the impact of these diverse traditions on one another in the age of world-wide communication.

WESTERN ART

The Egyptians

Around 2800 B.C., the period known as the Old Kingdom of the Nile was maturing. The royal architect, Imhotep, created a monumental funeral district for a King named Zoser. Among the palaces, temples, and other assorted structures built for Zoser's resting place was the first pyramid, a monument designed to last forever.

Forever was an important concept for the ancient Egyptians. They believed that, when a person died, the spirit left the body temporarily but would return. Upon returning, it would need a body to return to. Then the body, and its returned spirit, would need his or her personal belongings.

The average person had very few personal possessions, but for royalty the number of possessions posed quite a problem. Kings' tombs had to be carefully planned to hold royal treasures for the king's use and enjoyment through eternity. A problem remained, however. No matter how huge the burial chambers and storage rooms, they could not hold all that the monarch had accumulated. To compensate for this the kings hired artists to make pictures of their palaces, land, livestock, pets, and other personal possessions. Such things were depicted on the walls of their pyramids along with scenes of their triumphs in life. The ornate coffin of an Egyptian king appears on page 198 of Book One.

Egyptian art became highly stylized over thousands of years. There are several examples in Book One on pages 61–65. The sameness of Egyptian life and art over a period of 4,000 years is quite remarkable. There were successful invasions from time to time; there were benevolent rulers and terrible despots; but the average person continued to till the fields and was occasionally obliged to help in an enormous community effort or building project. We have learned a great deal about the Egyptians, their traditions, and their culture. They invented a system of picture writing called hieroglyphics (high´-er-o-glif´-icks), and they invented ink. Many of the pyramids and temples have been looted through the centuries; but many remain, and the wealth of art that they hold tells us much about the people of ancient Egypt.

The Glory of Greece

In a period of approximately three hundred years, the remarkable people of Greece provided the foundation of Western art, politics, science, and philosophy. The Greeks acknowledged that their civilization was a continuation of the Mesopotamian and Egyptian civilizations that came before them. The difference is in the way the Greeks developed their traditions.

Development is a good word to remember when you think of the Greeks. They boldly experimented and quickly adopted and adapted new ideas. For example, the oldest surviving Greek statues are carved from marble (Figure A-6). We know that these statues were an adaptation of still older wooden statues which have not survived the ages.

Figure A-6. Early Greek statue of Hera.
Hera from Samos. c. 560 B.C. Marble. Height approx. 6´4˝. Louvre, Paris. Courtesy Cliché des Musées Nationaux, France. ©Photo R.M.N.

Figure A-7. The graceful Nike of Samothrace.
Nike of Samothrace. Greece. c. 190 B.C. Marble. Height approx. 8'.
Louvre, Paris. Courtesy of Cliché des Musées Nationaux, France.
©Photo R.M.N.

How do we know this? The earliest marble statues are straight and tall and the poses are wooden. They look as though they were carved from the trunk of a tree. Typically, the Greek artists developed their sculpture from early woodenness into graceful, natural poses. The Greek sculptors took advantage of the different sizes of the blocks of marble. We can see this development by looking at figures A-6 and A-7.

The Greeks strove constantly for perfection in all of the arts. The proportions of their architecture have been copied throughout the centuries. Greek sculpture of the human body achieved almost perfect proportions, and these idealized figures were used by athletes as models for the development of a more perfect body. From rather crude beginnings, all of the fine arts were transformed in the short

history of these remarkable people to examples which are the foundation of Western civilization.

In 404 B.C., after a war that lasted for a generation, the great, enlightened city-state of Athens was defeated by the uninspired Spartan city-state. The glorious days of Greece were ended. Alexander the Great conquered the known world, and Greece fell in 323 B.C. A group of great Mediterranean sailors called Etruscans spread the art of Greece throughout the area and to the Roman Empire. Rome was to "liberate" Greece in 146 B.C., and Rome was to conquer the world.

The Grandeur of Rome

Roman art was so heavily influenced by the art of Greece that scholars have only recently given the Roman artists the credit due to them for their originality. Greek statues had been carted off to Rome and copies had been made from molds. While there is no doubt that Grecian art was the strongest influence on Roman art, the Romans developed a more natural style than that of the Greeks. A tradition in Roman households was to keep death masks of their ancestors, which were, of course, very realistic. This tradition led to more realistic portrayals in art, as opposed to the highly idealistic ones in Grecian art. An example of this realistic style is Figure A-8.

The Romans were among the great builders of history. Many of the bridges, roads, buildings, and aqueducts of the Roman Empire still exist. They may be found throughout Europe. The Roman invention of concrete made much of their construction possible. Shortly after the time of the birth of Christ, the Colosseum was completed. This immense structure held 87,000 spectators. Roman architects had perfected the arch and the barrel vault. They then combined multiple arches and intersected them around an axis which resulted in a dome. In homage to Roman gods, the great domed Pantheon was completed in A.D. 125. To enter the interior of the Pantheon is an unforgettable experience. The huge circular floor is topped by a sphere. The diameter of the interior and the height of the dome are the same, 144 feet. Try to envision this. It is almost one half the length of a football field. The weight of the dome is supported not only by the thick walls, but also by arches hidden in the walls by the architects.

The well-chronicled fall of the Roman Empire was more of a gradual erosion than a sudden fall. The Empire had become so widespread that governing it and protecting its borders became too big a burden for a city-state form of government. The city of Rome itself fell to barbarians called West Goths (also called Visigoths) in A.D. 410.

The Middle Ages

After the fall of the Roman Empire, a period of migration began. People wandered, searching for a place with some stability. There was precious little security for those who inhabited the former provinces of the Roman Empire. It was a world in ruins. The once great highways were decaying; the old order lay in chaos. What remained of classical Greek and Roman manuscripts gathered dust in abbeys and monasteries. These were the "Dark Ages," and they lasted for almost four centuries.

There were only a few lights in this darkness, but they were important lights. St. Benedict began building monasteries. His "Foot Soldiers of Christ" brought a measure of protection to the countryside. Those who had talent and ambition entered the Church. The Benedictines took in the needy, cared for the sick, and grew crops. Their followers grew in numbers, and new churches were needed. Naturally, the builders made use of a style that they knew. Many featured the Roman arch, and some were domed in the style of the Pantheon. However, new churches became increasingly larger.

During the eighth century the system of *feudalism* began. In this system the peasants (called *serfs*) worked the land for their lords, and the lords provided vital protection. Eventually, feudalism produced a calmer environment in Europe, in which towns were created and grew. The larger communities had tradespeople, and trade among communities became common. This rustic trading economy evolved into a money-based economy. Craftspersons became numerous and highly specialized; they formed guilds, which established professional standards for membership. The small, Romanesque churches began to be replaced by cathedrals (See Figures A-9 and A-10).

In 1144, the Abbot of St. Denis, a monastery near Paris, played an important part in architectural history. The abbot, named Suger, decided to enlarge his monastery in a very unusual way. The

Figure A-8. Roman sculpture was very realistic. Bust, presumably of the Roman general Sulla. (c. 138-78 B.C.) Marble. Lifesize. Venice, Museo Archeologica. Scala/Art Resource N.Y.

builders Suger selected introduced a new skeletal type of construction—ribbed vaults. This construction method included the creation of windows. Suger believed the divine radiance of heaven poured in with the light these windows admitted.

A new style of architecture spread, as civic pride resulted in funds to construct similar cathedrals in many parts of Europe. This meant work for architects and stone masons. The high spires of the cathedrals were raised to the glory of God. Ironically, their architectural style was named *Gothic* as a scornful criticism. The Italian critic Vasari thought it wrong to deviate from established Romanesque building traditions. He gave the style the name of

Understanding and Creating Art—Timeline 2

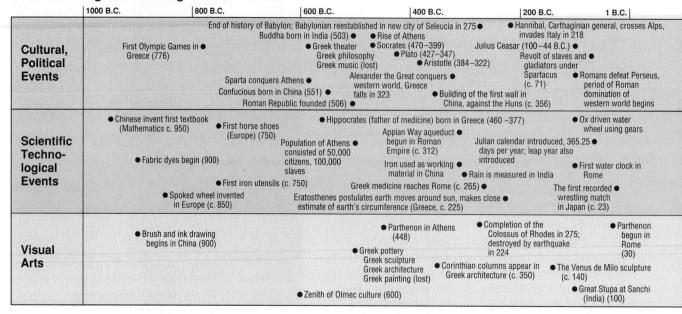

	1000 B.C.	800 B.C.	600 B.C.	400 B.C.	200 B.C.	1 B.C.
Cultural, Political Events		First Olympic Games in Greece (776) ●	Buddha born in India (503) ●; ● Rise of Athens; ● Greek theater; Greek philosophy; Greek music (lost); Socrates (470–399) ●; Sparta conquers Athens ●; Confucious born in China (551) ●; Roman Republic founded (506) ●	End of history of Babylon; Babylonian reestablished in new city of Seleucia in 275 ●; Plato (427–347) ●; ● Aristotle (384–322); Alexander the Great conquers ● western world, Greece falls in 323; Building of the first wall in ● China, against the Huns (c. 356)	● Hannibal, Carthaginian general, crosses Alps, invades Italy in 218; Julius Ceasar (100–44 B.C.) ●; Revolt of slaves and ● gladiators under Spartacus (c. 71)	● Romans defeat Perseus, period of Roman domination of western world begins
Scientific, Technological Events	● Chinese invent first textbook (Mathematics c. 950); ● Fabric dyes begin (900); ● Spoked wheel invented in Europe (c. 850)	● First horse shoes (Europe) (750); ● First iron utensils (c. 750)	● Hippocrates (father of medicine) born in Greece (460–377); Population of Athens ● consisted of 50,000 citizens, 100,000 slaves; Eratosthenes postulates earth moves around sun, makes close ● estimate of earth's circumference (Greece, c. 225)	Appian Way aqueduct begun in Roman Empire (c. 312) ●; Iron used as working ● material in China; Greek medicine reaches Rome (c. 265) ●	● Ox driven water wheel using gears; Julian calendar introduced, 365.25 days per year; leap year also introduced ●; ● Rain is measured in India; ● First water clock in Rome; The first recorded ● wrestling match in Japan (c. 23)	
Visual Arts		● Brush and ink drawing begins in China (900)	● Zenith of Olmec culture (600)	● Parthenon in Athens (448); ● Greek pottery; Greek sculpture; Greek architecture; Greek painting (lost); ● Corinthian columns appear in Greek architecture (c. 350)	● Completion of the Colossus of Rhodes in 275; destroyed by earthquake in 224; ● The Venus de Milo sculpture (c. 140); ● Great Stupa at Sanchi (India) (100)	● Parthenon begun in Rome (30)

the barbaric Goths who sacked Rome. The name survived, but the scorn was forgotten, and the Gothic style prevailed.

Stained glass bathed the interiors of Gothic cathedrals with a jeweled radiance. These glowing colors influenced artists producing illuminated manuscripts in monasteries. The windows took up much of the interior space formerly devoted to fresco painting and tapestries. Because they no longer had the great wall expanses of the Romanesque churches, painters were forced to seek other surfaces, such as wood and canvas, on which to paint.

Romanesque art had, for centuries, depicted the insignificance of the human being, in contrast with the concept of an all–powerful God. People of the time saw life as a preparation for the hereafter. The citizens of a Gothic city, while still glorifying God, were able to look around and enjoy some aspects of the world in which they lived. The groundwork was being laid for the great flowering of the human spirit we call the Renaissance (ren'-uh-sahns).

The Renaissance

Renaissance is a French word meaning "rebirth." The humanism of St. Francis, one of the most

Figure A-9. A Romanesque church. Main facade and entry, *Notre Dame la Grande*. 12th century A.D. Poitiers, France. Giraudon/Art Resource, N.Y.

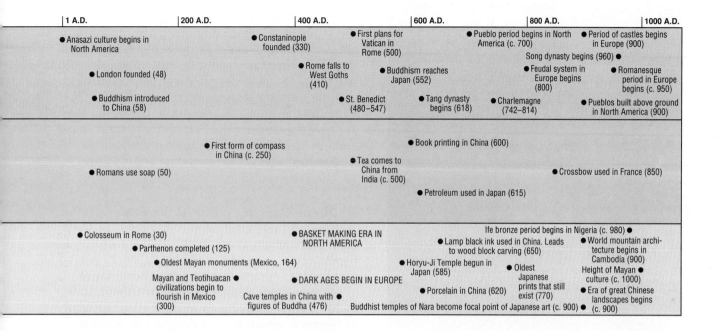

Timeline (1 A.D. – 1000 A.D.):

- Anasazi culture begins in North America
- Constantinople founded (330)
- First plans for Vatican in Rome (500)
- Pueblo period begins in North America (c. 700)
- Period of castles begins in Europe (900)
- Song dynasty begins (960)
- Rome falls to West Goths (410)
- Buddhism reaches Japan (552)
- Feudal system in Europe begins (800)
- Romanesque period in Europe begins (c. 950)
- London founded (48)
- Buddhism introduced to China (58)
- St. Benedict (480–547)
- Tang dynasty begins (618)
- Charlemagne (742–814)
- Pueblos built above ground in North America (900)
- First form of compass in China (c. 250)
- Book printing in China (600)
- Romans use soap (50)
- Tea comes to China from India (c. 500)
- Crossbow used in France (850)
- Petroleum used in Japan (615)
- Colosseum in Rome (30)
- BASKET MAKING ERA IN NORTH AMERICA
- Ife bronze period begins in Nigeria (c. 980)
- Parthenon completed (125)
- Lamp black ink used in China. Leads to wood block carving (650)
- World mountain architecture begins in Cambodia (900)
- Oldest Mayan monuments (Mexico, 164)
- Horyu-Ji Temple begun in Japan (585)
- Oldest Japanese prints that still exist (770)
- Height of Mayan culture (c. 1000)
- Mayan and Teotihuacan civilizations begin to flourish in Mexico (300)
- DARK AGES BEGIN IN EUROPE
- Porcelain in China (620)
- Era of great Chinese landscapes begins (c. 900)
- Cave temples in China with figures of Buddha (476)
- Buddhist temples of Nara become focal point of Japanese art (c. 900)

Figure A-10. A Gothic cathedral. West facade of *Salisbury Cathedral.* Begun c. 1220 A.D. Granger Collection, New York.

beloved of medieval saints, was combined with a renewed interest in the Greco-Roman spirit, which emphasized the importance of this world. The individual regained importance in everyday thought, life, and art. A family named Medici became very wealthy and powerful in Florence, Italy. The Medici, the rulers of the city, supported art and scholarship as patrons with a generosity that had not been seen before. (Nor has it been seen since.)

Around 1440 Cosimo de Medici built the first public library since ancient times. Cosimo's grandson, Lorenzo the Magnificent, presided over the "Golden Age" of Florence, and made it a city of unsurpassed beauty and splendor. After Lorenzo died in 1492, Florence, successfully invaded by France and Spain, fell. The Medici were expelled and the Renaissance moved from Florence to Rome. But the influence of the Medici did not end. Lorenzo's son became Pope Leo X, and Leo X was the patron of Raphael and Michelangelo.

Titans of the Renaissance

Leonardo Today we occasionally speak of a person who has a variety of interests and talents as a "Renaissance man." No one in history embodies

Figure A-11. The legendary *La Giaconda* (Mona Lisa). Leonardo da Vinci. *Mona Lisa.* About 1503-05. Oil on panel. 30 1/4" x 21". The Louvre, Paris. Courtesy Cliché des Musées Nationaux, Paris, France. © Photo R.M.N.

this ideal better than Leonardo da Vinci. Scholars have said that his genius was so colossal that it defies understanding. Leonardo believed that it was possible for art to provide a source for scientific understanding. Because artists are the best observers, Leonardo said they were the best equipped to investigate the natural world. His work shed light on an astounding number of disciplines, including botany, zoology, anatomy, light theory, mechanics, and weaponry. He drew designs for an enormous range of proposed inventions, such as underwater diving bells, aircraft, various weapons (including a stink bomb), and chariots. All of his scientific investigations, he said, were aimed at making him a better painter.

We have seen his great painting of *The Last Supper* in Book One (page 101). This painting is the standard by which any other painting on this subject must be judged. In spite of the deteriorating condition of the painting, it is still possible to marvel at the magnificent drawing of each head and the dramatic impact of the scene. Locate the vanishing point, and consider the logic of it. Leonardo's *La Giaconda* (*Mona Lisa*) is also legendary. The obvious relaxation of the subject as well as the expressiveness of the hands makes this a landmark in portraiture. See Figure A-11.

Raphael Raphael enjoyed the patronage of wealthy and powerful people. Although he lived only thirty-seven years, he lived like a prince, a happy, social man-of-the-world. Raphael's paintings typify the grand manner of the Renaissance.

He was born Raphael Sanzio in Urbino, Italy, in 1483. After studying art in three cities, he went to Florence, where he met the great architect Bramante. Bramante was so impressed by the artistic abilities of the young man that he took him to Rome to work for Pope Julius II. Julius died soon after and was succeeded by Leo X, a Medici, as you recall. Leo, who immediately recognized the talent of Raphael, was a good man for Raphael to find favor with. As a Medici, Leo was not against spending some money.

Raphael was influenced by Leonardo and Michelangelo. His madonnas have been acclaimed for their dignity, grace, and sweetness. The soft modeling of his madonnas reflects Leonardo's *Mona Lisa*. Raphael was known as "Il Divino Pittore"—the divine painter. When Bramante died, Raphael was named architect-in-chief of St. Peter's Cathedral, but he did not live to execute his ideas.

Raphael was greatly loved. When the "prince of painters" died, all Rome wept at his funeral.

Michelangelo If Raphael loved society, Michelangelo was his opposite. Raphael said that Michelangelo was "as lonely as a hangman." The words often used to describe Michelangelo are *intractable, irascible, tormented, impatient*—impatient with himself as well as others. He was totally devoted to his art, and completely confident in his work. He was a painter, poet, architect, and engineer, but considered himself a sculptor. He believed sculpture to be a superior calling, for a sculptor could, he

said, somehow share in the divine power to "make men."

Unlike Leonardo, Michelangelo did not trust mathematical method. To achieve proportion he felt that one must "keep one's compass in one's eyes and not the hand, for the hand executes, but the eye judges." His art departs from the strict form of the Renaissance, but then Michelangelo's art departs from all other art. It has great expressive strength and a sense of tragic grandeur. *Terribilita* is the word for this in Italian—the sublime combined with the fearful and awesome.

Michelangelo created works that defy the greatest writers' description. A detail of his Sistine Chapel ceiling painting appears on page 230 of Book One. The moment pictured, when the spark of life jolts into Adam from the hand of God, can only be appreciated; it cannot be described or duplicated. Michelangelo's *The Last Judgment*, another immense work (48 by 44 feet), is probably the most famous painting in Rome.

Michelangelo's seventeen-foot-tall statue of *David*, completed in 1504, was a direct link back to the Greek artists, with their sense of balance, proportion, and the beauty of the human form. It established Michelangelo as the most famous artist in Italy. He stands as a lonely colossus in art, striding across the centuries, the supreme genius whose work lives forever.

This was the Renaissance.

Figure A-12. Bronzino's cool, refined *Portrait of a Young Man.* Bronzino, *Portrait of a Young Man.* c. 1550. Oil on wood panel. Approx. 37 5/8" x 29 1/2". Metropolitan Museum of Art, New York. (H.O. Havermeyer Collection, bequest of Mrs. H.O. Havermeyer, 1929.)

Mannerism

Critic Giorgio Vasari, who coined the name Gothic, also originated the term *La Maniera (The Manner)* for describing the works done according to the high classical standards of the Renaissance. This term assumed a different meaning between 1520 and 1600. Painters who were known as **Mannerists** believed in a strong personal interpretation of compositional rules in painting. (Figure A-12). Works began to appear with the human figure idealized or somewhat abstracted. This led to distorted and elongated figures and unreal effects, which often appeared supernatural. For example, see El Greco's *View of Toledo* on page 93 of Book One. Mannerists used new color combinations which were a great departure from the rich hues of the grand masters of the Renaissance. Unusual combinations of violet, sea-green, light blue, rose, and lemon-yellow seem to shimmer in the works of the Mannerists. By the late sixteenth century, Mannerism had trouble developing further in color variations and in distortion. It was succeeded by a wondrous period in art, the Baroque.

Baroque

Baroque (buh-roke') was a term scholars used to describe any tedious piece of reasoning in the Middle Ages. Today, we recognize the vitality and greatness of the age of the Baroque. The period of the Baroque lasted from approximately 1600 to the early 1700s. During this period, the technical skills of artists were pushed to their limits; many feel that nothing has surpassed the art of the Baroque. It expresses the profound hopes and fears of its time, as well as the extremes of human emotion.

Figure A-13. Bernini's *David*. Gianlorenzo Bernini, *David*. 1623. Marble. Life-size. Galleria Borghese, Rome. SCALA/Art Resource, N.Y.

Everything about the Baroque seemed to be on a grand scale. A good place to begin is the architecture. King Louis XIV of France came to the throne at the age of five in 1643 and ruled for seventy-seven years. He built a great palace at what had previously been the royal hunting lodge at Versailles (vur-sigh'). This palace was a symbol of absolute power.

Baroque buildings were a combination of Greco-Roman style and Baroque enthusiasm. In architecture everything was sacrificed to dramatic effect, including convenience. For example, the kitchen at Blenheim Palace in Oxfordshire, England, lay 400 yards from the dining room.

There are many great artists of the Baroque period. In painting, their styles varied considerably, but a common characteristic was the use of light and darkness for effect. Look at the classroom reproductions of Velásquez´ *Maids of Honor* and Rembrandt's *Self Portrait*. Sculptors used space in a way that it had not been used before. Here we will

consider two particularly interesting Baroque artists who seem to capture the very essence of the period: Bernini and Rubens.

Gianlorenzo Bernini (bur-nee'-nee) was a technical virtuoso. He captured strong emotion in his work. As he prepared to carve his *David* (Figure A-13), Bernini spent days in front of his mirror looking at his own face again and again, trying to get the exact expression he wanted to put on David's face. Look at David. Do you think Bernini achieved the expression he wanted?

Let's consider why this work is so typically Baroque. First it is heroic. It demands its own space, and it also demands the space around it. Bernini selected the most dramatic instant in the story and gave us the one pose in a sequence that can be followed in our mind's eye. It demands the space for David to complete the action of hurling that stone at Goliath. Can you imagine this piece in a small niche in a corner? Energy bursts from David and flows toward his adversary. We can catch the entire story at first glance and then take the time to marvel at the artist's virtuosity.

Peter Paul Rubens was ideally suited for the bold age in which he lived. Rubens grew rich from his art but never lost his disciplined, amiable nature. He loved life, his fine home, his family, and his work. He was assisted by several apprentices in his studio who often finished details in his paintings. Rubens's output was enormous. He painted with spirit—big canvases for the big Baroque palaces. Like Raphael, Rubens was a successful and happy artist and man-of-the-world. His painting, *The Lion Hunt* (Figure A-14), is an example of the extravagant activity of the Baroque, which broke away from the tensions of the Mannerists.

Rococo

The word **rococo** (ruh-koh'-koh) is derived from the French word **rocaille** which means "little pebbles" or "shells." It is an appropriate name for this period of art, whose intricate designs remind us of the intricacies of a shell.

Louis XIV died in 1715 after seventy-seven years of rule in France. After his death, the court at Versailles was almost abandoned as people left this shrine to the emperor to build town houses in the city. Paris was the social capital of Europe in the eighteenth century. There has never been

Figure A-14. Rubens' extravagant painting, *The Lion Hunt.*
Peter Paul Rubens, *The Lion Hunt.* 1617-18. Approx. 8' 2" x 12' 5". Alte Pinakothek, Munich.

another period with such a focus on interior decoration. Famous, and not-so-famous, painters decorated the walls and ceilings of these homes. There were delicately carved portals, huge crystal chandeliers, and many elaborate mirrors. The paintings of the best known artists of the day were full of gaiety and color, showing laughing people enjoying themselves.

Louis XV replaced Louis XIV and reigned in France until 1774. The young king who then assumed the throne, Louis XVI, was uninterested in his official responsibilities. Meanwhile, the peasants and the citizens of Paris had become increasingly bitter about their poor living conditions and what they considered the excesses of the aristocracy. The Rococo period ended abruptly with the French Revolution of 1789. It had been in some ways the most trivial period in European history, and in some ways the most civilized.

We should not leave the Rococo period without noting the music of this time, which was far from trivial. The foundation for all modern music had been laid by the great Baroque master Johann Sebastian Bach (bahk). The composers of the Rococo period built their miraculous creations on Bach's foundation. Joseph Haydn was the father of the modern orchestra. Christoph Willibald Gluck revolutionized opera by creating strong plots and characters and simplifying the music. The immortal Wolfgang Amadeus Mozart (mote-sart) also composed during this period. Perhaps you can take

Figure A-15. The Rococo style is evident in this interior view of the Hôtel de Soubise in Paris. Gabriel-Germain Boffrand (18th Century), Salon della Principessa, Hôtel de Soubise, Paris. Photo courtesy SCALA/Art Resource, New York.

the time to listen to two compositions that will tell you more about the differences in Baroque and Rococo than words ever could. If you can, compare the thunder of Bach's *Toccata and Fugue in D Minor* to the exquisite strains of Mozart's *Concerto in E Flat Minor.*

Understanding and Creating Art—Timeline 3

	1,000 A.D.	1100 A.D.	1200 A.D.	1300 A.D.	1400 A.D.
Cultural, Political Events	● Macbeth defeated at Dunsinane, Scotland (1054) ● Start of First Crusade (1096)	● Chinese invent playing cards (1120) ● Oxford University founded (1167)	● King Richard the Lionhearted returns from Crusades (1194) ● Magna Carta (1215)	● Marco Polo returns to Italy from Far East (1295) ● Geoffrey Chaucer born in Britain (1340)	Portugese traders reach ● Benin, West Africa (1472) Ballet begins at Italian ● courts (1490) Gutenberg ● Bible (1455) ● Florence under Medici rule (1450–1492)
Scientific Technological Events	● Chinese use explosives (1151) ● Leif Ericson is supposed to have arrived in Nova Scotia in North America (1000)	● Water-driven mechanical clock in China (1090)	● Glass windows in English houses (1180) ● Tiled roofs in London (1212)		Leonardo ● invents the parachute (1480) ● Steel crossbow used in battle (1370) Christopher Columbus ● discovers New World The symbols ● + and − used (1498)
Visual Arts	● Oldest existing example of Yamato style painting in Japan (1068) ● Mesa Verde pueblo in Colorado (1073) ● Tower of London (1078)	● Angkor Vat in Cambodia (1150) ● Gothic cathedral at St. Denis (1144) ● Mimbres pottery, New Mexico (1150) ● Gothic period begins in Europe Notre Dame Cathedral in Paris (1167)	● Toledo cathedral begun in Spain (1227) ● Goose quill used in writing (1250)	Ming dynasty ● begins in China (1366) ● Aztec and Inca civilizations thrive (1300)	● Hans Memling (Dutch) born (1430–1495) Jan van Eyck perfects ● oil painting (1430s) Michelangelo born (1475–1564) ● ● Jan van Eyck, Dutch painter, born (1383–1441) ● Leornardo da Vinci born (1452–1519) Raphael born ● (1483–1520) Michelangelo's *Pieta* at RENAISSANCE PERIOD IN EUROPE ● St.Peter's in Rome (1498) ● Leonardo completes *The Last Supper* (1498)

Neo-Classicism

The period that followed the French Revolution brought a return to the styles of the Greco-Roman era which is called **Neo-Classicism.** It was a reaction against all that the Rococo period stood for. It quite successfully revived classical architecture. This influence was felt throughout the Western world and was particularly important to Thomas Jefferson in the United States. Jefferson developed his own architectural style based on Roman origins; a fine example is his Virginia home, *Monticello* (see Figure A-16). In France, the period was dominated by artist Jacques-Louis David (dah-veed´). David's severe, somber paintings had contributed to the revolutionary unrest in France. His theme was self-sacrifice, and he greatly revered ancient Rome. The revolutionary leader Robespierre was an associate of David. After the revolution, David was elected to the National Convention, where he voted to behead Louis XVI. He became the director of artistic affairs. In this role he tried to impose his own severe tastes in art on all of his countrymen. He proposed a law to destroy the works of certain painters, and another that would forbid all art except that of patriotic subjects. (This had been tried before and has been tried since. It never works.)

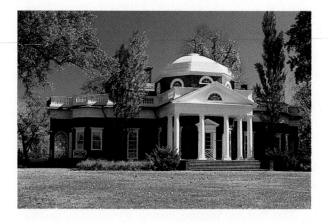

Figure A-16. Jefferson designed Monticello for his home. Thomas Jefferson, *Monticello*. Designed 1770. © Unifoto, Washington, D.C. © Philip Stewart.

The political life of France was volatile in those days. When Robespierre was deposed and executed in 1794, David fell from favor. However, he made a startling comeback with the rise of Napoleon in 1799. As "First Painter" to the Emperor, David recorded Napoleon's public life. One of his many paintings of the emperor is that of Napoleon leading his men across the alps (see page 27 of Book Two). However, Napoleon, after creating an

1500 A.D.	1600 A.D.	1700 A.D.	1800 A.D.
● Martin Luther begins Reformation (1517)	● King James Bible published (1611)	● J.S. Bach born (1685–1750)	● Mozart born (1756–1791)
● Queen Elizabeth I of England comes to throne (reigned 1558–1603)	● Havard College founded (1639) in Cambridge, Mass., U.S.A.	● George Washington born (1732–1790)	French ● Revolution (1789)
● Pizarro conquers the Inca of Peru (1533)	● Louis XIV comes to French throne at age of five (1643–1715)	● Handel born (1685–1757)	
	● Spanish Armada defeated by British (1588)	● Benjamin Franklin born (1706–1790)	● British Museum issued charter (1753)
	● Tea first drunk in England (1650)		● American Declaration of Independence (1776)
● Shakespeare born (1564–1616)	● First stockings, Paris (1657)		
	● Robert Hooke (English) invents the balance spring for watches (1658)		
	● Qing, the last Chinese dynasty, begun (1644–1911)		
● Turkeys from South America introduced to London (1524)	● Colonization of America begins Jamestown (1607)	● Isaac Newton discovers spectrum of white light (1666)	● Franklin invents lightning conductor (1752)
● Michelangelo designs fortifications for Florence	● Pilgrims come to New Plymouth (1620)		● James Watt invents steam engine (1775)
● Observation of Halley's Comet cause great fear, superstition (1531)	● Forks used for first time (French court, 1589)		● James Cook discovers Hawaii (1778)
			● Montgolfier Brothers make hot air balloon in France (1782)
● Michelangelo's David (1501–1503)	● El Greco born (1541–1614)	● Rembrandt born (1606–1669)	● Porcelain made in Europe (1710)
● Leonardo's Mona Lisa (1503)	● Beginning of Ukiyo-é painting in Japan (1550)	● Bernini sculpts his David (1623)	● Ogata Korin (1658–1716) unites the two great Tanō schools of painting in Japan (1702)
● Michelangelo starts Sistine Chapel ceiling painting (1508–1512)	● Velásquez born (1599–1660)	● Velásquez paints Maids of Honor (1656)	J.M.W. Turner ● born (1775–1850)
● Raphael appointed architect of St. Peter's (1515)	● Bernini born (1598–1680)	● Taj Mahal begun in Agra, India (1628; completed (1650)	● William Hogarth, English painter, born (1697–1828)
● First Mannerist art appears in Italy (1520–1600)			Rococo Art ends abruptly with French Revolution in 1789 and neo-classicism begins
			● Le Blon publishes pigment color theory (1756)
			● Francisco Goya, Spanish painter, born (1746–1828)

Empire, fell at Waterloo, and David was exiled to Brussels, Belgium, in 1816.

Romanticism

Romanticism was a strong reaction to Rococo and also to Neo-Classicism. It swept through Europe in the first half of the nineteenth century. Romantic artists painted highly emotional scenes using brilliant colors. Some bad art was produced as well as some very great art. The name most often associated with Romanticism is that of Eugéne Delacroix (del-ah-krwa´), although he should be remembered for being more than a Romanticist. Delacroix's bold use of color emphasized the drama of the scenes he painted and influenced almost all artists who followed him. In his portraits, Delacroix seemed to capture the romantic spirit of those he chose to paint. Delacroix's portrait of Frédéric Chopin, one of the great Romantic composers, captures the composer's spirit as well as his likeness (Figure A-17).

Realism

Realism dominated the art of the second half of the nineteenth century. The Realists rebelled against both the excesses of Romanticism and the

Figure A-17. Delacroix's *Portrait of Frédéric Chopin.* Eugéne Delacroix, *Frédéric Chopin.* 1838. Oil on canvas. 18" x 15". The Louvre, Paris. Courtesy Cliché des Musées Nationaux, Paris, France. © Photo R.M.N.

reverence for classic themes of the Neo-Classicists. The attitude of the Realists is expressed by their leader Gustave Courbet (coor-bay´) (1819–1877). When asked to add some angels to one of his paintings (a common practice at the time), Courbet said, "I have never seen angels. Show me some angels, and I will paint one."

Realism was an international movement. Its artists were concerned with depicting ordinary people doing ordinary things. If a subject had dirty feet, the dirt was included in the picture. Thomas Eakins, an American Realist, painted the operating amphitheater at the Gross Clinic in Philadelphia with the patient on the operating table, and Dr. Gross' scalpel and hands covered with blood.

The camera was coming into popular use. Paintings and sculpture were about as realistic as they could get. It looked as though art had reached a dead end. In what new direction could it possibly go? Answers came, and they came from unexpected sources.

INTERLUDE NUMBER TWO

In the first section of this history we traced the development of art in various parts of the world from prehistoric times to the end of the time period known as B.C. Our second section was devoted to the history of Western art, from its beginnings to the end of the nineteenth century. The section that follows is devoted to non-Western art traditions, from their beginnings through the latter 1800s. In the final section we will discuss art from the late 1800s to the present time, a period in which improvements in world-wide communication brought all the cultures of the world face to face.

NON-WESTERN ART

African Art

You will recall that in the first section we studied the art of the Nok civilization in Northern Nigeria. Art historians know that the Nok terra cotta figures were the result of a long tradition because of the refinement of the style and the sophistication of the workmanship. The source of that tradition, however, is unknown; very little remains today of works produced before the Nok period. With the disappearance of the Nok culture around the third century B.C., another long period elapsed with few remaining traces. We know from scattered remains that a more naturalistic style, based upon the highly stylized, exaggerated art of the Noks, was developing. This style is best defined in the art of the Ife (e´-fay), a culture which emerged some 1300 years after the Nok culture ceased to exist. The city of Ife is located about 150 miles south of the site of the Nok civilization. Despite the long time period between the two cultures, there is no doubt of the Nok influence on Ife art.

The Ife perfected the "lost wax" method of bronze casting and produced lifelike castings of their kings. The palace in the city of Ife is still the spiritual home of the Yoruba (yoh-roo´-buh) people, who are the most prolific artists of Africa. Ife art of the period that began around A.D. 1000, combines post-Nok naturalism with the exaggeration of the Noks. Nok and Ife sculptors are unique in African art, for both sculpted the human figure to life-size scale. In Ife art of A.D. 1000 to 1200, we see the beginnings of modern African sculpture. (Figure·A-18).

During the latter part of the twelfth century, an Ife master in bronze was a guest in the mighty city of Benin (buh-nin´) on the western coast of Africa. The artisans of Benin learned the art of bronze casting from this master. In 1472 Portuguese traders came to Benin. By that time the city was quite prosperous and had skilled artisans in many fields.

The Portuguese sailors described the city in detail. The king greeted them from an enormous palace. He sat upon an ivory throne under a canopy of Indian silk. The palace had beautiful courtyards, each with its own sentries. The walls surrounding the buildings in Benin were so highly polished they appeared to be marble. Many houses had intricately carved bronze birds perched on their walls and rooftops.

Africa had many other important kingdoms. The Ashanti (uh-shon´-tee) Kingdom is especially noted for its woven pieces. Ashantis reserved one special fabric for their ruler's use. This fabric, called Kente cloth, was woven from threads of pure gold and silk. It was perhaps the most luxuri-

ous cloth ever produced. An important ritual piece was a stool carved from a solid block of wood completely covered in hammered gold. This became the symbol of the Ashanti Kingdom.

African society has a long tradition of the dance. There are fine pieces of sculpture which express the vitality of the dance. In many cases masks were part of the rituals. These masks were later to have a significant influence on Western art. Masks often portrayed the profession of those who wore them. For example, one might portray a judge, another a policeman or a soldier. Many others represent animals.

In the section that follows we will discuss the effect of masks and other African art on the art of the twentieth century. African sculpture is a complicated, but most interesting, area of study. Examples range from very realistic to highly abstract. We rarely see examples of painted African sculpture in museum collections, yet most *are* painted. The mood or expression may also be deceiving. Expressions of terror or anger may only be meant to be amusing. Today, many Western traditions have been adopted or adapted by African artists. Others continue the art of their own proud traditions.

Art of the Far East

There are several influences common to the art of the Far East, and yet each of the cultures—Chinese, Japanese, Indian, Cambodian, Thai, Vietnamese—has its own character and traditions. A lifetime study of the art of the Far East could only begin to give you an appreciation of its diversity and richness. We will look at some of the highlights of this amazing body of artistic expression.

India You may recall the development of the Indus Valley civilization and its abrupt ending by invasion around 1800 B.C. From that time, all traces of art in that part of the world were lost for a thousand-year period. Few pieces remain from this long period, but we will see the influences of these invaders much later in the art of India.

The birth of Buddha in 563 B.C. is one of the significant events in world history, as well as in the history of Eastern art. Buddha was born a prince, and in his lifetime was a teacher of ethics. His teachings are the basis of one of the world's great religions. The Emperor Asoka (322–185 B.C.)

Figure A-18. An Ife king. Ife king figure, Yoruba. 10th - 12th centuries A.D. Bronze. 18 1/2" tall. Ife Museum, Nigeria. Courtesy the National Commission of Museums and Monuments.

was converted to Buddhism, and his conversion led to a rebirth of art. Great columns were erected to commemorate the life of Buddha. Monuments to Buddha, called stupas (stoo´-puhs) followed, such as the one known as the Great Stupa at Sanchi. Until the second century A.D., images of Buddha were considered irreverent. This belief changed dramatically, and the image of Buddha became one of the most important expressions of art in history. Buddhism spread throughout Southeast Asia, and influenced the art of many cultures.

Figure A-19. The pagoda is the architectural symbol of China.
Pagoda of Six Harmonies. A.D. 1153. Sung Dynasty. Hongchow, China. The Granger Collection, New York.

The other great influence on the art of India was that of the Hindu religion, with its supreme deities Siva and Vishnu. The roots of this influence go back to the invaders of the Indus Valley civilization many centuries before. Hindu temples were designed to be the residence of a god rather than to be houses of worship.

The gracefulness of the sculptured figures of the Hindu deities and their thousands of attendants is the very essence of Southeast Asian sculpture. These figures echo the Indus Valley civilization's realistic style in sculpture. They also echo the religious tradition of those who invaded and conquered the Indus Valley back in 1800 B.C.

The Hindu and Buddhist religions struggled for supremacy in Southeast Asia. One result is a series of the most elaborate architectural wonders of the ages—the great stupas of Buddhism and the Hindu temples dedicated to Siva and Vishnu.

China The great dynasty of Shang ended in 1027 B.C. It was overthrown by the Zhou (sometimes spelled Chou; pronounced joh), a dynasty that endured until 227 B.C. Shang traditions in bronze continued and, in the later Zhou era, jade carving reached a peak of perfection. The philosopher Confucius (kun-few´-shuss) lived from 551–479 B.C. Confucius was born at a time of great turmoil in the Zhou dynasty, and during his lifetime he constantly sought social reforms. His philosophy, which emphasized the need for social justice endured through the many cen-

turies of Chinese dynastic rule and was the dominant force in Chinese culture until the founding of the Chinese Republic in A.D. 1913. During the 2,000 years of Confucian dominance, important traditions in Chinese art were established. Apprentices spent years copying established masters and then produced their own images of the natural beauty of China. In Chinese art, human beings are treated as another part of nature. They are no more or less important than the trees, mountains, waterfalls, and rivers. (This characteristic is further discussed in Book One, pages 87 to 89.)

The influence of Buddhist art in China is most noticeable in the pagodas (puh-go´-duhs), which are the architectural symbol of China (Figure A-19). Pagodas are the Chinese adaptations of the massive Buddhist stupas of India.

Many dynasties have followed the Zhou. Some dynasties lasted for centuries; some were comparatively short. Several are known for particular excellence in one or more forms of expression. If you are planning to visit a museum that has a collection of Chinese art, it will be of help to spend time studying the specialties of some important dynasties before your visit.

One very important dynasty was the Tang (A.D. 618–907). Tang art has been described as the "international style," as the Tang empire extended from the Caspian Sea on the west to the Pacific Ocean on the east. It included Manchuria, Korea, and Vietnam.

Figure A-20. The "Cradle of Japanese Art."
Kondo (Golden Hall) Horyu-ji, Asuka period, 7th century A.D. Nara, Japan, Courtesy Shashinka Photo Library, New York.

We hope you can take the time to enjoy examples of painting and ceramic art of the Song (sometimes spelled Sung) and the Ming dynasties. You may find it to be, as many others have, the most satisfying art of all.

Japan The geography of the Japanese islands played an important role in the development of Japanese art. First, the separation of Japan from the Mainland delayed many of the cultural revolutions that had swept India and China. By the time these revolutions reached Japan, the art forms had reached maturity. Second, the Japanese islands are formed of volcanic rock. This rock is very dense and difficult to carve or to use in architecture. Wood became the basic building material, while bronze, clay, and lacquer (which comes from tree sap) were used in three-dimensional art.

In A.D. 552 a Korean ruler sent a bronze figure of Buddha to the Emperor of Japan. (Remember that this was 1,000 years after Buddha's time.) From this modest, late beginning, a great wave of Buddhist art swept Japan. Buddhist temples were erected and Buddhist sculpture dominated the relatively brief period of A.D. 552 to 645. These years were known as the Asuka (uh-suke-uh) Period, named for the Japanese capital at that time. Although brief, this period was very important in the history of Japanese art. The temple of Horyu-ji (hor´-you-gee) at Nara (Figure A-20) was built around A.D. 610. It is called the "Cradle of Japanese

Art." Through the years much of the original wooden temple has been replaced or restored, but some original parts survive today. These surviving parts are the oldest existing wooden buildings in the world.

Many other influences were to come to Japan from the mainland through the years. In the middle of the ninth century, trade with China ceased as a result of bad relations between the two countries. Japan became somewhat isolated. From that time, Japanese art developed its own traditions, occasionally borrowing from the cultures of its trading partners.

As you study Japanese painting and prints, you will see references such as "Yamato-e" or "Ukiyo-e." The *e* means "pictures of." *Yamato-e* means "pictures of Yamato," the area around Kyoto and Nara. *Ukiyo-e* means "pictures of the passing world." Hokusai's famous series of prints, the *Thirty-Six Views of Mount Fuji* (1824) is an important example of Ukiyo-e. You may recall one of these prints (on page 25 of Book One) that influenced Winslow Homer and many other Western artists.

Yamato-e art was highly decorative. Through the centuries Japanese art has acquired a delicacy and simplicity that mask the discipline that is required to accomplish such beautiful work.

Southeast Asian Countries The art of Cambodia, Thailand, and Java began on similar paths.

Understanding and Creating Art—Timeline 4

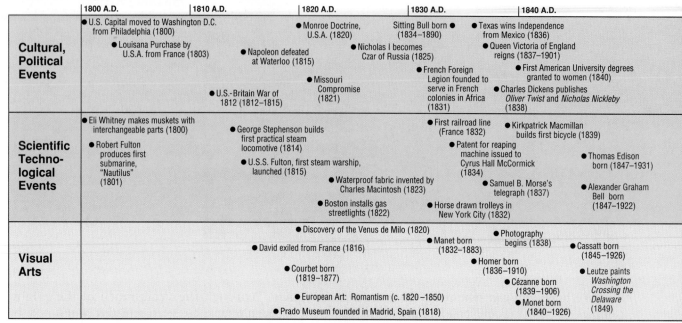

	1800 A.D.	1810 A.D.	1820 A.D.	1830 A.D.	1840 A.D.
Cultural, Political Events	● U.S. Capital moved to Washington D.C. from Philadelphia (1800) ● Louisana Purchase by U.S.A. from France (1803) ● U.S.-Britain War of 1812 (1812–1815)	● Napoleon defeated at Waterloo (1815)	● Monroe Doctrine, U.S.A. (1820) ● Missouri Compromise (1821)	● Sitting Bull born (1834–1890) ● Nicholas I becomes Czar of Russia (1825) ● French Foreign Legion founded to serve in French colonies in Africa (1831)	● Texas wins Independence from Mexico (1836) ● Queen Victoria of England reigns (1837–1901) ● First American University degrees granted to women (1840) ● Charles Dickens publishes *Oliver Twist* and *Nicholas Nickleby* (1838)
Scientific Technological Events	● Eli Whitney makes muskets with interchangeable parts (1800) ● Robert Fulton produces first submarine, "Nautilus" (1801)	● George Stephenson builds first practical steam locomotive (1814) ● U.S.S. Fulton, first steam warship, launched (1815) ● Waterproof fabric invented by Charles Macintosh (1823) ● Boston installs gas streetlights (1822)	● First railroad line (France 1832) ● Patent for reaping machine issued to Cyrus Hall McCormick (1834) ● Samuel B. Morse's telegraph (1837) ● Horse drawn trolleys in New York City (1832)	● Kirkpatrick Macmillan builds first bicycle (1839) ● Thomas Edison born (1847–1931) ● Alexander Graham Bell born (1847–1922)	
Visual Arts		● David exiled from France (1816) ● Courbet born (1819–1877) ● European Art: Romantism (c. 1820–1850) ● Prado Museum founded in Madrid, Spain (1818)	● Discovery of the Venus de Milo (1820)	● Manet born (1832–1883) ● Homer born (1836–1910) ● Cézanne born (1839–1906) ● Monet born (1840–1926)	● Photography begins (1838) ● Cassatt born (1845–1926) ● Leutze paints *Washington Crossing the Delaware* (1849)

However, its development was quite different in each.

Sea trading with India brought about a dramatic surge of art in Cambodia and Thailand at the start of the fourth century A.D. Both Hindu and Buddhist influences entered Cambodian art at that time.

A most unusual concept of architecture and sculpture began in Cambodia around A.D. 900. This is the concept of the "world mountain." The first example was the incorporation of a real mountain into the architectural design of a shrine. From this beginning, enormous complexes of highly decorated stone evolved. The temple to the Hindu god Vishnu at Angkor Vat is one such complex (see page 263, Book one). Another is the Bayon at Angkor Thom (Figure A-21).

The artists of Thailand concentrated on bronze and developed unique images of Buddha which were much different from other Buddhist art. The images have much simplicity and linear detail, such as double outlines around the features of the faces.

The immense stupa of Borobudur (boh-roh-bu-dur´), created in the eighth century A.D., is the most important monument in Javanese art. This enormous structure has over ten miles of relief

Figure A-21 These towering figures display the well-known Cambodian smile. Detail of the Bayon. Angkor Thom, Cambodia. Late 12th - early 13th century A.D. Art Resource, New York. INVC/Giraudon/Art Resource, N.Y.

| 1850 A.D. | 1860 A.D. | 1870 A.D. | 1880 A.D. | 1890 A.D. | 1900 A.D. |

American Civil War (1860–1865)
Louisa May Alcott publishes *Little Women* (1868)
U.S. installs first public telephone (1877)
Massacre at Wounded Knee (1892)
Population statistics, (1851) (in millions): China 430 Germany 34, France 33, Great Britain 21, U.S. 23
President Lincoln assassinated (1865)
Mark Twain publishes *The Adventures of Tom Sawyer* (1875)
Sir Arthur Conan Doyle publishes first Sherlock Holmes story (1887)
Charles Blondin (French) crosses Niagara Falls on tightrope (1864)
Jules Verne publishes *Around The World in 80 Days* (1872)
President Garfield assassinated (1881)
Spanish-American War (1898)
Lewis Carroll writes *Through The Looking Glass* (1871)
Franklin Delano Roosevelt born (1882–1945)

Crystal Palace built in London (1851)
Pasteur develops process of pasteurization (1864)
Bell invents telephone (1876)
Movie camera invented (1891)
Edison and J.W. Swan produce first electric lights (1880)
Suez Canal constructed (1859–1869)
Law of heredity outlined by Gregor Mendel (1865)
Edison invents phonograph (1877)
Rabies vaccine developed by Pasteur (1885)
Henry Ford builds his first car (1893)
Alfred Nobel invents dynamite (1866)
Gatling gun, 10-barrel rapid fire gun, invented by R.J. Gatling (1862)
London installs electric streetlights (1878)
First electric elevator (1889)

van Gogh born (1853–1840)
Whistler paints *The Artist's Mother* (1872)
Last Impressionist exhibit in century (1886)
Remington born (1861–1909)
Henri Toulouse-Lautrec born (1864–1901)
Joseph Stella born (1877–1946)
George Seurat born (1859–1891)
European art: Realism, Impressionism
Eadweard Muybridge publishes photo of horse in motion (1882)
Grant Wood born (1892–1942)
Frank Lloyd Wright born (1869–1959)
Louis Sullivan, American architect born (1856–1924)
Henri Matisse born (1869–1954)
Rivera born (1886–1957)
Picasso born (1881–1973)
O'Keeffe born (1887–1986)

carving. It reveals the dominance of Buddhist influence in Java at that time, despite the country's Hindu beginnings. In later Hindu temple carvings we can see the beginning of caricature that is so evident in the Javanese shadow puppets (as we have seen in Book One, page 274).

The kingdom of Champa (chom´ pah), a neighbor and great rival of Cambodia, existed from the third century A.D. until 1471. Champa is today known as Vietnam. Champan sculpture is distinct from Cambodian. Both often depict the Hindu god Siva, but the Champan heads are carved in a much coarser style and the bodies give the impression of more physical strength than do those of Cambodia. Dragons and other mythical beasts are depicted in later Champan art, along with much elaborate and intricate detail.

The Art of the Western Hemisphere (Before European Exploration)

Maya and Teotihuaca Two Central American cultures were established in the third and fourth

centuries A.D. They were the Mayan (my´-uhn) and the Teotihuacan (tay-oh-tee-whah´-kun).

The Mayan civilization was located on the Yucatan Peninsula of what is now Mexico, and extended into Honduras and Guatamala. The Maya produced huge ritualistic temples to their gods of the harvest. The relief sculpture of these temples, with its ornate style, is considered among the finest ever produced.

Carving on Mayan temples is on the outer walls, for their rituals were performed in the open air, where the gods could witness them. And what rituals! Among them was a game in which a ball was batted overhead, representing the sun. There was a strong incentive to win this game. The leader of the losing team was sacrificed to the sun god.

The Maya were particularly interested in time and its measurement. Their accomplishments in mathematics and the measurement of time are stunning. They easily predicted solar eclipses, and measured the orbit and revolution of the planet Venus with an error rate of only one day in 6,000 years.

The Teotihuacan civilization began about the same time as the Mayan. The word *teotihuacan* means "where one becomes a god" and refers to the city of that name, which was located just north

Figure A-22. The ruins of the Inca city of Machu Picchu. The ruins of the 15th century Inca city, Machu Picchu, Peru. The Granger Collection, New York.

and expanded, quickly building an empire. At the height of the Aztec power, their language spread throughout Mexico, and it is still widely spoken.

Aztec art can be puzzling. To understand it requires some knowledge of the Aztec religious rituals. The Aztecs believed that the sun god was locked in a never-ending battle with darkness. Each evening the sun god died; each morning the revived sun god drove the darkness away. This nightly revival of the sun god required blood—human blood—and the Aztecs practiced human sacrifice to nourish the sun god. The great stone temples and the elaborate costumes of the Aztecs were part of this ritual, as were the larger-than-lifesize stone carvings of their gods. These sculpted pieces were adorned with such things as skulls and representations of human hearts. In A.D. 1520 the Spanish conqueror Hernando Cortes, aided by many people under Aztec domination, overthrew the Aztecs.

Inca The Inca people were contemporaries of the Aztecs but lived 2000 miles to the south. The time span of these cultures is similar, for both were toppled by Spanish conquest. Francisco Pizarro ended Inca rule in 1533.

The native ground of the Inca was what is now known as Peru. However, at one time, the Inca civilization included most of the northern part of South America and had made inroads to the south. Inca temples were made of dry masonry, which means they did not use mortar. In this process the stonecutting has to be very precise. The famous ruins of the Inca city of Machu Picchu (Figure A-22) lie on a small plateau high in the Peruvian Andes. It is one of the most beautiful sites in South America.

Probably the most astonishing accomplishment of the Inca was their system of roads and bridges. The "Royal Road of the Mountains" was thirty feet wide and 3,750 miles long. The conquering Spaniards were awestruck. Using this road network, the Inca had a system for delivering messages similar to the old "Pony Express" in the western United States. The Inca, however, used human runners instead of horseback riders.

Many artistic achievements of the Native Americans of North America are discussed in *Understanding and Creating Art*. These achievements range

of present-day Mexico City. A very large city for its time, its population was approximately 100,000. The Teotihuacans constructed the largest pyramid in Mexico, which was dedicated to their sun god. It is approximately 700 feet wide at the base and 200 feet tall, and was part of a broad avenue of elaborately carved temples.

Aztecs—The People of the Sun In the fourteenth century the Aztec culture developed on the present-day site of Mexico City. The predecessors of the Aztecs in this region were known as the Toltecs. The Toltec empire had crumbled for many of the same reasons the Roman Empire collapsed. The Aztec people took advantage of the situation

from the ingenious architectural innovations of the Anasazi (the "ancient ones") two thousand years ago to twentieth century masters of traditional Native American forms of expression, as well as oil painting, lithography, bronze casting, and other forms associated with European traditions. Here we will look at the art of one group of Native Americans which developed independently of the others—the Eskimo.

In the past few decades, Eskimo art has been "discovered" and is quite fashionable. It appears in many museum collections and private collections. The Eskimo people have taken the utmost advantage of the raw materials available to them to make their art. These natural materials are whalebone, walrus ivory, stone, driftwood, and skins. The art is generally geometric in design and is often abstract and sophisticated. The subjects of Eskimo art are usually the animals on which the Eskimos are so dependent.

Eskimo architecture takes advantage of available materials, such as driftwood in Greenland, or stone and wood in other parts of the far north. In Labrador many Eskimos live in igloos in the wintertime. These structures are much more interesting than they appear at first glance. For example, blocks of clear fresh-water ice are cut at the beginning of winter to use as skylights. The igloo is an ingenious creation providing comfortable shelter in very harsh conditions.

BEYOND REALISM

New Directions for Western Art in Europe

When we left Western art late in the nineteenth century, the dominant force was Realism. However, you may recall that Realism seemed to have nowhere to go. The camera freed many artists from producing illustrative material. ("Freed" is the word often used, but "put out of work" was often the case.) The French poet and critic, Theophile Gautier (go-tyay´) said, "It is well known that something must be done in art, but what?"

The last great realist of this age was Édouard Manet (mah-nay´) (1832–1883). Manet's art was

Figure A-23. Manet's *The Fifer* draws the viewer's eye to the painting's surface. Édouard Manet, *The Fifer*. 1866 Oil on canvas. 63" x 38 1/4". The Louvre, Paris. Courtesy Cliché des Musées Nationaux, Paris, France. © Photo R.M.N.

to provide the beginning of an answer to Gautier's question.

Japanese block prints had become very popular in the 1860s. *The Great Wave off Kanagawa* by Hokusai is an excellent example. Manet closely studied the work of such Japanese artists as Hokusai and began to simplify his work and experiment with color.

He painted *The Fifer* (Figure A-23) in 1866, shortly after returning from Spain, where he had

spent a month studying the works of Velásquez. *The Fifer* is a very important painting because in it we can see how Manet broke with traditions that had dominated Western art since the Renaissance. In the Renaissance tradition painters used modeling (color and shading) to give the illusion of form and depth. This realistic method gives the viewer the sense of looking through the surface, as though through a window, to the subject of the painting. In this tradition, the purpose was the successful imitation of nature.

Let us now look again at *The Great Wave off Kanagawa.* Unlike the work of the realists, its colors are flat and lack gradation. They stand right next to each other. Now look again at *The Fifer.* Manet uses flat patches of paint with no modeling. The eye of the viewer is attracted to the painting's *surface.* The patches of color and the brushstrokes make the surface as important as the subject of the painting. This is no mere representation of the subject. The painting itself is the reality for the artist, and Manet has called our attention to *his* reality—the canvas. This break with the traditions of the Renaissance influenced all art that followed in the Western world. Manet pointed the way to nonrepresentational art.

The Impressionists drew inspiration from Manet. (If you have not studied the introduction to Impressionism in Book Two this would be a good time to do so.) They also admired Japanese prints and were very interested in the fleeting impressions that were obtained by camera "snapshots." By taking the intensity of light and atmospheric conditions into consideration, they gave their version of what the real world was like. Their efforts led art away from the purely representational and toward the dominant style of the twentieth century, which can be described as antirealistic.

Paul Cézanne (say-zahn´) thought that Impressionism, while beautiful, lacked a feeling of permanency. (Cézanne is also discussed in Book Two.) He wanted to make paintings that he felt were more solid, with what he considered lasting value. He sought more structure than he saw in Impressionist works. The Impressionists assumed that all the eye sees is color. Cézanne reasoned that, if the Impressionists were correct, it must follow that color would fulfill all of the structural functions of perspective, light, and shadow in painting. Color, and color alone, must be used to give depth and form to painted objects. He began experimenting with color to test these ideas for himself.

After many experiments, Cézanne concluded that color alone was not enough, and that line was also necessary. He needed line for organization. His works have a sense of order and serene harmony and are often described as containing "planes of color." Look at the two paintings of La Montagne Sainte-Victoire in Book Two. Can you see these "planes of color?" As the earlier and later paintings of the mountain reveal, Cézanne continually simplified, leaving out all unnecessary detail.

Probably no artist has ever been more concerned with the compositional principles of design than Cézanne. He would work on a painting for years, attempting to assemble natural objects into a perfection of design. The Cézanne still life (your classroom reproduction #16) took years to complete and was finished in 1890. Distortions were carefully made to create as perfect a design as possible. The arrangement of this still life produces order and clarity, and yet we see the distortion. Cézanne believed that art was not only the result of a reaction of the eye, but also of an action of the mind. After him, painting would not be the same.

During this time, there was great progress in architecture. Joseph Paxton's giant Crystal Palace Exposition Building in London (1851) was an architectural milestone, and not simply because it was constructed of iron and glass. Of equal importance was the fact that the entire structure was built in only six months. Many similar buildings followed. One unforeseen problem was the vulnerability of such structures to fire. After several had burned, architects devised a way to cover the iron framework with various forms of masonry which wouldn't burn.

Elisha Cook Otis invented the safety elevator, and the first electric safety elevator was installed in New York City in 1889. Steel began to replace iron in construction, and the combination of the steel framework and the elevator led to the modern skyscraper.

The first of the new architects to demonstrate that "form follows function" was Louis Sullivan. In many of Sullivan's buildings we can imagine the steel superstructure by looking at the building from the outside. Sullivan did *not* say that "beauty follows function," but many great architects

believe that it does. Others of the twentieth century feel differently, and we have many styles of skyscraper architecture now.

Some skyscrapers are popularly described as "post-modern." What this apparent contradiction in terms means is that an architect may adopt or incorporate some aspects of previous architectural styles or make embellishments of his or her own. The steel structure of these buildings is so strong that the outside and interior walls can actually be constructed from the top down. Try to imagine how this concept would strike a builder of a Romanesque church in the Middle Ages, whose thick walls had to support the roof.

THE TWENTIETH CENTURY

The pattern of deviation from Realism had begun. We have seen it start with Manet, continue with the Impressionists, and develop further by the careful, deliberate distortions of Cézanne. When you look at the art of the twentieth century, you may ask, "What is all this? I can see what Cézanne was doing, and I can see why he did it. But this stuff! How can one begin to understand it or enjoy it, and is it really worth trying to do so?"

There is no question that it takes a great deal of effort to understand modern art. In this section we give you the background to understand *why* Modern Art is as it is, and a small introduction to *what* it is. The Book Two introduction to Cubism and Futurism should also help you. However, you will have to make the effort to become deeply involved. No one can do this for you.

Let's begin by trying to understand the *why* of modern art. In the late 1800s many artists felt that realism could go no farther. This was also a time of unprecedented growth in technology. Countries were no longer isolated from one another. Traditions in the visual arts from many world cultures were being explored by Western artists for the first time. As we have seen, many of these art traditions were *not* representational. Western artists were not just attracted, many were overwhelmed, by the sophistication of the works which had evolved from different cultures. For example, in 1905 the French artist Maurice Vlaminck (vlah-mank´) showed an African mask to his friend, the painter André Derain (duh-rain´). Vlaminck

records that Derain was "speechless and stunned." That incident profoundly affected Derain's work. We can see the effects of non-Western art on many other artists in Part III of Book Two. The influence of non-Western art traditions on Western artists is one thing to remember and look for in modern art. Gautier had said, "Something had to be done in art, but what?" This part provides some examples of what artists thought could be done.

A second important *why* also relates to advancing technology, but in quite a different way. Technological and scientific advances have changed the way we view ourselves and the world around us. New theories in physics tell us there are no absolutes in space or time. Motion is relative to other objects (or systems of objects) which are also in motion. We are told the universe is expanding at an ever-increasing rate. Space and time are related. Time is really just another dimension—the fourth dimension. Faced with these theories, artists began to ask, "What is real in such a world, and how can I possibly capture it?"

The response of many artists was to decide that it was up to them to interpret what was real. For centuries artists had tried to portray the third dimension, depth, on a two-dimensional surface. Now artists were faced with a fourth dimension. Then why, many asked, should I try to give the illusion of only three dimensions on a canvas? Why not use the fourth dimension, time, to look at the subject of a painting from several different viewpoints?

The twentieth century brought terrible wars and bloody revolutions. Such destructive events made existence itself seem meaningless, and life a joke to many artists. As a result, artists experimented boldly. Many abandoned the idea of representing what they could see. Instead they tried to rebuild reality from their own personal experience.

As you have seen in your textbooks, not everyone in the twentieth century art world felt this way. Many artists, such as Andrew Wyeth, made their own versions of realistic art. Others, such as Georgia O'Keeffe, developed their own styles and are not easily classifiable. However, several general trends are indicated. They should be considered.

Modern art has a rather bewildering array of "isms". We will discuss several of the movements

Understanding and Creating Art—Timeline 5

	1900 A.D.	1910 A.D.	1920 A.D.	1930 A.D.	1940 A.D.
Cultural, Political Events	● Boxer Rebellion in China against Europeans (1900) ● First tour de France bicycle race held (1903) ● Great San Francisco earthquake kills 700, causes $400 million worth of property damage (1906)	● Mexican Revolution (1910) ● Qing dynasty falls, republic proclaimed in China (1912) ● First World War (1914–1918)	● Russian Revolution (1917) ● Mussolini forms facist government in Italy (1922) ● Dance known as "The Charleston" becomes popular (1925)	● World-wide depression (1929–1941) ● Franklin Delano Roosevelt is elected President with landslide victory (1932) ● Ernest Hemingway's *A Farewell To Arms* published (1929)	● Spanish Civil War begins (1936) ● Second World War (1939–1945) ● Europe, Japan start rebuilding process (1946)
Scientific Techno-logical Events	● Guglielmo Marconi transmits radio messages from Cornwall to Newfoundland (1901) ● First Model-T produced by Ford Motor Company (1908) ● Work begins on the Panama Canal (1904)	● Albert Einstein postulates general theory of relativity (1915)	● First regular radio programs broadcast in the U.S. by Station KDKA in Pittsburgh, Pennsylvania (1921) ● Insecticides used for the first time (1924) ● First talking picture (movie) (1927) ● First Charles Lindbergh (American) flies Atlantic (1927)	● Amelia Earhart (American) flies Atlantic (1932)	● First commercial television (1939) ● First successful helicopter flight (1940) ● Enrico Fermi splits atom (1942) ● First computer developed (USA) (1942) ● First atomic weapons used (1945)
Visual Arts	● Cubism begins (1907) ● Remington paints *Buffalo Runners* (1909) ● First Ashcan exhibition (1908)	● Frank Lloyd Wright designs the Imperial Hotel, Tokyo ● Armory Show, New York City (1913)	● Mark Chagall leaves Russia for Paris (1922) ● Work on Mt. Rushmore begins (1927)	● Empire State Building completed (1932) ● Picasso's *Guernica* (1937) ● Wright's *Falling Water* (1936)	● Western world art movements: Regionalism, Muralism in Mexico, Expressionism, Surrealism ● Mondrian's *Broadway Boogie-Woogie*

in modern art in this section. It may be helpful for you to think of modern art as having two major divisions. You may think of artists as being either *Expressionist* or *Abstractionist*. Works that are dominated by emotion may be thought of as **Expressionist.** Works in which formal, logical analyses seem dominant may be considered **Abstractionist.**

Expressionism comes from within. Artists use distortion and alteration to display the intensity of their feelings about their subjects, and reveal new worlds to us. Vincent van Gogh was a forerunner of Expressionism. A post-World War Two extension of Expressionism is called **abstract expressionism.** In this style, the artist is freed entirely from nature as well as from all traditional standards. The name is, as you can see, a combination of the two large divisions of modern art. It is generally associated more with Expressionism, as it is more akin to the emotional in art than the cool, unemotional approach of Abstractionism.

Abstractionist art does not come from within, but from without. The abstract artist selects, ana-

lyzes, and simplifies the subject. Much of Cubism, which is discussed in Book Two, can be classified as semi-abstract. This means that, if we look hard, we can identify most of the objects in a Cubist work.

There are many diverse movements in twentieth century art. The introduction to Cubism and Futurism in Part III of Book Two discusses two of them. We will now look at some of the other movements in twentieth century art.

Henri Matisse was a member of the group named the Fauves, which means "Wild Beasts" in French. **Fauvist** paintings were highly expressionistic with truly wild uses of intense color. For an example, see Matisse's painting of his wife, known as *The Green Stripe*, in Book Two.

Precisionists painted goemetrically precise pictures of smooth-surfaced objects, generally machines, buildings, bridges, or interiors of buildings. Joseph Stella's *American Landscape* in Book Two is a good example.

Dada is a movement that began as a protest against war in 1916. The term *dada* was reputedly

| 1950 A.D. | 1960 A.D. | 1970 A.D. | 1980 A.D. | 1990 A.D. |

● Korean Conflict (1950–1953)

● J.R.R Tolkien writes *The Lord of the Rings* (1954)

● U.S. establishes military council in South Vietnam (1962)

● President John F. Kennedy assassinated (1963)

● Dr. Martin Luther King assassinated (1968)

● U.S. Astronauts walk on the moon (1969)

● Senator Robert F. Kennedy assassinated (1968)

● Vietnam War ends (1973)

● U.S. celebrates bicentennial (1976)

● Full diplomatic relations between the U.S. and the People's Republic of China announced (1978)

● Germany reunited (1990)

● Space shuttle Challenger explodes, killing crew (1986)

● Eastern Europe turns toward democracy (1990)

● First color television introduced in the United States (1951)

● Telephone service via transatlantic cable introduced (1956)

● First human heart transplant operation performed by Dr. Christian N. Bernard (1967)

● First airplane flight around the world over both Poles (1965)

● Artificial heart first used during heart surgery (1963)

● World's first scheduled supersonic passenger service is inaugurated (1976)

● India becomes the sixth nation to explode a nuclear device (1974)

● Link between gasses from aerosole spray cans and damage to earth's ozone layer announced (1976)

● Wright's Guggenheim Museum, New York City (1959)

● Op Art begins (1965)

● Pop Art begins (1963)

● F. Buckminister Fuller's geodesic dome biosphere (1967)

● 300th anniversary of the death of Rembrandt (1969)

● Minoru Takeyama designs Ichi-Ban-Kan, department store in Tokyo (1970)

● Raphael's *Madonna and Child* purchased by Norton Simon for 3 million (1972)

● I.M. Pei Morton Myerson Symphony Hall in Dallas (1989)

● Late Twentieth Century Western World Art Movements: Minimalism—sculpture and painting Hard Edge painters Soft sculpture Photo realists Computer art

selected at random from a French dictionary. The dadist movement rejected all accepted conventions; it is aptly described as being anti-everything, including Dada. Its creations, as you can imagine, ranged from the fantastic to the absurd. Marcel Duchamp's photograph of the Mona Lisa with a moustache is an example of Dadist art.

Surrealism succeeded Dada, and was greatly influenced by the work of psychiatrists in the analysis of dreams. The Surrealist artists pictured the curious emotional quality of dreams, often with illogical collections of objects in dream-like landscapes. Surrealism was very popular in the period between the two world wars (1918–1939). As an art form, it was somewhat limited by the fact that artists were painting very personal feelings from dreams which may mean little to mass audiences.

The Swiss-German artist Paul Klee (clay´) had a simple, easily recognizable style of fantasy that had universal appeal. Look at his watercolor *Twittering Machine* (Figure A-24). What do you think is going on here? What purpose could possibly be served by turning that crank? Assuming this machine works when the crank is turned, could the twitters it produces be an adequate substitute for the twittering of real birds? What is Klee telling us about our industrialized world?

Op art artists produce physically unstable images which cause the illusion of movement in the viewer's eye. Op art was first introduced in the 1940s. Bridget Riley's *Current* in Book Two is an excellent example.

Claes Oldenberg's *The Dormeyer Mixer* (see your classroom reproduction) is a soft sculpture, and an excellent example of **Pop art**. The Pop art movement, which began in the 1950s, forces us to take a close look at familiar, everyday objects and think of their qualities as a part of, or an entire composition.

There are many other movements in modern art. Pop artists began to use multiple camera images to produce works depicting motion picture stars, such as Marilyn Monroe. This evolved into a form known as **Photo-Realism** in the 1970s. Photo-realistic works are made by projecting a photographic image onto a canvas and then painting over it. This movement has also expanded into

Figure A-24. What is Klee telling us here?
Paul Klee, *Twittering Machine*. 1927. Pen on oil transfer drawing on paper, mounted on cardboard, 25 1/4 x 19 inches. Collection, The Museum of Modern Art, New York. Purchase.

sculpture, with the purpose of always making the pieces as realistic as the object itself.

Where does this leave us as the twenty-first century begins? It is hard to predict new directions, but we are surrounded by a rich variety of styles with echoes from the past as well as glimmerings of the future.

This brief introduction to the history of the visual arts is simplified, but the authors have taken pains not to over-simplify. The examples and artists discussed here were carefully selected to illuminate a particular era or an artistic tradition of a part of the world. As much as possible, the works and artists chosen were *not* covered extensively in the other parts of your texts. None should be considered the "favorites" of the authors, or those you should remember to the exclusion of others. It is our hope that you will be challenged to take additional visual arts courses in your secondary school, and that you can take (or make) the time to study art history in depth. We warn you that it can be addictive, but also endlessly fascinating.

A P P E N D I X

CAREERS IN ART

INTRODUCTION

In this course you have studied art, and you have created art. Along the way, you have seen how artists in many fields earn a living.

There are comparatively few of us with the talent, determination, and patience to produce museum quality works of art. If you are one of the few, no more need be said to you about careers in art. Nothing will keep you from your destiny.

The skills you are learning are basic for an exciting career in one of many interesting fields. This appendix is designed as a reference which may be of help to you in planning secondary school courses and, perhaps, post-secondary school work. Your art teacher, your guidance counselor, and your school and community librarians can all help you locate more detailed information about specific art-related careers. We have grouped the career opportunities by category, ranging from careers in business and industry to careers in the preservation of history and education.

There is no such thing as a complete list of the opportunities for careers in the field of art. In the coming years the need for graphic communicators and similar careers will expand at an ever-increasing rate. You may well work in a medium that has not yet been imagined. The most important thing to remember is that art will always be based on the visual elements and compositional principles.

Graphic Design

Graphic designers are employed in many businesses. Among these are advertising agencies, newspapers, magazine publishers, book publishing houses, television studios, and art departments of retail stores

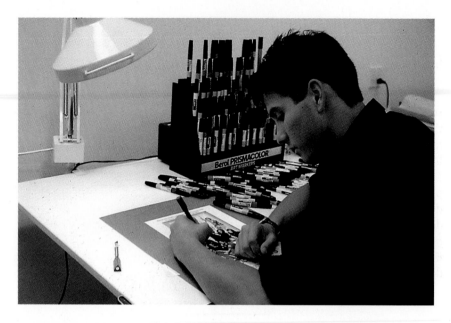

Figure B-1. A graphic illustrator prepares art for a publication.
* Photo by David Hanover.

and manufacturing companies. **Graphic designers** present information in a visually attractive and interesting manner.

The graphic designer must have a good command of the visual elements of art and the compositional principles of design. He or she also must understand the basics of graphic design, typography, and printing. The ability to write well will become of increasing importance for the very best jobs in an organization. Persons who have both graphic and journalistic skills are called **graphic journalists.**

Graphic journalists fill important roles in newsrooms and editorial offices in both print and electronic media. We will discuss the role of the graphic journalist further in the section on publishing and journalism.

Advertising Art

Graphics contribute to the fundamental purpose of advertising—persuasion.

A large advertising agency has several positions that demand skill in art. Some artists work in print media, some in electronic media. The graphic artist works closely with the copywriter to produce print ads. Photographers and illustrators produce the images used in print ads. The graphic designer arranges the images to express the message.

Creating television commercials requires the talents of many people. The job functions are the same as those necessary for producing a motion picture, and all workers must be skilled artists. These workers are the director, art director, animators, cinematographers, costume designers, prop managers, set designers, make-up artists, and other specialists, depending on the specific needs of various commercials.

If you are particularly interested in advertising, continue to take art courses in high school as well as courses in communications.

Fashion Design

There are many specialized positions in fashion design. They require highly skilled persons with a thorough background in art. They also require people who can work under pressure.

Whether working for a high fashion designer or a mass producer of ready-to-wear clothing, the fashion designer presents seasonal collections to the public each year. Each collection should be innovative, fresh, and identifiable as a product of the particular design house. Color, line, and texture are the basics in fashion design.

Employment positions in fashion design include fashion photographers, fashion illustrators (a very specialized career field), graphic designers, fabric specialists, fashion show specialists, display artists, set designers, and the clothing designers themselves. Many fashion houses produce their own accessories such as jewelry, eyeglasses, and perfume. Each of these requires packaging and promotion and, consequently, designers.

The Entertainment Industry

The need for persons with artistic talent in the entertainment industry provides many opportunities for artists of widely varying talents. These talents are as diverse as the various branches of the industry— motion pictures, theater, television, radio, opera, and ballet. There are specialized positions such as set designers, make-up artists, prop artists (who build, acquire, and manage the props used by the performers), animators, costume designers, cinematographers, color specialists, lighting specialists, special effects personnel, and the art director as well as the director herself or himself.

The entertainment industry also needs graphic designers, photographers, and illustrators for displays, brochures, advertising, programs, performance schedules, and billboards.

In this field talented people can advance quickly. On the other hand, they must start at entry-level positions to learn the specialties of the field they have chosen.

Publishing and Journalism

Design is of critical importance to the success of a book publishing house. Book designers plan and execute the layout of the books. Many designers are specialists in one or two fields of book design. For example, some work on elementary and high school textbooks, others specialize in college level texts, others in books on highly technical subjects such as medicine, and others in books of fiction and nonfiction. The book designer works under the supervision of the art director. Most publishing houses use a system that requires approval of every stage of book design, so the designer works closely with the authors, editors, and marketing personnel. The designer selects the type and type size, acquires or makes illustrations and photographs, selects colors for the design, designs the cover and makes or acquires art for the cover, and gives the book an overall feeling of unity.

Consider the design of this textbook. It is a book about the visual arts, so it should be attractive and showcase much great art. It also must

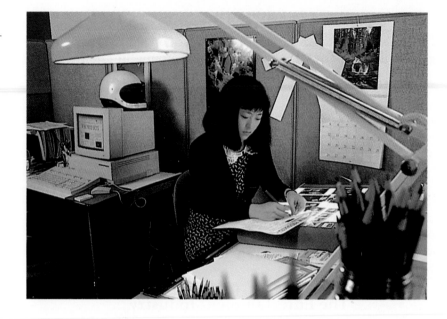

Figure B-2. A magazine designer.
Courtesy of Robert Holgren.

be useful and logically put together. For example, if the text on a page is about a Renaissance artist, the images on that page should feature work by that artist or of that period.

Magazine designers must completely understand their target audience. The graphic style of a high fashion magazine, such as *Vogue* or *Glamour,* would not be appropriate for a magazine on hunting and fishing, such as *Field and Stream,* or a newsmagazine, such as *Newsweek* or *Time.* A well designed magazine will have a feeling of unity throughout. Look at several different types of magazines in the library. Do you see a coordinated design throughout, or does a particular magazine appear to be a series of unrelated articles with no unity of design? Does the design seem appropriate for the target audience?

The use of computers has revolutionized graphic design in publishing. Using the computer the graphic designer can make changes in layouts quickly. This allows the designer to try many options that would formerly have taken hours. The result is greater freedom of expression.

Computer graphics have made the modern newspaper editor a graphic journalist. Reporters compose their stories on computers. Stories from the wire services, such as the Associated Press and Reuters, are electronically transferred to the computers of the news department. Wire service photographs are also sent by satellite and stored for review on the computer by the graphic journalist.

The graphic journalist can call up all of this information on the computer screen. The reporters' stories can quickly be edited and reorganized if necessary, by sending the appropriate instructions to the computer. The graphic journalist switches to the page mock-up program. A grid appears on the screen. Then he or she uses the grid to lay out the page, mixing photos, illustrations, and copy. The graphic journalist types out headlines and chooses the type style and type size for each story. At the press of a button, the laser printer furnishes a printed copy of the final page before the newspaper goes to press.

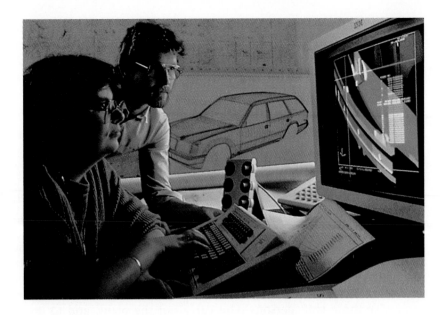

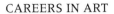
Figure B-3. An industrial design team.
Courtesy of International Business Corporation.

Illustrators, photographers, cartoonists, political cartoonists and, of course, art critics are among the other important positions in publishing.

Industrial Design

Industrial designers design everything from toothpaste dispensers to supersonic aircraft and nuclear submarines. Those that design products for the consumer market must consider appearance as well as function. Successful consumer products combine these two qualities.

Complex products, such as automobiles, are designed by teams of industrial designers, each expert in a particular field. Teams must strive to fit the safety, comfort, and appearance features of the interior into the streamlined aerodynamics of the exterior. The engine and other components under the hood must fit within the space that is under the hood. In practice, all of these considerations lead to design compromises. Computer aided design (CAD) has been of tremendous help to automobile designers in making such compromises.

If you have the opportunity to do so, look carefully at an automobile produced in the 1930s or 1940s and compare it with a new model. Start by looking under the hood of the old car. It wasn't much of a design problem to get the engine in there was it? With the limited number of gauges, the design of the dashboard was almost entirely a problem of appearance rather than functional considerations. Bench seating was standard, and was more a concern of the upholsterer than the designer. Now look at the new car. As you look under the hood, notice how the components fit tightly into the available space. The instrument panels for the driver are much more complex and are designed so that everything is within easy reach for safety. New safety features, such as air bags, must be fitted where other components were placed previously. Comfortable seating with several (or a large number of) options is available.

Successful industrial designers completely understand the characteristics of the materials with which they work. The great industrial designers have such mastery of the compositional principles that their designs successfully blend form and function.

Interior Design

The interior designer plans the interiors of buildings and homes and supervises the completion of these plans.

The first trait that an interior designer must possess is an extraordinary sense of the visual elements and compositional principles. He or she must also have the ability to present ideas clearly to clients. This presentation often includes detailed drawings, sample swatches, paint samples, and other items.

Successful interior designers build a network of sources for fabrics, wall coverings, lighting fixtures, floor coverings, kitchen and bathroom equipment, and art. They also build a network of contacts with skilled and reliable craftspersons. The interior designer must have the ability to supervise those craftspersons who carry out the plans, and to do this within a prescribed budget.

An interior designer may increase efficiency in a business by the arrangement of work space, the placement of desks, machines, and aisles, and the type and location of lighting. By making the workplace a more pleasant and comfortable place, the interior designer may also improve efficiency.

Museums

Mention the word *museum*, and the first image that comes to mind is most likely an art museum. In thinking about career choices, remember that there are many other kinds of museums, and each type employs working artists or provides opportunities for free-lance artists. Other types of museums include museums of science and natural history, aquariums, medicine, technology, aircraft, and railroad. These museums need photographers, technical illustrators, designers of exhibitions, display artists, and graphic artists for catalogs and promotions.

The art museum employs many people with a variety of artistic abilities. The curator of the art museum is an art scholar. The curator is in charge of acquiring pieces for the museum's collection as well as properly displaying them. The collection should be planned and arranged to give the viewers maximum educational as well as aesthetic value. The curator has a staff of exhibition designers and display artists to help with this function.

Many museums have education departments with a staff of specialists who prepare educational publications and programs in electronic media using the museum's collection. The staff also trains volunteer museum lecturers. These volunteers are called docents.

Several of the larger museums employ artists and craftspersons to design reproductions of works in the collection. These reproductions are sold at the museum and through catalog sales. The catalogs themselves are created by museum staff artists.

Another important position is that of the conservator. Conservators see that the collection is properly maintained and restore objects that

have been damaged or that need cleaning after the accumulation of centuries of soot.

Art Education

The qualifications for a career in art education include a minimum of a four-year college degree. The art teacher has an extensive knowledge of the major forms of expression, as well as knowledge of teaching procedures and of child growth and development.

A person who is considering art education as a career should truly enjoy developing the talent and challenging the abilities of others. He or she also must be willing to spend time developing an extensive knowledge of art history and aesthetics.

While preparing to teach in the public or private schools, most education majors must decide whether they want to specialize in elementary or secondary education in order to take the appropriate courses in college. Those who plan to teach at the college level will earn graduate degrees in their specialties.

Museum science courses may be taken by those who wish to specialize in museum education. Specialized courses are also available for those who wish to enter art therapy. Art therapists work with persons who are physically or emotionally handicapped, as well as with the blind and deaf. Art therapists use art as a means of opening communication.

GLOSSARY

A

Abstract art A twentieth century style of art in which ideas and subject matter are treated geometrically, or distorted to communicate meaning which is not a part of the subject matter itself. Abstract art stresses the visual elements and compositional principles more than the subject.

Abstract Expressionism A movement that began in New York City in 1946. The style is a revolt against all traditional styles and emphasizes spontaneous expression. It was termed *action painting* in 1953 by the critic Harold Rosenberg.

Acrylic paint Pigments mixed with an acrylic binder.

Aerial perspective A method of depicting depth on a flat surface by making distant objects smaller, placing them higher on the picture plane, and painting them in cooler colors, and in lower contrast and detail than closer objects. See also *Perspective*, compare *Continuous perspective* and *Linear perspective*.

Aerodynamics A branch of physics that treats the effects of the laws of motion of air and other gases on bodies in motion.

Aesthetic judgment The process of describing, analyzing, interpreting, and evaluating a work of art.

Aesthetics The study of the visual, literal, and expressive qualities of a work of art and the viewer's response to it. Also the branch of philosophy which is concerned with the qualities of art that create aesthetic responses and with the unique nature of art.

Air brush An atomizer which applies a fine spray of paint using compressed air. The tool allows smooth gradations of tone.

Alla prima A painting technique in which all color is laid on the support surface in one application, with little or no preliminary drawing or underpainting.

Allegorical figures Symbolic figures whose actions express generalizations or truths about human conduct or experience.

Amphistructure A structure that is part amphitheater and part sculpture.

Amphitheater An oval or circular building consisting of an arena surrounded by rising tiers of seats. The structure was invented by the Romans for tournaments and displays. The Colosseum in Rome is a good example.

Analogous colors Colors containing a common hue which are found next to each other on the color wheel, for example, blue and blue-violet.

Anasazi (ah-nah-sah'-zee) Navaho for *"the ancient ones,"* the ancestors of modern pueblo dwellers. The Anasazi culture arose in approximately A.D. 50.

Animation The process by which a sequence of images is projected rapidly, one after the other, creat-

ing the illusion of movement. Examples are film and television cartoons.

Apex The uppermost point.

Appliqué (ap-lih-kay') The technique of attaching shapes to a background by sewing or gluing.

Aqueduct A masonry channel used to convey water; invented and widely used by the ancient Romans.

Arch A curved structure spanning an open space.

Architecture The art of designing and constructing buildings, bridges, and so on.

Armory Show The first large exhibition of modern art held in America. It was held in New York City in 1913 and had a wide influence on the American art that followed it.

Art Creative work which results in objects and images often revealing beauty and insight. In the visual arts, these creations are intended to communicate meaning through symbols and images. In music, meaning is conveyed by sound; in literature, by words; and in ballet, by body movement.

Art criticism In the visual arts, the skill of understanding and making personal judgments on works of art.

Artisan A person expert in a skilled trade; a craftsperson.

Artist A person skilled in one of the fine arts, especially painting, drawing, sculpture, and so on.

Art nouveau (art noo'-voh) The "new art" of the 1890s, characterized by sinuous lines and highly foliated decoration.

Arts and crafts movement The revival of interest in hand-made crafts in late nineteenth-century England. The movement grew into an alliance of art and industry headed by William Morris. An abundance of hand-woven textiles, finely designed furniture, pottery, books, household utensils and wallpapers resulted.

Ashcan School An early twentieth-century group of artists who depicted scenes from everyday life in the city. The group, originally known as "The Eight," banded together in 1907, held their first exhibition in 1908, and helped organize the Armory Show of 1913.

Assemblage (uh-sem'-blidge) A three-dimensional work of art which is an extension of *collage*. It is also a building technique using a number of objects.

Asymmetrical balance Also called *informal balance*. In a two- or three-dimensional work it is the illusion of visual equality of sides of a design without the use of identical portions.

B

Background The part of the picture plane that appears to be farthest from the viewer.

Balance The compositional principle of design in which all of the elements appear to have equilibrium. There are three types of balance: formal or symmetrical, informal or asymmetrical, and radial.

Baroque (buh-roke') A style of art and architecture which originated in Italy at the end of the sixteenth century and lasted until the middle of the eighteenth century. The art of the Baroque has extraordinary energy, expresses strong emotion, and is characterized by strong contrast of light and dark.

Barrel vault A stone or brick roof in the shape of half a cylinder. It often covers rectangular space and is known as a *tunnel vault*.

Baseline The line (usually at the bottom of a drawing or painting) which represents the ground or floor, especially in artwork of young children.

Bas-relief (bah'-ree-leef) Also known as *low relief*. Architectural sculptured decoration with parts carved so as to project slightly from a surface (less than one half of the depth of the sculpted object). There is no undercutting of the object at all. Compare *High relief*.

Binder A medium mixed with pigment to make paint, dye, or crayon. It is also referred to as the *vehicle*.

Block A piece of wood or linoleum which is first engraved, then inked and pressed on a ground support to create a print.

Brayer A roller with a handle used to apply ink to a surface (such as a block).

Brushstroke The observable stroke by the artist's brush on a ground support.

Brushwork The character with which paint is applied to the ground support. The brushwork of each great painter is unique, and it can be admired independently of the subject of a painting.

Buddhism A religion of central and eastern Asia growing from the teachings of the Gautama Buddha (563–480 B.C.) Buddhist art was highly influential in all of central and eastern Asia.

Buttress A support projecting from the face of a wall which resists outward thrust. In Gothic architecture the *flying buttress* is an arch, projecting over the side aisle of a cathedral, which helps direct the outward thrust downward. The effect is the illusion of a floating, unsupported roof.

C

Calligraphy An Oriental method of elaborate brushstroke handwriting. Also any artfully produced, beautiful handwriting.

Canvas A closely woven cloth surface prepared for an oil painting. Also sometimes used to refer to the painting itself.

Caricature An exaggerated image often ludicrous, and often used in editorial cartooning. The practice of caricature goes back to ancient Rome.

Cartography Mapmaking.

Cartoon 1. A full-sized drawing made in preparation for a large painting, tapestry, or stained glass window. 2. A modern satirical drawing such as a political cartoon. 3. A panel strip or comic strip, humorous or serious. 4. An animated cartoon.

Carving The shaping of stone, wood, marble, or any block of material by the process of reduction, or taking away.

Casting The shaping of metal, usually bronze (an alloy of copper and tin) by the use of a mold.

Center of interest The area of an artwork that first attracts a viewer's eye.

Ceramics The art of pottery making. Pottery is shaped and then fired in a kiln or oven, which strengthens it.

Chiaroscuro (kyar-uh-skyoo'-roh) Italian for "clear and dark." The method developed during the Renaissance of arranging light and dark areas of a painting.

China Popular name for porcelain ware and statuary. It was so named because the Chinese first mastered the art of making fine porcelain. It took many centuries for Europeans to master the process. During those centuries the porcelain pieces became known as "China."

Clay Earthy material that is plastic when moist and stiffens as it dries.

Coil A long, snakelike roll of clay used in making pottery.

Collage The technique of building a low relief or two-dimensional picture by applying materials such as cloth or paper or cardboard to a ground support. It may be done in conjunction with a painting, or the whole work may consist of these applications. Also the work created by such techniques.

Collograph A form of relief printing in which prints are made by applying materials to blocks, inking the raised portions, and pressing the block to a surface. Also, the print resulting from this process.

Color A visual element of art with the properties of hue, value, and intensity. The eye perceives color through the reflection of light from the color to the eye.

Color scheme A scheme for organizing the colors of the palette selected for an artwork.

Color spectrum The array of colors visible to the human eye, produced by passing white light through a prism. The colors of this spectrum always follow the same sequence (red, orange, yellow, green, blue, and violet). The rainbow produces the same colors as white light when it passes through raindrops.

Color wheel A convenient display of the color spectrum bent into a circle. It is useful in organizing color schemes.

Communication The process by which understanding is reached through the use of symbols.

Compass A steel instrument used for drawing arcs and circles.

Complementary colors Two colors which are directly opposite one another on the color wheel. They are the colors which are least like one another, and which become dull when mixed. Placing them side by side intensifies each by creating the strongest possible contrast.

Composition The arrangement of the visual elements in an artwork; often used to refer to a work of art itself.

Compositional principles of design Rules by which artists organize the visual elements of art. They include repetition, variety (or contrast), emphasis, movement and rhythm, proportion, balance, and unity.

Computer art A broad term which may include computer graphics but usually applies only to artwork created on the computer, of a representational, abstract, or expressive nature.

Computer graphics Refers to the business diagrams, charts, graphs and page layouts created by graphic artists. It also includes the images, designs, plans and diagrams produced on a computer by designers, engineers, architects, and craftspersons, intended to be developed into other works of art such as buildings, cars, sculpture, etc.

Computer-generated imagery Refers to visual images, symbols, and designs generated by the computer, as graphics or works of art.

Conceptual art A drawing made from the imagination or memory in which the artist renders what is known about a thing, rather than what can be seen by looking at the subject.

Conservator The employee of a museum who sees that all pieces of art are properly cared for and restores, or arranges restoration of, those pieces needing special care.

Contour The boundary which delineates a form and distinguishes one form from another in a picture.

Contour drawing A method in which artists keep their eyes continuously on the subject while concentrating on reproducing the lines of the subject.

Contrast The compositional principle of design in which the artist chooses a variety of colors, textures, and patterns to add interest to a work.

Cool colors Those colors of the spectrum that suggest coolness such as blue, green, and violet. Cool colors seem to recede when used with warm colors. Compare *Warm colors*.

Craft guilds These guilds emerged in the late Middle Ages so that masters could set strict standards for their crafts and an apprentice system could be established. The apprentices studied and practiced the craft before becoming members of the guild.

Crafts The many forms of art that are useful as well as beautiful. Examples are quilting, ceramics, jewelry making, and weaving.

Crayons Sticks of pigment and wax which are used to make art.

Credit line A standard method of identifying a work of art reproduced in, for example, a book. It usually includes the name of the artist, the title of the work, the date the work was finished, the medium, size (height × width × depth), the source (museum, collection, or gallery), location of the source (city), donors of the work and date donated (if applicable).

Crosshatching A method of shading which gives the illusion of depth on a two-dimensional surface by the use of crossed sets of drawn or etched parallel lines.

Cubism An art movement in which subject matter is separated into geometric shapes or abstract designs, and which combines several different views of the subject. The first Cubist exhibition was in 1907.

Culture A particular stage of advancement of a civilization and the characteristics of that stage, such as its art and the skills, ideas, customs, and behavior of its people.

Curator One who selects the objects for a museum and maintains its collection.

Cursor The small arrow, cross (+ sign), or blinking light which indicates the position on the monitor screen where input will begin.

D

Dada French for hobbyhorse. A movement in art which originated at the beginning of the First World War and whose experimental art reacted against that war. The intent of the Dadaists was to go against all established conventions in art.

Dark Ages A period following the fall of the Roman Empire (from the fifth to the ninth century) which was characterized by migration of peoples, much political upheaval, and great social insecurity. Poverty and ignorance were widespread, and culture declined.

Design The plan for the arrangement of the visual elements in a work of art.

Dimension A measurement in one direction. In representational art, the three dimensions are height, width, and depth. Time is considered the fourth dimension, and many abstract artists have attempted to represent this fourth dimension visually.

Disk A flat, magnetized, circular storage device upon which computer programs, texts, and data are saved. See also *Flexi disk, Floppy disk,* and *Hard disk.*

Disk drive The device in which you place a disk; it reads the disk and sends its data, commands, and programs to the computer.

Distortion The twisting of a normal or original shape for dramatic effect.

Dome A combination of multiple arches or vaults around an axis which forms a hemispheric (half of a sphere) roof. Some domes are not true domes, since they may be, for example, octagonal.

Dominant element The visual element that is noticed first in a work of art, such as, perhaps, color in an Impressionist painting, or line in op art. Compare *Subordinate elements.*

Dye Pigment, or pigments in liquid, which may be soluble or insoluble. Dyes are used to give new color to material.

E

–e A suffix in the Japanese language which means "pictures of." Examples are Yamato-e (pictures of the region around Kyoto and Nara) and Ukiyo-e (pictures of the passing world).

Easel A tripod or stand on which the artist places the canvas or surface for a painting or drawing, or on which a work of art is displayed for viewing. In computer art, the easel is the working area on the monitor screen. It includes the window box, menu bar, color and pattern palettes, and the tool box.

Elements of art See *Visual elements of art.*

Embroidery Decorative stitching on fabric; also a piece with such work.

Emotionalism A means of making judgments about works of art on the basis of their emotional appeal to a viewer. Emotionalism may be only part of an aesthetic judgment. Compare *Imitationalism* and *Formalism.*

Emphasis A compositional principle of design in which the artist emphasizes one part of a work by the use of color, size or shape or a combination of these. Emphasis defines the *center of interest* and generally gives the work its meaning.

Engraving The process of cutting a design into a metal printing plate. Also, the artwork which results when the ink is applied to the plate and pressed to a surface. In the United States paper money is made by this process.

Equestrian statue A sculpture of a figure on horseback.

Etching A process in which a design is cut into a plate by repeated baths of acid; also, the resulting print. Compare *Engraving.*

Expressionism A twentieth–century aesthetic movement which rejected the representation of natural subjects. Expressionists believe that art should communicate the artist's emotions rather than a realistic image, and they use distortion as an important means of emphasis.

Eye level The horizontal line or line level with the eye in linear perspective.

F

Fabric Material produced by weaving, felting, or knitting. Examples are cloth, felt, and lace.

Façade 1. The front, or visible part of a building. Also, and less commonly, the visible front of anything. 2. A false front designed to give a favorable impression or to trick the eye.

Fauves (fove) French for "wild beasts." Artists so named because of their radical use of intense, pure color for emotional and decorative effect. The Fauvists' movement was the first important aesthetic movement of the twentieth century.

Fiber A long, continuous, fine piece of something, usually woven or spun into thread.

Figure In art, generally, the human form. Also, the area enclosed by planes or surfaces, as in a *solid figure.*

Fine arts The arts that are purely expressive rather than functional.

Fire The application of heat for the purpose of hardening pottery.

Flexi disk A plastic-encased, 3.5-inch disk for recording and saving data on computer which is inserted and removed from the slot in the disk drive.

Floppy disk A paper or plastic-encased, 5.25-inch disk for recording and saving computer programs and data.

Flying buttress See *Buttress.*

Folk art Decorative objects made by persons without formal art training. It is generally unsophisticated but not necessarily unskilled.

Font All the letters, and numbers of one size and type style. On a computer, the typeface which is selected; it names or identifies the style and size of the letters, numbers, and other symbols for data, commands, and text.

Foreground The area of the picture plane that appears closest to the viewer.

Foreshortening The effect of the application of the principles of perspective by the artist in depicting a figure or object. The result is lifelike, and appears to have depth. To achieve this effect, artists are trained to render exactly what they see, rather than what they know about the subject.

Form The three-dimensional visual element of art. Sculpture, for example, is three-dimensional with height, width, and depth. Artists use a variety of methods to give the illusion of form on a two-dimensional surface.

Formal balance A means of creating the feeling of visual equality on both sides of an artwork, achieved by the use of identical or very similar elements on each side of the composition. Also called symmetrical balance. Compare *Asymmetrical balance* and *Radial balance.*

Formalism A method of evaluating an artwork by critically judging the relationship of the visual elements of art to each other, and the artist's use of the visual elements. Compare *Imitatationalism* and *Emotionalism.*

Found objects Natural or manufactured objects chosen by an artist to create all or part of a collage or assemblage.

Free-form forms Irregularly shaped forms, as opposed to geometric forms. See also *Free-form shapes.*

Free-form shapes Irregular, often natural appearing shapes as opposed to those which are geometric. See also *Free-form forms.*

Fresco Italian for "fresh." A method in which pure powdered pigments are mixed in water and applied to a wet, freshly laid plaster ground support. The col-

ors fix as the surface dries, and the painting becomes a part of the plaster wall itself.

Futurism A movement begun by Italian artists in 1909. These painters attempted to represent machines or other objects and figures in motion, as well as sounds and smells. Futurists used what they called lines of force that curve, twist, dash, and cut across their paintings to show dynamic energy.

G

Gable The outside (usually triangular) section of a building's wall which extends upward from the eaves to the top ridge.

Gallery A place for exhibiting art. Also a commercial enterprise exhibiting and selling art.

Generate To produce programmed images and data on a computer screen.

Genre (zhon'-ruh) **art** Artworks that depict scenes from daily life.

Geodesic dome A prefabricated hemispherical dome made of light, strong, polygon shaped bars and covered with a thin but strong material; the invention of American engineer R. Buckminster Fuller.

Geometric forms Regularly shaped forms which can be precisely measured by mathematical formulas, as opposed to free-form forms. See also *Geometric shapes*.

Geometric shapes Shapes which can be precisely measured by mathematical formulas.

Gesture drawing A line drawing of a human figure which captures the movement and feel of the subject.

Glaze In ceramics, a thin, glossy coating fired into the piece. In painting, a transparent layer of paint which, when applied over another layer, modifies and reflects the light passing through.

Gothic A style of architecture and painting developed in Europe in the late Middle Ages. Gothic paintings are severe, formal portraits; Gothic architecture is characterized by slender vertical piers counterbalanced by pointed arches, vaulting, and flying buttresses.

Goths Barbarians who overran the Roman Empire and sacked Rome in A.D. 410.

Gouache (goo-ahsh') A method of painting using opaque watercolors. Also, a picture painted by this method. The opaqueness comes from using glue as the binder and adding a bit of white.

Gradation A technique highly developed by Renaissance painters in which one color is blended skillfully and almost imperceptibly into another in a painting, creating realistic, lifelike effects.

Graphic arts The visual arts applied to a flat surface, such as drawing, painting, lithography, engraving, etching; also, the techniques and crafts associated with each of these arts.

Graphic journalist A journalist who combines his or her writing skills with graphic design knowledge to produce informative graphics and/or publications.

Grid The pattern that results from intersecting vertical and horizontal lines on a surface.

Ground See *Ground support*.

Ground support The surface on which a drawing or painting is executed.

Guild See *Craft guilds*.

H

Handy A small clay shape that is smooth and pleasing to the touch.

Hard disk A 3.5-inch storage device of several million bytes (megabytes), in a non-removable case, for recording and storing large quantities of programs and data.

Hardware The basic equipment of the computer: monitor, disk drive, printer, hard disks, keyboard, and other peripherals such as joy stick, mouse, koala pad, or light pen.

Harmony In art, the combining of the visual elements of art in such a way that the similarities bind the picture into a pleasing composition.

Hatching A method of shading through the use of parallel lines. See also *Crosshatching*.

Hessian A German soldier paid to fight for the British during the American Revolution.

Highlight The small, brightest (usually white) area of a painting or drawing which depicts the strongest reflection of light in the work. Compare *Shadow*.

High relief Sculptural decoration to architecture, in which the parts of the sculpture are part of the architectural element, but project outward more than one half of their depth. Compare *Bas-relief*.

Horizon The line or point at which the earth and sky appear to meet.

Horizontal lines Lines that are parallel to the horizon or baseline.

Hue One of the three properties of color. It is the name given to a color whose unique properties give it a definite place in the color spectrum. See also *Value* and *Intensity*.

I

Icons Symbolic images which represent saints, religious persons, or other symbolic meanings. In com-

puter art, icons are the simple pictures which represent tools, lines and shapes in the computer tool box.

Imitationalism A method of evaluating a work of art by judging the degree to which the image represents the actual subject. Compare *Formalism* and *Emotionalism.*

Impression The imprint made by the pressure of a block or printing press on a ground surface. Also the name of a single copy made by this process.

Impressionism A style of painting which originated in France in the last half of the nineteenth century. It is characterized by bold brushstrokes of pure color laid next to each other to represent the effects of light on the subject.

Industrial Revolution The technological changes which led to economic and cultural change when the majority of workers became industrial workers, following the development of large-scale factory production in the last half of the eighteenth century.

Informal balance See *Asymmetrical balance.*

Input The data, commands, or programs which are entered into the computer for processing, display, and retrieval.

Intensity The brightness or dullness of color. Full intensity colors appear on the outer rim of the color wheel and are dulled when mixed with their complementary (or opposite) color, as shown in the interior sections of the color wheel. One of three properties of color. See also *Hue* and *Value.*

Intermediate color A color made by mixing a primary color with its adjacent secondary color. Blue-green is an example. Also known as *tertiary colors.*

Interpretation An explanation of the meaning of an artwork, based upon the viewer's observation and analysis.

J

Jade A gemstone, usually green, used in jewelry and carving, which can take a high polish.

-ji (gee) Japanese suffix meaning "temple." It follows the name of the temple, as in Horyu-ji.

Joy stick A small device with a movable upright stick (like a gear shift), used to move the cursor around the computer screen, (left and right, up and down, or in circles), to enter commands or objects, and to make selections on the computer screen.

Judgment The viewer's evaluation of an artwork, based on observation, analysis, and interpretation.

K

Kaolin A white, high-firing, non-plastic clay found in scattered deposits in Europe, North America, England, and Asia, used in making china and porcelain.

Keyboard An input device, consisting of several rows of keys with alphabetical letters, numbers, command keys (escape, return, etc.), and function symbols, used for entering data and commands on the computer.

Kiln A heated enclosure, such as an oven or furnace, used to harden clay.

Koala pad An input device with a magnetized pad that responds to pressures; it transmits images drawn on its surface by a special stylus to the computer screen.

L

Landscape A drawing, painting, or print depicting a natural scene.

Lapis lazuli (lap'-is laz'-yoo-lee) A semiprecious stone, usually rounded and of a bluish-violet color.

Light pen A pen-shaped input device sensitized to activate images or enter data when applied to the surface of the computer screen or to a magnetized pad or tablet.

Line The visual element of art that is a continuous mark made on a ground support and has one dimension—length.

Linear perspective A technique for giving the illusion of depth on a two-dimensional surface by the use of one or more vanishing points from an eye-level line. In *one point linear perspective* all lines recede and meet at a single point, forming guidelines to determine the relative size of objects on the picture plane. See also *Perspective.* Compare *Continuous perspective* and *Aerial perspective.*

Lines of force See *Futurism.*

Lintel A horizontal crosspiece over a window, door, or other opening which spans the opening and carries the weight of the load above it.

Lithography The process of making printed images from a stone or plate on which a drawing or design has been made.

Loom A frame for weaving.

Low relief See *Bas-relief.*

M

Manifest Destiny A statement or policy prominent in the 1800s which supported the expansion of the United States to the limits considered "natural" or "inevitable."

Mannerism A style of European art which emerged in the last half of the sixteenth century. Mannerism

broke away from the Renaissance traditions with a more expressive view of the landscape and the human figure. The pictures tended to be emotional with distorted shapes and bright, garish colors.

Mass drawing A process in which the artist concentrates on the weight, balance, and movement of the subject. It is usually accomplished by using the side of a drawing tool, which is approximately one-half to three-fourths of an inch wide.

Mat To frame a picture with a border heavier than the ground support. Mats are often cardboard.

Matte (mat) surface A dull, lusterless surface, such as paper. Compare *Shiny surface.*

Matte paintings Background paintings used in motion pictures to depict unusual and fantastic scenes.

Medieval Of or pertaining to the Middle Ages.

Medium The material used by an artist to create a work of art. A painter's medium is paints; a sculptor's, metal, wood, or marble, etc.

Menu A list of choices or options shown on the computer screen.

Menu bar The horizontal or vertical strip of titles or icons on the computer screen that lists the menu options.

Mesolithic Age Greek for "middle stone age." The period from 8000 B.C. to approximately 3000 B.C.

Mexican muralists The early twentieth-century Mexican artists who sympathized with the revolution in Mexico and who advocated mural painting as "people's art," since all could see the murals if they were painted on public buildings and walls. Prominent Mexican muralists were David Alfaro Siqueiros, Diego Rivera, and José Clemente Orozco.

Middle Ages A period of European history of approximately one thousand years following the fall of the Roman Empire and preceding the Renaissance.

Mimbres Spanish for "willows." Members of an ancient farming group of Native Americans in southwestern New Mexico. Their beautiful painted pottery is highly prized today and, though it was made around 1,000 years ago, looks as modern as anything produced since that time.

Mobile A piece of sculpture made of balanced suspended shapes which move freely with air currents.

Monitor The screen upon which computer entries and images are displayed and modified.

Monochrome Greek for "one color." A work completed with a color scheme using only one hue and all of its values.

Montage A composite picture made by combining two or more separate pictures.

Monumental art Art of a very large size, usually dedicated to the memory of some noted person. Examples are the Pyramids, the Sphinx, and the sculpture at Mount Rushmore.

Mosaic (moh-zay'-ik) A surface decoration made by inlaying pieces of colored stones or tile to form a pattern or picture. Also, the finished product.

Motif (moh-teef') A recurrent design element that sets the theme for a work of art.

Mouse A small input device on a wheel-ball which enters data into a computer and guides a pointer (arrow) around the screen to locate text; which inserts, moves, or modifies text, graphics, and data; or which gives instructions to the computer.

Movement A compositional principle of design in which the artist controls the movement of the viewer's eye within the work. This is *visual movement* as opposed to *actual movement* of a work (see *Mobile*).

Mural A painting, usually large, on a wall or ceiling.

Muralismo The tradition of people's art, exemplified by the murals of the Mexican Muralists of the twentieth century. See *Mexican muralists.*

N

Narrative painting A painting from which the viewer can get a story.

Negative print In photography, an image produced by reversing a positive print.

Negative space The empty space surrounding shapes and forms in an artwork. Negative space can be above, under, beside, and, in the case of sculpture and architecture, within the work. Negative space is said to define its opposite, positive space. Compare *Positive space.*

Neolithic Age Greek for "new stone age." It is a period from approximately 3000 B.C. to 1500 B.C.

Neutral colors Black, white, and gray.

O

Off-the-loom A weaving process by which linear materials (weft through warp) are woven without using a loom.

Oil paint Pigments mixed with oil. Oil painting has been dominant in easel painting since the sixteenth century.

Opaque Not transparent, not allowing light to pass through.

Op art A shortening of *optical art.* A form of abstract

art characterized by patterns which create an optical disturbance or illusion in the viewer's eye.

Operator See *User.*

Output Data or information resulting from computer processing and available to the user as a monitor display, a printout (called hard copy), or a file stored on disk.

Overlapping A method of showing depth in a painting, drawing, or sculptural relief. One object extends over another, covering part of the other, thus giving the appearance of greater closeness to the viewer.

P

Pagoda The Chinese version of the Buddhist stupa. The pagoda has become the architectural symbol of China. See *Stupa.*

Paint Pigment mixed with a binder.

Painterly Characterized by highly competent brushwork, it employs the techniques of chiaroscuro and gradation. The word originated to describe the style of the painters of the Renaissance.

Paleolithic Age Greek for "old stone age." In art, the ancient period from approximately 30,000 B.C. to 8,000 B.C., notable for cave paintings in various parts of the world.

Palette A tray used for mixing colors. Also the colors selected by an artist for a painting. On a computer program, the horizontal or vertical bar of colors, values, and patterns from which you select what you want to fill shapes, forms and spaces with.

Papier mâché (pay'-pur muh-shay') French for "mashed paper." A mixture made of newspaper and paste applied to a wire structure to create an assemblage.

Parallel lines Two lines that extend in the same direction, always equidistant, never meeting.

Pastels Sticks of pure powdered pigments mixed with resin or gum. In working with pastels an artist can see the exact effect of the colors immediately as there is no drying process which could effect a change.

Paste-up A model for a printed page as designed by a "paste-up artist." Most media now prepare paste-ups on computers rather than on paper or cardboard.

Perspective The technique of giving the appearance of three-dimensional space on a two-dimensional surface through the use of converging lines, overlapping, color (cool colors recede, etc.), detail, and variations in object size, and by the placement of objects on the picture plane. See also *Linear perspective, Continuous perspective,* and *Aerial perspective.*

Photogram A shadowlike image that is made by placing objects between a light source and light-sensitive paper.

Photography The art or technique of producing images on a sensitized film through the chemical reaction to light.

Photomontage A composite photograph made by combining two or more photographs.

Picture plane The surface of a painting or drawing.

Pigment A coloring substance which may be finely ground and mixed with a binder to make paint or dye, with resin or gum to form pastel sticks, or with wax to form crayons.

Pixel Short for *picture element;* the smallest single unit, or point of light, displayed on the computer screen.

Point of view The angle from which the artist sees the subject of his or her composition. Occasionally, also the angle from which the viewer sees the work.

Polyptich (pahl'-ip-tik) A picture or relief carving, usually an altarpiece, which is made up of four or more panels.

Pop art An artistic style which started in the United States in the 1960s, drawing its subject matter and techniques from the "popular" culture, such as advertising, product design, comic strips, television, and moving picture images.

Portfolio In computer art, the portfolio is the disk which contains examples of art work, images, notes and sketches. It is also a folder to hold examples of art work, notes, and printouts from the computer.

Portrait A work of art depicting a person, frequently only the head, or head and upper torso.

Positive space Shapes or forms in both two- and three-dimensional art. The spaces surrounding, between, and within the positive spaces are called *negative space.*

Post-Impressionism A painting style of the late 1800s that followed Impressionism and rebelled against it by emphasizing structure and the artist's subjective viewpoint. Post-Impressionists believed that Impressionism, while beautiful, lacked permanency. Leading Post-Impressionists were Paul Gauguin, Georges Seurat, Vincent van Gogh, and Paul Cézanne. See also *Impressionism.*

Pottery The shaping of clay into earthenware, stoneware, or porcelain.

Powwow A conference of Native Americans.

Precisionists Artists who painted geometrically pre-

cise pictures of machinery, buildings, bridges, and interiors to show the effects of industry. Their work, created in the 1920s and 1930s, is characterized by areas of flat color and precise contours.

Predella An Italian word naming the small strip of paintings which form the lower edge of a large altarpiece. It usually contains narrative scenes from the lives of saints.

Primary colors Red, blue, and yellow.

Principles of design See *Compositional principles of design.*

Printer Any device that prints text and graphics on paper from a computer.

Printing plate The prepared surface used to produce images in the printing process.

Printmaking The process of making an image which can be repeatedly reproduced by stamping, pressing, or by squeezing paint through a stenciled shape.

Prism A piece of glass of a triangular, wedge shape which can be used to separate white light into its spectrum of colors.

Profile The side view of the face of a figure, or a drawing of such a view.

Programming The process of writing a set of directions that control the operations of a computer.

Proportion The compositional principle of design that is concerned with the correct relationship of the various parts of the design, such as the parts of the human figure.

Pyramids Huge, elaborate burial monuments of the ancient Egyptian rulers. Pyramidal structures are found in other civilizations, most notably in Mexico.

Pueblo A communal dwelling place of the tribes of Pueblo Indians, constructed of adobe, in the southwestern United States.

Puppetry The creation and manipulation of nonliving objects which give the illusion of life in order to entertain an audience.

Q

Quilt A bedcover consisting of two layers of cloth filled with cotton, wool, or down, and held together by stitched designs. One side is generally decorated by diverse pieces of cloth sewn in a design, or by elaborate patterns of stitchery, or a combination of both.

R

Radial balance A form of balance in drawing and painting in which the most important object or figure is placed in the center and the other parts of the composition radiate around this central figure or object. Compare *Asymmetrical balance* and *Formal balance.*

Realism A European art movement of the nineteenth century which was a reaction against the idealism of the Romantic Movement. Realists painted street scenes, often depicting dirty, unpleasant figures. Gustave Courbet organized the first Realist exhibit in 1855.

Real texture Texture that one can actually feel, as opposed to *visual texture,* which is a creation of the artist.

Recede To move back or to appear to do so. Cool colors can be described as receding when placed with warm colors.

Refraction In art, the breaking up of a light ray (such as white sunlight) by causing the ray to pass through a medium (such as a glass prism). This process produces a spectrum of the colors of the ray.

Relativity A theory postulated by Albert Einstein in 1916 which related mass, motion, and energy. Its impact on the sciences and on many abstract artists was enormous.

Relief A work of sculpture in which the forms project out from the surface or are sunk into the surface. See also *High relief* and *Bas-relief.*

Renaissance (ren-uh-sahns′) French for "rebirth." The Renaissance was the intellectual rebirth of Europe which began in Italy in the fourteenth century.

Repetition The compositional principle of design in which one visual element or object is repeated.

Reportage drawing Drawing from memory.

Representational art Renderings in which the natural world is depicted accurately. Compare *Abstract art.*

Reproduction A copy of a piece of art.

Restricted palette The selection of a limited range of hues for a color scheme.

Rhythm The compositional principle of design in which the artist repeats the same visual element or objects to create the illusion of movement and hold and direct the viewer's attention.

Ribbed vaults Structural supports used to distribute the downward thrust of a roof evenly and to allow the use of lighter material for the roof. See *Vault.*

Rococo (ruh-koh′koh) A very elaborate artistic style which began in France immediately following the Baroque period in the eighteenth century and spread throughout Europe. Rococo artworks are characterized by great charm, subtlety, and delicate colors and

designs; rococo music is characterized by elegance and formality.

Romanesque (roh-mahn-esk') A style of architecture and sculpture prominent in Europe during the mid-to-late Middle Ages, rooted in the Roman Empire styles. Cathedrals had Roman arches, and many had domes. They required thick windowless walls to support the heavy roofs. The interior walls were painted, filled with mosaics, sculpted, and hung with tapestries.

Romanticism A European style of art prominent during the early nineteenth century, characterized by brilliant colors, exotic settings, and a great deal of drama and action.

S

Samurai A warrior class which existed in Japan in the sixteenth century and served feudal lords.

Sculpture Three-dimensional artworks created by carving, modelling, assembling, or casting.

Seascape A painting or drawing of the sea, or one in which the sea is the dominant component.

Secondary colors Colors made from equal mixtures of the primary colors: green (blue + yellow), orange, (red + yellow), and violet, (blue + red).

Sepia (see'pee-uh) A reddish-brown pigment prepared from the ink of scuttlefishes, such as the octopus.

Shade A hue, made darker in value by the addition of black or a darker hue. Compare *Tint*.

Shading Darkening parts of a picture by hatching, or the use of dark hues to create the illusion of a three-dimensional form. Also the gradation of one tint or shade into another. See *Hatching* and *Crosshatching*.

Shadow The area of a painting or drawing containing the reflection of the least amount of light, used to help create the illusion of form. Compare *Highlights*.

Shang Dynasty (1700–1027 B.C.) The first of the great dynasties in China. The bronzework of the Shang Dynasty is still unsurpassed.

Shape The visual element of art that has two dimensions: height and width. A shape is formed when a line crosses itself, creating an enclosed space. See also *Geometric shapes* and *Free-form shapes*.

Shiny surface A surface that reflects light. Compare *Matte surface*.

Silhouette (sill-oo-wet') The outline drawing of a shape or form filled in with black or a uniform color.

Silkscreen A screen made of fine silk which is stretched on a frame and treated in such a way that it becomes a stencil. The image is made by squeezing paint through the untreated areas.

Sketch To quickly draw a preliminary study of a scene or figure. Also, the drawing itself.

Slip A mixture of clay and water used to fasten two pieces of clay together (for example a handle to a cup) or to coat a piece before firing, for special effects.

Soft sculpture A piece of sculpture made of soft materials (for example, a fabric cover stuffed with kapok).

Software A program or programs used to direct the computer to execute a specific task.

Solvent A substance, usually a liquid, that is capable of dissolving another substance or substances. Great care should be taken when using a solvent.

Song (or Sung) Dynasty (A.D. 960–1279) A period of unequaled accomplishment in painting and ceramics in China.

Space The visual element of art that is the void, or area surrounding and within shapes and forms. Shapes and forms are defined by space. See also *Positive space* and *Negative space*.

Special effects In motion pictures, images or sound content added through the process of film editing or other work that takes place after the filming has been completed.

Spectrum See *Color spectrum*.

Stabile An abstract sculpture similar in many ways to a mobile, but made to be stationary.

Stained glass Glass colored by the addition of pigments, then cut and arranged in a design. Stained glass was important for its decorative effect in Gothic cathedrals.

Stencil In the silk-screen process of printing, the surface through which ink is pressed and on which an image is formed.

Still life A picture of an arrangement of inanimate objects. Also, these objects, when used as a subject for a picture.

Stippling The technique of applying small dots of color with the tip of the brush in painting, or small dots of black or gray in drawing.

Stitchery The process of ornamenting a fabric by passing a threaded needle through the fabric. Also, the item made or decorated in this way.

Stone Age The period of history in which human beings used instruments, weapons, and utensils made of stone.

Stop-action photography The use of fast shutter speeds to achieve a photograph of a figure or object in motion.

Story boards A series of drawings that displays the outline of a story, for example, for television advertisements, animated cartoons, and motion pictures.

Stupa (stoo'-puh) A monument to Buddha. Stupas originated in India but are found throughout eastern Asia.

Subject That which an artwork represents. In a portrait, it is a person; in a landscape, the actual scene; in abstract art, it may only exist in the artist's mind.

Subordinate elements The elements of an artwork that are less noticeable than the dominant element.

Subtractive method The sculptural process of taking material away from a solid block.

Sunk relief A method of carving in which the design is entirely sunk beneath the surface of the block. See also *Relief, Bas-relief, High relief.*

Support surface See *Ground support.*

Surrealism A style of art developed shortly after the First World War which depicted the working of the subconscious and unconscious mind—the mind's fantasies and dreams.

Symbol Greek for "token" or "sign." In art, a visual image that represents something else.

Symmetrical balance See *Formal balance.*

T

Tang Dynasty A Chinese dynasty ruling from A.D. 618—907, famous for its art and literature. Tang art was designated the international style as the empire extended from the Caspian Sea on the west to the Pacific Ocean on the east.

Tapestry A woven, embroidered, or painted ornamental fabric used as a wall hanging.

Technique A means of expressing oneself visually through working with materials.

Tempera A paint in which pigments are mixed with egg white or other opaque liquids.

Template (or *templet*) A guide or pattern for the formation of a shape, such as a square or triangle.

Terra cotta A durable clay that is usually reddish brown in color after being kiln-burnt. Terra cotta is usually unglazed.

Tertiary color See *Intermediate color.*

Texture The visual element of art that employs the sense of touch; the feel of an artwork's surface. Texture may be natural, and actually have the feel that it appears to have, or visual, and only give the appearance of that texture. See also *Visual texture.*

Three-dimensional Having height, width, and depth, as in a sculpture. Compare *Two-dimensional.*

Thrust The stress that tends to push an architectural member of a structure outward.

Time exposure Exposure of film for a relatively long time. Also, the photograph that results from this process.

Tint A lighter value of a hue, created by the addition of white. Compare *Shade.*

Tipi A conical-shaped dwelling of the North American Plains Indians usually made of animal skins held up by an understructure of slim poles.

Tools Implements used to apply paint to a support surface, such as brushes, palette knives, sticks, or fingers.

Transparent The property of a material that allows light to pass through it so that objects beyond can be seen. Compare *Opaque.*

Two-dimensional Having height and width but not depth, as in a painting, print, or photograph. Compare *Three-dimensional.*

U

Unity The compositional principle of design in which all of the visual elements come together both as subject matter and as a design to create a feeling of wholeness and completeness.

User The person who is using the computer or giving the commands to the computer.

V

Value The degree of lightness or darkness of a hue, dependent upon the amount of light a surface reflects. One of the three properties of color. See also *Tint, Shade, Intensity,* and *Hue.*

Vanishing point The point at which receding parallel lines appear to converge on the horizon.

Variety The compositional principle of design through which different colors, shapes, forms, lines, patterns, textures, and sizes are used to add visual interest to an art work.

Vault An arched structure, such as a roof or ceiling.

Vehicle See *Binder.*

Visual arts The arts that are created to be seen.

Visual elements of art The elements artists use to create works of art: color, line, shape, form, space, and texture.

Visual movement See *Movement.*

Visual texture The illusion of texture created by the artist on a flat surface. See also *Texture*. Compare *Real texture*.

Volume The space within a form, such as an architectural form.

W

Warm colors Those colors of the spectrum that suggest warmness, including red, yellow, and orange. Warm colors seem to advance when used with cool colors. Compare *Cool colors*.

Warp The lengthwise threads in weaving.

Watercolor Transparent pigments mixed with water which are used as paint. Also painting made with such paints.

Weaving Forming a cloth by interlacing strands of material such as yarn.

Weft The horizontal threads in weaving.

Window The open working area displayed on the computer screen in which the imagery, data, and text appear when generating graphic images, charts, graphs, textual information, or when entering commands. The window is a temporary work area.

Woodcut An engraved block of wood. Also the print made by applying ink to this block and pressing it upon a surface.

World Mountain Massive architecture and sculpture created from a Cambodian concept around A.D. 900. An important example is the temple at Angkor Vat.

Y

Yarn A continuous strand of spun fibers used in making cloth, knitting, or weaving.

Z

Zhou (or Chou, Dynasty) (joh). A Chinese dynasty which lasted from 1027 to 227 B.C. During this period jade carving reached a peak and the philosopher Confucius (551–479 B.C) lived.

Ziggurats (zig'-uh-rats) Giant stepped temples of mud bricks constructed by ancient Mesopotamians. The interiors were decorated with fresco and sculpture.

INDEX

ACKNOWLEDGMENTS

Student Art

1. From the teaching files of the Palm Beach County, Florida Schools:

Figure 49A	*Figure 145B*	*Figure 146B*
Figure 49B	*Figure 146A*	*Figure 147*
Figure 145A		

2. From the collection of the authors:

Figure 66	*Figure 70*	*Figure 92*	*Figure 169*
Figure 67A	*Figure 71*	*Figure 101*	*Figure 171A*
Figure 67B	*Figure 80*	*Figure 102*	*Figure 186*
Figure 68	*Figure 90*	*Figure 103*	*Figure 187*
Figure 69A	*Figure 91*	*Figure 148*	*Figure 188*
Figure 69B			

Figure 170: Janice Milejczak. *Autumn Tree.* Conniston Jr. High School. Palm Beach County Schools, Florida. Jacalyn R. Garland, Teacher. *Figure 171A:* Adelise Smart. Charles/ Mixed media. Ft. Clarke Middle School. Alachua County Schools, Florida. *Figure 171B:* Consuela Cooper. *Self Portrait.* Jerry Thomas School. Palm Beach County Schools, Florida. Nancy DeDominicis, Teacher. *Figure 178:* Stephen Wilkson. *Untitled.* Palm Beach Gardens School. Palm Beach County Schools, Florida. William Walter, Teacher. *Figure 179:* Stephanie Smith. *Untitled.* Logger's Run School. Palm Beach County Schools, Florida. Mariellen Davis, Teacher. *Figure 201:* Elizabeth Kowalchuk. *Untitled.* Forest Hills School. Palm Beach County Schools, Florida. Pearl Mitchell Krebbs, Teacher. *Figure 202:* Courtesy Maryanne Corwin, Boca Raton High School. Palm Beach County Schools, Florida. *Figure 207A:* Group Project. *City With People.* Collographic Print. Gove School. Palm Beach County Schools, Florida. Rayburn White, Teacher. *Figure 207B:* From the collection of Joanna Brown, Art Supervisor, Palm Beach County Schools, Florida. *Figure 208:* Leslie Mansfield. *Untitled.* Wellington School. Palm Beach County Schools, Florida. Jim Housbrick, Teacher.